Drawing

FIFTH EDITION

a contemporary approach

Teel Sale

Claudia Betti

THOMSON ™
WADSWORTH

Australia • Canada • Mexico • Singapore • Spain
United Kingdom • United States

THOMSON

WADSWORTH

Art and Humanities Editor: *John R. Swanson*
Development Editor: *Sharon Adams Poore*
Assistant Editor: *Amy McGaughey*
Editorial Assistant: *Rebecca F. Green*
Technology Project Manager: *Melinda Newfarmer*
Marketing Manager: *Mark Orr*
Marketing Assistant: *Kristi Bostock*
Advertising Project Manager: *Vicky Wan*
Project Manager, Editorial Production: *Kathryn M. Stewart*
Print/Media Buyer: *Barbara Britton*
Permissions Editor: *Bob Kauser*

Production Service: *G & S Typesetters*
Text Designer: *Gopa*
Photo Researcher: *Lili Weiner*
Copy Editor: *Myia Williams*
Cover Designer: *Preston Thomas*
Cover Image: *Untitled* (detail) 1971, Cy Twombly.
 Cy Twombly Gallery, The Menil Collection, Houston.
 Gift of the artist. Design by *Preston Thomas.*
Cover Printer: *Banta Book Group/Menasha*
Compositor: *G & S Typesetters*
Printer: *Banta Book Group/Menasha*

For more information about our products, contact us at:
Thomson Learning Academic Resource Center
1-800-423-0563
For permission to use material from this text, contact us by:
Phone: 1-800-730-2214 **Fax:** 1-800-730-2215
Web: http://www.thomsonrights.com

Library of Congress Control Number: 2002115362

ISBN 0-534-61335-7

Wadsworth/Thomson Learning
10 Davis Drive
Belmont, CA 94002-3098
USA

Asia
Thomson Learning
5 Shenton Way #01-01
UIC Building
Singapore 068808

Australia/New Zealand
Thomson Learning
102 Dodds Street
Southbank, Victoria 3006
Australia

Canada
Nelson
1120 Birchmount Road
Toronto, Ontario M1K 5G4
Canada

Europe/Middle East/Africa
Thomson Learning
High Holborn House
50/51 Bedford Row
London WC1R 4LR
United Kingdom

Latin America
Thomson Learning
Seneca, 53
Colonia Polanco
11560 Mexico D.F.
Mexico

Spain/Portugal
Paraninfo
Calle/Magallanes, 25
28015 Madrid, Spain

PREFACE

Drawing holds a formative, critical place in today's art, both in aesthetics and practice. Contemporary drawing involves complex responses, innovative practices, and reassessment of significant definitions established over the past century. Drawing in the twenty-first century plays a seminal role in rethinking and redefining key issues such as the discourses of Modernism and of Post-Modernism, of language and art, the relevance of art history to contemporary art, and the role of art in a sociopolitical context.

The word *contemporary* in this book's title has two implications: First, the drawing methods are up to date, and second, the artistic concepts and concerns considered in the selection of the illustrations are current. We have emphasized art's multidimensional pursuit of significance, which frequently means going beyond the conventional rules of composition. It is our hope that students will begin to look at contemporary art's relationship to earlier art in terms of continuity and challenge, and to recognize that today's art has its roots in a long-standing tradition. In a time of cultural upheaval, artists have turned their energies in new and different directions to frame their work in the context of cultural changes.

In *Drawing: A Contemporary Approach* the formal elements are presented through a study of spatial relationships. The text is built around a series of

related problems, each of which is designed to develop fluency in drawing, offer experience in handling media, foster self-confidence, and promote an understanding of art elements and their role in the development of pictorial space. Further, the text introduces a vocabulary that reflects new concepts and current concerns in art.

Through our own experience we know that drawing can be taught effectively using the approach set forward in this book, presenting rationally determined problems in a logical sequence. This edition contains a large number of new problems, along with others that have been updated to reflect today's art practices. All have been specially designed to stimulate students to make sensitive, intellectual, and emotive responses in solving them. A related series of fundamental steps and diverse techniques lead student-artists to discover their own capabilities and powers of observation and execution. Relevant to this goal is the addition of sketchbook and computer projects related to the topic of each chapter.

In this new edition we have aimed for the full spectrum of drawing practices used by the present generation of artists. Pictorial processes and analytical bases are amplified. We investigate the numerous means contemporary artists employ to overturn the structure of the common perception of an image, and how they extend the limits of conventional art space.

Diligence and commitment to the practice of drawing are hallmarks of this book. Through illustrations of works on paper, prints, watercolors, paintings, photography, and even sculpture, we have presented the incredible range of possibilities open to present-day artists. This broad range of art production demonstrates to the student the indispensable role of drawing in every aspect of art making.

In keeping with current art trends, this edition includes the work of a large number of international artists, ethnic artists, and self-taught artists. Engagement with another culture's art is like learning another language; it enriches our understanding and offers us clues to cultural grounding.

All the chapters have been revised to incorporate contemporary developments, and analysis of new work has been included. The opening section of Part II, "Spatial Relationships of the Art Elements," has been amplified with an extended discussion of historical treatment of spatial conventions, along with an expanded section of illustrations. The number of color plates has also been increased. Major changes appear as well in Chapter 10, "Thematic Development," where new themes in appropriated images, the figure, and portraiture are included, along with the theme of word-and-image.

Major insights into the wonderful complexity of the art scene, we hope, can be gained through the topics highlighted in Chapter 11, "A Look at Art Today." In this chapter we have explored the discourse concerning Modern and Post-Modern art, and the role that drawing plays in such new areas as appropriation, installations, body art, systems art, and outsider art.

We hope this book will direct students along an ambitious path of growth in visual, intellectual, imaginative, and aesthetic responses; we hope it will help them recognize that art is the mirror of our times and that it is our duty to consider carefully these reflected images.

I wish to thank those who have assisted and encouraged me in preparing this book, especially my husband, Rick, a great art companion and editor, and my son, Thomas, who prepared the newly added computer projects. I would like to express appreciation to the reviewers: Martin Ball, Kent State

University; Jen Dietrich, University of Minnesota–Duluth; Laura Hargrave, University College of the Cariboo; Janet Nesteruk, Northwestern Connecticut Community-Technical College; Masha Ryskin, SUNY Brockport; and Jessie L. Whitehead, Lincoln University of Missouri. I would also like to express my appreciation to the Wadsworth team for their hard work and support: John R. Swanson, Sharon Adams Poore, Rebecca F. Green, Melinda Newfarmer, Kathryn M. Stewart, and Mark Orr. I want to acknowledge the inspired work of Lili Weiner, our photo researcher. And finally, thanks to Gretchen Otto and the staff of G & S Typesetters.

It is my hope that this book not only helps prepare students for a career in art but for a life in art as well.

Teel Sale
Denton, Texas
January 2003

DEDICATION

For the best art companions, critics, and
collaborators—Rick, Tom, and Dottie.

T.S.

CONTENTS

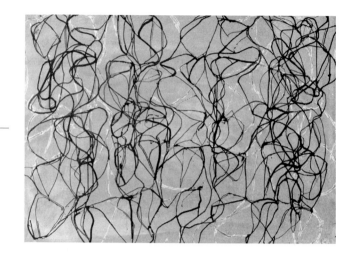

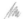
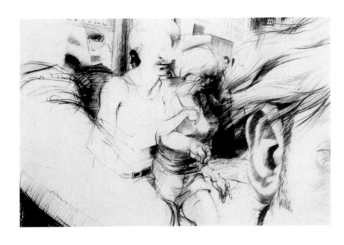

PART II
Spatial Relationships of the Art Elements

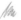

CHAPTER 6 *Texture* 193

CHAPTER 7 *Color* 223

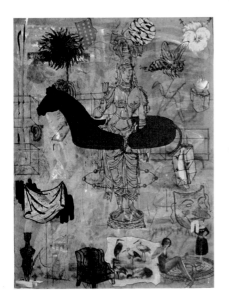

PART III

A Contemporary View

CHAPTER 9 *Organizing the Picture Plane* 273

CHALLENGES TO TRADITIONAL COMPOSITIONAL
 APPROACHES 273

CHAPTER 10 *Thematic Development* 299

PART IV

Practical Guides

INTRODUCTION
TO
DRAWING

Drawing:
Thoughts and Definitions

Drawing is the true test of art.
J.-A.-D. INGRES

DRAWING SPEAKS IN A VOICE LIKE NO other art form. Drawing provides a common ground for communication; it offers us a dialogue with ourselves and with others, the viewers. It engages us on vital emotional, intellectual, and spiritual levels. Focusing on time, space, and energy, artists give material form to their ideas, and nowhere are these ideas more readily accessible than in drawings. Drawing can turn fragile material into conceptual strength. It can record a fleeting movement with the sweep of the implement across the page. Drawing is as intimate as a hushed conversation; it is as personal as the artist's touch and as revelatory as an artist's signature. It extends both mind and spirit; it is an exciting activity that promotes a deep respect for looking and thinking. It has been called the most delectable of all the arts.

Drawings have an appeal because of their immediacy and their ability to reveal how they were made. In his book *The Sense of Sight* (p. 149), the British

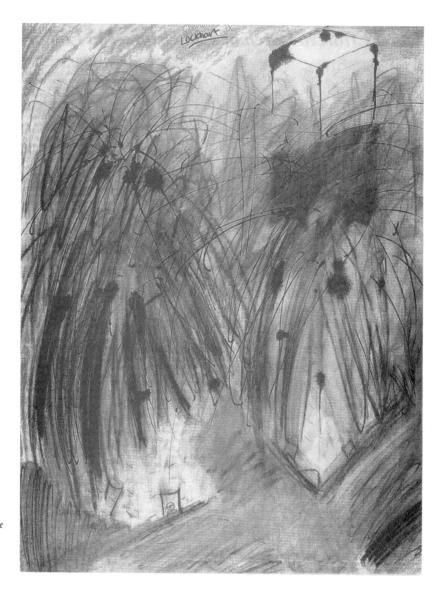

1.1. CHARLOTTE LOCKHART. *World Trade Center*. Drawing. 9th grade, Greenwich Academy, Greenwich, Conn. Permission granted by the Lockhart family.

critic John Berger observed, "The drawn image contains the experience of looking. . . . A drawing . . . encompasses time." Diversity is its middle name. A drawing can be autobiographical, political, polemical, didactic, playful, dramatic, poetic, informative, or conceptual. It can be as small as a stamp or as monumental as a wall. It can be as quiet as a single mark or as busy as an anthill.

Drawing can address a particular experience, and although it does not make the relationship between the personal and the universal fully and completely explicit, the drawing can afford insightful glimpses into that experience. The agitated, explosive, and expressive drawing in figure 1.1 was made by 14-year-old Charlotte Lockhart after the World Trade Center disaster on September 11, 2001. Charlotte said, "I sort of felt better" after making the drawing. "It didn't help totally. . . . But it does help a little to express what you're feeling." Schoolrooms around the country were forums for students to

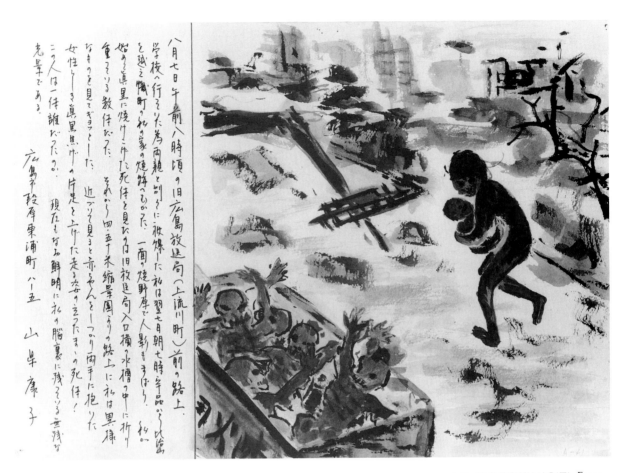

八月七日午前八時頃の旧広島放送局（上流川町）前の路上。

学校へ行く途中、両親と別れに被爆した私は翌七日朝七時半頃から比治山を越え幟町の私の家の焼跡へ向った。一面の焼野原で人影もまばら。私は始めて真黒に焼けこげた死体を見ながら旧放送局へ入口横の水槽の中で祈り重ねている数体だった。それから四・五十米縮景園より路上に私は異様なものを見てギョッとした。

近づいて見ると赤ちゃんをしっかり両手に抱いた女性らしき真黒焦げの片足を上げた走る姿の立ったままの死体！

現在もなお鮮明に私の脳裏に残っている無残なこの二人は一体何だったか。

広島市段原東浦町八一五　山畠康子

先輩である。

1.2. YASUKO YAMAGATA. From *Unforgettable Fire, Pictures Drawn by Atomic Bomb Survivors.* Hiroshima Peace Culture Foundation, Hiroshima. © By permission of NHK (Japanese Broadcasting Corp.) and Hiroshima Peace Culture Foundation.

express their feelings about the horrific event. The healing effect of expressing one's feelings through visual means is employed by people of all ages and from all parts of the globe.

The act of drawing can evoke memories; it can call up feelings; it can shed light on life's impulses—on death, love, power, play, intellectual pursuits, work, and on our dreams and emotions. What wrenching memories the drawing in figure 1.2 elicits! It was made by a 49-year-old Japanese survivor of the "unforgettable fire" caused by the atomic bomb dropped on Hiroshima in 1945. Alongside the drawing is a written description of that event. Although it was not drawn by a professional artist and, in fact, was made more than 30 years after the bombing, the impressions the drawing conveys reverberate with the horror and immediacy of the moment. Clearly, our interest in these two drawings is not art-critical: They are depictions of terrifying events. The affinity between the two works is fundamental; both convey human responses that speak volumes more than mere media accounts.

The concentration required in looking at and questioning the appearance of objects and the sheer exuberance of making things has not changed since the earliest drawings were made. We humans have had a long history of making our marks on the world, an impulse that began in prehistoric times and continues to the present. The engaging cave drawing from southeastern

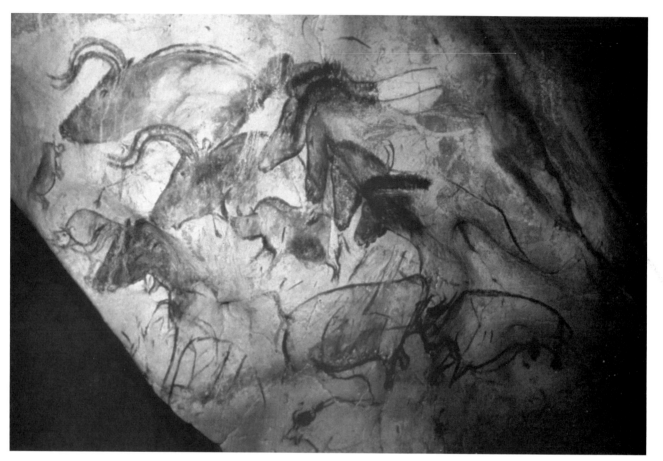

1.3. Chauvet cave paintings at Vallon Pont-d'Arc, France. © Jean Clottes/Sygma/Corbis.

France, over 30,000 years old, is one such work (figure 1.3). The group of animals, whose overlapping contours transform into a living image, features simple but well-observed profiles. The more than 300 animal drawings found in the cave were accompanied by a group of red handprints of the artists who made the images with charcoal, ochre, and red hematite. Although the cave painters' intent is different from a graffiti drawing done in our time (figure 1.4), both drawings share an exuberance regarding what it is like to be alive. In some deeply satisfying way, mark making affirms our presence in the world. The directness and physicality of drawing are basic to its nature. The notion of mark making is a key to the identity of the medium.

Art—especially the discipline of drawing—along with philosophy, history, and literature, helps us interpret our experiences visually, emotionally, and aesthetically. As mature human beings we try to create wholeness in ourselves; one recognized way to achieve that goal is through the creative process. For the visual artist, drawing lies at the very core of that process.

Drawing is the most democratic of all art forms, and today, as never before, it connects us directly to artists worldwide. Influences on contemporary drawing come from all parts of the globe. There is an inclusiveness of expressions in current drawing ranging from Southeast Asian images to African textiles. The drawing (figure 1.5) by the filmmaker Nina Sabnani is a still from her

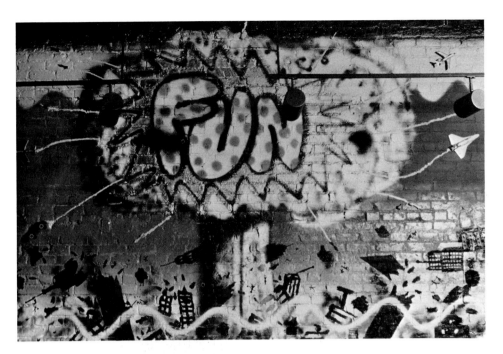

1.4. KENNY SCHARF. *Untitled (Fun)*. 1982. Spray paint on wall, Tony Shafrazi Gallery. © 1996 Kenny Scharf/Artist Rights Society (ARS), New York.

film *Shubh Vivah*, which confronts the issue of dowry. The style of the animation frames is derived from traditional ritual paintings made by the women of Bihar, India, with whom Sabnani collaborated. The stylized work is based on mythological themes. Traditionally the paintings were made as a preliminary installment of dowry that confirmed the marriage contract. In Sabnani's film the images pose a protest against that primitive practice.

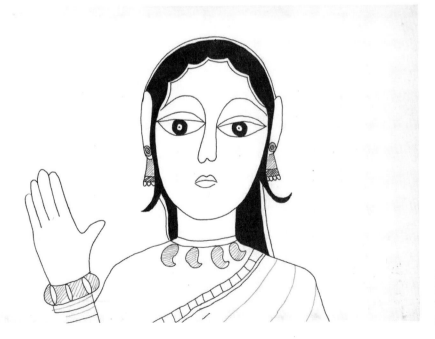

1.5. NINA SABNANI. Still from *Shubh Vivah* (*Happy Wedding*), based on ritual art by women of Mithila, Bihar. 1984. Permission granted by Nina Sabnani.

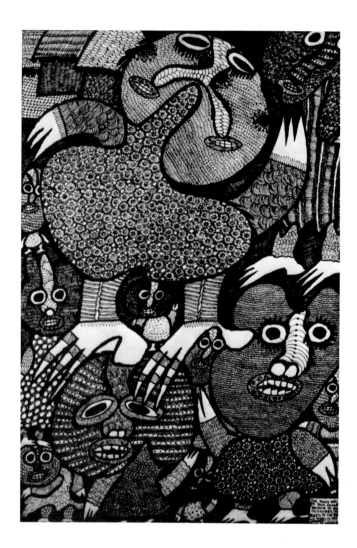

1.6. MICHAEL ABYI. *The Twins Who Killed Their Father Because of His Properties.* Ink on fabric, 2'9" × 1'10" (84 cm × 56 cm). Collection Claudia Betti. Photo by Pramuan Burusphat.

The African artist Michael Abyi also deals with a mythic subject in *The Twins Who Killed Their Father Because of His Properties* (figure 1.6). The artist's fertile imagination has conceived fantastic creatures made up of invented textures and shapes in a compact space. Abyi has drawn the images with dye on fabric. Drawings such as Sabnani's and Abyi's are valued not only for their accessibility but for their intimacy and their potential to work through ideas. This conceptual approach is called *visual thinking;* along with much practice at making and looking at drawings comes the more evolved stage of visual literacy and acceptance of different cultures, ideas, and people.

Drawings can have their effect with the most modest of means—one only need think of the childhood pleasure that came from making marks in the sand as Zairian children are doing in figure 1.7. Not only artists make drawings, of course; people of all ages and from all walks of life participate joyfully in this activity. Elizabeth Layton, a woman in her nineties, came to art late but she has made a successful career making art whose subject is youthful old age. In her drawing (figure 1.8) we encounter a new/old Cinderella. This fresh interpretation is a fantasy based on a childhood story; the shaky line comes from

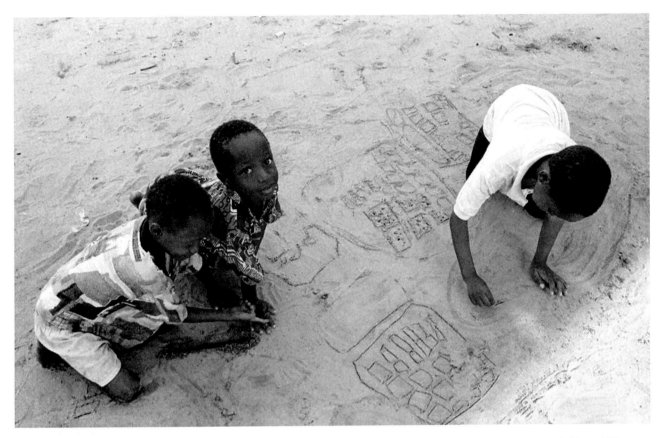

1.7. Photo of Zairian children. AFP Photo/Christophe Simon.

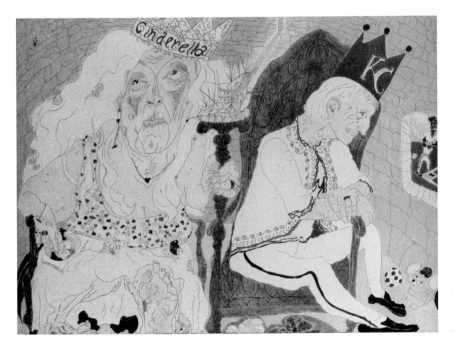

1.8. ELIZABETH LAYTON. *Cinderella.* 1986. Lithograph, 1′10″ × 2′6″ (56 cm × 76 cm). Lawrence Arts Center, Kans. Gift of the artist.

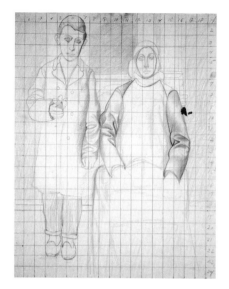

1.9. ARSHILE GORKY. Sketch for *Portrait of the Artist and His Mother.* 1926–1936. Graphite on squared paper, 2′ × 1′7″ (61 cm × 48.3 cm). Alisa Mellon Bruce Fund, Photograph © 2002 Board of Trustees, National Gallery of Art, Washington. © 2003 Estate of Arshile Gorky/Artists Rights Society (ARS), New York.

a hand that may be trembling but whose direction is sure. Layton's vivacious and imaginative art is like the play of children, finding symbolic, emotional meaning in objects and situations. Through her art we have a foretaste of what it is like to be old and to have a great sense of humor.

Across time and cultures drawing has always ranked high among the visual arts. From the Renaissance to the end of the nineteenth century, drawing was regarded as a conservative medium, seldom the subject of innovation. It was seen as a first step in the early idea of a work, a support to painting, sculpture, and architecture, and it still serves artists in this manner, as can be seen in figure 1.9. Arshile Gorky's preparatory drawing itself is derived from a photograph taken in Armenia, where he was born in 1912. Using this image, a double portrait of himself and his mother, he painted two versions. Gorky drew and redrew many preliminary sketches and studies, confirming the conceptual effort that went into their making. His experimental variations are the product of inventive manipulations. The drawing has been overlaid by a grid to help the artist accurately transfer the image to the canvas in preparation for painting.

In the Renaissance, drawing was particularly suitable for visually describing the newly emerging disciplines of anatomy, perspective, and geometry, and it required the most stringent intellectual application. Artists have always valued other artists' drawings, but it was only in the seventeenth century that collectors other than artists began to display drawings in rooms called "cabinets," rooms with especially built storage drawers where drawings could be taken out, admired, and studied. Drawing—no longer a subsidiary to painting, sculpture, and architecture—was established as a major discipline in its own right. The attention paid to drawing continued to the twentieth century, and from the 1950s to the present there has been a graphic explosion unlike any other period in art. Think of how many images one comes in contact with on a daily basis, in magazines and books, on television and in films, in advertisements, on billboards, in newspapers, and on computers. The World Wide Web is itself a web of images.

Traditionally drawings can be classified into four types:

1. Those that investigate, study, and question the real, visible, tangible world.
2. Those that record objects and events.
3. Those that communicate ideas.
4. Those that are transcriptions from memory—a way of collecting and keeping impressions and ideas, a way of making visible the world of our imagination.

The sketch has been a traditional first step in a long path that leads to a more finished work of art, and although artists still use sketches as preliminary steps, drawing as an independent activity, as an end in itself, is an emphasis of contemporary art.

Drawing serves a wide variety of purposes: from psychological revelation to dramatic impact, from social commentary to playful, inventive meandering, from accurate transcription to vigorous, informal notation. Increased freedom in all art forms is a characteristic of our times, and certainly drawing has been in the forefront of innovation. New graphic technologies are introduced daily, and because drawing has proven to be a flexible discipline for

1.10. TERRY WINTERS. *Graphic Primitives.* 1998. A set of nine laser-cut woodblocks, each 1'6" × 2' (46.2 cm × 61.5 cm). Courtesy of the artist and Matthew Marks Gallery, New York.

experimentation, it has gained strength and vitality from its newfound role. We can easily classify computer-generated images as drawings: They make use of graphic means, they employ the art elements of line, color, shape, texture, and value, and they are on paper. Terry Winters scanned his original drawings into a computer and manipulated them by elongating, enlarging, repeating, and reducing. The final digitized drawing was then used as a master to program a laser cutting of a woodblock from which the final prints were made (figure 1.10). They resemble aerial views of a landscape or targets for a bomb site. It is interesting to note that although they have a digital, electronic look, they are definitely revelatory of Winters's stylistic signature. Many digital works bear no such relationship with the artist's style; these are extraordinary works, interesting for the process and for the final product.

So as not to limit its definition to pure graphic means (a more traditional definition), the term *works on paper* emerged, used by museums, galleries, and art critics to designate a broader category to include all things on paper, such as printmaking, photography, book illustration, and posters, but even this expanded classification does not fully cover the role of drawing. As we have seen

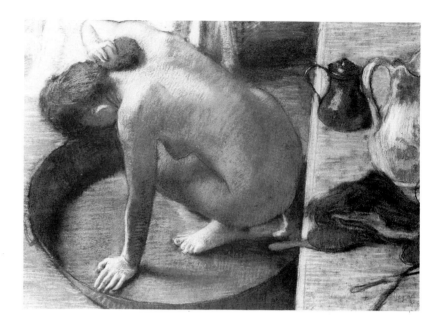

1.11. EDGAR DEGAS. *The Tub.* 1886.
Pastel on cardboard, 2′4⅝″ × 2′8⅝″
(73 cm × 83.2 cm). Musée d'Orsay, Paris.
© Photo RMN, Paris.

in graffiti and prehistoric rock drawings, mark making can be done on any surface—clay, glass, fabric, even on the earth itself.

Historically, the implement and the hand served as the foundation of draftsmanship, but in contemporary art, it is frequently the appearance of the material, the smudges and marks of the medium itself, that are privileged over recognizable subject matter. Long thought of as "the mother of the arts," drawing was at the same time foundational, basic, and peripheral, seen primarily as the preparatory step in the development of both idea and form. In Renaissance Italy, drawing (*disegno*) not only embodied the creative idea but also was revelatory of both the draftsman's manual dexterity and of his cognitive process, or the strength of his ideas. Today drawing is a preeminent medium: it is economical—that is, ideas and images can be quickly sketched; it is flexible; it is open to experimentation. New technologies stretch its boundaries even further; drawing's parameters have yet to be approached. The physical allure of a drawing, the sensuality of the various drawing media and surfaces, is appealing. Many a child has thrilled to the gift of a new box of crayons and a pristine new drawing pad.

The immediate past plays a historically important role in the formation of more recent art. Impressionism in the late nineteenth century pointed the way for drawing on its path toward independence. In Edgar Degas's work, his drawings are not subsidiaries of the paintings (figure 1.11). Concerns that are still pertinent to today's artists occupied Degas: how to fit the figure into the limits of the paper, how to resolve a composition that is divided, how to compress a three-dimensional form onto a two-dimensional surface.

In the latter part of the nineteenth century, the Post-Impressionist Georges Seurat clearly stated his ambition to make drawings that were equal in importance and in finish to paintings. He aimed for an independence of draftsmanship, not secondary to or preparatory for a painting; his goal was to redefine, reinvent, and reinvigorate drawing. The portrait of the artist's mother

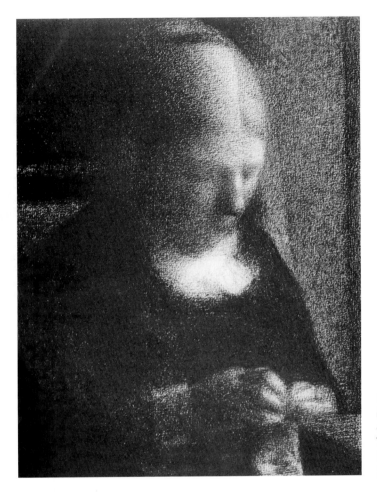

1.12. GEORGES SEURAT. *The Artist's Mother (Woman Sewing).* 1882–1883. Conte crayon on paper. 1′¼″ × 9½″ (31 cm × 24 cm). The Metropolitan Museum of Art, Purchase, Joseph Pulitzer Bequest, 1955 (55.21.1).

(figure 1.12) suggests a mysterious isolation; it is exact, thoughtful, and exquisitely controlled. The image is not delineated by line; rather, the figure emerges quietly in its stately, simple shape from the dark space that encompasses it. The interior space reinforces the idea of the woman involved in a meditative activity, *Embroidery,* the title of the drawing.

Not until the mid-eighteenth century were drawings framed and hung on walls. The first work of an artist to be displayed in a public exhibition was a large drawing by a friend of Seurat, Edmond-François Aman-Jean. It was exhibited in Paris at the Salon des Independants in 1883.

Our aesthetic underwent radical changes during the fast-paced twentieth century. As modern viewers came to accept fragmentation in real life, many drawings that previously were seen as unfinished came to be accepted as complete. Paul Cézanne, often acclaimed as the father of modern art, pointed drawing in a new direction. He affirmed the role that intelligence and conceptualization play in art; he defined art as personal perception. The study of Cézanne's work reveals the concentration and freshness of purpose he brought to each work of art. He aimed at integrating line and color; he saw drawing as a means of structurally organizing space and volume. His approach was first to

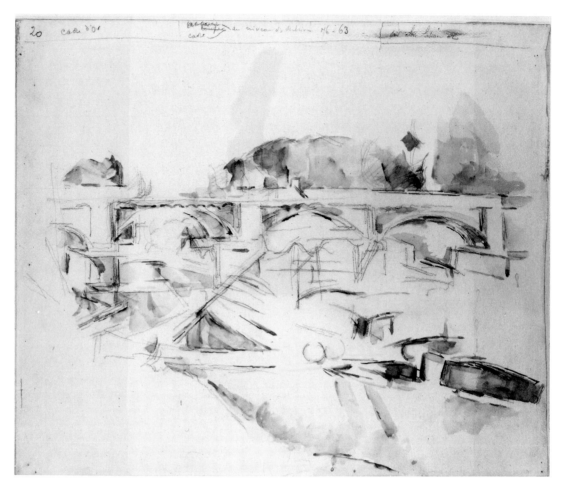

1.13. PAUL CÉZANNE. *View of a Bridge.*
c. 1895–1900. Watercolor over black chalk,
1′7¼″ × 1′11⁹⁄₁₆″ (4.89 m × 5.98 m).
Yale University Art Gallery. The Philip L.
Goodwin, B.A. 1907 Collection.

draw in lines, gradually constructing planes from the grouped fragmented lines. In *View of a Bridge* (figure 1.13), Cézanne requires the viewer's full participation to relate line with shape. The viewer must mentally fill in his lost-and-found line.

Although contemporary artists have not relinquished drawing's traditional functions, they have seriously reconsidered and transformed the nature of drawing and its uses. In the years before World War I, a real innovation in drawing was the introduction of collage into fine art by the Cubists (figure 1.14). The new popular technique posed important art questions concerning what is real and what is illusionary. Some critics have called collage the most notable innovation in drawing in 300 years. In the 1950s and 1960s artists began an in-depth appraisal of drawing and its role in art. They redefined the very nature of art, mixing categories and blurring borders between drawing, photography, sculpture, painting, and objects from the real world. Mixed-media works are now in the forefront of art. Issues of perception and representation have been reassessed. This reflexive examination is still a major component of art. Expansive, even explosive, trends in contemporary art have given drawing a more inclusive and active role than ever before.

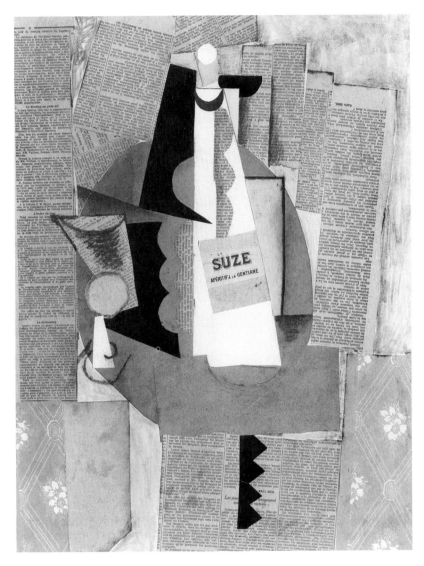

1.14. PABLO PICASSO. *Bottle of Suze.* 1912. Charcoal, gouache, and pasted paper, 2'1¾" × 1'7¾" (64 cm × 50 cm). Washington University Gallery of Art, St. Louis. University purchase, Kende Sale Fund, 1946. © 2003 Estate of Pablo Picasso/ Artists Rights Society (ARS), New York. Photograph © 1997 The Museum of Modern Art, New York.

The process of creating art may seem like a confusing maze to the beginning student. A way through this complexity is to recognize that art has certain categories or divisions. Drawings, as we all know, are not of interest only to artists; illustrators, choreographers, designers, architects, scientists, filmmakers, engineers, and technicians make extensive use of drawings. Just as there are different uses for drawings, there are many types of drawings.

SUBJECTIVE AND OBJECTIVE DRAWING

In its broadest division, drawing can be classified as either subjective or objective. *Subjective* drawing emphasizes the artist's emotions; *objective* drawing, on the other hand, conveys information more important than the artist's feelings.

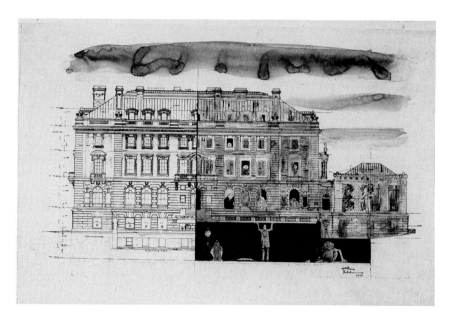

1.15. CHARLES ADDAMS. (United States, 1912–1988). *Embellished Elevation of the Carnegie Mansion.* 1975. Watercolor on photostat, 1'6⅟₁₆" × 2'1⁷⁄₁₆" (45 cm × 64.6 cm). Cooper-Hewitt Museum, Smithsonian Institution, gift of Nino Luciano. Art Resource, New York. 1975-87-1.

The left half of the drawing by the humorist Charles Addams (figure 1.15) is an elevation of the facade of the Carnegie Mansion; it is concerned with design information such as measurement, scale, and proportion between parts, and thus belongs to the objective category. The right half of the drawing, however, is subjective, ridiculous and playful in its embellishment of what is today the Cooper-Hewitt Museum. Addams has ensconced his macabre cartoon characters in and under the mansion. A group of artists was invited to commemorate the museum's seventy-fifth anniversary by altering the architectural drawing of the building. Artists were asked to use the elevation plan of the museum as a backdrop for their transformations. Addams's subjective images stand in sharp contrast to the objective mechanical rendering of the museum.

Another set of drawings that clearly contrasts the subjective and objective approach can be seen by comparing an anatomical drawing made in the seventeenth century with a work made in the twentieth century. For an anatomical illustration (figure 1.16), it is important that every part be clearly visible and descriptive. It is surprising to realize that it was not until the sixteenth century that anatomical drawings were made from actual observation of the body. Pietro da Cortona, an Italian artist, worked with a surgeon during actual dissections. Although anatomical figures offer a wealth of scientific information, our modern sensibility finds Pietro's drawings odd owing to their lifelike poses and their placement in a classical landscape. The culture in which an artwork is made is a strong determinant; without actually knowing the date of this work, one could estimate in what century it was made.

When we compare Pietro's drawing with one by Jean-Michel Basquiat (figure 1.17), we see what a great distance in time and sensibility the practice of drawing has traveled. The skull has always been a popular artistic and literary image because of its emotionally loaded content. Basquiat depicted his mask-like yet animated skull using a primitive, crude technique that is characteristic of his work. The images are drawn in a primitive style that supports the underlying content. Basquiat's cryptic imagery takes on the appearance of a

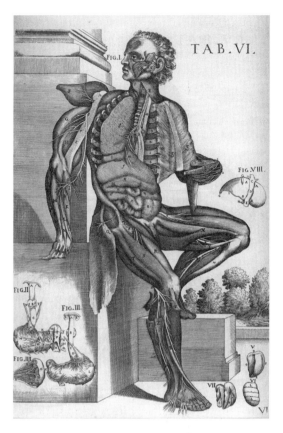

1.16. PIETRO DA CORTONA. Plate VI from *The Anatomical Plates of Pietro da Cortona.* 1618. Copper engraving.

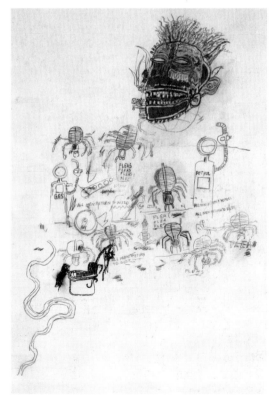

1.17. JEAN-MICHEL BASQUIAT. *Untitled (Fleas).* 1986. Graphite, oilstick, and ink on paper, 3'6" × 2'5⅞" (1.07 m × 74 cm). Courtesy the artist. © Jean-Michel Basquiat/Artists Rights Society (ARS), New York/ADAGP, Paris. Robert Miller Gallery, BASQ-1124.

secret, symbolic, hieroglyphic language. We imagine the artist working in a frantic, obsessive mode as if an inner demon were directing the drawing. The play on the word "flea" and its homonym or sound twin, "flee," gives us a clue to unravel the artist's coded message. The trailing lines suggest a pathway leading off the page; the gas pumps are a power source for movement, and together the images reinforce the idea of "fleeing." The repeated phrase "All men return to dust" reiterates the idea of a journey. The dominant death's head leaves the viewer in no doubt that the journey Basquiat has in mind is the final one.

This subjective style not only conveys the artist's heightened feelings but engenders a heightened response from the viewer as well. Basquiat's seemingly untrained handling of the media supports the raw and unwelcome message. Of course, not all subjective drawings are as extreme as Basquiat's, nor are all objective drawings as readily classifiable as an anatomical illustration.

Informational Drawing

Informational drawing falls under the objective category and includes diagrammatic, architectural, and mechanical drawings. Informational drawings may clarify concepts and ideas that are not actually visible. Many serious twentieth-century artists have used art as documentation and information. The husband-and-wife art collaborators Christo and Jeanne-Claude use Christo's drawings in their presentations requesting permission from authorities to execute their involved work. Figure 1.18 is a drawing made for a project in Colorado, proposing the installation of a series of horizontal fabric panels over the Arkansas River. Christo combines photographs, collage, and drawing to create an accurate visual description of the curtained river as it will appear when installed. The viewer is thus presented with two categories of visual information. The drawing both reveals the outer form and conceals the inner structure of the altered landscape, and the drawn contour map at the top of the drawing gives the exact location of the segment of the river to be covered. The schematic

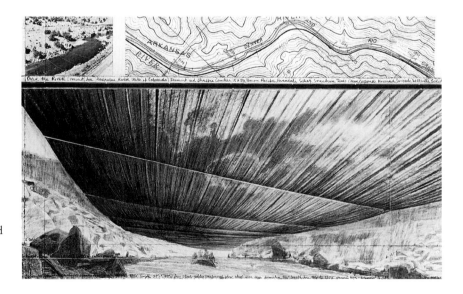

1.18. CHRISTO. *Over the River: Project for the Arkansas River, State of Colorado. Drawing 2001.* 2001. Pencil, pastel, charcoal, wax crayon, photograph by Wolfgang Volz, hand-drawn topographic map on tracing paper and tape. In two parts, 1′3″ × 8′ and 3′6″ × 8′ (38 cm × 2.44 m and 1.07 m × 2.44 m). Photo Wolfgang Volz. © 2004 Christo.

map traces the contours of the adjacent mountains and highlights the path of the river. Christo and Jeanne-Claude wrap and curtain landscape sites as well as urban structures such as bridges and buildings; dramatic and unexpected sculptural forms result. To receive permission for their engineered projects, Christo and Jeanne-Claude must make appeals to multiple public entities. The drawings are an invaluable means to communicate complex spatial and structural solutions to the authorities who grant permission. The interaction with the public is engaging on multiple levels: environmentally, politically, socially, culturally, educationally, aesthetically, and economically (the sale of drawings, collages, and early work pays for the expenses of the projects).

Diagrammatic drawings, a type of working drawing, demonstrate a visual form of shorthand. They are used widely in designs for buildings and city planning. Plan drawings make use of a code or a key that relays essential data contained in the drawing, such as information concerning construction materials and scale.

The architect Zaha Hadid was born in Baghdad, Iraq, and now works in London. She has achieved worldwide attention for the innovative nature of her designs. To convey her new visions, she has adopted radical methods of representation, departing from traditional architectural drawings. In figure 1.19 we see one of her dynamic site plan drawings. Influenced by modern art of the twentieth century, Hadid combines the traditional flat, two-dimensional plan with an illusionistic three-dimensional segment that emerges from the center of the drawing. Her work embodies the idea that social and technological changes require new uses of space and new attitudes to our built environment. Her building plans have a vibrating life, reflecting Hadid's philosophy that buildings are not static objects but animated extensions of the people who inhabit them.

Just as there is a key to reading a diagrammatic drawing, there is a key to reading artists' drawings, and that key is to be like Hadid: open, alert, absorbed, and focused on the visual material at hand.

Schematic Drawing

Another type of objective drawing is the *schematic* or *conceptual drawing*, a mental construct rather than an exact record of visual reality. A biologist's schematic drawing of a molecular structure is a model used for instructional purposes. Comic book characters and stick figures in instruction manuals are familiar examples of schematic drawings. They are an economical way to give information visually. We know what they stand for and how to read them. They are *visual conventions*, just as the cowboy riding into the sunset is a literary convention. Such schematization is easily understood by everyone in Western culture.

The two broad categories of subjective and objective overlap. A schematic or conceptual drawing may be objective, such as those used in an instruction manual. Or it may also be subjective, like a child's drawing in which the proportions of the figure are exaggerated in relation to its environment and where scale is determined by importance rather than by actual visual reality.

Saul Steinberg, an artist involved with the philosophy of representation, uses the schematic, cartoon approach in a subjective manner to parody

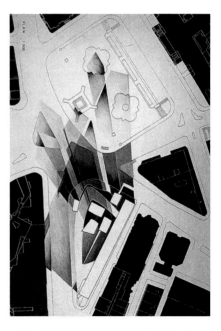

1.19. ZAHA HADID. *Site Plan for Grand Buildings Project.*

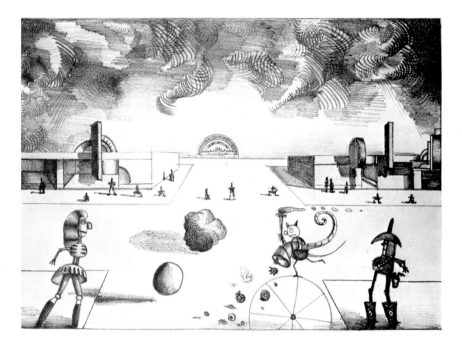

1.20. SAUL STEINBERG. *Main Street.* 1972–1973. Lithograph, printed in color, 1'3¾" × 1'10" (40 cm × 56 cm). Museum of Modern Art, New York. Gift of Celeste Bartos. © 2003 The Saul Steinberg Foundation/Artists Rights Society (ARS), New York. Photograph © 1997 The Museum of Modern Art, New York.

contemporary life. In *Main Street* (figure 1.20), he employs a number of conventions to indicate movement. The swirling lines used to depict the clouds suggest a turbulent sky; the cloud and ball, trailing long shadows, seem to be scurrying along at a quicker pace than the rather static figure, whose thrown-back arms and billowing skirt are indicators of a slower motion. The humorous intent is intensified by a shorthand style; in other words, "reading" the conventions is part of the enjoyment of the work; it is like recognizing an inside joke. Steinberg thought of drawing as a kind of writing. His work crosses the division between popular and fine art. Not only is his work shown in galleries, it is also seen on magazine and book covers and is published in the form of cartoons and posters. A flourishing movement in contemporary art involves schematized drawings that employ apparently direct and simple means to carry sophisticated ideas and subjective expression.

Pictorial Recording

Another important category in drawing is *pictorial recording*. The medical illustrator, for example, objectively records an image with almost photographic accuracy. Realism has both traditional and contemporary advocates. Art terminology makes a distinction between various types of realism, such as naturalism, social realism, romantic realism, surrealism, magic realism, hyper-realism, and photo-realism. Imitating certain photographic techniques can lead to highly subjective effects. It has been observed that contemporary realism is more sharply focused than in earlier treatments of realism. A number of contemporary artists are concerned with duplicating what the camera sees—both its focus and distortion. This movement is known as *Photo-Realism*. The work of these artists suggests a bridge between subjective and objective art, for even in

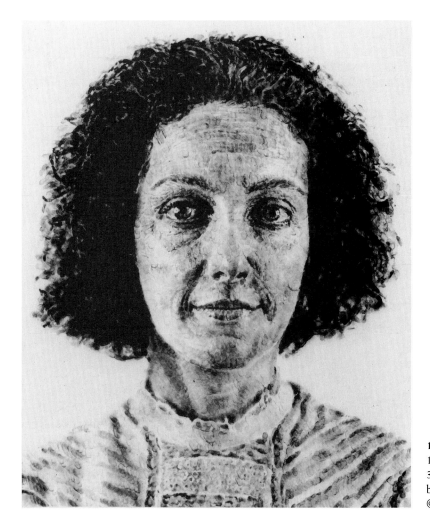

1.21. CHUCK CLOSE. *Emily/Fingerprint.* 1986. Carbon transfer etching, 3′10″ × 3′½″ (1.173 m × 93.1 cm). Published by Pace Editions and Graphicstudio. © Chuck Close.

the most photographic drawing or painting, a part of the artist's personal style enters.

In the Photo-Realist portrait *Emily/Fingerprint* by Chuck Close, the strongest element of subjectivity is the technique used to make the drawing (figure 1.21). We associate fingerpainting with children's activities, yet Close's application of paint using his actual fingerprints is far removed from a naive technique. Close is concerned with surface texture and with revealing what he calls the "personal identity of my hand." At first look we think the image may have been generated by a computer, but the structure of Close's work is a result of ordering the image through a use of grids. His innovative approach results in a contemporary look, one not usually associated with portraits. He takes a photograph of his subject, enlarges it to the size of the finished work, then, using a small grid, he transfers the image square by square to paper or canvas. Next comes the time for strict analysis; beginning at the top and working across and down, he duplicates the values from the photograph, imitating the photograph's range of grays, whites, and blacks. The relationship between the adjacent grid units is of crucial importance to the final product. Close is as

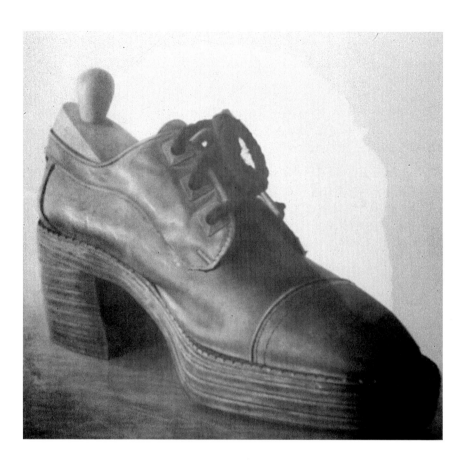

1.22. SHIMON OKSHTEYN. *Man's Shoe.* 1994. Pencil and graphite on canvas. 6′ × 6′4″ (1.83 m × 1.93 m). O.K. Harris Works of Art, New York.

interested in how an image is represented and perceived as much as he is with what is depicted.

It is hard to believe that the image in figure 1.22 is a drawn image. Think what powers of concentrated observation went into the making of this meticulous rendering. What scintillating verisimilitude! The monumental scale of the work is likewise impressive, over six by six feet. Shimon Okshteyn's pencil and graphite drawing can be classified as hyper-realistic. It is as if we could reach out and touch the actual leather of the shoe. This work proves that the illusionistic image can be presented in many guises. Realism is an illusive and slippery category.

Subjective Drawing

Just like every other human activity, artistic production carries with it a full range of the subjective element. Alice Neel is more interested in the psyche of her sitters than in a direct transcription of visual reality. Although she works from direct observation, she has said she is more interested in what people are like underneath the surface. Neel's style is spontaneous, energetic, and obviously highly subjective. In the portrait of Andy Warhol (figure 1.23), as in her other portraits, she uses distortion, an unfinished quality, and an uncomfortable arrangement of limbs and posture as theme and variation. Warhol's eyes are averted, the focus is internal, and his vulnerability is suggested by his closed eyes and scarred body. The psychological truth for Neel is more im-

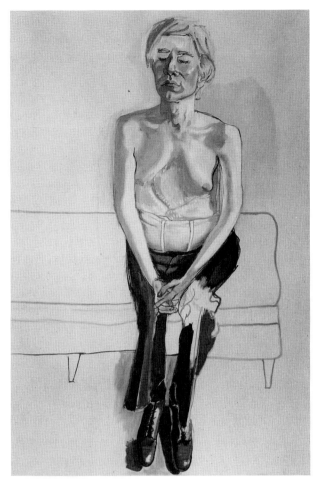

1.23. ALICE NEEL. *Andy Warhol*. 1970.
Oil on canvas, 5′ × 3′4″ (1.52 m × 1.02 m).
Whitney Museum of American Art,
New York. Gift of Timothy Collins.
© Estate of Alice Neel. Courtesy Robert
Miller Gallery, New York. © Photo:
Geoffrey Clements.

portant than literal realism. A drawing, then, may be slightly or highly personal; there are as many degrees of subjectivity as there are artists.

THE VIEWING AUDIENCE

Why look at art? Art presents alternative ways of making meaning through seeing. It offers a different kind of "reasoning" not available through other types of communication. It expands the relationship between what we see and what we know. And finally, art's messages enrich our lives inexhaustibly.

Now let us make a set of distinctions concerning whom the drawing is intended for. Artists make some drawings only for themselves. How many times have you jotted a quick sketch on a scrap of paper as a reminder? The speed with which the sketch can be executed is in pronounced contrast to the slower painstaking detail required in works such as that of Close and Okshteyn. A preparatory drawing is frequently noted in broadly drawn strokes, conveying the idea economically and deftly. Changes occur between the initial sketch and the final work; sketches are loose notations, the shorthand of drawing.

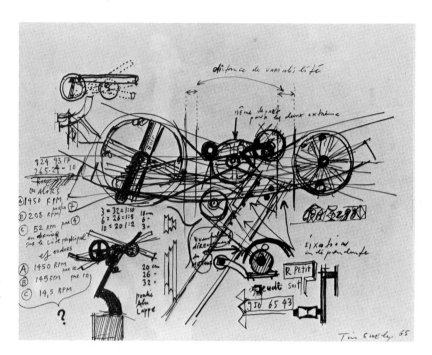

1.24. JEAN TINGUELY. *Study of Machine.* 1965. Ink, 1′⅝″ × 1′3⅞″ (32 cm × 40 cm). Courtesy Iolas-Jackson Gallery, New York. © 2003 Jean Tinguely/Artists Rights Society (ARS), New York/ADAGP, Paris. Photograph Ivan Dalla-Tana.

Drawings not specifically intended for a viewing audience, however, do not prevent our enjoyment of them. Jean Tinguely's *Study of Machine* (figure 1.24) gives the viewer an insight into his playful mind. Tinguely was a Swiss sculptor whose machines were designed to incorporate unpredictable motions. It has been noted how ironic it is that such haywire machines would come from a country known for its precision clockwork. His animated inventions make a wry commentary on the role of the machine in our technological society. Tinguely's lighthearted drawing style conveys this idea of the machine's taking on a life of its own. With their programmed improbable actions, his sculptures are a delight to see. What a feat to make art that makes such a good-natured criticism of a mechanized world gone berserk! A look at the artist's intimate sketch gives us a glimpse into Tinguely's offbeat creative process.

Because his style is so widely recognized, we cannot view a work of art by Pablo Picasso without many of his other works coming to mind. Perhaps we should say, "because his *styles* are so widely recognized." In figure 1.25 we see three distinct styles, all hallmarks of Picasso's virtuosity as one of the premier draftsmen of the twentieth century. Not only is his style personal, his themes are stated in a highly personal way. Duality, a favorite subject for Picasso, is relayed by depicting opposite poles—male/female, man/beast, reveler/contemplator—each depicted with an appropriate line quality. The *anima*, the female figure on the left, emerges from a deep recess, certainly an appropriate representation of the unconscious. This figure is drawn in a complex network of lines, whereas the adjacent figure is simply and delicately presented. We see the man-beast in a transitional state; the lines are more tentative, not so exuberantly drawn as in the third figure, where the Minotaur reigns. In the Minotaur figure, the frenzied, swirling, thick lines describing a drunken, Dionysian state overpower the man part of the figure with the delicately drawn upper torso and arms. The Minotaur myth in Picasso's work is given an updated, twentieth-century, Jungian interpretation.

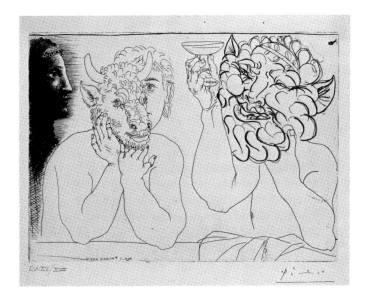

1.25. PABLO PICASSO. *Jeune Homme au Masque de Taureau, Faune et Profil de Femme.* March 7, 1934. Etching, 8¾″ × 1′3⅜″ (22 cm × 31 cm). Courtesy Edward Totah Gallery, London. © 2003 Estate of Pablo Picasso/Artists Rights Society (ARS), New York.

Some works are more meaningful when viewed in relation to the works of earlier artists—that is, when seen in the perspective of art history or in the context of cultural differences. Art about art has always intrigued artists, and contemporary art has a lively concern with this subject. Our understanding of Richard Hamilton's print (figure 1.26) is increased when we know the source

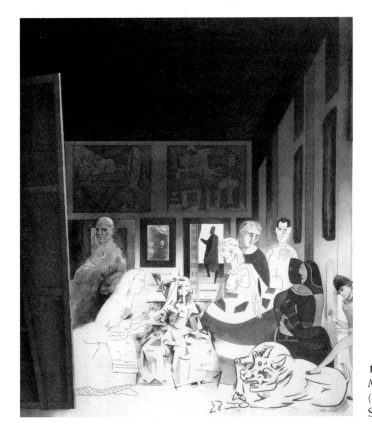

1.26. RICHARD HAMILTON. *Picasso's Meninas.* 1973. Etching, 1′10⅝″ × 1′7³⁄₁₀″ (57.5 cm × 49 cm). © 2003 Artists Rights Society (ARS), New York/DACS, London.

of his image, Diego Velázquez's *Las Meninas*, painted in 1656. Hamilton has replaced the original models, maids in waiting from the Spanish Renaissance court of King Phillip II, with figures from Picasso's works. Standing at the easel is not the original Velázquez, but the grand impostor Picasso himself! Not only has the artist brought into the seventeenth century this troupe of characters taken from the many styles of their creator, but also he has been so bold as to replace the royal collection hanging on the walls with masterpieces from Picasso's work. As if that were not enough, Picasso is sporting a communistic emblem on his artist's smock, adding insult to injury to the monarchy itself! Hamilton's print imitates the lush lights and darks of the original painting; light and tone are the very substance of the work. Three hundred years later Velázquez still stands as the ultimate Spanish master of the seventeenth century, just as Picasso stands as the great artist-innovator of the twentieth century. Incidentally, Picasso made many homages to Velázquez in prints, paintings, and drawings—many from this same source.

SUBJECT AND TREATMENT

Another major determinant in a work of art is the subject to be drawn. Once the subject is chosen, the artist must determine how it is to be treated. Innumerable modes of expression are subsumed under drawing. Landscape, still life, and figure are broad categories of subject sources. Nature is a constant supplier of imagery, both for the ideas it offers and for the structural understanding of form it gives. Two widely different approaches to landscape can be seen in the drawings by Christo (see figure 1.18) and Steve Galloway (figure 1.27).

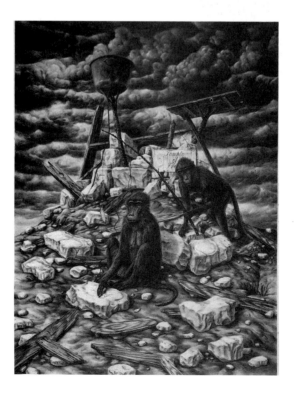

1.27. STEVE GALLOWAY. *Please Me (in the temple of frogs)*. 1988. Charcoal on paper, 4′10½″ × 3′9″ (1.49 m × 1.14 m). James Corcoran Gallery.

Whereas Christo proposes changes to an existing landscape, Galloway's landscape suggests a narrative or allegory. It is imaginary and metaphoric. In *Please Me (in the temple of frogs)* the eerie setting carries a psychological depth. The ominous, brooding sky sheds a strange light on the rocky terrain. The composition is crowded with carefully rendered details, and the structural weight of the rocks and the heavy gathering clouds activate the surface. The splintered wooden planks and disassembled structure set the stage for an unsolved mystery. The primates seem to have momentarily stopped their task to look quizzically at the viewer. The odd scene raises more questions than it answers. It brings together an acute way of perceiving with a mode of imagining that is both real and surreal. The animals are leading a secret life of which we humans are permitted only a glimpse. In fact, the secret life of art is lived in drawings. Galloway's work attests to this claim.

The artist may choose an exotic subject, such as Masami Teraoka's watercolor (figure 1.28), which combines a traditional Japanese style with contemporary Western materialistic ideas. Teraoka looks back to seventeenth-century Japanese art for technique, style, and image and invests it with a modern message. The Samurai Businessman (What a contradiction! Or is it?) is weighted down with accoutrements of the modern world—briefcase, watch, and calculator. His upward gaze, a convention in Japanese art, lends a note of insecurity, certainly not a trait of a real samurai warrior.

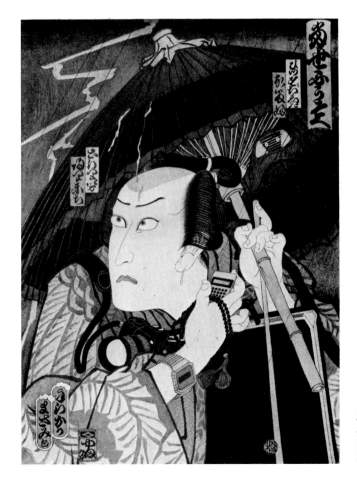

1.28. MASAMI TERAOKA. *Samurai Businessman Going Home.* 1981. Watercolor on paper, 1′1¼″ × 9¾″ (34 cm × 25 cm). Private collection. Pamela Auchincloss Gallery.

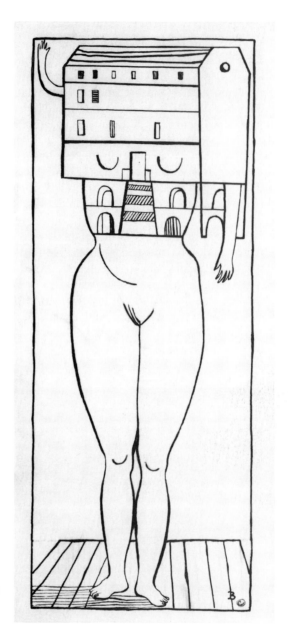

1.29. LOUISE BOURGEOIS. *Femme Maison.* 1947. Ink on paper, 9⁵⁄₁₆″ × 7⅛″ (25.2 cm × 18 cm). Solomon R. Guggenheim Museum, New York 92.4008. © Louise Bourgeois/Licensed by VAGA, New York.

Some artists find significance in a commonplace subject, as in the Louise Bourgeois house (figure 1.29). Bourgeois's image is reductive, abstracted, and symbolic. Here is what the artist has to say about this image: ". . . this woman is in a state of semiconsciousness, because, first of all, she believes she can hide, which is a foolishness; nobody can hide anything. And secondly, nobody would present herself naked the way she does. . . . She does not know that she is half naked, and she does not know that she is trying to hide. That is to say, she is totally self-defeating because she shows herself at the very moment that she thinks she's hiding" (Bourgeois, p. 45). In a way, all of Bourgeois's work (she is a preeminent sculptor) is fraught with trepidation, pain, anger, and guilt. Her work is full of tension between self-revelation and withdrawal, and as the

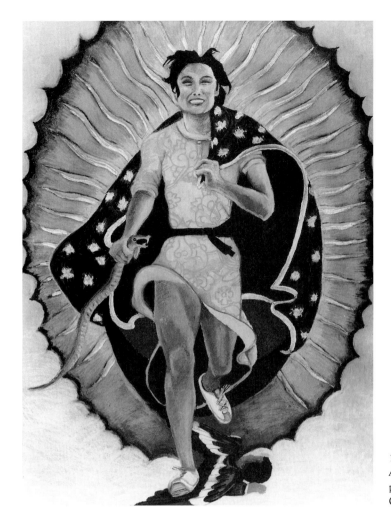

1.30. YOLANDA M. LÓPEZ. *Portrait of the Artist as the Virgin of Guadalupe.* 1978. Oil pastel on paper, 2'8″ × 2' (81 cm × 61 cm). Collection of the artist. Photo: Bob Hsiang.

critic Lawrence Rinder said, ". . . for Bourgeois, making drawings is as necessary as locking the door each night" (Bourgeois, p. 12). She says, "Drawings have a featherlike quality. Sometimes you think of something and it is so light, so slight, that you don't have time to make a note in your diary. Everything is fleeting, but your drawing will serve as a reminder; otherwise it is forgotten" (Bourgeois, p. 21).

Both the exotic and the commonplace may be equally provocative to the artist. An image can be treated symbolically, standing for something more than the literal image, as in Yolanda M. López's *Portrait of the Artist as the Virgin of Guadalupe* (figure 1.30). The artist gives explicit directions for interpreting her drawing in its title. López is a Chicana artist who seeks to undermine the clichés of her culture. In this drawing, the Mexican icon, the Virgin of Guadalupe, is cast as a modern, athletic young woman grasping a serpent, a symbol of her nation, and trailing a star-studded cape as she bursts out of the flame-shaped halo. Although the artist takes a humorous approach, she intends serious political implications. López is among many multicultural artists whose goal is to make art that will enlighten and reshape human consciousness to bring about social change.

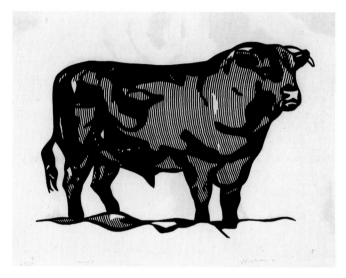

1.31. ROY LICHTENSTEIN. *Bull I* from *Bull Profile Series.* 1973. One-color linecut, 2'3" × 2'11" (69 cm × 89 cm). Courtesy Gemini G.E.L., Los Angeles. © Roy Lichtenstein.

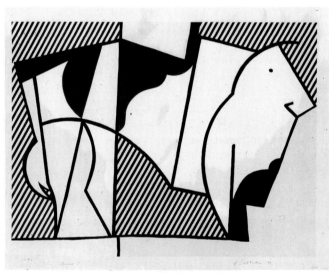

1.32. ROY LICHTENSTEIN. *Bull III* from *Bull Profile Series.* 1973. Six-color lithograph, screenprint, linecut, 2'3" × 2'11" (69 cm × 89 cm). Courtesy Gemini G.E.L., Los Angeles. © Roy Lichtenstein.

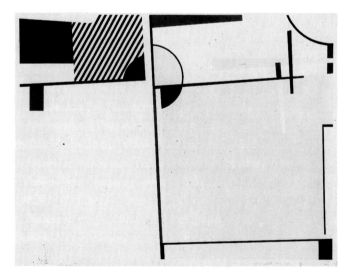

1.33. ROY LICHTENSTEIN. *Bull IV* from *Bull Profile Series.* 1973. Five-color lithograph, screenprint, linecut, 2'3" × 2'11" (69 cm × 89 cm). Courtesy Gemini G.E.L., Los Angeles. © Roy Lichtenstein.

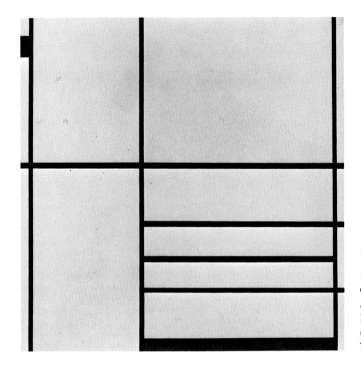

1.34. PIET MONDRIAN. *Composition in White, Black and Red.* 1936. Oil on canvas, 3'4¼" × 3'5" (1.02 m × 1.04 m). Museum of Modern Art, New York. Gift of the Advisory Committee. © 2003 Mondrian/Holzman Trust/Artists Rights Society (ARS), New York. Photograph © 1997 The Museum of Modern Art, New York.

Images work on a variety of levels, on the rational as well as the irrational, on the conscious as well as the unconscious. They can have multiple, simultaneous, but different meanings: perceptual and formal, cultural and personal, experiential and imaginative, psychological and political. The manner in which an artist chooses to depict a subject can be simple or complex. The image can be an object taken from the real world and then altered beyond recognition, as in the oversized comic book style work by the Pop artist Roy Lichtenstein (figures 1.31, 1.32, and 1.33). Trained as a commercial artist, Lichtenstein works in a stylized, abstract manner. His comic book style works on a double level as both fine art and commercial art. In the three drawings illustrated here, we see an image of a bull abstracted through a number of stages. Lichtenstein selects his images from both popular and art-historical sources; here he makes a wry comment mirroring the style of the twentieth-century Dutch painter, Piet Mondrian (figure 1.34). Lichtenstein is fond of images that are clichés, borrowed images that he invests with humor and irony. Lichtenstein's references are a dizzying path to follow—what looks like a rather simple strategy is layered in its content.

Mondrian's work evolved from recognizable images through abstraction to its final, purely nonrepresentational stage. It deals with an abstracted treatment of nature. Mondrian praised abstraction as "the true vision of reality" (Mondrian, p. 338). He strove for a neutral form using reductive means—horizontal and vertical lines, geometric rectilinear shapes, and primary colors. His nonobjective compositions (his style is called Purism) are devoid of associative meaning related to objects in the real world. Balance and stability, attained through a precise arrangement of vertical and horizontal elements, carried a spiritual meaning for Mondrian, and were thus crucial compositional concerns. Form embodies meaning. In fact, abstraction is an essential process in every work of art; the manipulation of images and ideas demand it.

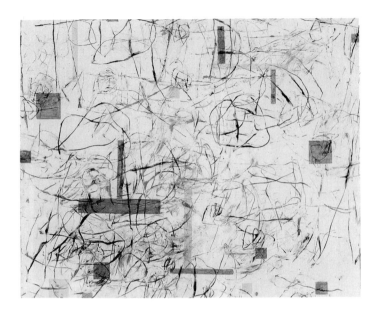

1.35. LOUISA CHASE. *Untitled.* 1987. Oil on canvas, 6′6″ × 7′ (1.98 m × 2.13 m). Courtesy Brooke Alexander, New York.

Louisa Chase's drawing on canvas (figure 1.35) is an example of how mark making itself can be the subject of art. The confined geometric shapes recede into a field of vigorously stated, layered marks. Try to imagine the work in its original size, over six by seven feet. The marks become great sweeping gestures, tracing the physical motion of the artist as she worked. It becomes a backdrop for movement, time, and energy. Chase employs two modes—one using simple geometric shapes and the other asserting obviously handmade, random marks. She imposes diametrically opposed orders. It is as if something had gone awry in a Mondrian painting. Could we be witnessing a graffiti attack on a modern Purist work?

CONCLUSION

The process of drawing develops a heightened awareness of the visual world, an awareness that is both subjective (knowing how you feel about things) and objective (understanding how things actually operate). Perception, the faculty of gaining knowledge through insight or intuition by means of the senses, is molded by subjectivity as well as by the facts of the world. Art is a reflection of the culture in which it is made.

Drawing affords you an alternative use of experience. It provides a new format for stating what you know about the world. Through drawing you are trained to make fresh responses and are furnished with a new way of making meaning. Finally, drawing teaches you to observe, distinguish, and relate.

The therapeutic value of art is well accepted; the intellectual benefits are many. Art is a way of realizing one's individuality. Creativity and mental growth work in tandem. The making of art, the making of the self, and the development of one's own personal style are all a part of the same process.

We have looked at a few of the many reasons why artists draw and a few of the many means available to an artist; now the exciting process of drawing begins.

Learning to See: Gesture and Other Beginning Approaches

Drawing is a verb.
RICHARD SERRA

JENNIFER MONSON, AN EXPERIMENTAL choreographer, sees parallels between dancing and animal navigation, and we can extend the comparison to include drawing. She observes that there are three stages an animal goes through to learn migratory patterns: exploration, repetition, and memory. Artists, like dancers, learn to chart motion and duration. In drawing you learn to draw a subject by following its forms. Time, the duration it takes to "map out" the forms, is an essential element. Drawing is a mode of imaginary travel or migration from a mental state to a material record, a dance involving artist, materials, and subject. The Korean artist Park Yooah charts the movement of a figure in figure 2.1. To keep our metaphor alive, we might interpret it as a choreographed dance imitating birds' takeoff and landing patterns. The drawing unfolds in time and motion, the two basics of this simple notation.

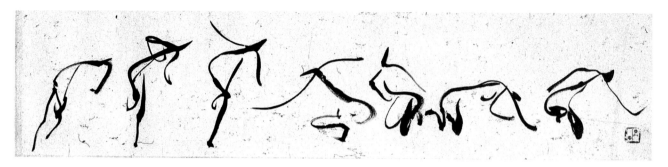

2.1. PARK YOOAH. *Movement II.* Meok
Oriental ink on paper, 1'1" × 4'7"
(35 cm × 1.4 m). Collection Park Ryu
Sook Gallery, Seoul. Walker Art Center,
Minneapolis, Minn.

The mark that records the movement of the artist's implement, a two-dimensional movement in space, is the most basic feature of drawing. In addition to this spatial notation, drawings evoke a time response—the time required to make the movement that creates the mark. Marks should never become mechanical but they should be automatically responsive to the subject being drawn. Structural improvisation is valued both in dance and in drawing. In art, as in physics, the time/space relationship is crucial. Time is involved in observation, in scanning objects in space, and in the act of drawing itself. Think of the movement of your eyes as they dart back and forth, focusing and refocusing on different objects at different times as you glance about the room. Movement and time are two of the most essential features in making and looking at a drawing. The lines in Auguste Rodin's energetic Cambodian dancer (figure 2.2) are rhythmic and energized; the drawing pulsates. Rodin has projected the model's kinetics onto the paper; the rhythms of the marks fluctuate between fast and slow.

A recent show at London's National Portrait Gallery was built around the study of the interaction between the eye, hand, and brain of an artist while drawing a face. Machines measured controlled and unconscious responses of an artist, Humphrey Ocean, and non-artists. The result was that the researchers, neuro-psychologists and neuro-physiologists, believe that the artist does indeed see things differently. The artist explores the subject through a rapid series of "short fixations," as many as 140 per minute, lingering for as long as one second at least 12 times a minute. Another sensor traced hand movements as they marked both on and off the page, recording the hand's movement in air, the markings on the page, and the amount of pressure exerted on the drawing implement. A magnetic resonance imaging technique scanned the brains of the subjects while they copied photographs of faces and abstract shapes in a small sketchbook. Most surprising were the findings that the seeing process for non-artists takes place in the visual cortex at the back of the brain, whereas the artist mainly engaged the frontal part of the brain, the site of emotion. It was here, too, that the artist stored previous information taken from the photographs and earlier drawing experiences. "In essence, the control subjects were simply trying to copy what they saw. But Humphrey was creating an abstracted representation of each photograph. He was *thinking* the subjects," explained John Tchalenko, the scientist who conducted the study (Alan Riding, "Hypothesis: The Artist Does See Things Differently," *New York Times*, May 4, 1999, Living Arts p. 2). Figure 2.3 shows the finished face drawing and a computerized version of the artist's hand movements.

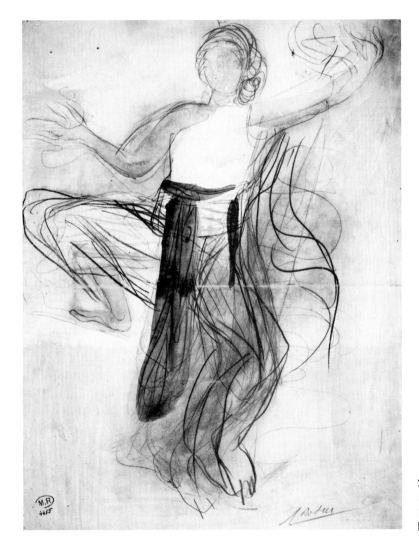

2.2. AUGUSTE RODIN. *Cambodian Dancer.*
1906. Lead pencil and watercolor drawing,
1′1⁷⁄₁₀″ × 10½″ (34.8 cm × 26.7 cm).
INV.M.R. 4455 © Musée Rodin, Paris.

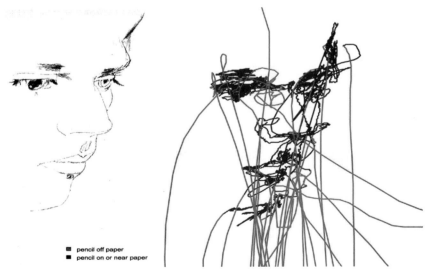

■ pencil off paper
■ pencil on or near paper

2.3. HUMPHREY OCEAN. *Computerized
Version of Hand Movement and Finished Drawing.*
1999. Original reconstruction of pen
movements by Professor Chris Miall,
University of Oxford, 2′7³⁄₁₀″ × 1′11³⁄₇″
(79.5 cm × 59.5 cm). National Portrait
Gallery, London, England. © Photo by
Chris Miall.

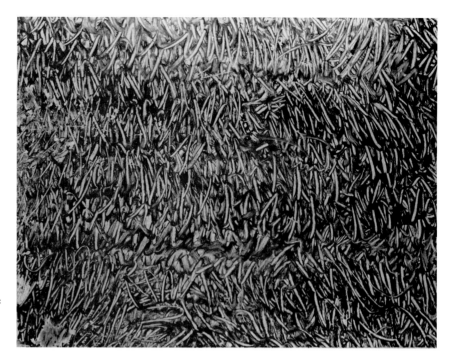

2.4. JOEL SHAPIRO. *Untitled.* 1968. Grease and graphite on paper, 1′6″ × 1′11″ (48 cm × 58 cm). Private collection. Photo: Mates and Katz. Paula Cooper Gallery, JS 48. © 2003 Joel Shapiro/Artists Rights Society (ARS), New York.

We are so accustomed to seeing reproductions of art, reduced in size and reproduced by mechanical means, that we often miss the handmade quality so valued in one-of-a-kind drawings. This handmade quality is called *facture,* a term that refers to the process or manner of making something. In art, and especially in drawing, facture is of prime importance. The kinds of marks artists make hold clues to unraveling the meaning of the drawing. We will discuss this further in the succeeding chapters as we look at specific works of art, but for now it is important to focus attention on the marks that go into making a drawing. Note what kinds of tools, media, and surfaces are being used. You will learn to build a descriptive vocabulary to discuss the quality and purpose of the marks, becoming aware of the speed or slowness with which they were made, registering their physical characteristics, and tracing the signs of facture in the drawing. For example, the crosshatched line, the scribble, the faint trailing line, the boldly stated ripping mark—all are signs of facture. Another descriptive term is *pochade,* in French, a rapidly made sketch, a shorthand notation, an abbreviated drawing. In a quickly made sketch, the speed of execution mirrors a burst of energy; it is a mirror of time, action, and medium.

In the drawing by Joel Shapiro (figure 2.4), facture is self-evident. The surface is built up of multiple overlaid marks that are scribbled across the entire surface. The expressive, loosely controlled marks point out the properties of the media—grease and graphite. This greasy substance is pushed to the edge of each mark; the center of the mark remains clean and white, thus giving dimension to each line—every line appears outlined. Row after row of overlapping marks create a unified field. Viewers are left to make their own associations: a grassy field, a scribbled-out letter, or a woven textile are some of the associations that come to mind. The ambiguity of what the marks could refer to or mean is an enticing part of this piece, but the real subject of the

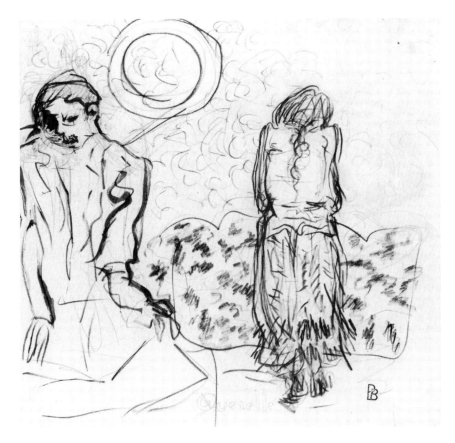

2.5. PIERRE BONNARD. *La Querelle* (*The Quarrel*) 1900–1910. Pencil and black chalk with brush and ink, 7⅜″ × 7⅞″ (18.7 cm × 20 cm). Private collection. © 2003 Artists Rights Society (ARS), New York/ADAGP, Paris.

work is the act of mark making itself. The randomness and rapid gestural marks affirm the hand of the artist and point to the artist's interest in the process, in what goes into making a work of art. Shapiro is classified as a Minimalist; Minimalism defines itself through the materials used, without illusion or allusions outside the work itself. Shapiro's drawing does not represent a subject or an object in the real world; it is a drawing made for drawing's sake. We find many contemporary artists like Shapiro whose subject is a philosophical investigation into what goes into making art.

Drawing takes into consideration intellectual awareness, somatic (body) responses, and consciousness at all levels. It is accessible to everyone; it is literally at the tips of your fingers. Drawing plays a central role in the evolution of an artist's work, and nowhere is this more apparent than in the evolution of figurative work. In Pierre Bonnard's drawing of two figures in a room (figure 2.5), the artist presents an emotional scene, a quarrel. The figures turn away from each other; the agitated marks mirror the tension between the couple. Texture, line quality, and composition reinforce the theme.

Drawing provides a format for the development of formal ideas (as we have just seen in Shapiro's work, where form takes precedence over other considerations), for iconographic ideas (*iconography* deals with the symbols used in a work of art), and for expressive and emotive possibilities. Drawing not only offers a fresh point of view, it is truly the place where a maturation of ideas and

forms takes place. Whether an artist chooses to work abstractly or figuratively, learning to draw directly from life is essential.

An important aspect of time as it relates to drawing is memory. Both making and looking at drawings develop memory. Your visual experience is enriched by learning to see through the practice of drawing. You should develop the habit of carrying a sketchbook with you to jot down quick notes and sketches as an aid to memory. Consciously be aware of trying to retain mental images. It is a discipline that will pay off in many ways, not only in art, but in life as well.

The two basic approaches to drawing both involve time. The first approach, called *gesture,* is a quick, all-encompassing overview of forms in their wholeness. The second, called *contour,* is an intense, slow inspection of the subject, a careful examination of its parts. Offshoots of these two basic approaches are *continuous-line drawing* and *organizational-line drawing.*

GESTURE DRAWING

As we have seen in the description of the experiment recording an artist's eye and hand movements, eye-to-hand coordination lies at the very core of drawing. The formal definition of the word *gesture* amplifies its special meaning for the artist: the act of moving the limbs or body to show, to express, to direct thought. There is a physicality of motion in drawing that is not always visually evident in other art forms, and as a result of this physical energy, drawings communicate an emotional and intellectual impact. The gestural approach to drawing is actually an exercise in seeing. The hand duplicates the motion of the eyes, making a movement that quickly defines the general characteristics of the subject: placement, shape, proportion, relationship between the parts, and a definition of planes and volumes as well as their arrangement in space.

In figure 2.6 we see how efficiently a gestural drawing by the acclaimed contemporary architect Frank Gehry records his initial ideas for a building in Cleveland, Ohio. Gehry's metal-wrapped buildings require such intricate engineering that they could not be built without the use of powerful computer systems, such as those used in designing jet airplanes. For Gehry, gestural drawings are an essential first step in indicating spatial notations to describe the flowing curves and major planar segments of the yet-to-be-built structure. Spatial relationships between the swirls, blocks, and cubes jotted down in Gehry's energetic gestural shorthand are eventually translated into scale models, and then into a virtual model. The instrument that Gehry uses at this stage is one that was developed to map the human spine. This tool is connected to a computer monitor where lines and planes create the three-dimensional virtual rendering. Gehry's buildings resemble monumental environmental sculptures. "The dream, as you prepare the drawings and the models, . . . has to come out the other end with the passion and feeling you invested in it," explains Gehry in a *New York Times Magazine* article (Alex Marshall, "How to Make a Frank Gehry Building," April 8, 2001, p. 64). And to think that the dream begins with a sketch, a gesture drawing, executed in just seconds!

Gesture is not unlike the childhood game of finding hidden objects in a picture. Your first glance is a rapid scan of the picture in its entirety; then you

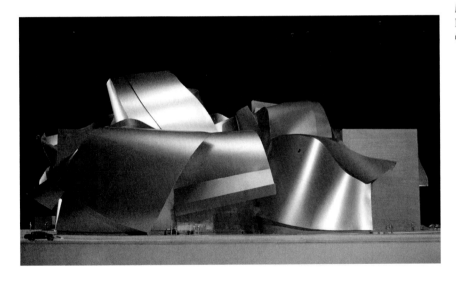

2.6. FRANK GEHRY. Sketch, Real Scale Model, Virtual Model for the Peter G. Lewis Building, Cleveland, Ohio. 1987. © Gehry Partners, LLP.

2.7. WILLEM DE KOONING. *Folded Shirt on Laundry Paper.* 1958. Ink on paper. 1′4⅞″ × 1′1⅞″ (42.9 cm × 35.2 cm). Area Editions, Santa Fe, New Mexico. © The Willem de Kooning Foundation/ Artists Rights Society (ARS), New York.

begin searching out the hidden parts. In Willem de Kooning's gestural ink drawing (figure 2.7), the viewer is first struck by the highly active lines, which lend a kinetic effect to the drawing. Our eyes are orchestrated by the movement of the line slashing across the page. The marks are not contained within a form; they cross over, search out, and quickly describe the artist's eye and hand movements. It is not until we read the title of the drawing, *Folded Shirt on Laundry Paper,* that we begin to unravel the image, what the critic Klaus Kertess called "active, slipping semblances of form" (*Willem de Kooning: Drawing Seeing/Seeing Drawing* [New York: Drawing Center, 1998]). De Kooning frequently traced or glued portions of his gestural drawings directly onto the canvas to retain their energy and sense of immediacy. (The drawings were made on velum, a translucent surface.) The shirt drawings were a theme he employed over an extended period of time. De Kooning is known as a modern master of the gestural approach.

Gesture is indispensable to establish unity between drawing and seeing. It is a necessary preliminary step to gaining concentration. We can recognize friends at a glance, and from experience we do not need to look at them further for identification. We perform an eye scan unless something makes us look intently—unusual clothes, a new hairstyle, or the like. For most daily activities, too, a quick, noninvolved way of looking is serviceable. For example,

2.8. IAN MCKEEVER. *Staffa—Untitled.*
1985. Pencil and photograph on paper,
2′6″ × 1′10″ (76.2 cm × 55.9 cm).
Collection of the artist.

when we cross the street, a glance at the stoplight, to see whether it is green or red, is sufficient. We may add the precaution of looking in both directions to check for cars; then we proceed. This casual way of screening information is not enough in making art, however. Even if the glance at the subject is quick, our eyes can be trained to register innumerable facts. In the subject to be drawn, we can train ourselves to see nuances of color, texture, lights and darks, spaces between objects—measurable distances of their height, width, and depth—the materials from which they are made, the properties of each material, and many more things.

The gestural approach is used to establish meaning in the mixed-media drawing, pencil and photograph on paper, by Ian McKeever (figure 2.8). He uses gestural line to unite the two different techniques, photography and drawing, in a body of work whose subject is the processes of the natural world. McKeever likens the two techniques to the landscape itself in that they are both able "to expose and obscure, reveal and conceal . . . they are like the agents of land erosion breaking down and rebuilding surfaces" (Godfrey, *Drawing Today,* p. 33). How well gesture suggests the idea of a world in flux!

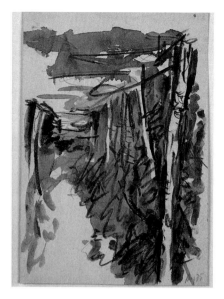
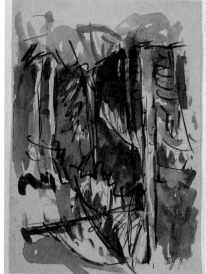
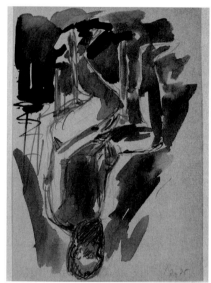
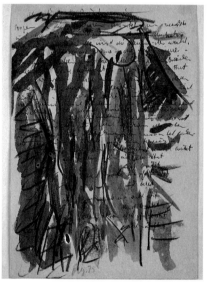
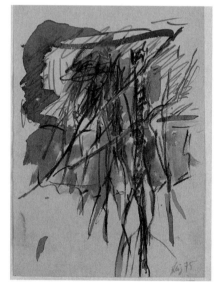
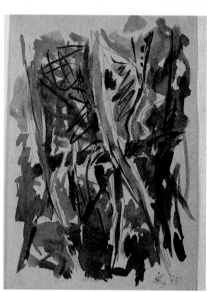

2.9. GEORG BASELITZ. *Sachsische Motive 1971–75* (six from a series of fifty-four). Watercolor, 9″ × 6¼″ (23 cm × 16 cm). Michael Werner Gallery.

In the page of gestural drawings by Georg Baselitz (figure 2.9), in what first appear to be pages full of nonrepresentational mark making, we begin to discern landscape studies (with one seated figure). The upside-down images are the trademark of Baselitz's identifiable style. His interest in abstraction and his desire to energize traditional subject matter—landscape, still life, and figure—gave impetus to his novel approach. Like Baselitz, many artists explode even the most basic definitions of drawing.

Gesture is more than seeing and organizing, it is an essential first step. Gesture is a metaphor for the energy and vitality of both the artist and the subject. A good example can be seen in the energized, electric work by Suthat Pinruethai (figure 2.10). The marks pulsate back and forth across the five-unit grid; the scribbled, gestural lines not only move across the various units but seem to vibrate from front to back. Some lines are in focus; others are blurred

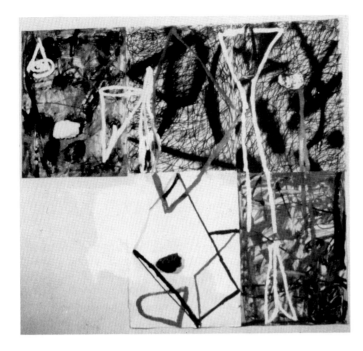

2.10. SUTHAT PINRUETHAI. *Pom Pom*. 1988. Monoprint, crayon, oilstick, and assemblage, 5'8" × 6'2" (1.73 m × 1.88 m). Courtesy Gallery West, Los Angeles.

and shadowlike. The last lines drawn were the white ones, and it is through them that the units are tied together. What can be the meaning of the missing module and of the one, much simpler, composition? Could the drawing be visually akin to the sound of some complex syncopated beat?

Another powerful example of gestural marks serving to communicate ideas is Mario Merz's crudely drawn beast (figure 2.11). The ambitious scale of

2.11. MARIO MERZ. *Animale Terrible*. 1979. Mixed media on canvas, 7'5¾" × 15'6" (2.3 m × 4.75 m).

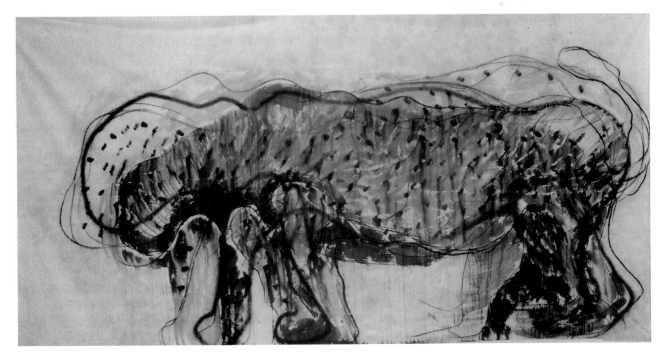

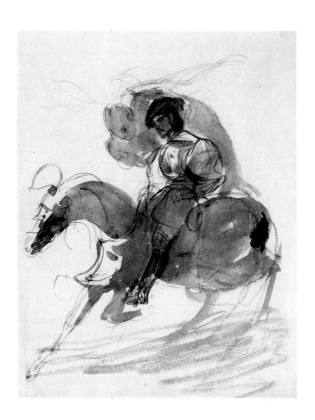

2.12. EUGÈNE DELACROIX. *The Constable of Bourbon Pursued by His Conscience.* 1835. Sepia wash over black chalk or pencil, 1′3½″ × 8⅝″ (39.5 cm × 22 cm). Öeffentliche Kunstsammlung, Basel. Photograph by Martin Buhler.

the drawing reinforces Merz's metaphor for brute nature. His use of animal imagery looks back to another fertile twentieth-century art period, German Expressionism, and like many of the artists in that movement, Merz sees the artist as a modern primitive, a "vagabond" or "nomad." Note that this *animale terrible* has no eyes. Merz asserts illogic, disorder, chance, and change in his work; the aggressively drawn, hulking animal carries a challenge, an anti-techno-scientific message. The artist obviously did not find this beast in the real, tangible world; rather, it comes from the world of his imagination. The marks used in building the powerful image are not only the result of loose, broad wrist and hand movements, they are made with large arm gestures, involving shoulder rotations and physical movement across the fifteen-foot length of the drawing. The drawing becomes a backdrop against which the drawing performance takes place.

Artists throughout history have used the gestural approach to enliven and organize their work, from the Renaissance to the present. The sense of space is activated in the drawing by the nineteenth-century Romantic artist Eugène Delacroix (figure 2.12). By a forceful application of the swirling, dynamic marks, a sense of movement is economically accomplished. We see how suitable brush-and-wash drawings are for gestural notation. The ink wash has dissolved some of the underlying black chalk marks, thereby producing interesting tonal and textural changes. A sense of drama results from the contrast between light and dark. The title, *The Constable of Bourbon Pursued by His Conscience,* reveals Delacroix's narrative intent; the constable's conscience, a dark, amorphous form, seems to have taken hold of him. Technique and content are perfectly melded.

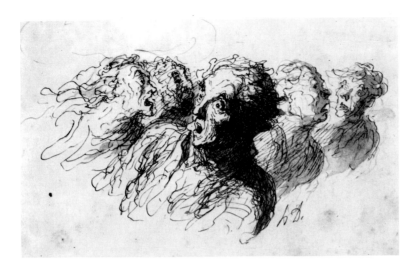

2.13. HONORÉ DAUMIER. *The Riot Scene.* 1854. Pen and wash, 6¼″ × 10¼″ (16 cm × 26 cm). Location unknown.

2.14. BEATRICE CARACCIOLO. *Untitled.* 1999. Mixed media on paper, mounted on board, 4′10¼″ × 9′8″ (1.48 m × 2.95 m). Courtesy of the artist and Charles Cowles Gallery, New York.

Honoré Daumier is classified as a nineteenth-century Realist whose major contribution as a draftsman is unparalleled. He documented the social ferment in the period following the French Revolution. In his hands gesture is a forceful tool for conveying the frantic movement of a crowd and an unsettled sense of change that underscores the agitation of the times (figure 2.13). We see how adaptable gesture is to caricature. Daumier's satirical visual criticism of the period was a novel approach for the time; his drawings remain as fresh and alive as when they were made. His use of angle and confrontational close-up is a precursor of the news camera.

Artists in contemporary times continue to be attracted to gesture as an aid to seeing, but the real attraction of gesture for the artist is the energized mark making it provides. In Beatrice Caracciolo's large work on paper, we see how suggestive gesture can be of landscape (figure 2.14). Although the marks themselves take priority over the subject, the division in the drawing between the marked area and the washed space at the top of the drawing suggests a horizon. Further, the heavier weighted lines in the lower right-hand corner offer a spatial interpretation because the mountainlike form is more diffused and lighter in value. The vigorously stated marks organize the picture plane and

2.15. GEORGE BUNKER. *Bibemus Motif.*
1979. Pastel. 10″ × 1′1″ (25.4 cm × 33 cm).
Department of Art, University of Houston.

indicate mass and weight. The toned paper and smudges suggest a sense of light and shadow. The spontaneously weighted lines are created by changing pressure on the drawing implement, a technique that helps define the spatial relationships between near and far.

We might call artists' use of landscape "an internalization of the natural world." Gesture, as quickly and boldly as it can be stated, has the capability to convey an experience of vastness, even of light and air, as seen in the pastel drawing by George Bunker (figure 2.15). Bunker worked on-site in quarries, orchards, shorelines, and fields. Like many artists, he drew sustenance from nature. In his diary, he reminded himself, "Keep in mind only the feeling of light/ time/air/place—the *still* idea &—the sensuous manifestation." Gesture trains the eye and the hand, and it opens the door most effectively to unexplored abilities.

Before Beginning to Draw

Some general instructions are in order before you begin. Now is the time to consult Guide A, "Materials," which is found in the back of the book; it contains a comprehensive list of materials for completing all the problems given in this book. Before beginning to draw from the figure or a still life, experiment with the media in your drawing kit: pencils, graphite sticks, pen and ink, brushes and ink, charcoal, crayons, and chalks. Remember the discussion on facture at the beginning of the chapter? Fill several pages in your sketchbook with some media experiments, using the full range of implements. On each page group lines, changing the weight and pressure on your drawing implement. Vary the marks from long to short, from heavy to thin. When you have gotten a feel for each medium, noting its inherent character, make a unified

field drawing, one in which the marks continue from side to side and cover the page from bottom to top. Refer to the Shapiro drawing in figure 2.4.

After you have made several pages of marks, lay out the drawings side by side and make a list of words that describe the various line qualities you have made. Note which characteristics are a result of the medium itself and which characteristics are created by the hand that made them. Try to make marks that look like sounds sound: percussive, soft, loud, rolling crescendos with staccato accents. In fact, it is a good idea to make gesture drawings while listening to music. The music not only helps you relax, it encourages a rhythmic response.

As you have seen from this introduction to the gestural technique, gesture drawing can be done in any medium. For now, however, in the initial stages of making figurative drawings (drawings of the model, still life, or landscape), I recommend using compressed stick charcoal, vine charcoal, or ink (with 1-inch or 2-inch [2.5 or 5 cm] varnish brush or a number 6 Japanese bamboo-handled brush). In the beginning of each drawing session, you can use vine charcoal on newsprint. Since vine charcoal is a very powdery substance, it does not adhere well to the paper and can be easily wiped off with a leather chamois skin, enabling you to make several quick gestural drawings on the same sheet of paper. The drawback to vine charcoal is that it breaks very easily and does not make a range of darker marks. However, the toned paper that results from rubbing out previous drawings makes an interesting surface to work on. Of course, vine charcoal drawings can be sprayed with a fixative to make them more permanent.

After you have learned the basic technique of gesture, begin to draw and experiment with a full complement of drawing implements. Changes in media make for exciting results.

Gesture drawing involves large arm movements, so the paper should be no smaller than 18 by 24 inches (46 × 61 cm). You can use a newsprint pad for dry media (it is too absorbent for wet media), and an inexpensive bond paper for wet media. Heavy brown wrapping paper that comes on rolls is ideal for both wet and dry media. Bond paper is smoother and allows a more flowing line. Later you can experiment with different papers. In any case, it is imperative to pay attention to the surface you are working on; it is a major determinant of the quality of the marks made on it.

Until you have fully mastered the technique of gesture, it is essential to stand (not sit) at an easel. Stand at arm's length from your paper, placing the easel so that you can keep your eyes on the still life or model at all times. Make a conscious effort to keep the drawing tool in contact with the paper for the entire drawing; in other words, make continuous marks.

In the initial stages, while you are becoming acquainted with the limits of the paper and with placement and other compositional options, you should fill the paper with a single pose or a single view of the still life or landscape. Later, several gesture drawings can be placed on a page. The drawings should be timed. At first, they should alternate between 15 and 30 seconds. Then gradually increase the time to three minutes. Spend no more than three minutes on each drawing; the value of quick gesture is lost if you take longer.

When you draw from a model, the model should change poses every 30 seconds for a new drawing. Later the pose is increased to one minute, then to two minutes, then to three minutes. The poses should be energetic and active.

Different poses should be related by a natural flow of the model's movement. The goal is to see quickly and with greater comprehension. Immediacy is the key. Spend at least 15 minutes at the beginning of each drawing session on these exercises.

Types of Gesture Drawing

You will work with five types of gesture drawing in this chapter—line, mass, mass and line, scribbled line, and sustained gesture. The distinctions among the five, along with a fuller discussion of each of the types, follow.

LINE GESTURE EXERCISES

Line gesture describes interior forms, following the movement of your eyes as you examine the subject. These lines should vary from thick to thin, from wide to narrow, and from heavy to light.

The marks in Jasper Johns's pencil drawing of a flag (figure 2.16) are a virtual inventory of gestural line quality. The lines range widely in weight and from light to dark; some are tightly grouped whereas others are more openly spaced. Johns leads the eye of the viewer over the surface of the drawing by the use of lights and darks. If you squint your eyes while looking at the composition, you will see how the distribution of darks creates an implied movement, and how stability is achieved by a concentration of the heavier marks at the bottom of the drawing. In line gesture marks can be tangled and overlapped, and they are always spontaneously and energetically stated. They may resemble a scribble, but it is not aimless or meaningless.

Once you begin to draw, keep the marks continuous. Do not lose contact with the paper. Look for the longest line in the subject. Is it a curve, a diagonal, a horizontal, or a vertical? Allow your eyes to move through the still

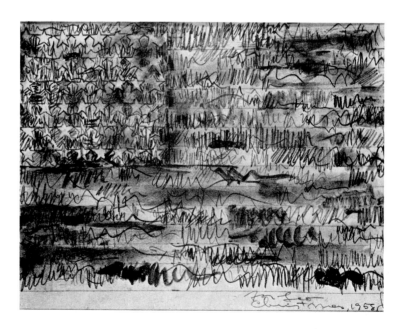

2.16. JASPER JOHNS. *Flag.* 1958. Pencil and graphite wash on paper, 7½″ × 10⅜″ (19 cm × 26 cm). Private collection. © 2003 Jasper Johns/Licensed by VAGA, New York.

life, connecting the forms. Do not simply follow the edge or outline of the forms. Coordinate the motion of your hand with the movement of your eyes.

In gesture you are not concerned with copying what the subject looks like. You are describing the subject's location in space along with the relationships between the forms. Keep your eyes and hand working together. Your eyes should remain on the subject, only occasionally referring to your paper. This procedure will be uncomfortable at first, but soon you will learn the limits of the page and the location of the marks on it without looking away from the subject. You will develop keener peripheral vision as you become more accustomed to this way of looking.

As you draw from the model, avoid a stick-figure approach. Begin your marks in the center of the forms, in the interior of the body, and move outward to the edges. Note the angles of the various body masses—upper and lower torso, upper and lower legs, angles of arms and head. Indicate the most obvious directions and general shapes first. Go from the large to the small. Begin at the core of the subject rather than at its outer edge.

The pressure you apply to the drawing implement is important; vary heavy, dark lines with lighter, looser ones. The darker lines might be used to emphasize areas where you feel tension, where the heaviest weight, the most pressure, the most exaggerated shape, or the most obvious change in line direction exists. By pressing harder on the drawing implement as you note objects farther from you, and by lightening the pressure for those nearer to you, you will have indicated the important spatial difference between background and foreground spaces. The ability to suggest spatial location is at the core of drawing from life.

In drawing it is easier to indicate height and width measurements of objects than it is to suggest depth, the third dimension. You are drawing on a surface that has height and width, so lateral and vertical indications—horizontals and verticals—are relatively simple. Careful observation will serve you well. The paper has no depth, so you must find a way to indicate this crucial measurement. The use of diagonals, or angles penetrating space, is of prime importance.

In gesture drawing the tool is kept in constant contact with the paper. Draw each object in its entirety even though the objects overlap and block one another and you are unable to see the entire form. The same is true when drawing the figure; draw as if the figure were transparent, as if you were able to see through the form.

It is a challenge for the artist to relay the effect of motion, but gesture is particularly effective in capturing the idea of movement. Have the model rotate on the model stand, making a quarter turn every 30 seconds. Unify the four poses in one drawing. Walter Piehl's rotating figure (figure 2.17) depicts a cowboy with his lasso. The indication of movement is especially pronounced in the areas of hat, hands, and boots (also the most important focal areas for reinforcing the subject of the drawing).

Another exercise especially appropriate for gesture drawing is one that has as its subject a continuous linear movement, seen in figure 2.1. The series of seven quick poses of a figure in motion could have been taken from an animated strip; each pose smoothly moves into the next. The artist has captured the time sequence in an economical way, using deft strokes related to oriental calligraphy. The means are reductive, yet the transitions have been lyrically recorded.

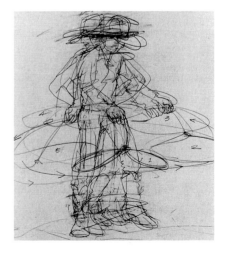

2.17. WALTER PIEHL JR. *The Merry-Go-Round.* 1988. Pencil, 2′ × 1′4″ (61 cm × 41 cm). Courtesy the artist.

Experimentation with linear media is encouraged. Any implement that flows freely is appropriate. Both found implements and traditional ones are recommended.

Try to avoid centrally placed images every time. Lead the viewer's eyes to another part of the page by varying the placement or by concentrating darks away from the center. Experiment with the activation of the entire surface of your paper by making the composition run off the page on several sides.

A good subject for gesture is fabric. Through a network of a variety of lines, try to convey the idea of folds, pleats, and creases using loose and languid gestural marks. Keep in mind the volume of the fabric as it rises and falls, and try to indicate some suggestion of the chair or pillow under the fabric that gives it shape. A draped model is another good subject for gesture drawings.

MASS GESTURE EXERCISES

In *mass gesture* the drawing medium is used to make broad marks, creating mass as opposed to line. Use the broad side of a piece of compressed charcoal broken to the length of 1 or 2 inches (4 cm), or use wet medium applied with a brush. Remember to keep the marks broad.

When you draw from a still life, place objects in a spatial arrangement with intervals between them to provide areas of empty spaces. A tricycle, a tree branch, or a vase of flowers, for example, might serve the same purpose, affording intervals of negative spaces between the parts. In some of your mass gestures, make your marks in these blank, negative spaces first. Emphasize the negative shapes. When you are drawing from the figure, focus on the negative space surrounding the figure and on the enclosed empty shapes, those formed between arms and body, for example.

As in line gesture, the pressure you apply to the drawing tool is important; vary heavy, dark marks with lighter shapes. Draw through the forms, keeping your implement in constant contact with the paper. Imagine that you are making contact with the entire object, that you are reaching into space and indicating the volumetric aspects of the subject. Try to avoid centrally placed shapes every time. Lead the viewer's eyes to another part of the page by different placements or by concentrating darks away from the center. Experiment with activating the entire surface of your paper by making the composition run off the page on three or four sides.

Again, as in line gesture, try to differentiate between various levels of space: foreground, middle ground, background. This important aspect is conveyed by controlling the darks and lights in your drawing.

In addition to the important spatial differentiation that mass gesture offers, it has the added bonus of indicating lights and darks at an early stage. Light and dark shapes unify a drawing; they help direct the eye of the viewer through the composition; they suggest atmosphere and space; and they are an important expressive device, as we discuss later. Mass gesture helps you translate not only important general information from the subject to your drawing—information dealing with light and spatial arrangements, measurement, and relationships between the various parts of the subject—it also gives the viewer insight into your personal response to the subject.

Not only is mass gesture effective in drawing, it is an appropriate technique for painting as well. Donald Sultan's large painting illustrates the use of mass gesture for conveying light and dark (figure 2.18). Energetic marks and

2.18. DONALD SULTAN. *Firemen March 6, 1985.* Latex paint, tar, vinyl tile on Masonite. 8′½″ × 8′½″ (2.44 m × 2.44 m). Museum of Fine Arts, Boston. Tompkins Collection. Courtesy of the artist.

splotches activate the surface of the painting. Sultan employs *tenebrism,* an exaggerated use of light and dark, to create a dramatic scene. The two figures of the firemen are silhouettes thrown in relief against the burning building. Ragged contours, like splintered charred wood, reinforce the subject of the painting. The rapidity with which the painting was made echoes the destructive speed of the fire. Sultan uses latex and tar on Masonite to duplicate a burnt texture. Subject, materials, and technique match the powerful forces of the conflagration.

The rapidity and ease with which the drawing was made come as a result of his mass gesture technique. The texture is rich, the reductiveness of means is appealing. The powerful forces of mass and energy and the physicality of the drawing are extraordinary.

MASS AND LINE GESTURE EXERCISES

Mass and line gesture offers the benefits of both techniques; it combines the two approaches in one drawing. The rules are the same. Masses and lines may be stated with wet or dry media, or a combination of both.

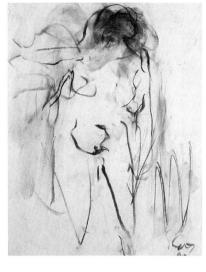

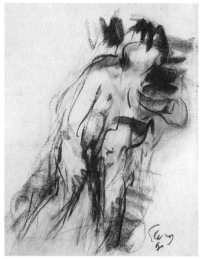

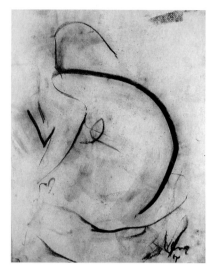

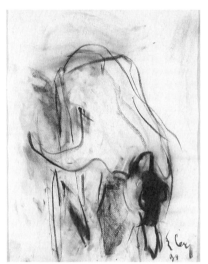

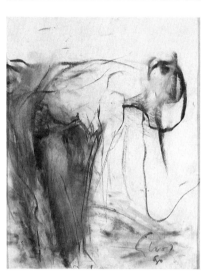

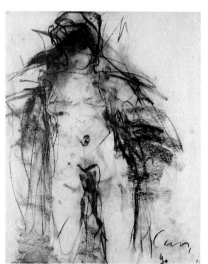

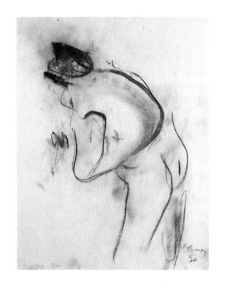

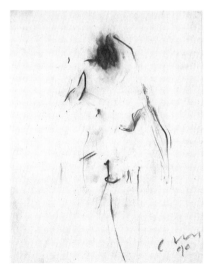

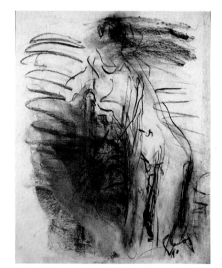

Begin with either mass or line, and then alternate between the two. Define the more important areas with sharp, incisive lines. In the nine charcoal panels by Eugene Leroy (figure 2.19), the artist has drawn a series of poses using this approach. Some are quite minimal, and others are more complex. You can see in these drawings how the addition of mass can distinguish foreground and background, and how a sense of light and shadow is evoked along with a feeling of weight. These drawings are excellent examples of studies that can be made in just minutes.

Indicating the forms as though they were transparent, restate the drawing; correct and amplify your initial image. You may wish to change the position or placement of the forms, or to enlarge or decrease the scale of certain parts. Keep the drawing flexible, capable of change. Francisco Goya's brush and ink drawing (figure 2.20) is an excellent example of a mass-and-line drawing taken to a more finished state of development. Note how weight and tension are indicated by areas of darker wash. Goya relays to the viewer the stress felt in the porter's body—in the man's midsection bowed over by the weight of his cargo and in his legs nearly buckling under from his efforts. The ground itself seems to bear the weight of his load.

Try to fill the entire space; do not neglect the empty or negative space. Begin laying wash areas in the negative space, and then add positive shapes. Let the washes cross over both positive and negative space. Karl Umlauf's piece (figure 2.21) crosses over the categories of sculpture and drawing by combining actual three-dimensional objects, such as shelves and bones, with a gestural drawing of the same subject. Note the way Umlauf has completely filled the space of the drawing; the images seem to extend beyond the limits of the paper. Darker marks offset the skeletal images, which are lighter than their enclosing spaces. Smudges create an atmospheric space in this work.

2.19. **(left)** EUGENE LEROY. *Untitled.* 1990. Charcoal on paper, nine panels 2'1/4" × 1'7" (63 cm × 48 cm). Michael Werner Gallery.

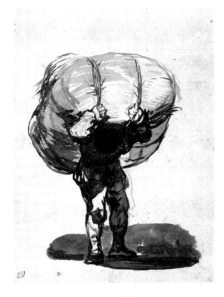

2.20. FRANCISCO DE GOYA Y LUCIENTES. *Le Portefaix* (*The Porter*). Brown wash, 8⅔" × 1'6⁹/₁₀" (22 cm × 48 cm). © Reunion des Musees Nationaux/Art Resource, New York.

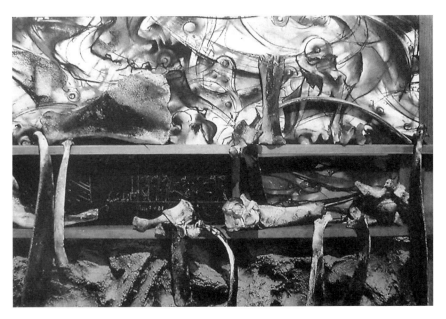

2.21. KARL UMLAUF. *Altered States V* (detail). 1990. Charcoal, paper, bone, and wood, 4'2" × 5' × 3" (1.27 m × 1.52 m × 7.6 cm). Courtesy of the artist.

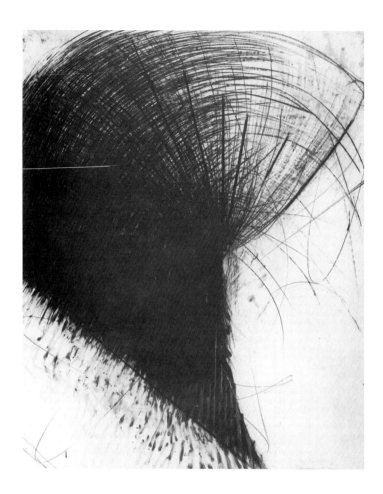

2.22. HEIDE FASNACHT. *Untitled.* 1984. Charcoal, pastel, and oil on paper, 5′ × 4′ (1.52 m × 1.22 m). Tabriz Fund, 1988 (88.2). Arkansas Art Center, Little Rock.

In the drawing by Heide Fasnacht (figure 2.22), a single volumetric shape is depicted using mass and line gesture. The powerful motion of the conic form reminds us of a storm or an explosion, some mighty force in nature. Fasnacht's smudged fingerprints convey the physicality of her gestural involvement in the five-foot-high drawing. One can imagine the broad sweep of the arm in the process.

The British painter Francis Bacon says that for him accident always has to enter into his drawing; otherwise, he feels as if he is simply making an illustration of the image. Speed of execution is one means of creating such unexpected effects. A major part of aesthetic intelligence is the alertness and willingness to put accidents to creative effect. Extraordinary things can happen quickly if you remain attentive to the events in your drawing.

SCRIBBLED LINE GESTURE EXERCISES

The *scribbled line gesture* consists of a tighter network of lines than in the preceding exercises. The sculptor Alberto Giacometti's triple-head drawing (figure 2.23) is a good example of this technique. The free-flowing ballpoint pen builds volume; the multiple, overlapping lines create a dense mass that builds the volumetric heads. The scribbles begin at the imagined center

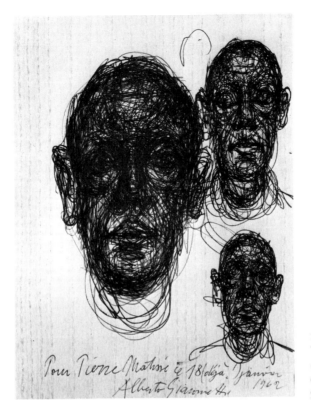

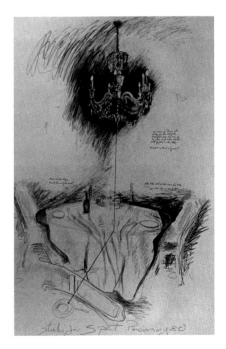

2.23. ALBERTO GIACOMETTI. *Diego's Head Three Times.* 1962. Ball-point pen, 8⅛″ × 6″ (21 cm × 15 cm). Private collection. © 2003 Alberto Giacometti/Artists Rights Society (ARS), New York/ADAGP, Paris.

of the subject. The lines build on one another, moving from the interior to the outside edge of the form. This technique has a parallel in sculpture: the use of an armature or framework to support a volumetric mass of clay or plaster the sculptor is modeling. Drawing played a major role in Giacometti's art. In his concentrated drawings we detect the same concerns that occupied him as a sculptor: the ideas of weight and weightlessness and spatial location and penetration.

In a scribbled line gesture, the outside of the form will be somewhat fuzzy, indefinitely stated. The darkest, most compact lines will be in the core of the form. The outer edges remain flexible, not pinned down to an exact line. As in the other gesture exercises, the drawing tool remains in constant contact with the paper. The scribbles should vary between tight rotation and broader, more sweeping motions.

In addition to charcoal, good choices of media for scribbled line gestures include wax crayons, felt-tip markers, pencil, and ballpoint.

Negative space is an appropriate place to begin a scribbled line gesture. The marks will slow down and be somewhat more precise as they reach the edge of the positive shapes. In Mac Adams's *Study for Three-Part Poison* (figure 2.24), the gestural marks at the bottom of the drawing are concentrated in the negative space surrounding the table and chairs. The lower half of the drawing is far less precisely stated than the upper section with its more refined and carefully drawn chandelier. This precision is counterbalanced by the swiftly drawn gestural marks that emerge from the darkness surrounding the light fixture. Without the gestural drawing in the negative space the objects would be static and inert. The activation of the negative space enlivens the drawing and

2.24. MAC ADAMS. *Study for Three-Part Poison.* 1980. Graphite on paper, 5′4″ × 3′4″ (1.63 m × 1.02 m). Commodities Corporation, Princeton, N.J.

attracts our attention. By changing the pressure on the drawing tool, Adams creates a weighty, dominant mass on either side of the table and behind the chandelier. This concentrated mass of lines behind and around the chandelier is in contrast to the delicacy of line and shape in the lamp itself. For Adams the chandelier is a symbol of luxury and is, therefore, an ominous object. He uses this image frequently in his work as a metaphor for art—the danger that lies in seeing art as mere luxury. In this drawing the focal point is clearly the chandelier. To ensure that viewers get the point, Adams draws a precise arrow directing our eye to the lower left, to a schematically drawn bowl—the container of the poison?

If you have begun most of your drawings in the center or top of the page, try to change your compositional approach and consider a different kind of placement, one that emphasizes the edges, sides, or bottom. You can develop a focal point by being more precise in one particular area of the drawing. By varying the amount of pressure on the drawing tool and by controlling the density of the scribbles, you can create a range from white to black.

SUSTAINED GESTURE EXERCISES

The use of *sustained gesture* combines a description of what the object is doing with what it actually looks like. Verisimilitude is not a primary concern in these beginning exercises; they are, however, a path to more accurate observation and drawing. Sustained gesture begins in the same spirit as before, with a quick notation of the entire subject. After this notation, however, an analysis and examination of both the subject and the drawing take place. At this point you make corrections, accurately establishing scale and proportion between the parts. In addition to drawing through the forms, you define some precise edges. The result is that the sustained gesture drawing actually begins to look like the object being drawn.

In *Man Seated at Table* (figure 2.25) by the Italian artist Sandro Chia, the gestural underpinning of the drawing is apparent throughout. The drawing offers the viewer real insight into the artist's decision-making process. Faint traces of earlier figures, the altered scale of the head of the seated figure, a shift in the placement of the feet and table base—all are faint memories of various stages of the drawing. Revealing part of a work that has been drawn or covered over is called *pentimento* in Italian, meaning correction. Chia has maintained the gestural approach throughout the drawing. In the final stage some edges have been strengthened by a darker contour line. The extended gestural approach reinforces the drawing's implied meaning; the shifting figure, the skull, and the spiral indicate that change is its primary subject. So you can see that the *pentimenti* actually contribute to and reinforce the meaning of the work.

Before drawing a still life, think of a verbal description of what it is doing. If you speak of a drooping flower, an immediate visual image comes to mind. This is a good way to approach sustained gesture. Look at the subject. Is the bottle *thrusting* upward into space? Is the cloth *languishing* on the table? Find descriptive terms for the subject and try to infuse your drawing with a feeling that is commensurate with the verbal description. Drawings have a nonverbal way of communicating. Allow your drawings to speak!

If you are drawing a model, take the pose yourself. Hold the pose for three minutes. Where do you feel the stress? Where is the most tension, the heaviest weight in the pose? Emphasize those areas in your drawing by using

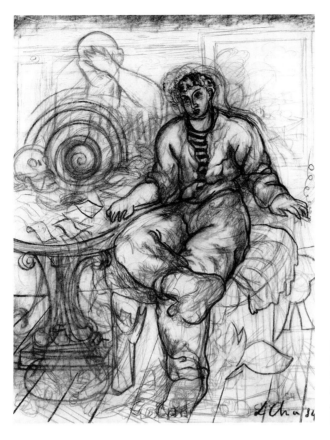

2.25. SANDRO CHIA. *Man Seated at Table.* 1984. Charcoal and pencil on paper, 3′2″ × 2′6″ (97 cm × 76 cm). Arkansas Arts Center Foundation purchase, 1985. Acc. no. 85.62. © 2003 Sandro Chia/ Licensed by VAGA, New York.

a darker line. Lighten the marks where there is less weight. Thinking of the attitude of the model and empathizing with the figure's pose will add variety and interest to the exercises and will help infuse the drawing with an expressive quality. In addition, your memory of various poses will be enhanced, so that when you are drawing without a model, you have your "body memory" to count on. There is no doubt, in Goya's drawing of the man bent over by the weight of the bundle on his back (see figure 2.20), that Goya was totally aware of and empathetic to the forces of weight and tension in the figure.

Quick gestures take from 30 seconds to 3 minutes. The sustained gesture takes longer—5, 10, even 15 minutes, as long as the spirit of spontaneity can be sustained.

In a sustained gesture you may begin lightly and darken your marks only after you have settled on a more definitely corrected shape. Draw quickly and energetically for the first two minutes; then stop and analyze your drawing in relation to the subject. Have you stated the correct proportion and scale among the parts? Is the drawing well related to the page? Redraw, making corrections. Alternate drawing with careful observation of the subject. Avoid making slow, constricted marks. Do not change the style of the marks you have already made. Give consideration to the placement of the subject on the page, to the distribution of lights and darks; look for repeating shapes. Try to avoid overcrowding at the bottom or sides of the paper. Look for a center of interest, and, by a more precise line or by a sharper contrast between lights and darks in a particular area, create a focal point.

Not only in this exercise, but throughout your career, it is imperative to stand back and look at your drawing from time to time as you work. Drawings change with viewing distance, and many times a drawing will tell you what it needs when you look at it from a few feet away. Another trick is to assess the drawing as it is reflected in a mirror. The mirror image will be reversed, and frequently this reversal reveals glaring imbalances or mistakes. Remember Bacon's admonition about being responsive to accidents.

Of all the exercises discussed, you will find sustained gesture the most open-ended for developing a drawing. Try to keep these 10 important points in mind as you work on gesture exercises.

GUIDELINES FOR GESTURE EXERCISES

1. Stand while drawing.
2. Use paper at least eighteen by twenty-four inches (46×61 cm).
3. Use any medium. Charcoal or ink is recommended.
4. Use large arm movements.
5. Scan the subject in its entirety before beginning to draw.
6. Be aware that the hand duplicates the motion of the eye.
7. Keep your drawing tool in contact with the paper throughout the drawing.
8. Keep your eye on the subject being drawn, only occasionally referring to your paper.
9. Avoid outlines. Draw through the forms.
10. Vary the place on the paper where you begin the drawing—top, bottom, edges, center.

OTHER BEGINNING APPROACHES

Other beginning approaches are *continuous-line drawing, organizational-line drawing,* and *blind contour.* Like gesture, these techniques emphasize coordination between eye and hand. They help translate information about three-dimensional objects onto a two-dimensional surface. They have in common with gesture the goal of seeing forms in their wholeness and of seeing relationships among the parts.

CONTINUOUS-LINE DRAWING EXERCISES

In a *continuous-line drawing,* the line is unbroken from the beginning to the end. It is a single line, more slowly stated than a gestural line. The drawing implement stays in uninterrupted contact with the surface of the paper during the entire length of the drawing. Jasper Johns's charcoal drawing *0 through 9* (figure 2.26) is an example of this technique. The numbers are layered, stacked one on top of the other, all sharing the same outer edges. The numbers are transparent and slightly unintelligible; the overlapping intersecting lines create shapes independent of the numbers themselves.

Once you make contact with the paper (you may begin anywhere: top, bottom, side), keep the line flowing. The completed drawing gives the effect that it could be unwound or unraveled. Rather than using multiple lines, use a single line; however, as in gesture, draw through the forms as if they were transparent. The line connects forms, bridging spaces between objects. Not only are outside edges described, internal shapes are also drawn. A continuous, overlapping line drawing has a unified look that comes from the number of enclosed, repeated shapes that naturally occur in the drawing. The resulting composition is made up of large and small related shapes (figure 2.27).

Again, as in gesture, try to fill the entire surface of your paper. This, too, will ensure compositional unity. Let the shapes go off the page on at least three sides. Vary the weight of the line, pressing harder in areas where you perceive a heavier weight or a shadow, where you see the form turning into space, or in areas of abrupt change in line direction. Line, shape, and movement result from the continuous, overlapping line exercise.

When you use the continuous-line technique in making a smaller drawing, the shoulder, elbow, and wrist are less involved than when you are working on a larger format. Nevertheless, the line should remain continuous, loose, and varied in width. Between drawings, with drawing implement in hand and without making contact with the paper, occasionally rotate the wrist, making loose gestures in the air. This will keep the line relaxed and interestingly varied. The resulting enclosed forms should also vary in size and shape. The overlapping lines can be made lighter as the forms come forward and darker as they move into the background space.

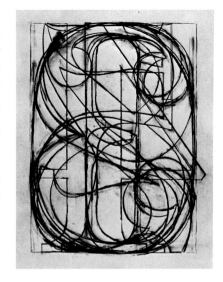

2.26. JASPER JOHNS. *o through 9.* 1960. Charcoal on paper, 2'5" × 1'11" (74 cm × 58 cm). Collection of the artist. © 2003 Jasper Johns/Licensed by VAGA, New York. Photograph by Rudolph Burkhardt, New York.

2.27. RICK FLOYD. *Continuous Line Drawing.* 1984. Pencil, 2' × 1'6" (61 cm × 46 cm). Private collection. Photograph by Danielle Fagan, Austin, Tex.

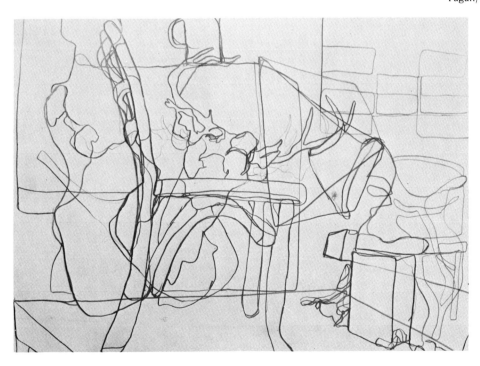

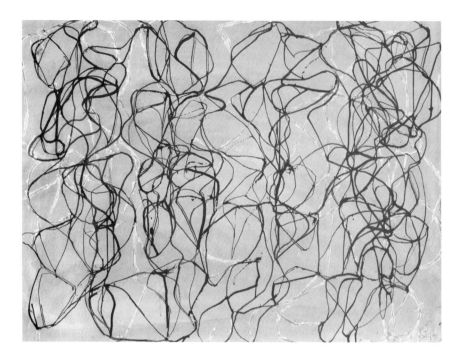

2.28. BRICE MARDEN. *Cold Mountain Addendum 1*. 1991–1992. Ink, ink wash, and gouache on paper. 2′2″ × 2′10¼″ (66 cm × 87 cm). Collection of the artist. © 2003 Brice Marden/Artists Rights Society (ARS), New York.

The continuous, overlapping line drawing is not only a beginning exercise. Many artists make use of this technique for finished drawings, as can be seen in Brice Marden's drawings, paintings, and prints (figure 2.28). As in Baselitz's work, where the upside-down image is a clue to his style, in Marden's art the continuous, overlapping line is a touchstone or stylistic indicator. Although the lines are nonillusionistic, there is a suggestion of volume, of the lines shadowing each other. The thick, curving, interlocking line is not only a carrier of style, it is also a carrier of content. Marden developed his technique-as-subject after a visit to Asia in the mid-1980s. His forceful work has an organic, fluid, nearly musical, scriptlike quality that is related to Chinese calligraphy. He claims an identification with the landscape and, more important, with the Taoist life energy the landscape embodies. Marden's line seems to hover above the surface rather than penetrate space. The background surface creates a shallow plane in front of which the lines perform.

Graphite sticks or pencils, conté crayons, litho markers, felt-tip pens, brush, and pen and ink are suggested media for continuous-line drawing. Any implement that permits a free-flowing line is appropriate. The following list highlights some important points to keep in mind when doing continuous-line drawing.

GUIDELINES FOR CONTINUOUS-LINE DRAWING

1. Use an implement that permits a free-flowing line.
2. Use an unbroken line for the entire drawing.
3. Keep your drawing implement constantly in contact with the paper.
4. Draw through the forms as if they were transparent.
5. Describe both outside edges and internal shapes.

6. Fill the entire surface of your paper, encompassing positive and negative shapes.
7. Vary the weight of the line.
8. Use continuous, overlapping lines.

ORGANIZATIONAL-LINE DRAWING EXERCISES

Organizational line provides the framework for a drawing. This framework can be compared with the armature upon which a sculptor molds clay or the scaffolding of a building. Organizational lines take measure; they extend into space. Like gestural lines and continuous, overlapping lines, they are not confined by the outside limits of objects. They, too, are transparent; they cut through forms. Organizational lines relate background shapes to objects; they organize the composition. They take measurement of height, width, and depth of the objects and the space they occupy. Like gesture, organizational lines are grouped; they are stated multiple times.

Use a pencil or graphite stick to make an organizational-line drawing of several objects in a room; include background space and shapes such as the architectural features of the room—ceiling, juncture of walls, doors, and windows. Begin with horizontal and vertical lines, establishing relative heights and widths of each object and of the background shapes. Note Giacometti's use of organizational line in figure 2.29. His searching lines extend into space beyond the confines of the objects to the edge of the picture plane. The

2.29. ALBERTO GIACOMETTI. *Still Life.* 1948. Pencil on paper, 1′7¼″ × 1′1½″ (49 cm × 32 cm). Collection of the Modern Art Museum of Fort Worth. Gift of B. Gerald Cantor, Beverly Hills, California. Copyright © Alberto Giacometti/Artists Rights Society (ARS), New York/ADAGP, Paris. Photo by Danielle Fagan, Austin, Tex.

objects themselves seem transparent; they are penetrated by groups of measurement lines. Multiple lines are clustered at the edges of forms, so the outer edge is never exactly stated; the edge lies somewhere within the cluster. The background space is organized by a number of squares and rectangles, loosely and lightly stated. The drawing is structured around the relationships between the table, the vase, and the architecture of the room.

In your organizational-line drawing, continue to correct basic shapes, checking on proportion between the parts and on relative heights and widths. Look for diagonals in the composition; state the diagonal lines in relation to the corrected horizontal and vertical lines. Continue to refine the drawing, registering information about scale and space. Let the background lines cut through the foreground forms of the still life, thus uniting background and foreground. Extend the horizontals and verticals; allow them to travel into space. This will tie foreground to background. By extending the lines describing the objects into space, you will create some repeating organizational shapes. Remember Bacon's admonition to be on the lookout for accidents.

By closing one eye (to diminish depth perception) and holding a pencil at arm's length, you can measure the height and width of each object and make comparisons between objects. This is called *sighting* and is an important device in training yourself to quickly register proper proportion. It is an indispensable aid for learning to translate three-dimensional objects onto a two-dimensional surface.

In addition to helping you establish correct proportion and placement between the parts, the buildup of multiple, corrected lines creates a sense of volume, of weight and depth in your drawing. After you have drawn for 10 minutes or longer and when you have finally accurately established proper proportion between the parts, you can then darken some of the forms, firmly establishing their exact shape. By this means you create a *focal point,* an area that is more developed and visually important than the rest of the drawing. You can direct the viewer's eyes through the drawing by means of these more developed areas of darker lines and more precisely stated shapes.

Erasers as drawing tools can be introduced at this point. Do not use the eraser to correct. Instead, use it as a drawing implement. Hold it exactly as you would hold a drawing tool and make multiple "negative," white, erased marks. The result will be some interesting, indefinite, blurred marks. Alternate using the original medium and eraser to finish the drawing. Erasure marks secure the drawing to its surface; they seem to fasten the marks to the page. The rich texture made by the eraser will also establish a spatial and atmospheric feeling to the drawing. Again, as with other drawing media, experiment with different kinds of erasers: kneaded erasers are suitable for use with powdery media; gummed erasers are less abrasive than most other erasers and will not destroy the paper's surface; Pink Pearl erasers with their gritty texture allow for more complete removal of graphite and pencil marks; white plastic erasers have a smooth texture that is less destructive to the paper's surface and is suitable for working with graphite, pencil, or colored pencil. There are even erasers in the shape of pens that contain a chemical to remove ink marks. Try experimenting and note your successes.

Many artists use organizational line for its analytical approach in the beginning stages of a drawing. The armature this technique provides may be disguised under the completed work, or, as in Giacometti's drawings, it may be left as an exciting record of how the drawing was built. It is an indispensable

technique for artists, whatever their field of concentration. Here are some important points to keep in mind when doing organizational-line drawings.

GUIDELINES FOR ORGANIZATIONAL-LINE DRAWING

1. Begin with multiply stated horizontal and vertical lines, both actual and implied; add diagonal lines last.
2. Establish relative heights and widths of all objects and background shapes.
3. Allow lines to penetrate through objects, establishing relationships between objects.
4. Correct basic shapes.
5. Check and correct proportion and relative heights and widths of your subject.
6. Extend lines through objects and into negative space.
7. When you have established accurately observed proportions, darken some of the forms, emphasizing their exact shapes.

BLIND CONTOUR EXERCISES

The clearest way to distinguish among contour, gesture, and continuous overlapping line is to look at an example of each. You probably have already identified the artist who made the gestural drawing of a vase of tulips (figure 2.30). Yes, it is by Georg Baselitz; his upside-down images are a sure

2.30. GEORG BASELITZ. *Untitled VI (Tulips)*. 1983. Pencil and charcoal on paper, 2′ × 1′5″ (61 cm × 43.2 cm). Collection of the Erasmus, Gemeente-Museum, The Hague. Photo courtesy Michael Werner Gallery, Cologne/New York. © Georg Baselitz.

2.31. ELLSWORTH KELLY. *Tulip* (detail). 1992. Graphite on paper, 2′6″ × 1′10½″ (76.2 cm × 57.2 cm). Courtesy of the artist and Matthew Marks Gallery, New York.

indicator of his style. The contour drawing, an elegantly drawn single tulip, is by the Minimalist Ellsworth Kelly (figure 2.31). The single incisive line is like a laser that slices a paper-thin line through space; or, as one observer noted, the delicate form seems to levitate, hovering just above the paper. (What a joy looking at art brings! So many interpretations and ideas can be embodied in a single image.) The elongated form pushes the upper limits of the paper. The subject is taken from real life and echoes its delicacy and tender form. The third tulip drawing (figure 2.32) is a monumental drawing by Donald Sultan. The image was made with charcoal to create a dense mass of continuously scribbled, overlapping lines. Some of the smudged line occasionally moves over onto the white background to create a visual contradiction. In one view, the dense form seems to recede into the paper; a second interpretation sees the mass as coming forward. The critic Clare Bell has a third spatial interpretation: she sees the tulip as a bulb, "a bulb still buried beneath the ground, a giant living mass waiting to burst. . . . Caught between two worlds, Sultan's tulip looks as if its only option is implosion." ("Tulip Times," *Art on Paper*, July-August 1998, p. 12.)

In contrast to the immediacy of the gestural approach, which records forms in their wholeness, the contour approach is a slower, more intense inspection of the parts. A contour line is a single, clean, incisive line that defines edges. It is, however, unlike outline, which states only the outside edge of an object. An outline differentiates between positive and negative edges. A contour line is more spatially descriptive; it can define the interior complexity of planes and shapes. Outline is flat; contour is *plastic*, that is, it emphasizes the three-dimensional appearance of the subject.

2.32. DONALD SULTAN. *Black Tulip, Nov. 2, 1983.* Charcoal on paper, 4'2" × 3'2" (1.27 m × 96.5 cm). Private collection, Boston. Courtesy of the artist.

A quick way to understand the difference between contour and outline can be found in the Benny Andrews drawing *Yeah, Yeah* (figure 2.33). The artist has combined outline and contour to good effect in a single drawing. The figure of the musician is primarily outlined; the exceptions are the left hand and features of the face, which, along with the guitar, are delineated in contour line. These three areas create a pyramidal focal area that supports the theme of the drawing, the intensity and single-minded focus of a musician. The empty, outlined figure promotes a sense of melancholy similar to the feeling in music that the blues project. Simple means can produce powerful results.

An effective way to distinguish between contour and outline is to imagine the difference in the outline of a pencil and the lines that make up its contours. If you were drawing a pencil using contour line, you would draw a line at the edge of every shift in plane. The ridges along the length of the pencil, the juncture of the metal holder of the eraser with the wood, the insertion of the eraser into its metal shaft—all are planar changes that would be indicated by contour line. In addition to structural, or planar, edges, contour line can indicate the edge of value, or shadow, the edge of texture, and the edge of color.

There are a number of types of contour, several of which are discussed in chapter 5, "Line." Here in our discussion of beginning approaches, we will concentrate on working with *blind contour,* an exercise that enhances accurate observation, drawing without looking at your paper. Some general instructions are applicable for all types of contour drawing. In the beginning use a sharp-pointed implement (such as a 2B pencil, ballpoint pen, or pen and ink). Precision and exactness require a precisely made line. Contour drawing demands a single, incisive line. Do not retrace already stated lines, and do not erase for correction.

In blind contour, keep your eyes on the subject you are drawing. Imagine that the point of your drawing tool is in actual contact with the subject. Do not let your eyes move more quickly than you can draw. Keep your implement

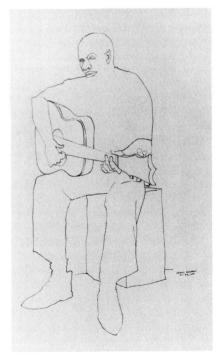

2.33. BENNY ANDREWS. *Yeah, Yeah.* 1970. Ink on paper, 1'6" × 1' (46 cm × 30 cm). The Arkansas Arts Center Foundation Collection; the Museum Purchase Plan of the NEA and the Barrett Hamilton Acquisition Fund, 1981. 81.23.

in constant contact with the paper until you come to the end of a form. It is imperative to keep eye and hand coordinated. You may begin at the outside edge of your subject, but when you see that line turn inward, follow it to its end. In a figure drawing, for example, this technique may lead you to draw the interior features and bone structure without completing the outside contour. Remember to vary the pressure on the drawing tool to indicate weight and space, to imply shadow, and to articulate forms.

Draw only where there is an actual, structural plane shift or where there is a change in value, texture, or color. Do not enter the interior form and aimlessly draw nonexistent planes or make meaningless, decorative lines. (In this regard, contour drawing is unlike a continuous, overlapping-line drawing, where you can arbitrarily cross over shapes and negative space.) When you have drawn to the end of an interior shape, you may wish to return to the outside edge. At that time you may look down and realign your drawing implement with the previously stated edge. With only a glance for realignment, continue to draw, keeping your eyes on the subject. Do not worry about distortion or inaccurate proportions; proportions will improve after a number of sessions dedicated to contour.

In contour drawing time is slowed down. You are not recording the subject in its entirety, as in gesture; in contour you are going from the parts to the whole. Try to extend the length of time you spend on any one drawing; however, it is imperative to keep alive the spirit of careful, intense observation. Eye and hand are one in this technique. A finished product is not the goal; the focus is on process. No other exercise hones your visual acuity like contour.

For this exercise choose a complex subject; in the beginning a single object or figure is appropriate (figure 2.34), such as a bicycle, typewriter, or skull. Distortion and misalignment are a part of the exercise. Do not, however, intentionally exaggerate or distort. Try to draw exactly as you see. If you have a tendency to peep at your paper too often, try placing a second sheet of paper on top of your drawing hand, thereby obscuring your view of the drawing.

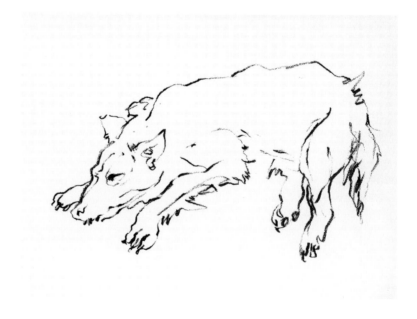

2.34. SANDRA FERGUSON TAYLOR. *Fuzzy.* 2002. Charcoal pencil, 8″ × 10″ (20.3 cm × 25.4 cm). Courtesy of the artist.

Blind contour drawing should be done frequently and with a wide range of subjects—room interiors, still life, landscape, and figure. Here are some important points to keep in mind when doing blind contour exercises:

GUIDELINES FOR BLIND CONTOUR DRAWING

1. Use a well-sharpened pencil, ballpoint pen, or pen and ink. Later, found implements, such as twigs and ink, can be used, but in the beginning use a sharp-pointed implement.
2. Keep your eyes on the subject.
3. Imagine that your drawing tool is in actual contact with the subject.
4. Keep eyes and hand coordinated. Do not let your eyes move more quickly than your hand.
5. Draw only where there is an actual structural plane shift, or where there is a change in value, texture, or color.
6. Draw only existent planes. Do not make meaningless lines.
7. Do not retrace over already stated lines.
8. Do not erase for correction.
9. Remember that contour line is a single, incisive line.
10. Vary the weight of the line to relay information about space and weight and to offer contrast.
11. Slow, accurate observation is the goal.

SUMMARY

Gesture drawing is a manifestation of the energy that goes into making marks. It is a record that makes a visual connection between the artist and the subject drawn, whether that subject is from the real world or from the world of the imagination. It can take place in the initial stages of a drawing and can serve as a means of early thinking about one's subject; it is an idea generator. People in all walks of life make use of gestural drawings, but for the professional artist, the technique is foundational.

Gestural marks can be the subject of the drawing or the carrier of an idea in the drawing. Gesture drawing, then, encourages empathy between artist and subject. The gestural approach gives the drawing vitality and immediacy. It is a fast, direct route to that part of us that has immediate recognition, that sees, composes, and organizes in a split second. Through gesture drawing we bring what we know and feel intuitively to the conscious self, and this is its prime benefit.

These foundational, basic approaches—gesture, continuous-line, and organizational-line drawing—train us to search out underlying structure. They are a quick means of noting planes and volumes and locating them in space. They help us to digest the whole before going to the parts, to concentrate in an intense and sustained way. The three approaches furnish a blueprint for a more sustained drawing and provide a compositional unity early in the drawing.

Contour drawing, on the other hand, offers a means to a slow, intense inspection of the parts. It refines our seeing and leads us to a more detailed

understanding of how the parts relate to the whole. The more you practice the more disciplined your drawings will be (figure 2.35).

These beginning approaches introduce some ways of translating three-dimensional forms onto a two-dimensional surface. We are made aware of the limits of the page without our having to refer constantly to it. These approaches offer a means to establish unity in the drawing, to place shapes and volumes in their proper scale and proportion. They introduce lights and darks as well as a sense of space into the drawing, suggest areas for focal development, and provide rhythm and movement.

Finally, these beginning approaches provide a flexible and correctable beginning for a more extended drawing. They give options for developing the work and extending the drawing over a longer period of time. They point the route to a finished drawing.

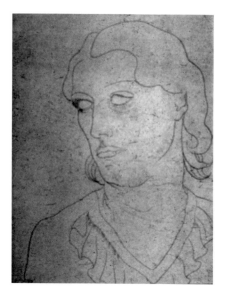

2.35. JOHN STORRS. *Lady with Ruffles.* 1931. Silverpoint, 1′½″ × 9⅝″ (31.8 cm × 24.4 cm). Signed and dated l.l in silverpoint: STORRS / 30-3-31-2. Estate of the artist. Courtesy of Valerie Carberry Galley, Chicago, Illinois.

SKETCHBOOK PROJECTS

At the conclusion of each chapter you will find recommendations for sketchbook projects to be done in tandem with the studio problems. Each of these beginning projects is ideal for sketchbook work.

Before you begin, read the first two Practical Guides at the end of the book on materials and keeping a sketchbook.

Since the steps for each beginning technique have been thoroughly discussed in this chapter, it should be sufficient to offer you some ideas appropriate for each project; then you are on your way to an exciting career in drawing.

PROJECT 1
Gesture Drawings

One major change from the instructions that were given previously in regard to gesture drawing involves scale. Since the sketchbook is so much smaller than your drawing pad, and since you will be drawing while seated rather than standing at an easel, remember that the gestural movement will be more limited. Your shoulder should still be relaxed and the wrist kept loose. It is recommended that you not hold the drawing implement in the same way you hold it for writing; this produces a constricted line. You want the impetus for the movement to come from the arm and wrist even though the motions are scaled down, so experiment with handling the drawing tool loosely, holding it in the middle of the shaft or at the opposite end of the marker.

Here are some suggestions for subject matter for gesture drawings in your sketchbook:

Animals, your own pet or animals in a zoo
People in a shopping mall
Sports events
Children in parks or playgrounds
Café scenes
People dancing
People waiting for buses or in buses, planes, or trains

Landscapes (parks, waterscapes, city scenes, buildings)
Family members or roommates performing daily chores
Interior scenes (classrooms, dormitory rooms, rooms in your home)
Clothing hung in closets, draped on chairs, thrown on the floor
Draped fabric, unmade beds
Musicians performing
People attending concerts

These are only a few suggestions for getting started; you will come up with your own personal list of favorite subjects in no time. Daily dedication to gesture will give a secure underpinning to your drawing skills. Devote at least 15 minutes a day to gesture drawing outside the classroom.

PROJECT 2
Continuous-line and Organizational-line Drawings

Continuous-line and organizational-line drawings can be done with more static subject matter than gesture drawings. For more effective results you should choose subjects that are arranged in spatial relationships, such as a group of objects on a table, a room setting that involves a grouping of furniture, or a landscape. Keep in mind the idea of transparency; make the lines cut through forms and through space. The relationship between the forms should be foremost in your mind. Choose subjects that vary in size, height, width, and depth, and try accurately to relate them to each other. Proportion and scale will become second nature to you after a while.

PROJECT 3
Blind Contour Drawings

Literally anything and everything make appropriate subjects for contour drawings. Making contour drawings is a form of meditation. You can spend five minutes or an hour on a single drawing, depending on your time and mood. You probably have played the childhood game of repeating a word so many times that it loses its referential meaning and becomes pure sound. This could be an analogy for what happens in the process of a slow contour drawing. You are looking so intently at the object that you forget the name of the object being drawn. This is an ideal state in contour. You become so absorbed in looking that the object becomes pure form. Here is a starter list for blind contour subject matter:

Hands
Feet
Gloves
Articles of clothing
Fruit or vegetables
Plants
Tools
Drawing implements
Desktop articles
Vehicles such as bicycles, motorcycles, automobiles, trucks
Toys

Friends—sleeping, reading, working, playing
Animals
Self-portraits
Contents of a drawer, refrigerator, or cabinet

With dedication and commitment to keeping a sketchbook you will be surprised at the progress you will make, at how skillful you become in drawing. Blind contour is a technique that pays off in a hurry. Note your improvement after the first 50 drawings, then after the first hundred. You will be amazed at how keen your observation has become and how much control you have gained.

Many artists have made the claim that drawings are closer to the bone than any other art form; that being so, your sketchbook should be a real anatomical volume.

PROJECT 4
Automatic Drawing

Related to gestural technique is the Surrealist experiment with automatic drawing (figure 2.36). The Surrealist André Masson characterized his

2.36. ANDRÉ MASSON. *Automatic Drawing.* 1925. Ink, 1'3½" × 9½" (39.4 cm × 24.1 cm). Musée National d'Art Moderne, Paris. Reunion des Musees Nationaux/Art Resource, NewYork. © André Masson/ Artists Rights Society (ARS), New York/ ADAGP, Paris.

response to the process as a "happy surprise or a strange malaise" (Doris A. Birmingham, "André Masson's Trance/Formations," *Art on Paper*, March–April 1999, p. 49). The technique is a form of self-hypnosis. The first condition is to free the mind and to enter into a trancelike state; second, to abandon oneself to "interior tumult"; and third, to begin rapid mark making or, as the Surrealists called it, "writing." Automatic drawings are works made without prior planning, deliberation, or forethought. Despite certain similarities between them, they can be remarkably diverse. "When one goes very quickly, the drawing is mediumistic, as if dictated by the unconscious. The hand must move quite rapidly so that conscious thought cannot intervene and direct the gesture," Masson advised.

Automatic drawing can be done throughout your drawing career. It is an ideal relaxing technique, and you will learn how it can furnish you with fresh, new ideas. Think of it as a mind-cleaning exercise; it clears the mind, conditions the eye, and relaxes the hand.

SPATIAL
RELATIONSHIPS
OF THE ART
ELEMENTS

. . . ambiguity is the principal source of the inexhaustible richness of art. If we do not quickly tire of a picture or a piece of music, it is because we do not always see exactly the same pattern of colored patches or hear the same pattern of tonal pitches. Instead, we pick up or resonate each time to somewhat different relations within the pattern. . . . The picture or music, however aesthetically pleasing in its own right, is not only interpretable as an abstract pattern of patches in space or pitches in time; the picture or music is also interpretable as, say, the play of moonlight and of violins overlapping waters on the shore of some distant summer's day.

ROGER N. SHEPARD, PERCEPTUAL AND COGNITION PSYCHOLOGIST,
FROM HIS BOOK *MIND SIGHTS*

DEVELOPMENT OF SPATIAL RESPONSE

Octavio Paz writes that our senses are "capable of extending throughout the entire universe and touching it. Not seeing with one's hands but touching with one's eyes" (Paz, *Convergences*, p. 296). In chapter 2, "Learning to See," we discovered how this is possible—to see with our hands and touch with our eyes—and we began to see how important space is to the artist. The sculptor Sarah Sze's definition of her work as "conversations with space" is applicable to all art. Humans have a susceptibility to spatial illusions; we readily interpret marks on a surface as spatial notations. This tendency stems from three main sources: first, our perceptual and cognitive systems (that is, the way we gather information from the world around us); second, psychology, the way we feel about things; and third, the culture we live in. We are pro-

grammed to make spatial assessments; in fact, we are fascinated with space and with *visual, perceptual,* and *spatial ambiguities.* An ambiguity presents two or more incompatible interpretations. No doubt you have played the game of seeing an object as one thing at one time, and a second thing at another time. Both interpretations cannot be mutually held. The famous image is that of the rabbit-duck, or of the vase made by two profiles of a person. The images switch back and forth as your eyes and brain make alternating interpretations. You are probably familiar with the drawings and prints of the Dutch artist M. C. Escher, whose work has been widely reproduced on posters and T-shirts; his images by now have become visual clichés (figure II.1). Escher's popularity attests to our interest in spatial ambiguities.

Since the Modernist period began in the latter part of the nineteenth century, artists have favored spatial ambiguity in their work. Note with what simple means the Surrealist Oscar Domínguez has presented a complex spatial statement (figure II.2). The reductively drawn head transforms from (or into?) a square plane, itself lying on top of (or behind?) the red border. The

II.1. M. C. ESCHER. *Relativity.* 1953. Lithograph, 11″ × 11⅖″ (28 cm × 29 cm). © Cordon Art.

II.2. OSCAR DOMÍNGUEZ. *Tete.* 1950. Oil on canvas, 1'9⅔" × 1'6" (55 cm × 46 cm). Sotheby's catalogue LN5173 #539. © 2003 Oscar Domínguez/Artist Rights Society (ARS), New York/ADAGP, Paris.

curved line at the top can be interpreted as the top of the head or as an eyebrow floating above a rectangular form bisected by an arc. Is the rectangle a window

into space? Or is it the square-headed man's eye? Is the crescent the side view of his eye? Or are we looking through a window at a moon?

As we have just seen in Domínguez's work, marks are not simply two-dimensional lines on paper; rather they are spatial illusions, notations of objects and ideas in a spatial context. We instantaneously read these marks as forms in space. The predilection or propensity of humans to perceive pictorial depth is universal, but our emotional responses to depicted space change over time with differing cultures. Cultural differences affect our attitudes toward space, not simply the fact of virtual depth, but the way we perceive and depict pictorial space. (By *pictorial space* we mean the kinds of space that are used on the *picture plane*, the surface on which the artist works, such as canvas or paper.) The video artist Bill Viola has said that the art deals with "how the world meets the mind, not the eye." He adds, "Experience is so much richer than light falling on your retina." Our experiences are culture-based, so it is not a surprise that our art should reflect our culture.

The drawing by Francis Yellow, a Lakota artist (figure II.3) is a striking example of the role cultural difference plays in art. Employing a number of spatial devices, the Native American artist recorded a battle between the Plains Indians and U.S. soldiers. This spatially complex work uses a number of sophisticated pictorial devices to present a historical record. A nineteenth-century map of Nebraska, contemporaneous with the event, provides the surface, the ground, both literally and figuratively, on which the encounter takes place. Familiar Western conventions of overlap, distance, and scale are bypassed, and a powerful spatial code has

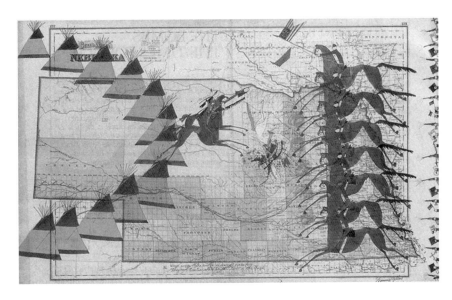

II.3. FRANCIS YELLOW. *Wicoun Pinkre Maka Kin Ta Wicokunze Oyake Pelo ("They Said Treaties Shall Be the Law of the Land.")* Painting on a nineteenth-century map.

II.4. Drawing by a Tunisian child, from *Their Eyes Meeting the World* by Robert Coles, p. 77. Copyright © 1992 by Robert Coles. Reprinted by permission of Houghton Mifflin Company. All rights reserved.

been employed. The teepees are symbolic representations of the many Indian groups who took part in the battle; the abstracted horses and riders are contingent and overlap slightly, melding into one spinelike shape. The space used in this drawing is a *stacked space*, which indicates a spatial progression moving from bottom to top, from near to far; however, there is no shift in scale to differentiate figures closer to the viewer from those farther away.

A difference in battle plan is relayed in the lineup of the two opposing forces; the straight line of the cavalry confronts the phalanx of the opposing fighters. The drawing resembles a game board in that it would seem logical to view this drawing as if it were on a table rather than hung on a wall. The analogy is apt when we recall that chess was developed as a war strategy game. In the center of the "board" Yellow has depicted the first bloody encounter; the mythic red horse and rider rear violently into space while below them is a bloody blur of the enemy. The negative spaces between the horses' chests and hindquarters echo the triangular patterns made by the teepees. From the sideline tiny guns and treaties are waved in the air, forming a frieze behind the soldiers. The title tells all: *They Said Treaties Shall Be the Law of the Land.* The work is from a collection of Plains Indian drawings made between 1865 and 1935, powerful in their retelling of a historical mo-

ment. The abstract map furnishes a moving underlay to the work—even the Indians' homeland has been abstracted and taken from them.

Art establishes a dialogue between the work of art and the viewer; it uses a syntax made up of the *formal elements;* that is, the elements of art used to create form: color, line, shape, value, and texture. Form in art is created by the endless, fascinating, and changing arrangements of the elements; a critical aspect of art is the way color, line, shape, value, and texture can be used to create pictorial space. We look at art not only through the subject matter but through the interconnections of form and content.

A crucial stage in learning about art—for the viewer, but especially for the artist—is the development of a spatial response, an insight into the complex aesthetic and technical problems art presents. It is this knowledge that enhances the art experience and turns it into a meaningful experience.

The chapters in Part II deal with the five art elements: shape, value, line, texture, and color, and the conventions used to create various spatial illusions. These elements will provide the building blocks for your own personal construction of space. Now let us take a look at a very complex topic, the different kinds of pictorial space and how they contribute to the meaning of a work of art.

II.5. ENRIQUE CHAGOYA. *Uprising of the Spirit.* 1994. Acrylic and oil on paper, 4′ × 6′ (1.22 m × 1.83 m). Los Angeles County Museum of Art (partial and promised gift of Ann and Aaron Nisenson). Gallery Paule Anglim.

We all have a subjective response to space; each of us experiences and interprets space in an individual way. A child's idea of space differs from an adult's. Children throughout the world are attracted to art because of the way it helps them make sense of the world and their place in it. In figure II.4 a Tunisian child has drawn a view of his hometown, an orderly, happy, idealized place filled with people, places, and events important to him. Like other children's drawings, this one makes use of *conventionalized* or *symbolic space*, as opposed to *illusionistic, realistic,* or *naturalistic space*. Objects that are more important are larger, even though they occupy a more distant space. We recognize the conventions, the keys to interpreting the drawing. For example, the objects at the bottom of the page are meant to be closer whereas objects at the top of the page are to be seen as farther away. Fronts, sides, and roofs of buildings are depicted as if the viewer had an aerial view, but the mosque and the red building at the top of the page are drawn frontally; in other words, the child artist has shifted his viewpoint. Figures, plants, and animals are depicted schematically—note the stick figure at the upper left. A puzzling inset, a picture-within-a-picture, is placed off-center just below the road. Two children, their bodies cut off by the frame, appear to be looking out of the inset (a window superimposed on the otherwise logical space of the drawing) onto the scene unfolding in front of them. If our interpretation is correct, the child artist has invented a very clever and personal device for showing us a view from his world. Both people and ob-

jects inside this space-within-a-space are drawn in a much smaller scale than the objects outside. Very little overlapping occurs; it is as if each object in the young child's world occupies its own assigned position. Spatially, this drawing carries the happy message that all is well in this teeming world of activity.

Pictorial space has been treated differently in different eras and cultures. A graphic example of this diversity can readily be seen in a 1994 drawing by Enrique Chagoya, *Uprising of the Spirit* (figure II.5), whose subject is once again the clash between two divergent societies, the collision of European and New World cultures. The tragic displacement and destruction of the indigenous Mexican culture by the invading Spaniards in the sixteenth century created a hybridization that continues even today with the imposed popular culture of Mexico's North American neighbor (represented in the drawing by the ironic entrance of a comic book character, Superman). In this work we see the conflicting icons representative of three cultures, each occupying a different space. Chagoya has recontextualized images from three different historical periods and geographical locations to signify the clash of three competing ideologies. Their spatial integration into a single work of art results in a format that is loaded with meaning, on a formal, artistic level, on a socio-historical level, and on a personal level for the bicultural artist.

Chagoya's images originate from sixteenth-century sources whose spatial differences could not be

II.6. *Nine Pairs of Divinities*. Mixtec codex, Mexico. Fourteenth–sixteenth century. Vatican Library, Rome. Photo: Vatican Library.

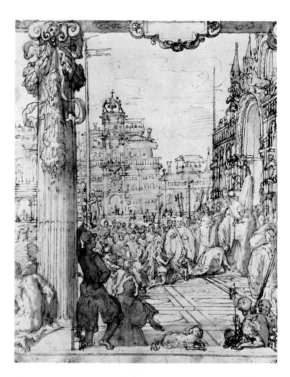

II.7. FEDERIGO ZUCCARO. *Emperor Frederic Barbarossa before Pope Alexander III.* Late sixteenth century. Pen and ink wash over chalk, 10⅜″ × 8½″ (26 cm × 21 cm). Pierpont Morgan Library/Art Resource, New York. 1973.29.

more pronounced. The flattened space in a Mixtec codex, or manuscript book (figure II.6), contrasts with the illusionistically deep space in a Renaissance drawing by Federigo Zuccaro (figure II.7), although both were produced during the same period. In the Mixtec panel the space remains flat because of the use of un-modeled, or flat, value shapes and outlines. The figures share the same baseline (the imaginary lines on which they stand). Hieroglyphs in each unit form a repeating pattern, which further flattens the space. The back-ground is empty; the main focus remains on the posi-tive figures and their static and symbolic relationship with one another. In the lower right panel we see an ex-ample of *hierarchical space*, a spatial system that depicts persons and things according to rank, class, or status. The sacrificial victim is drawn on a much smaller scale than the priest and god, who are at the top of the hier-archy; the figures stand in symbolic relationship to one another. The Mixtec artist was governed by a hierar-chy of forms, both in his art and in his culture.

By contrast, the sixteenth-century Italian artist depicts a stepped progression of space. This effect

is achieved through *perspective*, a convention unique to European art. Perspective literally means "to look through," as through a "window into space," which is exactly how Renaissance space was conceptualized. Perspective was the art of picturing objects in a scene or a landscape as they would appear to the eye in relationship to distance, space between objects, and proportion—in other words, to mirror relative sizes and positions of the objects as they were perceived in real space. In Renaissance perspective, everything con-verges on the eye of the viewer, who is centered in front of the artwork or in front of the window into space. The single spectator, as John Berger observes, could be only in one place at a time (unlike God with the capability of omni-location). So perspective rein-forced a philosophical, hierarchical religious belief, just as the Mixtec codex did.

This convention of privileging the optical spatial interpretation rose to its highest achievement in the Renaissance. A way of thinking, associated with the de-velopment of mathematically based systems of per-spective, is actually a philosophical mode. This one-

II.8. A. R. PENCK. *T.III.* 1981. Dispersion on canvas, 6′7″ × 9′2½″ (2.01 m × 2.81 m). Collection Martin Sklar, New York.

stance position, challenged throughout art history since the Renaissance, was forever changed in the nineteenth century with the invention of the camera, where multiple viewpoints could easily be effected. To quote Dziga Vertov, a revolutionary 1920s Russian film director: "I'm an eye. A mechanical eye. I, the machine, show you a world the way only I can see it. . . . Freed from the boundaries of time and space, I co-ordinate any and all points of the universe, wherever I want them to be. My way leads towards the creation of a fresh perception of the world. Thus I explain in a new way the world unknown to you" (from a 1923 article by Vertov, quoted in Berger, *Ways of Seeing*, p. 17). This could be the mantra of twentieth-century art.

In his depiction of the meeting between the emperor and the pope, Zuccaro creates an illusion of ceremonial, deep space. He places the figures and buildings in realistic proportion to one another by making objects diminish in size as they recede into the distance and by using darker washes and more precisely drawn lines in the foreground. The picture plane is penetrated by diagonal lines (on the ground and in the building on the right) that lead the viewer into a logical deep space. Column, figures, and building seem to be washed by a gentle atmospheric light; soft grays and whites differentiate between the various volumes. Unlike the Mixtec artist, Zuccaro had as a goal the depiction of perceptually realistic, albeit idealized, space.

To help clarify some new terms with which to start building a vocabulary to discuss pictorial space, let's categorize some work according to spatial arrangements. In some drawings artists translate objects as they exist in real space, which has height, width, and depth, onto a flat surface, which has only height and width. The space conveyed can be relatively *flat* or *shallow*, it can be *illusionistic*, that is, giving the impression of space and volume, or it can be *ambiguous*, neither clearly flat nor clearly three-dimensional.

In A. R. Penck's work (figure II.8), figures are stated in minimal terms—they are made up of flat shapes creating a very limited depth. (Of course, any mark on paper distinguishes between positive space

and negative space.) Penck even dispenses with overlap, a common device for conveying the idea of arrangement of forms in space. The shapes resemble cutout forms with jagged edges. There is an illogical scale shift from the rather uniformly sized symbols to the taller figure on the right, which creates an ambiguity in scale. The work is abstract but highly personalized. Penck (a pseudonym; the original Penck was a geologist who studied the Ice Age) works in an autobiographical mode. His crossing (during the time of the Berlin Wall) from East Germany to the West provided him with an archetypal theme of passage. The bleak images produce a powerful impact of primitive and mythic import. We classify this artist's space as flat, two-dimensional space.

CATEGORIES OF SPACE

A work that employs flat shapes while introducing overlap is the collage *Roots Odyssey* by the African-American artist Romare Bearden (figure II.9). A more complex space than used in the Penck work is achieved by a division of the picture plane to indicate various levels of space: sky, water, ship, land, and figure. The looming foreground silhouette on the right claims the dominant conceptual space. The outline of Africa and the slave ship seem to spring from the figure's imagination. The rising sun and the abstracted birds provide a sense of implied movement and symbolically represent Bearden's hope for freedom. Each shape is clearly two-dimensional, yet overlap and scale shift contribute to a limited or shallow space. The angle of the masts and the diagonal movement of the flat white birds offer spatial relief from the static vertical stripes that indicate the figure's shoulder. How different these two works are, Penck's and Bearden's, yet they both deal with the same subject matter: crossing over and dispersion.

Jim Nutt suggests a theatrical space for his metaphorical narratives (figure II.10). Illogicality abounds in his quirky, ingenious, and wildly convoluted spatial innovations. The spaces conveyed in Nutt's explosive domestic scenes are *ambiguous*, neither clearly flat nor clearly three-dimensional. Nutt's spatial inventions have been compared to puppet productions of surreal fairy tales, an appropriate description except for the very adult psychological realism they embody. Dominating the work is the signature Jim Nutt frame, large pattern-painted frames that nearly overpower the scenes they

II.9. ROMARE BEARDEN. *Roots Odyssey.* 1976. Offset lithograph, printed in color, 2′4⁵⁄₁₆″ × 1′9″ (68.4 cm × 53.4 cm). Collection Ben and Beatrice Goldstein, New York. © Romare Bearden Foundation/Licensed by VAGA, New York.

enclose. The frame in *Not So Fast* has a rather hypnotic effect with its vibrating gray dots that make up the pattern. (The painting is black, white, and subtle grays, so there is no complication of color interaction to further confound the viewer.) Large dark quarter-circles that resemble heavy reinforcement tabs tack down the four corners of the enclosed central scene; they serve to "corner in" the participants in the drama. The shallow stage-like space is created by the receding wall and ceiling, whose rigid diagonal grid flattens even while suggesting a spatial penetration of the picture plane. And what about that zany scale shift from hand to hand, from one body part to another (look at the ears and arms), not to mention the tiny figure who occupies what logically should be the nearest space at the bottom of the picture plane? The patterning within the tie,

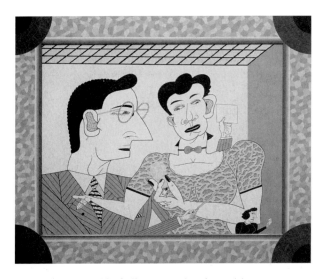

II.10. JIM NUTT. *Not So Fast.* 1982. Acrylic on Masonite, acrylic on wood frame, 2′6¾″ × 3′1½″ (78 cm × 95 cm). Private collection. Phyllis Kind Gallery. AP1984.23.

ure II.11) His spatially three-dimensional illusionistic motifs are large in scale, mirroring his interest in architectural structure. Talasnik's forms seem to have been stripped of their outer skins. He conveys an illusion of volume by building a rich tactile surface created by abrasions, erasure, and rubbing. *Rubbing* is a means of transferring texture from an actual tactile surface to the surface of the paper. (Remember how as a child you made rubbings of coins? This is the same process.) The result is a dramatic *chiaroscuro* effect; that is, using light and dark to create an illusion of volume and dimension—another spatial device developed in the Renaissance. (Leonardo da Vinci is the best-known practitioner of chiaroscuro.) Through modeling from light to dark and suggesting cast shadow, Talasnik's exaggerated structural shapes could be monumental scaffolds into a cosmic space. It is interesting to note that the skeletal forms are adapted from computer-derived grids; his technique resembles weaving. The forms are more suggestive of gigantic baskets with their interwoven contours than mechanically derived forms. The three-dimensional constructions seem to be wheeling in space; even the narrow dark shape at the bottom of the drawing suggests a vast horizontal plane on which the forms have been anchored; the lighter, faded-out structures seem to have been cut loose from their moorings and to be floating off into space. Talasnik's abraded surfaces suggest a passage of time and layers of history, the real subject of his work.

Twentieth-century artists have made many innovations with space, not the least of which is the combination of pictorial space and real, actual, three-dimensional space. Joseph Cornell is an artist who has brought this hybrid art form to a high level of achievement. Cornell's boxed tableaux contain fantasy worlds

suit, dress, hair, and inner ears is a flattening device, and the overlap of arms and hands is a spatial indicator canceled by the arm and hand in front being smaller than the shape they cover. Details of clothing and hairstyles are specific to the 1930s: Could there be a reference to those films that dealt with complex male-female relations? It is not only Nutt's subject matter and spatial arrangements that attract us; his inventive use of formal elements and his refined technique contribute to the richness of the work. Spatial ambiguity is a perfect foil for his psychologically ambiguous content.

An artist who exploits the spatial confines of the two-dimensional picture plane is Stephen Talasnik (fig-

II.11. STEPHEN TALASNIK. *New Frontier.* 1993–1994. Graphite on paper, 1′2″ × 4′8″ (35.6 cm × 1.42 m). Albertina Museum, Vienna.

II.12. JOSEPH CORNELL. *Untitled (Juan Gris)*. 1954.
Box construction, wood, cut papers, and found objects;
1′6½″ × 1′ × 4¼″ (47 cm × 32 cm × 12 cm). Philadelphia
Museum of Art. Purchased, the John D. McIlhenny Fund.
© The Joseph and Robert Cornell Memorial Foundation/
Licensed by VAGA, New York.

and have been aptly called visual poetry (figure II.12).
His ready-made found objects are juxtaposed to create
metaphorical narratives. To look at Cornell's work is to
look into a dreamworld. His work is preoccupied with
a sense of infinite space; his images are taken from re-
produced, printed material. The juxtaposition of the
real with the unreal makes for symbolic, lyrical, and
poetic connections. In the box created in honor of the
artist Juan Gris, the walls are papered with collage frag-
ments; the relationship between foreground (bird) and
background (box) is an ambiguous one—like the spa-
tial ambiguity found in Gris's work (see figure 5.16).
Within the box, the bird and sky are clearly illusionis-
tic and volumetric; the cockatiel and limb are realisti-

cally or naturalistically rendered; the sky forms a back-
ground for the exotic bird and at the same time it can
be read, on both formal and metaphorical levels, as a
window into space. (Yes, there it is again. Cornell, who
was well informed on art history, makes a reference to
Renaissance space.) The printed text provides a tex-
tured background for the flat, cutout, two-dimensional
black shapes, while the ring, ball, and wooden bird sup-
port are actually three-dimensional. This ready-made
combine is a compendium of space: two-dimensional,
three-dimensional, and a combination of both, ambig-
uous. Cornell's choice of ambiguous space is in perfect
harmony with his coded message to Gris, a Cubist
master of ambiguous space. And what better image for
space than a bird that occupies both levels of our lit-
eral, environmental space: land and sky!

As we have seen in contemporary art, it is very
difficult to confine an artist's use of space to one
category. Donald Baechler's Post-Modern work is a *pas-
tiche* (a combination of several imitated styles in one
work) of several spatial conventions (figure II.13). Post-
Modernism is characterized by layering images appro-
priated from various sources, both from popular cul-
ture and from art. In Baechler's work the centralized
black-and-white flower is flattened by the heavy delin-
eating outline. The background is an irregular grid of
squares and rectangles made up of patterns of large and
small dots. The regularity of pattern creates a limited
depth; the larger dots tend to come forward whereas
the smaller ones recede into a shallow space. A variety
of spatial treatments are used in the rectangular insets
that surround the central image. In the lower left, a
hooded head is treated traditionally with modeling
and shading; an imitative or illusionistically three-
dimensional space is the result. The same is true for the
lemons and lime in the adjoining square; however, their
isolation from the background makes them appear to
float, so here the spatial interpretation is a bit more am-
biguous. Two small insets taken from cartoon strips
employ relatively flat, conventional or symbolic space;
the pair of silhouetted figures in the lower right are
flat, two-dimensional shapes; the two sets of concentric
circles create a spatial tension owing to their shift in
scale; and the pages of printed numbers invoke yet an-
other kind of space.

Ordinarily we do not think of words and letters
as occupying space; they are so integrated to their neu-
tral backgrounds, we do not perceive a spatial context
when we see printed textual material. Again, for every
rule there is an exception. During his Pop art years in

II.13. DONALD BAECHLER. *Black Flower #1.* 1994. Gouache, gesso, and collage on paper, 4'11" × 3'11" (1.499 m × 1.194 m) overall. Sperone Westwater.

the 1960s, the artist Jasper Johns used numbers and letters as images (see figures 2.16 and 2.26). He purposefully chose flat objects such as targets and flags to make a break with spatially illusionistic subject matter. His breakthough ideas have been widely disseminated. Today it is quite common for artists to use letters and numbers in their work and to depict them as having volume and mass, as occupying space just as other actual three-dimensional objects do.

Baechler has established a subtle tension between all the parts of a spatially complex work. Because the images and background texture are arranged in a vertical and horizontal format, the sense of movement and depth is limited. Baechler's big risk (and his big success) is to integrate that looming, clunky flower image with the subtle and disparate images that lie behind it.

PRECURSORS OF CONTEMPORARY SPATIAL DEVELOPMENT

The concept of space began its radical changes over the last quarter of the nineteenth century. Not only have artists' concepts of space changed, our ideas concerning real, physical space have changed. We have only to consider how speed alone can alter one's perception of space to realize that our concept of space is radically different from that of our predecessors as our knowledge of our place in the cosmos changes.

Impressionism marks the time when artists began to lay claim to a painting as an object in its own right, autonomous, separate, and different from its earlier role as imitative of the real world. It was at this moment that

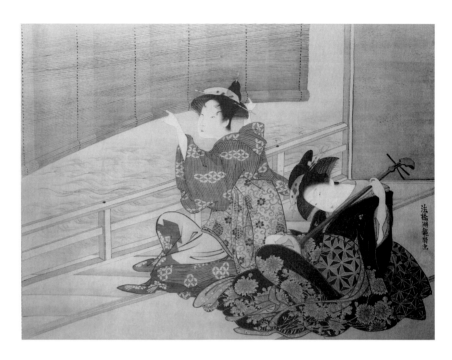

II.14. ISODA KORYUSAI. *A Courtesan Playing the Samisen.* ca. 1785. Hanging scroll, ink and gold on silk, 4′ × 2′ 9/16″ (1.219 m × 62.4 cm). Kimbell Art Museum, Fort Worth, Texas.

art's release from its limited function of illusion began. The Impressionists declared in their work and in their writings that visual reality is not only the imitation of the surface appearance of objects, but that visual reality is in a state of flux, altered by the quality of light and captured by the changing viewpoints of the constantly moving eye. These artists were scientific in their investigation of the properties of light and color, and they experimented with how (rather than what) we perceive. A radical shift from the perspectival space of the Renaissance began in earnest with Impressionism. The latter quarter of the nineteenth century was a time of transition, when the category of information became the conveyor of a different type of reality. Scientific investigations into optics, into light, color, and perception came to the fore. Such periods of transition are always highly interesting, not only in art but in all fields of inquiry. The optical image was seen "in a different light," so to speak.

It is interesting to note that among the major influences on the spatial innovations of the Impressionists were the eighteenth-century Japanese Ukiyo-e artists—painters of the floating world (figure II.14). The Impressionists were attracted to the very different spatial arrangement in Eastern art: the use of flat, unmodeled areas of color and pattern, an unexpected eye level, bird's-eye view, and cut-off edges. These compositional devices were particularly suited to the newly emerging camera. Japanese subject matter, like that of

the Impressionists, dealt with intimate scenes. Religious paintings, portraiture, and history paintings were of no interest to the Impressionists. New images, new techniques, and new ideas demanded a new space, which the Impressionists found in Eastern art. Globalization is not such a new development after all.

New ideas of pictorial space, along with new scientific discoveries in the perception of light and color, occupied both the Impressionists and their successors, the Post-Impressionists. In their intense concentration on light as conveyed by color, the Impressionists minimized the illusion of volumetric forms existing in an illusionistic three-dimensional space. The Post-Impressionists sought to revitalize pictorial space by re-creating solids and voids while having them occupy a limited depth (figure II.15). Georges Seurat sought to synthesize the findings of the Impressionists with ideas of traditional illusionistic space and structure. He places his figures in an arrangement of diminishing perspective and unifies and flattens the surface of the work with a pattern of colored dots. By these means he reconciles the flatness of the picture plane, maintains modern concerns of light and color, and introduces weight and volume into the composition. Seurat was interested in classical structure; he was especially attracted to Egyptian stacked perspective, where forms at the bottom of the picture plane are read as being closer to the viewer whereas those at the top are seen as occupying a deeper space.

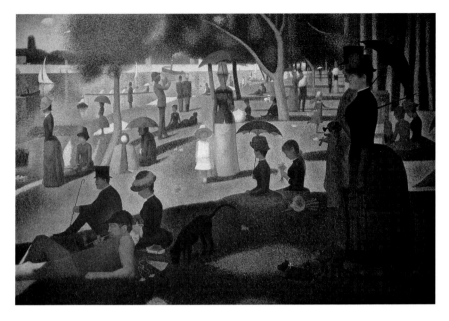

II.15. GEORGES SEURAT. *A Sunday on La Grande Jatte—1884.* 1884–1886. Oil on canvas, 6′9¾″ × 10′1¼″ (2.075 m × 3.08 m). Art Institute of Chicago; Helen Birch Bartlett Memorial. 1926.224. Photograph © 1995, The Art Institute of Chicago. All rights reserved.

Paul Cézanne was a seminal figure who exerted a major influence in establishing twentieth-century concepts of space. He has been called the father of Modern art. His space is not recognizable as natural space, but one can discern how his complex idea of illusionistic space is integrated on a flat surface (see figure 1.13). The planes or edges of the objects slide into one another, joining surface and depth. Cézanne's new technique of depicting volume as it exists in space opened the way for the revolutionary look of Cubism, where forms were distorted, segmented, analyzed, and revised. New ways of looking demanded new ways of dealing with space. In Cubism objects and figures from the real world were reduced to geometrical abstractions. The Cubists followed Cézanne's celebrated directive to treat nature in terms of "the cylinder, the sphere, the cone" (Arnason, *History of Modern Art*, p. 150)—in other words, to interpret forms in their simple and broad dimensions.

In addition to introducing reductive, abstracted forms, Cubists shattered the traditional idea of perspective by combining multiple views of the same object in a single composition (figure II.16). The single event depicted in Renaissance space was replaced by

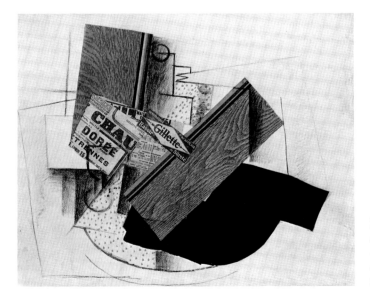

II.16. GEORGES BRAQUE. *Still Life on a Table.* 1913. Collage, 1′6½″ × 2′¾″ (47 cm × 62 cm). Private collection. © 2003 Georges Braque/Artists Rights Society (ARS), New York/ADAGP, Paris.

II.17. WASSILY KANDINSKY. *Study for Improvisation* 28 (second version). 1912. Watercolor, India ink, and pencil on paper, 1'3⅜" × 1'10⅛" (39 cm × 56.1 cm). Solomon R. Guggenheim Museum, New York. The Hills von Rebay Foundation. 1970.127. © 2003 Wassily Kandinsky/Artists Right Society (ARS), New York/ADAGP, Paris.

"a discontinuity of space"; the image was presented in multiple views—side, top, inside, outside, showing collapsed and simultaneous views of a single subject and of the space surrounding it. The resulting space is highly ambiguous, combining flat diagrammatic forms with modeled volumes. The Cubists not only described objects in new ways, they depicted space itself as if it were made up of tangible planes and interlocking shapes. The work is complex in its arrangements; in a Cubist composition spatial relationships proliferate— not only relationships between objects but relationships between objects and space. In viewing a Cubist work, the viewer must adopt multiple stances, multiple vantage points. The object is seen simultaneously from below, above, from inside, from the back. There is a vertiginous aspect in response to the fractured, mul-

tiple, manipulated views. Cubist works were visual equivalents of Albert Einstein's theories of time, light, and space. In the early years of the twentieth century, both science and art presented a world where disjunction and discontinuity coincided. New insights offered by the emerging fields of psychiatry and sociology presented artists with new metaphors. Cubism is closely linked with these new ideas in the air; it reflected and grew out of an exciting, dynamic, and volatile time.

At the same time the Cubists were challenging accepted ways of depicting space, the Russian artist Wassily Kandinsky laid claim to be the first artist to create a completely abstract work, a watercolor made in 1910. It was made as he was writing his theoretical justification for nonfigurative art, *Concerning the Spiritual in Art*. In Kandinsky's work energy is a result of the

II.18. MAX ERNST. *". . . hopla! hopla! . . ."*. 1929. Collage, 4″ × 5⅝″ (10.2 cm × 14.3 cm). Collection of the Modern Art Museum of Fort Worth, Museum Purchase, The Benjamin J. Tillar Memorial Trust. © 2003 Max Ernst/Artists Rights Society (ARS), New York/ADAGP, Paris.

forms being unbalanced and unattached; they seem to move through a cosmic space. Rather than the fixed window into space, Frank Stella suggests that Kandinsky shows us a "mobile window" that presents "a slice or a plane of a larger spatial whole" (Stella, *Working Space,* p. 113). In the Russian artist's watercolor shown here (figure II.17), images rotate in space; the surface of his work is filled with free-falling forms.

The premises of Cubism were logical; they were supplanting Renaissance space with a new vision, a modern space that fit the times. The Surrealists defied logic and rationality. Their name literally means "above the real"; their intent was to explore "the more real world behind the real"—that is, their interests were in psychology rather than anatomy, an interest of the Renaissance (see figure 1.16). The psychoanalytical research done by Freud was of particular interest to them.

It is no surprise, then, that Surrealistic space is disjunctive and exaggerated; it has a hypnotic power of eliciting an otherworldly space that comes from the realm of the subconscious. Scale shifts and unexpected juxtapositions characterize the recognizable Surrealistic style. Max Ernst was one of the leaders of the movement, and like his fellow artists, his goal was to bring together on the picture plane both outer and inner reality. He had an unending source of evocative dream images (figure II.18). His work remains as popular today as when he made it. You are already familiar with a popular technique used by the Surrealists to tap into their subconscious—automatic drawing—which was introduced in chapter 2.

Joan Miró, the Spanish artist whose work bridged Cubism and Surrealism, built a repertory of abstracted, invented pictorial signs, using luminous, pure, unmod-

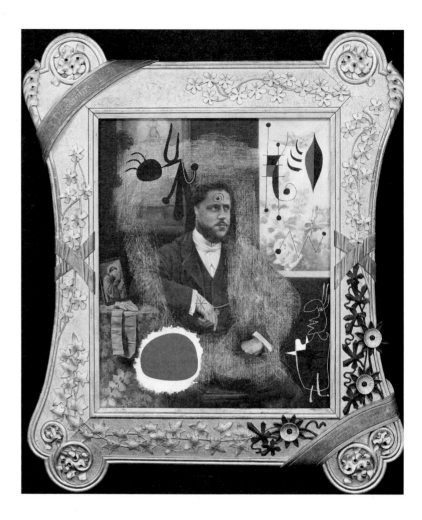

II.19. JOAN MIRÓ. *Portrait of a Man in a Late Nineteenth-Century Frame.* 1950. Oil on canvas with ornamented frame, painting 3′1⅛″ × 2′7½″ (96 cm × 80 cm); overall, including frame, 4′9½″ × 4′1¼″ (1.46 m × 1.25 m). Museum of Modern Art, New York; gift of Mr. and Mrs. Pierre Matisse. © 2003 Joan Miró/Artists Rights Society (ARS), New York/ADAGP, Paris. Photograph © 1997 The Museum of Modern Art, New York.

ulated color shapes. These biomorphic, organic forms furnished the means for his antistyle and his self-avowed attack on painting. This attack is clearly evident in his *Portrait of a Man in a Late Nineteenth-Century Frame* (figure II.19). Miró challenged conventional art historical ideas of space (and bourgeois tastes) by effacing the found painting with his cryptic shapes, disembodied signs, and splatters of colors, leaving the anonymous man's face and hands intact. This abraded, scratched, and altered portrait—the original was done in a style popular at the turn of the century—contains a number of traditional spatial references: the spatial penetration by the window in the upper-right-hand corner has been canceled by the addition of Miró's mysterious lines and shapes; the photograph on the table suggests another reference to two-dimensional space; and finally, the religious painting on the back wall is all but obliterated and replaced with one of Miró's dark, schematized, symbolic signs, suspended in air. The result-

ing space is a jolting combination of three-dimensional space and relatively flat, two-dimensional space. Miró's added flat shapes and lines insistently bring the viewer's attention back to the two-dimensional surface of the painting. The scumbled, sanded background creates a pulsating space that is not strictly confined to one definite plane. The two conflicting styles, one traditional and conservative, the other abstract and radical, share an uneasy coexistence. By presenting the work in such an ornate, overdone heavy gold-leaf frame, Miró underscores his condemnation of end-of-the-nineteenth-century tastes and accepted conventions. His lifetime involvement with *Biomorphic Surrealism*, which uses abstract forms rather than recognizable objects and figures, contributed to a real breakthrough in new approaches to space and abstract imagery in the twentieth century.

Post–World War II, in the 1940s and 1950s, the Abstract Expressionists (sometimes called Action paint-

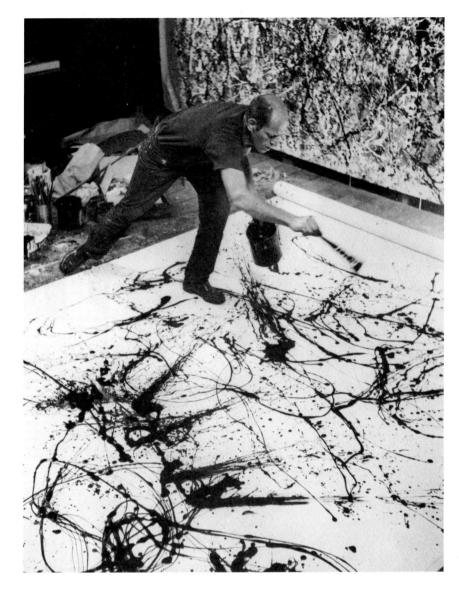

II.20. HANS NAMUTH. *Jackson Pollock, 1950.* Photograph. © 1991 Estate of Hans Namuth, courtesy Center for Creative Photography, University of Arizona.

ers), many of whom worked in the style of Biomorphic Surrealism, carried the idea of pictorial space in another direction. Their emotionally explosive, vigorous, painterly attacks resulted in surfaces of rich complexity that force us to think of space in a totally new way. The painted surface is a record of the intensity of the process of painting itself fed by an inner psychological force.

Jackson Pollock was the standard-bearer for this movement. He developed a unique method of painting; by laying the canvas on the floor, he was able to walk around it and paint from all sides. Dipping a brush or stick into enamel (a liquid commercial house paint, not artists' oil from a tube), he applied paint with rapid ges-

tural movements, dripping, splattering, and pouring, allowing the liquid paint to weave rhythms over the surface. The brush remained just above the canvas, so both orientation of the canvas and technique of paint application were radical departures. The shift from the vertical to the horizontal had a surprising spatial effect on the finished work (figure II.20). Seeing the paintings hung upright, the viewer responds to the energy (often vehement), fluidity, and freedom the works embody. The critic Leo Steinberg described Pollock's work: "manifestations of Herculean effort, this evidence of mortal struggle between man and his art" (O'Connor, *Jackson Pollock*, p. 72). The wall-size mural scale used by the Abstract Expressionists sets their work apart; the

words *heroic* and *sublime* were often used to describe their psychologically loaded productions.

The use of the accidental in Pollock's work (and in that of the other Action painters) was not itself accidental; as B. H. Friedman explains, "He improves, using the accidental, accepting the accidental (as one does, in nature), but not being dominated by it . . ." It was a means of relaying the Abstract Expressionist intent— motion, energy, and inner expressive feelings made visible. Pollock, along with his fellow artists, felt that Abstract Expressionism was not an appropriate label. He said their work was neither nonobjective nor nonrepresentational. "I'm very representational some of the time, and a little all of the time. But when you're painting out of your unconscious, figures are bound to emerge. We're all of us influenced by Freud, I guess. I've been a Jungian for a long time . . . painting is a state of being. . . . Painting is self-discovery. Every good artist paints what he is" (O'Connor, p. 73).

Abstract Expressionist images are not "images of" anything; they are a result of action. Rather than looking out into space at the horizon, it is as if the viewer's vantage point were above, from an airplane, looking down to the flat surface of the earth. This fundamental change from looking through an illusionistic, horizontal space to looking through a skein or web of paint signals a real departure in the viewer's spatial response to the work. Franz Kline's startling black-and-white configurations (figure II.21), boldly executed, seem like patterns on the earth seen from miles away. The space is actually ambiguous because, in spite of the pictorial associations and illusions, the viewer is first and foremost aware of the marks on the surface of the canvas or paper. The insistent reference back to the picture plane, to its flatness and its edges, is the hallmark of Modernist space. This characteristic is called *the autonomy of the picture plane.* It is a quality inherent in all Modern art; in spite of the illusion painted on the flat surface, the viewer is always mindful of the surface and its limiting edges, regardless of the shape of the flat picture plane, whether it be round, oblong, or multisided. Abstract Expressionists made the final break with Renaissance pictorial, perspectival space. (Renaissance painters disguised their brush stroke; their surface was smooth so as not to interfere with the illusion of space that penetrated the window—the viewer "saw through" the surface of the painting.) Action painters focused the viewer's attention on the picture plane itself and on the medium used, on the nonreferential marks and how they were made.

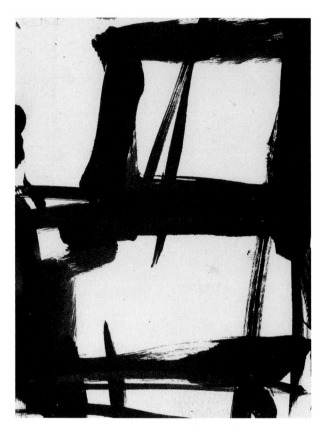

II.21. FRANZ KLINE. *Untitled.* 1954. Oil on paper, 11″ × 8½″ (28 cm × 22 cm). Collection of the Modern Art Museum of Fort Worth, Museum Purchase, The Benjamin J. Tillar Memorial Trust. © 2003 Franz Kline Estate/Artists Rights Society (ARS), New York.

This fertile movement showed artists how non-objective art can serve as a concentrated emotional field, a place where the physical, individual marks are the subject themselves. It opened the door to a purely visual experience, not tied to a narrative or to an external reference. It simply refers to itself; nevertheless, it makes use of pictorial space, the space of the picture plane, what the artist Frank Stella has called "working space."

In the aftermath of the Abstract Expressionist movement, which lasted well into the 1950s, Robert Rauschenberg, along with other Pop artists, brought further spatial innovations to art. Pop artists' aim was to reintroduce everyday life back into art. They objected to the division between high art and low art, between fine art and the popular production of images through photography—advertising, newspaper, magazines, comic books. Many Pop artists were trained in

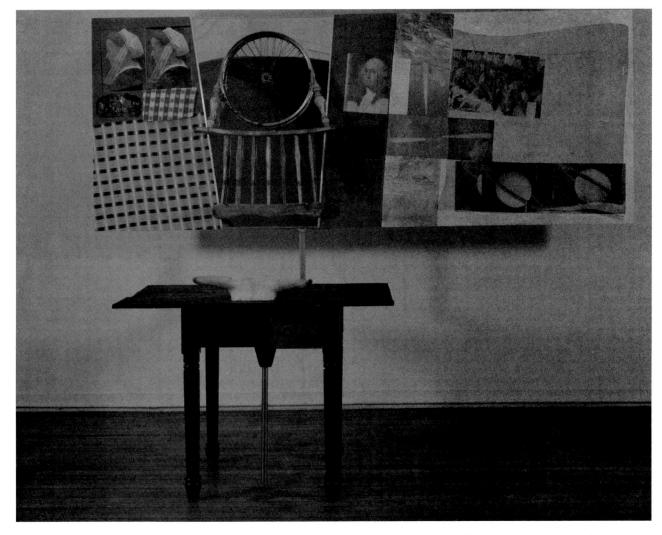

II.22. ROBERT RAUSCHENBERG. *The Vain Convoy of Europe Out West* (*Kabal American Zephyr*). 1982. Solvent transfer, acrylic, fabric, and paper on wood, with wood table, wood chair back, metal wheel, plastic traffic cone, license plate, animal horns, and metal oar, 6'2" × 8'1½" × 3'5½" (1.88 m × 2.451 m × 1.054 m). Private collection. Photographer Glenn Steigelman. © Robert Rauschenberg/ Licensed by VAGA, New York.

commercial art and were quick to use advertising and commercial art techniques in the production of their work. Pop art's goals were the antithesis of Abstract Expressionism. Pop artists were opposed to the idea of the avant garde and the idea that the art object was inherently endowed with special value or significance. Andy Warhol's art antics are widely known; his Campbell's soup cans and Brillo boxes are themselves clichés of consumer clichés. Pop artists lifted subjects directly from the shelf and presented them as isolated objects in a blank, white space. In imitation of advertising practices they used silkscreen and other commercial repro-

duction techniques in making their art. The resulting space is a flat, limited, two-dimensional space. The negative space surrounding the objects seems of little import as it contributes to meaning or allusion to another kind of space.

Although Rauschenberg had an enormous respect for Abstract Expressionist painting, his antiheroic, democratic imagery was at odds with that of his Modernist predecessors (figure II.22). Rauschenberg realized that collage need not be limited in dimension, that it could be scaled to whatever size he chose, and some of his choices were extraordinary: chairs, tables,

stuffed goats and roosters, and pillows and mattresses are among the many objects from the real world that he incorporated into his paintings and drawings. He called his composite works "Combines." Unlike other artists who incorporated found objects in their work, he did not reconfigure the objects; they were left as they were, lifted from real space to have a life on another surface. This hybridization flew in the face of Modernist aesthetics; purity of categories had been strictly enforced. To mix different genres (such as painting, sculpture, photography, craft) violated the purity of the Modernist art object. Rauschenberg took nonart material and turned it into compositionally intricate works; he "re-presented" photographs from newspapers, magazines, advertisements that he transferred by rubbing or by silkscreen onto the picture plane. The blank space of a printed page is thought of as a neutral surface; we do not consider words on a page as a spatial illusion, but Rauschenberg (along with his fellow artist and collaborator Jasper Johns) introduced a new visual and spatial ambiguity by using flat printed matter as image. What once was thought of as uninflected space, Rauschenberg converted to a multidimensional space. His "impure," complex layering of images alongside ordinary objects from everyday life broke the modernist claim that art was a separate sphere of existence and that it had an intrinsic aesthetic value.

The critic Leo Steinberg characterized Rauschenberg's working surface as a "flatbed picture plane" (Steinberg, *Other Criteria*, p. 82); that is, it is like a flat, horizontal surface on which anything can be placed. Steinberg saw this new conception of the horizontal plane as a depository for "culture." This notion is unlike the horizontality of a Pollock painting; although Pollock painted by standing over his canvases, the resulting space suggests a cosmic or galactic space. The idea of horizontality remains in a Rauschenberg work even when it is hung on a wall. Pollock's paintings were bounded by the rigid edge of the canvas stretcher or by frames; Rauschenberg does not enclose his two-dimensional drawings-paintings-prints by stretchers or frames, so the free-floating surfaces of fabric and handmade paper become dimensional objects affected by movement and light from the environment in which they are placed. His new method of presentation was greatly influential for Installation art that is so widely seen today. Rauschenberg says he "collaborates" with his materials, giving them free rein to play various roles in his art. "One of the questions that I remember the

answer to was, 'What is your greatest fear?' and I said, 'That I might run out of world'" (Hopps and Davidson, *Robert Rauschenberg*, p. 30).

CONTEMPORARY SPATIAL DEVELOPMENT

Stylistic pluralism is the result of the diverse directions art took in the second half of the twentieth century, exhibiting a proliferation of styles, philosophies, and ideas. Rather than one style replacing another in a historically linear fashion, as was characterized by the Modernist movement from the turn of the century, today styles coexist side by side; therefore, we see all types of pictorial space currently in use.

An innovative use of pictorial space, and one peculiar to contemporary art, is that of the Photo-Realists, who faithfully record the patterns that a camera sees—both its focus and distortion. Photo-Realists reintroduced representational imagery into art, but with a real difference; the subject was the photograph itself. Duplicating what the camera sees and how a photograph looks results in a space that is three-dimensionally illusionistic and flat at the same time. An unmistakable photographic flatness combines with the volumetric illusion that ultimately results in a distinctive combination that is neither clearly two-dimensional nor unequivocally three-dimensional; it's another hybrid space. Although the Photo-Realist movement began in the 1970s, it is still employed by a number of artists who continue to make new innovations in technique. This can be seen in Chuck Close's Photo-Realistic work created with fingerprints (see figure 1.21).

In the 1950s, Color Field painting (as its name implies—a solid flat field, or plane, of color), led to Minimalism, or Reductivism, which focuses on art's formal properties, such as color and shape (figure II.23). By drawing the geometric figures directly on the wall of a room, Sol LeWitt engages viewers not only on the visual or perceptual level but involves them in a physical and temporal participation as well. Site-specific work, such as LeWitt's, drawn on a museum wall, can only be complete when the viewer moves through the space of the room in which it is displayed. The aim is to reinstate art to a total vital experience, not only by means of visual sensations but by employing other sensations as well, such as the quality of light in the room, the natural sounds occurring in the space, the way it

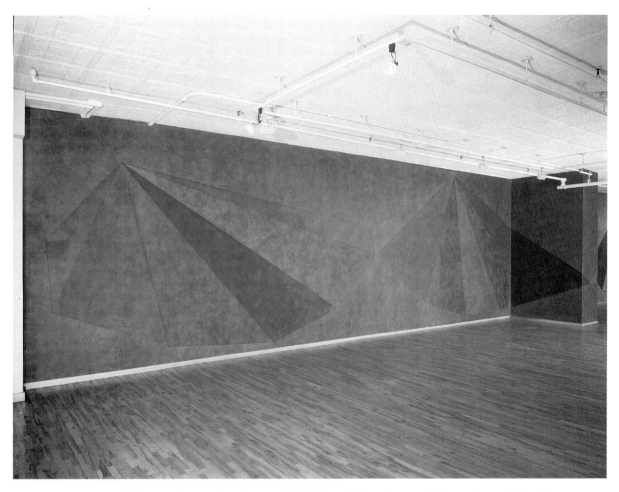

II.23. SOL LEWITT. *Multiple Pyramids.* 1986. Installation at John Weber Gallery. © 2003 Sol Lewitt/Artists Rights Society (ARS), New York.

feels to be contained in that space—these all become part of a particular experience, unique to each viewer. LeWitt's images have a presence that is self-contained; that is, they are stripped of references outside the drawing itself. The planes that form the sides of the figures force a three-dimensional interpretation. In spite of their multisidedness there remains a sense of spatial ambiguity owing to the extreme change in value, in light and dark, in the adjacent planes. The shaded side dominates, and if one concentrates on these gray planes intently, they seem to shift their positions spatially. In addition, the fact that they are suspended in space lends them a sense of ambiguity. LeWitt confronts the viewer with questions concerning perception and thereby sets the stage for a real dialogue between the viewer and the art.

An outgrowth from Minimalism was a group of artists who began (and the movement continues today) to work with light itself—not light depicted on a two-dimensional surface, as in the Impressionist movement, but real, actual emitted light. Like the Impressionists, Light artists are involved in perception, in how we see what we see, how light can radically alter our accepted perceptions of space and volume. In spite of the space in which the lights are installed being a real three-dimensional space, the colors and intensity of the light easily create an ambiguous space—one that is experienced not only on the retinal but on the visceral level as well.

Two other movements that grew out of Minimalism in the late 1960s and early 1970s were Conceptual art and Earth art. Conceptual art deals with written,

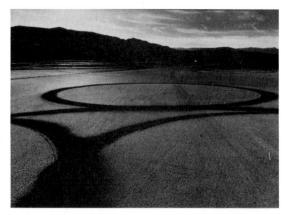

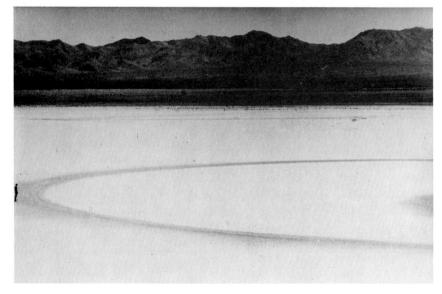

II.24. MICHAEL HEIZER. Three views of *Circular Surface Planar Displacement.* 1971. Earth construction, Jean Dry Lake, Nevada, 400′ × 800′ (121.92 m × 243.84 m). Courtesy Sam Wagstaff.

drawn, or merely conceived ideas or proposals of artworks that may or may not be carried out; it deals with the idea, with the concept, rather than the physical manifestation of the artwork. Both Conceptual art and Earth art were initiated as strategies to bypass the politics of commodification and influence of museums and galleries. (Needless to say, these institutions were quick to display the proposals, which were either in the form of conceptualized drawings or simply written descriptive texts. So the goal of independence from the established art system was quickly sidetracked.) The space of these proposals must be conceptualized in the reader's mind.

Earth art deals with site-specific work made for a special geographical location. Sometimes the artwork is documented by photographs; at other times, it is necessary to travel to the actual geographic site to view the work. You would not think that drawing could play

a major role in this movement, but drawing is an essential practice for Earth artists, both in their proposals for the project as well as the actual work. In *Circular Surface Planar Displacement* by Michael Heizer the lines incised into the earth were "drawn" by the wheels of a motorcycle (figure II.24).

We could not have a discussion of pictorial space without including the contemporary artist Frank Stella, whose entire body of work has dealt with reinvigorating space as it is used in abstract art (figure II.25). Our traditional concept of the rectangle as background for a two-dimensional work of art is subverted by Stella's curved and expressively colored sculptural shapes that aggressively jut from the wall and occupy, rather than depict, actual, projective, three-dimensional space. His works are on a large scale, eccentric and exciting. Stella has written that he seeks an emotional impact of space; he believes that this emotive, new approach to pictorial

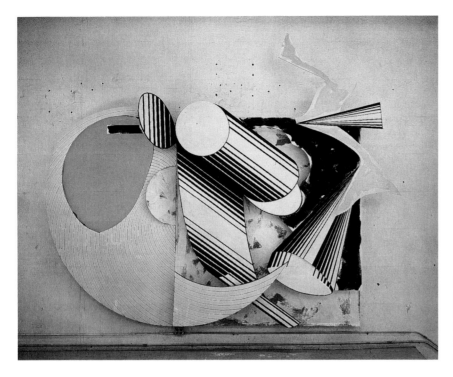

II.25. FRANK STELLA. *Diavolozoppo* (#2,4x). 1984. Oil, urethane enamel, fluorescent alkyd, acrylic, and printing ink on canvas, etched magnesium. Knoedler & Co. © 2003 Frank Stella/ Artists Rights Society (ARS), New York.

space is an antidote to what he sees as abstraction's "inability to project a real sense of space" (Stella, p. 46).

Post-Modernism, a late twentieth-century development, is an attitude more than a style and employs the full range of pictorial space: flat, ambiguous, and illusionistic, frequently including all in the same composition. One particularly interesting development has been the overlay of images; even more innovative is the fact that the images are unrelated by technique, as in the Baechler drawing (see figure II.13).

Josef Levi's Post-Modern mixed-media painting-drawing places two immediately recognizable icons side by side, forcing them to share the same space (figure II.26). But isn't that an impossibility? Mona Lisa's face harks back to her origins, the Italian Renaissance; the style is revelatory of time and place; the treatment of the portrait incorporates telltale techniques of sixteenth-century art: chiaroscuro, modeling from light to dark across the face, carefully modulated values, cast shadow, idealized features, smooth brush strokes. Levi even imitates the aged, cracked surface of the painting.

The other Liz is unmistakably a Pop icon from the 1960s. The baby-blue paint on Liz Taylor's face is flatly applied; commercial rather than fine art techniques are suggested. The features delineated in black seem to have been mechanically silk-screened onto the

surface in imitation of Andy Warhol's painting technique. The hair of both women is merely suggested; although they are left unfinished they provide enough clues for the viewer to recognize the hairstyles. The background space encircling Mona Lisa is faintly manipulated, whereas the negative space behind Liz's head is painted a flat mauve. The space used in this dual

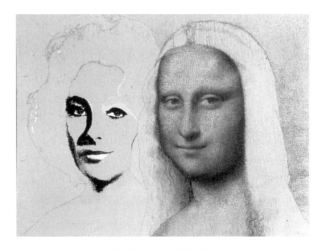

II.26. JOSEF LEVI. *Still Life with Warhol and Leonardo.* 1993. Acrylic and graphite on canvas, 3′1″ × 4′ (94 cm × 1.22 m). O.K. Harris Works of Art, New York.

portrait is definitely ambiguous; the styles are incompatible. Andy Warhol and Leonardo da Vinci! Pop and Renaissance on a collision course! It takes real mental effort to try to see the faces as existing on the same plane—Liz's face "pops" out (pun intended); in contrast, Mona Lisa's head seems to recede as if moving back to her proper century. Disjunction and disorientation, appropriation and irony, criticism and humor—all are defining traits of Post-Modernism. What history lies between these two clashing symbols!

THE INFLUENCE OF ELECTRONIC SPACE

Current technological developments have made major inroads in our ideas and perceptions of space; for example, advances in computing power have radically changed the way architecture is designed and constructed (see figure 2.6). Production processes, reproduction processes, digital tools, computer modification programs, photographic and paint programs, and new developments in video are only a few of the many technological advances that bombard us today. It is important to consider the kinds of new metaphors technology offers and how it can contribute to our aesthetic production. Video art is by now a category in art like painting or sculpture. Electronic space is decidedly

different from the categories of space set forth in this discussion.

Obviously, the computer and video screen are of a different character and quality than paper or canvas. They are literally made up of particles of light and energy—not merely a translation of light and energy, which so occupied the Impressionists. Yet in a sense they are more neutral than traditional art surfaces. The viewer is definitely not tricked into thinking they are a window into space, at least not Renaissance space. The tactile difference is the defining one; there is an identifiable quality to a mark that has been electronically made. Artists have always been drawn to new materials and new techniques, so it is not surprising to find that technological influences abound in contemporary art (figure II.27). Josefa Losada-Stevenson's color thermal transfer and lithograph from a computer-generated image definitely attests to technological influences! There are telltale clues to the technology the artist used, yet the creative thinking and problem-solving that goes into making a drawing by hand underlies the work. It's not the machine that makes the art; the person who knows how to adapt the technology to serve art's purpose is the real creator. It is interesting that Picasso and his created characters are the subject of this print; Picasso was eager to experiment and to take advantage of whatever new developments came his way.

Howardena Pindell's photograph is a still taken from a video screen drawing. Light, energy, space, and

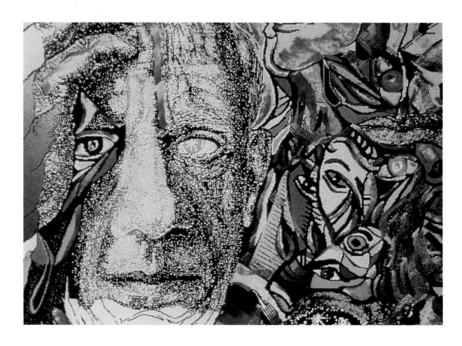

II.27. JOSEFA LOSADA-STEVENSON. *Dreaming Picasso 1.* 1989. Color thermal transfer and lithograph from computer-generated image, 1'5" × 1'8" (43.4 cm × 51 cm). Courtesy of the artist.

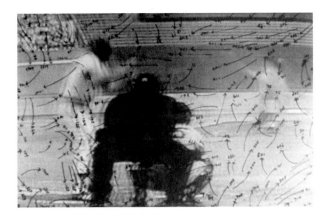

II.28. HOWARDENA PINDELL. *Untitled (Video Drawing: Baseball Scenes).* 1974. Color photograph, 11″ × 1′2″ (27.9 cm × 35.6 cm). The High Museum, Atlanta. Courtesy of the artist.

movement go into its making. The drawing makes a sly comment on television sports shows with their instant playback ability. It's as if a sports announcer had gone berserk with his analysis of baseball plays (figure II.28).

Just as the artists at the beginning of the twentieth century were influenced by the founding of modern physics, new ideas in psychology and sociology, the invention of film and radio, the introduction of mass production and circulation of newspapers, new construction capabilities of steel and aluminum, and the invention of the airplane, today's artists respond to new technological developments.

Machines will never replace the kind of critical thinking and informed making that is required in art. Your eyes, your thoughts, and your hands are indispensable. You can use new technologies to help you carry out your artistic plans, but beware of facile means. There really are no shortcuts to a rich life filled with art experiences.

EMOTIVE SPACE

Before we conclude our discussion of space, let's come full circle and look at one more example of how space has been used by a nonprofessional artist. We began our introduction to space with a child's drawing; we will conclude with a look at a powerful drawing made by a self-trained artist.

Martin Ramirez was a mute and withdrawn psychotic for many years. Institutionalized as a schizophrenic for the last 30 years of his life, Ramirez turned to drawing as a sympathetic companion. Meager supplies forced him to improvise materials. He glued to-

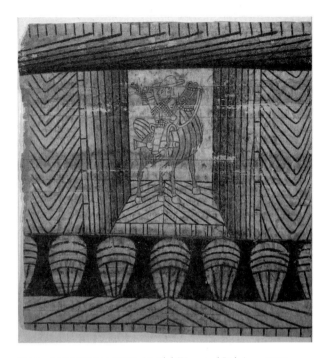

II.29. MARTIN RAMIREZ. *Untitled (Horse and Rider).* c. 1950. Pencil on paper, 2′1″ × 2′ (63.5 cm × 61 cm). Phyllis Kind Gallery.

gether old scraps of papers, cups, candy wrappers— anything he could find to create a drawing surface. Often he made glue from mashed potatoes and water, even from bread and saliva. His working methods reflected his psychotic nature; he kept his drawings rolled up, working on only a small exposed area at a time.

The space in his drawings reveal his inner fears (figure II.29). Entrapped animals occupy spaces too small to contain them. Walls close in on the frightened personal stand-ins. In his *Horse and Rider*, a pencil drawing on paper, the horse has its head thrown back as if in anguish. The legs are peculiarly proportioned; the back legs are longer and nearer the viewer than is logical. The stereotypical *bandito* character (he could be one of Picasso's cast) has his head completely twisted backward. He wears a shoulder harness and bullets. Both he and the horse are taut with tension; they seem ready to run. But where? The tomblike space seems to close in on them; the illogical space is psychologically loaded. Our body responds to the confinement and our hearts pound in empathy. Striking and moving work is being done throughout the world by artists who are outside the mainstream of art. Their work is eagerly sought by galleries, museums, and collectors alike. Sadly, much of Ramirez's work was destroyed

intentionally by insensitive caretakers. We are fortunate that a few of his powerfully emotive works survive.

We have seen how space can depict an inner world, a psychic reality, or an actual, external reality. Space can alienate, distance, absorb, expand, or condense. It can refer to a dream space, a theatrical space, or a psychological space. It can be a void or it can be dynamic. Space can be mythic and symbolic. It can be chaotic or orderly, frightening or soothing. Space is yours to manipulate as you choose.

In this survey of some of the major changes in the development of pictorial space in contemporary art, you can see the importance of spatial ideas for artists. Whether the emphasis is on flat, shallow, illusionistic, actual, or ambiguous space, the concept of space is a challenge of lasting interest to all who are dedicated to art, makers and viewers alike. It holds the key to unraveling the manifold meanings art can have.

The chapters in Part II deal with the spatial relationships of art elements, beginning with shape, value, line, texture, and color. In each chapter we consider the way the elements can be used to create different kinds of space. At the end of each chapter you will find a summary of the spatial characteristics of that element. Part II concludes with a chapter dealing with spatial illusion and perspective. By the time you reach the end of this section, you will be well versed in the many uses of pictorial space.

SKETCHBOOK PROJECT

The sketchbook is flexible. It can be used as a drawing pad, as a notebook, and as a scrapbook. The following project encourages some informative collecting for spatial references to be used throughout your career as an artist.

PROJECT 1
Making a Space Folder

Find at least 10 examples each of three-dimensional, illusionistic space; two-dimensional or relatively flat space; and ambiguous space, a combination of both two- and three-dimensional space in the same work. You will be surprised by how many examples you can find in everyday life from such sources as newspapers, magazines, and postcards, not to mention books on art. Either make a photocopy of each work or cut out the actual illustration and make a space folder for them. Attach an accompanying page for each example and write an analysis of how each kind of space has been created. You might begin by labeling each sample in your collection according to the three basic categories. Then jot down a few notes that indicate the characteristics that determine your decision. As we complete each chapter, look at your samples once again and amplify or correct your initial assessments. For example, after we have worked with some exercises in the following chapter on shape, you will have an expanded idea of how shape can be used to create various kinds of space.

Throughout the course, as you find other examples of spatial treatment that appeal to you, clip them and add to your file. You will soon have a folder of material to assist with your own work.

Simple exercises like this will open your eyes to new possibilities in looking at and making art, and they will be the means by which you build a solid critical vocabulary to use in art analysis and critiques, both of which are essential tools for the artist.

Shape/Plane
and Volume

*What I look for in the beginning are shapes, a subdivision of the square.
You might say I think in terms of Matisse when I start. In my youth I did color
separations for equipment supply catalogues, which was about reducing
everything to flat shapes. Before that I did lithographs and prints in the Army
and learned how to work up an image in stages, so I've taught myself to work
the same way in paint: go after the big shapes first, then make them three-dimensional,
from Matisse toward Vermeer.*

PHILIP PEARLSTEIN

SHAPE

THE FIRST ELEMENT TO CONSIDER IN
learning to create pictorial spatial relationships is shape. A *shape* is a configu-
ration that has height and width and is, therefore, two-dimensional. An ob-
ject's shape tells you what that object is. We will begin our investigation into

3.1 JOEL SHAPIRO. *Untitled.* 1996.
Silk screen, edition of 108, 3′9″ × 3′3″
(1.09 m × 99 cm). © 2003 Joel Shapiro/
Artists Rights Society (ARS), New York.

pictorial space first with shape; then we will learn how shape can be converted to plane; and, finally, we will consider how shape and plane can be made to appear as volume. Shapes can be divided into two basic categories: geometric and organic. Squares, rectangles, triangles, trapezoids, rhomboids, hexagons, and pentagons, as well as circles, ovals, and ellipses are only a few of many *geometric shapes* that are created by mathematical laws dealing with properties, measurement, and relationships of lines, angles, surfaces, and solids.

Geometric ordering principles have been used since prehistoric times. Cave paintings and petroglyphs make use of triangles, circles, squares, crosses, and other geometric forms, simple shapes to symbolize objects in the real world and to convey deeper meanings. Elementary geometric figures help us communicate in a universal language; simple signs can be read more quickly

3.2 WILLIAM DALEY. *Conic Loop Revisited.*
1994. Wall drawing, graphite, whiteout
on Strathmore board, 2′6¼″ × 3′4⅛″
(76.8 cm × 1.019 m). The Arkansas Arts
Center Foundation Purchase, '94 Tabriz
Fund. 1994.047.

and effectively than words—think of signage in international airports and on highways. Geometric forms lend themselves well to repetition and alteration and are favored for making patterns and decorations. The Constructivists were a group that took not only a new approach to abstraction but promoted a progressive, utopian means of constructing a better society. Modular and serial ordering principles furnished new imagery to carry out fresh ideas. Although they were contemporaneous with the Surrealists, the Constructivists, with their logical, rational approach, were in direct opposition to the Surrealists, whose subconscious was the source of their imagery.

The geometric tradition established by the Constructivists is still at work in contemporary art as seen in Joel Shapiro's work (figure 3.1). Shapiro's motifs are rectilinear forms overlaid onto an activated background. He uses slightly altered and repeated geometric shapes whose points of contact vary from shape to shape. It is this subtle difference of placement that creates interesting tensions in the drawing.

Geometric forms are useful for analyzing and reducing objects to their basic fundamental shapes, as seen in the drawing by the ceramicist William Daley (figure 3.2). Both his ceramic objects and his drawings make use of the interplay of geometric shapes suggestive of steps, fans, cylinders, lobes, and arcs. The drawings are preparatory in the sense that Daley uses them as responses to a three-dimensional work in progress, as an aid for searching out potential shapes, and for finding solutions to problems. His usual method of

3.3 DOROTHEA ROCKBURNE. *Stele.* 1980. Conté crayon, pencil, oil, and gesso on linen, 7'7¼" × 4'3¼" (2.32 m × 1.30 m). Emmerich Gallery. © 2003 Dorothea Rockburne/Artists Rights Society (ARS), New York. Photograph by Rick Gardner, Texas Gallery, Houston.

working is to grid off sections of 11- by 14-inch paper; using a ballpoint pen, he then draws shapes that will be incorporated into his pots. The interplay of geometric shapes includes details of both interior and exterior views. In large, temporary wall drawings made directly on the studio wall, he uses a compass and straightedge for a more mechanical effect. There is a suggestion of volume in Daley's drawing owing to the double outline of certain forms; otherwise the shapes remain flat and two-dimensional. In spite of their spatial flatness, the forms suggest architectural structures as seen from multiple vantage points.

A drawing that uses a more reductive shape vocabulary is the one by Dorothea Rockburne (figure 3.3). The ideas of clarity and presence are created through the use of two modular units—triangles and squares of the same size. *Modeling,* which is the change from light to dark over a form, is employed at the edges of the triangles, suggesting folded paper, but these volumes are contradicted by the insistence of the rigid black outline that dominates the right side of the composition. Actually, this black line is a continuation of the rectangle, which forms the center folds of the origami-like shapes that complete the drawing. (Origami is a Japanese technique of folding paper, an appropri-

ate allusion for the work with its impeccable and refined sensibility.) Rock-burne's drawing has a presence that is self-contained and meditative.

A second category of shape (as opposed to geometric forms) is *organic shape*, less regular than geometric shape and sometimes referred to as *biomorphic, amoeboid,* or *free form.* An example of organic shape can be seen in a drawing by another potter, Betty Woodman, whose ceramic works combine fine art and craft (figure 3.4). Woodman isolates and recombines the component parts of vases and their supports (as in *Drawing for Balustrade #81*). Using a two-part composition, Woodman uses repeating organic shapes; the washes suggest transparent glazed surfaces used in ceramics. The outlines of the shapes change from ocher to red to green as they define curves. Just as Woodman deconstructs a vase to cancel traditional uses and to reveal new meanings, her drawing presents fragments in an analytical, innovative, and expressive mode. Her drawing reminds us of the artist Fairfield Porter's advice that it is important to remember the subject matter in abstract painting and the abstraction in representational work.

Usually we find a combination of geometric and organic shapes in an artist's work. In *Interior with Profiles* (figure 3.5), Romare Bearden combines geometric and amoeboid shapes in a well-integrated composition. The figures in Bearden's collage are built of organic shapes, whereas the background is predominantly geometric—squares and rectangles. Texture is an important element in Bearden's work; shapes are created both by textural patterns and by flat and modeled values—in the hands and in the objects in the background. The collage is organized along horizontal and vertical axes, which both flatten and stabilize the composition. The figures remind us of an Egyptian frieze. There is a timeless quality in Bearden's work that comes from his faultless sense of

3.4 BETTY WOODMAN. *Drawing for Balustrade #81.* 1993–1994. Mixed media on paper, 7'11" × 4'5" (2.41 m × 1.35 m). The Arkansas Arts Center Foundation Purchase, '94 Tabriz Fund. 1994.049.002.

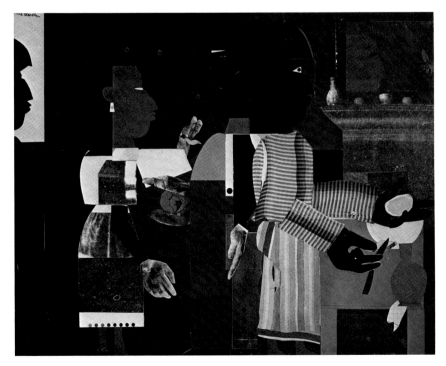

3.5 ROMARE BEARDEN. *Interior with Profiles.* 1969. Collage, 3'3¾" × 4'1⅞" (1.01 m × 1.27 m). First National Bank of Chicago. © Romare Bearden Foundation/ Licensed by VAGA, New York.

3.6 ALAN MAGEE. *Braid* (detail). 1980. Watercolor on paper, 1′10″ × 2′6″ (56 cm × 76 cm). © Alan Magee. Permission of the artist.

balance and rhythm. Unity is achieved by repetition of shape and value. Spatially, the work is very complex; it is difficult to locate exactly each figure in relationship to the other. This ambiguity of placement is further reinforced by the illogical scale between the parts.

As you have seen, shapes can be made by value, line, texture, or color. They may even be *suggested* or *implied* as in the drawing by Alan Magee (figure 3.6), in which the braid is a focal point as well as a stand-in for the figure itself. By use of line, color, and value, Magee suggests the neck and chin of the model. The negative white space is conceptually filled by the viewer. Although the shape of the figure is not explicitly shown, we imagine it to be there. The off-center focal point of the braid is in contrast to the white void that surrounds it. A close range of values is used, shadows are pale, the transition from the drawn area to the white of the page is gradual—we are led into the focal point by the faint values suggesting the shape of the head. Magee's watercolor suggests the concentrated, measured time it took him to observe and draw.

Perception is such that we fill in an omitted segment of a shape and perceive that shape as completed or closed (figure 3.7). We tend to perceive the simplest structure that will complete the shape rather than a more complex one (figure 3.8). We group smaller shapes into their larger organizations and see the parts as they make up the whole (figure 3.9).

The heavy, open circular form made by a dragged-out brush in the work on cardboard by the Abstract Expressionist Robert Motherwell conveys the artist's interest in stylistic gesture (figure 3.10). Paint and accompanying splatters have been applied by quick turns of the brush. The eye is compelled to

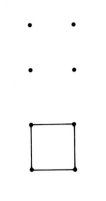

3.7 Incomplete shapes are perceived as completed or closed.

3.8 The four dots are perceived as forming a square rather than a more complex shape.

3.9 Smaller shapes are perceived as part of their larger organization.

3.10 ROBERT MOTHERWELL. *Untitled (Black Gesture)*. 1982. Acrylic on rag board, 2′5″ × 1′11″ (74 cm × 58 cm). Collection of the Modern Art Museum of Fort Worth, Museum Purchase; gift of the artist. © Dedalus Foundation, Inc./Licensed by VAGA, New York.

complete the circle in spite of the emphatic final circular flourish of the brush mark. This abrupt ending to the flow of the shape provides tension in the drawing. The constricted opening leads the eye into an interesting enclosed, calm white shape. Motherwell is well known for his mastery of black and white forms and for the intensity they convey. Many contemporary artists purposefully contradict accepted rules of composition and of perception; like Motherwell, they challenge the viewer visually to complete the circle.

Shapes of similar size, color, value, texture, or like form attract each other; it is by this means the artist organizes the picture plane and directs the viewer through the composition. Like attracts like. Normally, small shapes tend to recede and large shapes to advance. Overlap suggests a spatial positioning.

POSITIVE AND NEGATIVE SPACE

On the *picture plane*—the surface on which you are drawing—there is another distinction between shapes, that between positive and negative. *Positive shape* refers to the shape of the object drawn. In Robert Longo's drawing (figure 3.11), the dark, isolated, positive shape of the jacket is the subject of the work. This somewhat menacing form is at first glance difficult to identify; it overpowers the figure below. There is nothing in the empty background (negative space) to give further information. The man is unidentifiable; his coat seems menacing.

Negative space describes the space surrounding the positive forms. Negative space is relative to positive shapes. In Jacob Lawrence's pencil drawing (figure 3.12), a family is gathered around a table. The floor forms a ground for the chair, for the child in the foreground, for the baby, and for the table. The chair is negative to the father as is the table top; the plane of the table is also nega-

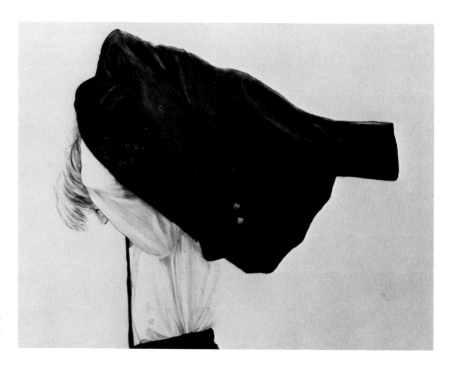

3.11 ROBERT LONGO. *Untitled.*
1978. Charcoal on paper, 2′6″ × 3′4″ (76 cm × 1.02 m). Collection Robert Halff. Metro Pictures. © University Art Museum, University of California, Santa Barbara.

tive to the child and the book, to the objects on the table and to the mother's hand. The wall is negative to the mother and child but positive to the rectangle representing the door. The tree, in turn, is positive to the space behind it. The mother is negative to the child in front of her but positive to the wall behind her. This convoluted description unravels the way shape is used to create space. Although the space in Lawrence's drawing suggests a movement from near to far, it is a compressed progression from bottom to top of the picture plane. The idea of a progressive space lies more in the viewer's mind than in the drawing itself. The objects on the table are placed as if the table were horizontal, when, in fact, it is sharply tilted. Because of overlap we have no difficulty deciphering the spatial layout of the drawing, but it is unrelated to the way space functions in the real world. The spatial ambiguity in Lawrence's composition gives the drawing its power. The two elements of line and shape are the carriers of the drawing's meaning—unified shapes for Lawrence in this work symbolize a unified family.

In real life we are conditioned to search out positive shapes, but this habit must be broken in making art. On the picture plane all shapes, both positive and negative, are equally important. Combined, they give a composition unity. As we have seen in Lawrence's drawing, the integration of positive and negative shapes is so complete that it is nearly impossible to classify each shape as either positive or negative. The progression of space in the work does not follow a completely logical recession seen in real life; for example, the objects on the table seem to be stacked on top of each other. The only true penetration of space is in the diagonal line behind the tree. The table functions as both foreground and background. Shapes that we logically know are more distant seem to advance; for example, we know the mother and father are located

3.12 JACOB LAWRENCE. *The Family.* 1957. Pencil on paper, 2′3¾″ × 1′11″ (70 cm × 58 cm). The Arkansas Arts Center Foundation Purchase: Museum Purchase Plan of the NEA and the Tabriz Fund, 1974. 1974.011.00b.

3.13 HENRI MATISSE. *Artist and Model Reflected in a Mirror.* 1937. Pen and ink on paper. 2'1⅛" × 1'4" (61.3 cm × 40.7 cm). The Baltimore Museum of Art: The Cone Collection, formed by Dr. Claribel Cone and Miss Etta Cone of Baltimore, Maryland. BMA 1950.12.51. © 2003 Succession H. Matisse/Artists Rights Society (ARS), New York.

at opposite ends of the table although the mother's arm and hand appear to be on the same plane as the father's head. Notice also the relationship between the size of the mother's and father's hands; the mother's hand appears larger even though she is farther away. The scale of the baby defies all logic. Lawrence uses variations on shapes of similar size (for example, the circular heads and the repeating rectangles of books, table, and wall) to attract each other, and by this means he achieves a taut composition. The visually tight, interlocking shapes underscore the tight, interlocking family unit. So shape and the way it is used is a device for creating meaning in a work.

In Henri Matisse's *Artist and Model Reflected in a Mirror,* the figure and its reflection are left blank. There are a few cursory notations indicating facial features and a necklace, but the overall effect is emptiness (figure 3.13). The emphasis has shifted from positive to negative. Reverse values—in which the background is drawn while the foreground or main subject is left blank—results in spatial dislocation. The blank figure and its reflection echo the paper

3.14 DONALD SULTAN. *Black Tulip Feb. 28, 1983*. Charcoal and graphite on paper, 4′2″ × 3′2″ (1.27 m × 96.5 cm). Courtesy of the artist.

on which it is drawn. The spatial ambiguities in Matisse's work are not accidents or mistakes. His goal was to integrate all the shapes on the picture plane—figure and field, foreground and background, positive and negative shapes—so they become one tightly knit, spatially integrated work. They all exist on a flat surface; the perceptual play with spatial illusion remains. We are aware that this is not a traditional space. The space of the picture plane asserts itself, a defining characteristic of Modernism.

Geometric and organic patterns, used widely throughout Matisse's work, are another spatial device; whether the patterns describe objects in the foreground or whether they are patterns we know to be in the background (for example, wallpaper), they meld into a flat plane.

Using recognizable subject matter does not limit an artist's involvement with formal innovations. (The word *formal* refers to the elements of art— shape, line, value, texture, color—and how they are used on the picture plane.) The spatial complexities in Matisse's work are stimulating both aesthetically and intellectually.

In the Donald Sultan work (figure 3.14), positive and negative shapes switch with each other. Viewing the image one way, we can see the black shape as positive; viewing it another way, we see the black shape as background to the white forms. This positive-negative interchange is signatory of Sultan's style. The rich, matte-black of the charcoal establishes a strong physical presence, and the powdery residue enlivens the white spaces. Sultan

purposefully chooses images that can be interpreted as either abstract or concrete, such as the tulip with its head turned inward to the leaves as in this drawing, creating a composite shape that is more than the sum of its parts. But the viewer is always aware of the materiality of his work; the medium is the message. Sultan reduces elements to shape and value, and he further reduces value to black and white. Since Sultan works with such simple subject matter, it is surprising to learn that he works from photographs. Using a Polaroid camera, he sets up still lifes in his studio and photographs them using an extremely limited depth of field; in other words, he focuses the image on one plane. The objects are cropped to go off the page. The composite shapes depend on the negative shapes to define them. This "flip-flopping" between figure and ground relate to film, where positive and negative are reversed.

We should not conclude our discussion of shape without first looking at a new way in which silhouette is being used by contemporary artists. Take a look once more at Donald Baechler's work on paper (see figure II.13). In the lower-right-hand corner you will see an appropriation or quotation from the nineteenth-century—two men in silhouette. (Silhouettes, or shadow portraits, were developed at the end of the eighteenth century as a way to produce inexpensive likenesses, but by the middle of the nineteenth century they were replaced by the invention of the camera.) Baechler says he is attracted to silhouettes "because of their emblematic rather than their illustrational quality." He says, "I see them as shapes, allowing an image to become an abstraction . . ." (Elizabeth Hayt, "Simple, Austere, an Old Genre Is Daringly New," *New York Times*, November 16, 1997, AR 51).

Along with Baechler, there are a number of contemporary artists who are working in the silhouette genre, among them Kara Walker, Elliott Puckette, and the team of David McDermott and Peter McGough, collaborative artists who have adopted the life of the early nineteenth century, going so far as to live in a house with no electricity or running water. They draw traditional silhouette portraits by candlelight. (Incidentally, their sitters are also decked out in period clothing.)

Walker, a black artist, uses silhouette tableaux as elements in her narrative art derived from antebellum slave sources from African-American history. She subverts the clichés concerning the slavery era. A starker black history is retold in Walker's graphic work. Her large, detailed black-paper cutouts are

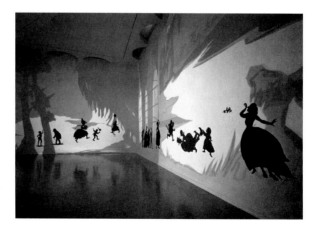

3.15 KARA WALKER. Installation view of *Insurrection.* 2000. Paper cutouts. Solomon R. Guggenheim Museum, New York. Photo by Ellen Labenski/Guggenheim Museum.

arranged directly on the wall as seen in an installation at the Solomon R. Guggenheim Museum (figure 3.15). Walker's work is another example of the medium being a carrier for the meaning in her work. "Silhouette looks so clear-cut, so crisp, it operates just as derogatory stereotypes do, making a reduction out of a real person" (Hayt, AR 51).

The terms *positive/negative* and *figure/ground* are interchangeable. Other terms are *foreground/background*, *figure/field*, and *solid/void*. Negative space is also called *empty space*; the spaces between objects or shapes are called *interspaces* or *interstices*.

PROBLEM 3.1
Composite Shape Problem

Draw a silhouette of two combined objects so that they create a composite shape. Have the objects overlap in one or more areas so that enclosed positive and negative shapes occur. We have seen an example of a merging of forms in the Sultan drawing, in which the tulip shape combines with the leaf and vase shapes to create a unified, single, composite shape (see figure 3.14). You may use ink or acrylic if you want a crisp outline, or use charcoal to create a dense mass and a more indefinite edge. Observe the edges of Sultan's image; pay attention to the leftover negative shapes. Make the drawing tangent to edge on at least two sides. Keep in mind the idea of cropping the shape. Do not use a centralized shape surrounded by negative space.

A more complex handling of composite shape can be found in Mary Dryburgh's *Large Crow* (figure 3.16). The bird is clearly defined; however, the remaining shapes are not immediately recognizable as objects from the real world. Is the bird perched on a branch? On a window? Or are the shapes invented analogous forms that relate compositionally to the crow? One can detect references to the crow's beak, head, wing, and tail in the surrounding positive and negative shapes. The negative white spaces are activated by smudges and powdery deposits from the charcoal. The crow is backlit, but otherwise the various positive and negative shapes occupy different levels of space. (One need only note the spatial ambiguity of the shapes in the lower half of the drawing.) The treatment of the bird and its accompanying shapes carry mythic overtones; it is not only the bold dark forms that assert themselves, the treatment of the medium itself carries a message.

Now that we have puzzled over what the background shapes might be, let us hear the answer directly from the artist herself: "A papier-mâché decoy sitting in my studio window amid assorted treasures. I like to start my drawings with an observed reality and explore other possibilities from that point."

3.16 MARY DRYBURGH. *Large Crow.* 1993. Charcoal on paper, 2′ × 1′7″ (61 cm × 48 cm). Collection of the artist. Photograph by Photosmith.

PROBLEM 3.2
Interchangeable Positive and Negative Shapes

Make an arrangement of several objects or use figures in an environment. In this drawing, emphasize the negative spaces between the objects or figures by making them equal in importance to the positive shapes.

In a second drawing place emphasis on negative space. This time try to make the positive and negative shapes switch off with one another; that is, see if you can make the positive forms seem empty and the negative shapes positive.

3.17 ROBERT BIRMELIN. *The City Crowd, the Ear.* 1978. Conté crayon on paper, 1'10" × 2'5¾" (56 cm × 76 cm). Arkansas Arts Center Foundation Purchase, 1984. 84.49.

Robert Birmelin, in his oddly titled drawing, *The City Crowd, The Ear* (figure 3.17), places great emphasis on negative space. The centralized figure is a faceless, empty white shape. Dark values, lines, and textures define the interstices or spaces between the figures. The foreground figure is cropped by the picture plane; it is massive and is swiftly moving out of the picture plane to the right. The implied movement is from upper left to lower right. Negative shapes play the major role in defining not only space, but the positive figures as well. The empty white figures are set in relief against their adjoining dark shapes. The line direction that symbolizes hair, the repeated lines that indicate the thighs of the walkers, and the marks that delineate the large, encircling, indefinable shape on the left side of the picture plane—all lead the viewer into the center of the drawing and into the bustle of the crowd.

PROBLEM 3.3
Geometric Positive and Negative Shapes

Make a quick, continuous line drawing of a still life. You may wish to refer to the description of this technique in chapter 2. Redraw on top of the drawing. Regardless of the actual shapes in the still life, reduce both positive and negative shapes to rectangles and squares. Repeat the problem, this time using ovals and circles. You will, of course, have to force the geometric shapes to fit the actual still life forms.

Look carefully at the subject. Which shapes are actually there? Which shapes are implied? Which types of shapes predominate? In asking these questions you are giving yourself some options for the direction the drawing is to take. You may note circular forms, so you would use ovals, ellipses, and circles in your analysis. In making this reductive analysis, you are bringing to consciousness information that will be helpful as you extend the drawing.

3.18 ADA LIU SADLER. *Taliesin West* #2.
1992. Pastel, 1'6" × 1'6" (46 cm × 46 cm).
Joseph Chowning Gallery, San Francisco.

Repeat the initial procedure, using landscape as a subject. Use only organic forms in both positive and negative shapes. One way to ensure that negative spaces form enclosed shapes is to make the composition go off the page on all four sides.

PROBLEM 3.4
Invented Negative Shapes

Choose any subject—landscape, still life, or figure. In your drawing invent some negative shapes that relate to the positive shapes of your subject.

Ada Liu Sadler structures her drawing of a lawn chair around the ready-made patterns found in the chair's webbing (figure 3.18). The geometric shapes move around the picture plane to create a spatially intriguing design with a simple subject matter, a truncated view of a lawn chair. Cast shadows dominate the composition; they form an undulating grid that anchors the chair in its special place, in its unique light. A series of implied triangles formed by the chair's tubular construction offers a secondary shape theme. A consistency in the direction of the pastel strokes flattens the remaining background negative shapes. Form and variation are the keys to this integrated,

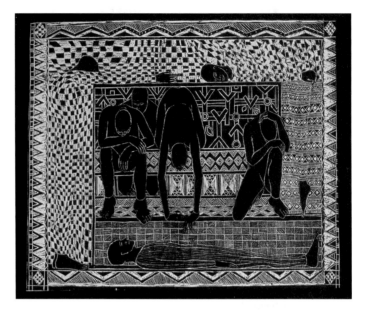

3.19 KRISTINE SPINDLER-GUNNELL. *People of the Raffia Palm.* 1993. Woodcut, 1'11" × 2'2" (58 cm × 66 cm). Arrowmont Purchase Award. Courtesy of Arrowmont School of Arts and Crafts, Gatlinburg, Tenn.

decorative work. The shapes take the lead in structuring the composition both visually and spatially.

PROBLEM 3.5
Collaged Negative Spaces

Begin by using torn paper to represent the negative spaces in a still life. Then impose a simple line drawing of the still life, allowing line to cross over the torn paper shapes. This procedure will help integrate the positive and negative areas. Use enclosed shapes in both positive and negative spaces.

Imagine the Sadler drawing to be a collage with each shape cut out and reassembled and with the lines that form the chair and shadows imposed onto the cut-out paper base.

A cropped view of a group of chairs, a bicycle, or an arrangement of tree limbs would make a good subject for this problem.

PROBLEM 3.6
Enclosed Invented Positive and Negative Shapes

For this drawing you invent a subject. It may be taken from your memory of a real object or event or it may be an invented form or abstraction, but it should be a mental construct. Look back at the discussion of conceptualized drawings in chapter 1 to familiarize yourself with their nature.

Once you have thought of a subject, draw it by using enclosed shapes in both positive and negative space. Define the shapes by outline, by texture, or by flat value. Fill the entire page with enclosed shapes. There should be no leftover space.

The print by Kristine Spindler-Gunnell could have been made in response to this problem (figure 3.19). A rather simple and static composition within a composition, an insert, using simplified figures is enhanced by the addition of the enclosing frame. Repeating geometric shapes weave a pattern of

3.20 PHILIP PEARLSTEIN. *Mickey Mouse Puppet Theater, Jumbo Jet and Kiddie Tractor with Two Models.* Early stages of an oil painting. Robert Miller Gallery, New York.

subtle secondary shapes. The various conceptual levels of space contribute to a mythic interpretation. The artist has combined line, texture, and flat value patterns to create a spatially complex work.

THE SHAPE OF THE PICTURE PLANE

The quote by the artist Philip Pearlstein at the beginning of this chapter tells how important it is in the beginning stages of a drawing or painting to use shapes to subdivide the picture plane. In figure 3.20 we see two states in the development of a work. Pearlstein works from models (not from photographs), and he makes numerous drawings for each finished work. For his paintings he draws directly onto the canvas with vine charcoal, which allows him to wipe out areas he is not happy with.

3.21 IRVING TEPPER. *Third Cup of Coffee.* 1983. Charcoal on paper, 3'7¾" × 4'3½" (1.111 m × 1.308 m). Arkansas Arts Center Foundation. Purchase, 1984. 84.43.

3.22 NEIL JENNEY. *Window* #6. 1971–1976. Oil on panel, 1'3¾" × 4'9½" (1.01 m × 1.46 m). Thomas Ammann, Switzerland.

The shape of the picture plane is a major determinant of the layout of a drawing or painting. Irving Tepper centralizes his image in a square format (figure 3.21); the placement of the cup is slightly off center—the target area of the coffee seems perfectly located. A centralized image can present the artist with a problem of how to handle the four corners, but Tepper has resolved the drawing by using a variety of circular shapes and interesting groupings of abstract lines that reverberate outward from the saucer. The viewer looks directly down into the cup, and this unusual point of view has the effect of transforming it into an abstract interplay of spherical forms. It is interesting to note that Tepper is a sculptor who works in clay.

Neil Jenney's image in figure 3.22 conforms to its eccentrically shaped frame. The tree branches are particularly suited to the chopped-off format; the angle of the limbs points to the lopsided structure, and the enclosed negative shapes—the intervals between limbs and edges of the frame—establish a secondary theme. We are reminded again of the traditional window into space. Jenney has certainly updated the window; it is an unmistakable twentieth-century version.

SHAPE AS PLANE AND VOLUME

It has been difficult to speak of shape without occasionally referring to *volume*, which is the three-dimensional equivalent of two-dimensional shape. Shapes become volumetric when they are read as *planes*. In the graphic arts and in painting, volume is the illusion of three-dimensional space. Volume defines *mass*, which deals with the weight or density of an object.

The way shape turns into volume can be seen in an illustration of a cube. If you take a cube apart so that its six sides, or planes, lie flat, you have changed the cube from a three-dimensional form into a two-dimensional shape (figure 3.23). This new cross-shape is made up of the six planes of the original box and is now a flat shape. If you reassemble the cube, the reconnected planes (the sides, top, and bottom) once again make volume. If you make a representation of the box seen from below eye level with one of its corners turned toward you, it will be composed of only three visible planes. Even if you draw only these three planes, the illusion of three-dimensionality remains (figure 3.24). If you erase the interior lines, leaving the outer outline only, you have again changed volume into a flat shape (figure 3.25).

The key word here is *plane*. By connecting the sides, or planes, of the cube, you make a *planar analysis* of the box. You make shape function as plane, as a component of volume.

3.23 Cross-shaped form made from an opened box.

3.24 Diagram of a cube.

3.25 Cube diagram with interior lines erased.

3.26 JOEL SHAPIRO. *Untitled, 1979.* Two parts: Charcoal and gouache on paper, 1′11¹⁄₁₆″ × 3′½″ (58 cm × 93 cm). Paula Cooper Gallery. © 2003 Joel Shapiro/ Artists Rights Society (ARS), New York. Photo: eeva-inkeri. JS 243.

Joel Shapiro's diptych, or two-part drawing (figure 3.26), is a concrete example of how a shape can be perceived spatially in two very different ways. Shapiro is a minimalist sculptor whose work is concerned primarily with perceptual differences. Polarities lie at the core of his work: presence/absence, discrete/nebulous, color/noncolor (the dark, flat shape on the right is in actuality a saturated red), dimension/flatness, certainty/uncertainty, ambiguity/decisiveness. The two corresponding large shapes are fixed in their positions, yet there can be a multiplicity of interpretations in reading them. Shapiro plays with the flatness of the picture plane and the flatness of the two-dimensional shape as opposed to the illusion of the form on the left, which has been broken up into a group of planar shapes. Analyze this shape for the number of ways it could refer to an object in space. The four lines that extend outside the object's enclosed planes confound our perception of the figure as a box; the perspective in support of this interpretation is not accurate. Not only does the artist engage the viewer in perceptual games with reduced means, he invites the viewer to be involved in the process; the handmade quality of his drawings with their smears and smudges is a major part of their appeal.

Using a more traditional presentation of shape as plane, Clarence Carter creates an illusion of volume by connecting adjoining shapes (figure 3.27). A monumental effect is achieved by seemingly simple means; the smaller, connected shapes of the stairs lead to the middle ground occupied by the two smaller buildings set at an angle. Smaller, fainter steps climb to the larger, more frontally placed building in the background. Carter achieves an architectural unity by interlocking planes, by the progression of small to larger shapes, and by the distribution of lights and darks.

We have one more way to transform shape into volume—by modeling. *Modeling* is the change from light to dark across a surface to make a shape look volumetric. By modeling, Edward Ruscha converts what is normally conceived of as a flat image into a floating, dimensional shape (figure 3.28). The word *Chop* appears to be a ribbon unwinding in space. Ruscha's intent of divorcing

3.27 CLARENCE CARTER. *Siena.*
1981. Acrylic on canvas, 6′6″ × 5′
(1.98 m × 1.52 m). Courtesy Gimpel/
Weitzenhoffer Gallery, New York. By
permission of the artist.

3.28 EDWARD RUSCHA. *Chop.*
1967. Pencil on paper, 1′1¼″ × 1′11⅞″
(34 cm × 56 cm). Collection of the
Modern Art Museum of Fort Worth, gift
of the Junior League of Fort Worth.
© Edward Ruscha/Licensed by VAGA,
New York.

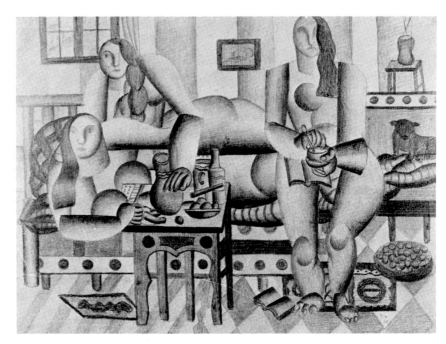

3.29 FERNAND LÉGER. *Three Women*. 1920. Pencil, 1'2½" × 1'8" (37 cm × 51 cm). Rijksmuseum Kroller-Muller, Otterlo, Netherlands. © 2003 Fernand Léger/ Artists Rights Society (ARS), New York/ ADAGP, Paris.

3.30 Shape analysis of Fernand Léger's *Three Women*.

the word from its semantic function is further enhanced by such an unexpected presentation.

You can clearly see the modeling technique in Fernand Léger's pencil drawing (figure 3.29). Figure 3.30 reduces the Léger composition to shape. By comparing the two images you can see how modeling transforms shapes into volume. The shading from light to dark is more pronounced on the women's forms. A spatial contradiction is the result of the combination of flat, cut-out shapes with illusionistically rounded forms. Léger has also used contradictory eye levels; for example, we see the women from one vantage point, the rug and floor from another—as if we were floating above the scene—and the table-tops from yet another. The composition is structured by means of repetition of volumes and shapes.

Another means used to create a sense of volume is overlapping. Léger uses overlapping shapes, but the use of contradictory eye levels creates an illogical space. In Diego Rivera's *Study of a Sleeping Woman* (figure 3.31), the figure is constructed by a progression of forms, one overlapping the other from the feet to the dark shape of the hair. The viewer's eye level is low; we look up to the figure. The full, organic shapes are given volume by use of modeling concentrated at those points of maximum weight and gravity. The compact, compressed form fills the picture plane. The simple overlapping volumes are the primary means by which a feeling of monumentality and timelessness is achieved.

The following problems will offer some new ways to think about shape and volume. Remember to change the size and shape of your paper format to help challenge your compositional abilities.

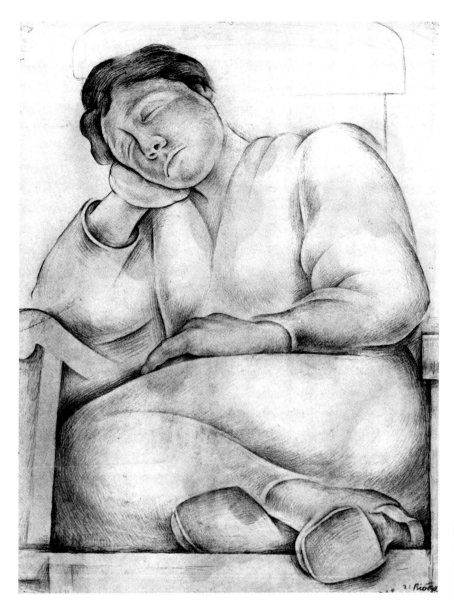

3.31 DIEGO RIVERA. *Study of a Sleeping Woman.* 1921. Black crayon on off-white laid paper, 2′½″ × 1′6½″ (62.7 cm × 46.9 cm). Courtesy of the Fogg Art Museum, Harvard University Art Museums. Bequest of Meta and Paul J. Sachs.

PROBLEM 3.7
Shape as Plane and Volume

Using paper bags, a stack of boxes, or bricks as your subject, draw the edges of planes rather than the outside outline of the objects. Concentrate on the volumetric aspect of the objects, that is, on how shapes connect to create volume. Use line to define planes. You may wish to develop a focal point using shading in one small area of the drawing as in the example by Magee (see figure 3.6).

Make a second drawing that is primarily tonal and more volumetric, where planar change is indicated by the use of white, black, and gray shapes as in the Carter work (see figure 3.27).

PROBLEM 3.8
Planar Analysis

Using your own face as subject, make a planar analysis in a series of drawings. By the time you have finished several drawings, your eye will have become attuned to looking for the intersection of planes. A sharpened pencil works well for this problem. You need to feel that you are defining incisive edges of planes, although you may restate the lines multiple times. Begin by drawing the larger planes or groups of planes; then draw the smaller units. Work from the general to the specific. The larger planes of the face are forehead, cheeks, and chin. Break these larger planes into smaller units. The more complex the form, the more complex the planes that build up the form will be. Eyes, nose, and ears require many more planes than the forehead. Each person will have a different interpretation, just as each individual face is different. As the planes recede, use value to describe where they turn into space. Use line to suggest a change in planar direction. Ignore light and shadow except as they reveal structure.

After you have become familiar with the planar structure of your face, construct a three-dimensional mask from cardboard or bristol board. The sculptured mask should be life-size, made to fit your face. Keep a sketch pad handy to redraw and correct the planar relationships. This interplay between stating the form two-dimensionally and making a three-dimensional model will strengthen your understanding of the process involved in creating the illusion of volume.

Cut out the planes and use masking tape to connect them to one another. Making a three-dimensional analysis is an involved process. Look for the most complex network of planes. Note how the larger shapes can be broken down into smaller, more detailed groups of planes. More complex areas present interesting challenges.

When you have completed this problem, you will have gained real insight into how larger planes contain smaller planes and how large planes join one another to create volume.

Paint the mask white. You have now de-emphasized the edges of the planes to create a more subtle relationship between them. Place the mask under different lighting conditions to note how various light directions emphasize different planes.

PROBLEM 3.9
Rubbed Planar Drawing

Read through *all* the instructions for this problem carefully before beginning to draw. Spend at least an hour on this drawing.

Use a 6B pencil that is kept sharp at all times. To sharpen the pencil properly, hold the point down in contact with a hard, flat surface. Sharpen with a single-edge razor blade, using a downward motion. Revolve the pencil, sharp-

ening evenly on all sides. Use a sandpaper pad to refine the point between sharpenings. Draw on white charcoal paper.

Draw from a model. Using vine charcoal, make several line-gesture drawings to acquaint yourself with the pose. You may use Pearlstein's method of rubbing out sections of the drawings that need to be corrected and redraw, establishing proper proportion between the parts of the figure. When you are ready to begin drawing, use a light line to establish proportions and organizational lines. Again, as in the head study, analyze the figure according to its planar structure. Begin drawing the largest planes. What are the figure's major masses? Upper torso, lower torso, upper legs, lower legs, head? Work from the general to the specific. Determine where the figure turns at a 90-degree angle from you and enclose that plane. Basically reduce the figure to two planes, front and side for each segment of the figure. Of course, you are looking for multiple interconnecting planes, but this first planar division between front and side is the first important step in planar analysis. Seek out the major volumes of the body and draw the planes that make up these volumes. After you have drawn for three or four minutes, rub the drawing with a clean piece of newsprint. Replenish the newsprint squares often. Rub inward toward the figure. Two warnings: Do not rub the drawing with your fingers, because the oil from your hands will transfer to the paper and make splotchy marks. Do not rub the drawing with a chamois skin because it removes too much of the drawing. Redraw, not simply tracing the same planes, but correcting the groupings. Alternate between drawing and rubbing. Continue to group planes according to their larger organization.

This technique is different from the continuous movement of the gesture and overlapping line drawings. Here you are attempting to place each plane in its proper relation to every other plane. Try to imagine that the pencil is in contact with the model. Keep your eyes and pencil moving together. Do not let your eyes wander ahead of the marks.

When viewed closely, this drawing might resemble a jigsaw puzzle, each plane sharing common edges. When you stand back from the drawing, however, the planes begin to create volume, and the result will be a more illusionistically volumetric drawing than you have done before. The rubbing and redrawing give the planes a volume and depth.

This exercise is actually an exercise in seeing. Following the instructions will help you increase your ability to concentrate and to detect planes and groups of planes that are structurally related.

One of the most significant concepts to take shape in twentieth-century sculpture was that of construction. Prior to this century the three-dimensional mass of carved or sculpted forms was dominant. The Cubists, with their involvement in the breakup of space, pioneered the faceted surface both in sculpture and in the two-dimensional arts. Picasso revolutionized sculpture with his constructions made of paper, string, metal, wire, and wood. These constructed objects shifted the emphasis from sculpted or carved masses to a constructed and sculptural space and laid the groundwork for the use of collage in sculpture as well as in painting.

The Russian Constructivists (who adopted their name in 1921), with their revolutionary goals (both for society and for art), employed the new Cubist forms and principles in their work. The idea of structural laws dictating form and activating space became a central tenet of their movement.

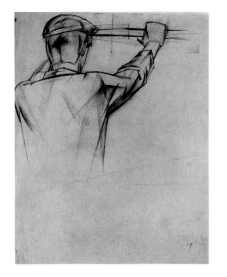

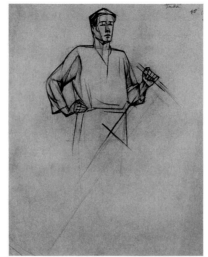

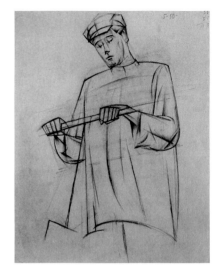

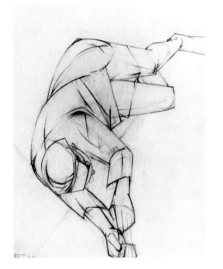

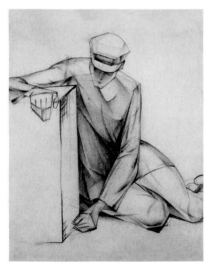

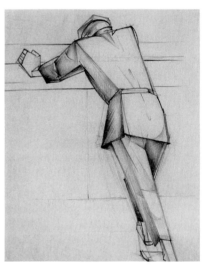

3.32 ALEXANDER BOGOMAZOV. *Figure Studies I–VI.* Pencil on paper, I: 1928, 1′1″ × 10″ (33 cm × 25 cm). II: ca. 1926–1928, 1′1½″ × 11¼″ (34 cm × 28 cm). III: ca. 1926–1928, 1′2¾″ × 11½″ (37 cm × 29 cm). IV: ca. 1926–1928, 1′1½″ × 11½″ (34 cm × 29 cm). V: 1926, 1′4⅜″ × 1′⅜″ (42 cm × 31 cm). VI: 1926, 1′4⅜″ × 1′⅜″ (42 cm × 31 cm). Arkansas Arts Center Foundation Collection. I: EL 4.1.1986, 95.26.1, Anonymous Loan from Andre Simon, 1986. II: EL 4.2.1986, 95.26.2, Bequest of Andre Simon, 1995. III: EL 4.3.1986, Bequest of Andre Simon, 1995. 95.26.3. IV: EL 4.4.1986, Bequest of Andre Simon, 1995, 95.26.4. V: EL 8.1.86, Lent by Andre Simon, 1986. VI: EL 8.2.1986, Bequest of Andre Simon, 1995, 95.26.6.

Analyze the group of figure studies by the Russian artist Alexander Bogomazov (figure 3.32) before beginning this problem. He has employed a technique similar to the one described above. The third and fourth drawings indicate the beginning stages, and the last two drawings of the seated and leaning man show how the planes are converted to volumes through modeling.

PROBLEM 3.10
Basic Volume

The preceding problems provided you with some experience in drawing a volumetric form. For this problem use a different subject for each drawing—landscape, still life, or a figure in an environment. Think in terms of basic volumes. Render the subject in a quick, light, overlapping line; then impose volumes regardless of the actual forms in the still life. You will have to

force volumes to fit the subject; for example, you might choose either a cylinder or a cube to represent the upper torso of a figure. Remember to register which volumes are actually there and which ones are implied. Look for repeating volumes to help unify your composition, as in the Bogomazov studies. As in the planar analyses, you should go from the large to the small, from the general to the specific. Remember the two bridges between shape and volume: shapes stated as planes appear volumetric, and modeling over a shape creates volume.

PROBLEM 3.11
Modeling and Overlapping

Arrange several objects in deep space. Then draw these objects, exaggerating the space between them. Arrange large and small shapes on your paper, overlap shapes, and use different baselines for each object. In your drawing try to distinguish between foreground, middle ground, and background. Use charcoal, white chalk, and eraser. A chamois skin and a kneaded eraser work well with charcoal. Begin the drawing by using soft vine charcoal that can be rubbed out after you have make a number of gesture drawings one on top of the other.

Think in terms of the different levels of negative space—horizontal space between the objects, vertical space above them, and diagonal space between them as they recede into the background. Imagine that between the first object and the last are rows of panes of glass. Because of the cloudy effect of the glass, the last object is more indistinct than the first. Its edges are blurred, its color and value less intense, its texture less defined. A haze creates a different kind of atmosphere between the first and last object. The illusion of depth through atmospheric effects such as those just described is called *aerial perspective*.

An extension of the preceding problem is to model negative space. Use a still life or figure in an environment and concentrate on the different layers of space that exist between you and the back of the still life or figure. Make the shapes change from light to dark; model both positive and negative space; different lights and darks will indicate varying levels. This modeling of negative space is a plastic rendering of the subject, an illusionistically three-dimensional description of objects in the space they occupy. Your drawing should show a feeling for the different levels of space. Do not confine your marks within an object; allow them to cross over both positive and negative forms. A rich surface texture can be achieved by varying the direction of the marks and by erasure and rubbing. In your drawing use the eraser as a drawing tool; try to imagine that the eraser can actually model space; use it to "reach inside" the picture plane to the various levels of space.

SUMMARY

DIFFERENT KINDS OF SPACE

A shape is two-dimensional if it has an unchanged or unmodulated value, color, or texture over its entire surface. Uniformity in color, value, or texture will make an otherwise volumetric form appear flatter. A form outlined by an unvarying line creates a two-dimensional effect.

Shapes functioning as planes, as the sides of a volume, give an illusion of three-dimensionality. Shapes can be given dimension by tilting them, truncating them, or making them move diagonally into the picture plane.

When both flat, two-dimensional shapes and three-dimensional volumes are used in the same drawing, the result is ambiguous space. If a shape cannot be clearly located in relation to other shapes in the drawing, ambiguous space again results.

If a line delineating a shape varies in darkness or thickness, or if the line breaks, that is, if it is an implied line, the shape becomes less flat. Imprecise edges, blurred texture, and the use of modeling tend to make a shape appear volumetric. Modeling, the change from light to dark across a shape, transforms it into volume, creating the illusion of three-dimensionality.

SKETCHBOOK PROJECT

PROJECT 1
Shaping the Composition to the Format

In your sketchbook draw five or more different formats to be used as picture planes—a long horizontal, a square, a narrow vertical, a circle, and an oval. Quickly make a composition in each unit, using the same subject in each of the formats. Change the composition according to the demands of the framing shape. You will have to adjust your composition from format to format, juggling the relationships between size, shape, and value. Each different outside shape demands a different arrangement of the internal forms. You may use recognizable subject matter or nonobjective images, or you may choose a subject from art history and alter its composition to fit each specific picture plane. Do not change subject matter from one drawing to the next. The arrangement of the formal elements inside the picture plane is what must undergo change.

COMPUTER PROJECT

Today most art departments offer access to computers; many art students own a personal computer, so problems using the computer as an aid to drawing will be offered, when appropriate, after the sketchbook problems at the end of each chapter. The computer projects given in this text were designed by Tom Sale. They were created in Adobe Illustrator, but could be modified for other programs such as Adobe Photoshop, Microsoft Paint, MacPaint, and others.

Students with access to a digital camera will find it a useful tool for collecting images; in addition a camera can provide a quick and entertaining way to visually document ideas, stories, and so forth. Sketchbook ideas using a digital camera might include such subjects as "My Route to Class," "Things I Found on the Ground within a Fifteen-foot Radius of My Front Door," or "Ten Interestingly Shaped Trees."

PROJECT 1
Using a Computer to Determine and Modify Shapes / Experimenting with the Relationship between Positive and Negative Space

1. Using the pen tool, create an interesting organic shape. Fill in the shape with solid black. With the convert anchor point tool (or with other tools such as the reflect, rotate, transform, and filter tools), create several variations of the original shape. This shape can be manipulated by stretching, reversing, and resizing; all of the manipulated shapes will be visually related because they have all been based on the original shape.

2. Create a rectangle that will serve as the picture plane. This plane should be slightly smaller than your maximum printable size (typically 8½ × 11″). Arrange the shapes on the picture plane so they are all tangent (touching one another) and spilling over the edges of the picture plane on at least three sides. You have now created a composite shape.

3. Using the pen and convert anchor point tools, trace the left-over, or negative spaces, created between the composite shape and the edge of the picture plane. Fill these negative shapes with solid black and arrange them in a new composition.

4. Using some of the original positive shapes and some of the negative shapes, experiment with a series of compositions. (In making the composition you may need to rescale some of the pieces.) After you have made a dozen or more compositions, convert some shapes to white. By layering shapes and having areas of cross-over value, you will have created varying levels of space as well as additional new shapes.

As you work through this exercise you may notice the technique is similar to cutting out shapes with scissors. The computer, however, allows you to make multiples and to manipulate the shapes more quickly and cleanly, leaving you more time to experiment with more variations than is possible using manual techniques (figure 3.33).

You could easily make an *homage* to Joel Shapiro by creating a similar work on the computer (see figure 3.1). In art terms, an homage is a derivative work of art in the style of another artist to show respect to the creator of the original work. More often than not in contemporary art, quotations or homages take the form of irony. Richard Hamilton's homage (see figure 1.26) is in fact a double tribute—to both Velázquez and to Picasso—and it definitely has an ironic edge.

A computer-derived homage would not be inappropriate since the later Constructivists (their work continued late into the twentieth century) were the first artists to make use of the computer in determining and modifying shapes.

Make a file to store selected compositions; these will serve you in good stead when you are stuck for an idea or when you are looking for a solution to problems in other compositions. You may even decide to convert one of the more successful arrangements into a finished drawing using cut paper, acrylic paint, or brush and ink. You can revise this problem, and instead of using black and white you could used colored or textured shapes. Continue adding to your repertory of computer drawings by converting and applying information you have learned in class to computer drawing techniques.

3.33 Computer drawings dealing with composite shapes and negative space. Courtesy of Tom Sale.

Value

> To use black is the clearest way of marking against a white field, no matter whether
> you use lead or charcoal or paintstick. In terms of weight, black is heavier, creates a larger
> volume, holds itself in a more compressed field. It is comparable to forging. . . .
> A black shape can hold its space and place in relation to a larger volume and alter
> the mass of that volume readily.
>
> RICHARD SERRA

FUNCTIONS OF VALUE

VALUE HAS THE MOST EMOTIVE AND expressive potentiality of all the elements. Simply defined, *value* is the gradation from light to dark across a form; it is determined both by the lightness and darkness of the object and by its natural color—its *local color*—and by the degree of light that strikes it. This chapter is concerned not with color or hue, but with value, the range from white to black as seen in the scale in figure 4.1. An object can be red or blue and still have the same value. What is important in determining value is the lightness or darkness of the color. This approach is

4.1. Value scale, from 100 percent white to 100 percent black.

achromatic. It is difficult to learn to separate color from value but it is an essential task in art. We have two good examples of this separation in everyday life—in black-and-white photography and in black-and-white television.

If you squint while looking at an object or at color television, the colors diminish, and you begin to see patterns of light and dark instead of color patterns. When the value is the same on both the object and its background, you easily lose the exact edge of the object; both object and negative space are united by the same value. Although value can be confined to a shape, it can also cross over a shape and empty space; it can begin and end independently of a shape.

These two different applications of value can be seen readily in comparing the work of Rick Bartow, a Native American Yurok, and José Bedia, a Cuban now living in Florida (figures 4.2 and 4.3). Both retain cultural, ethnic traditions in their art, using subjects valued for their spiritual and emotive significance. Bartow's wounded animal is a stand-in for the artist himself, who uses Yurok myths and motifs for self-examination. An intensity of feeling is achieved by the vigorously scumbled, gestural application of values crossing over both positive and negative shapes. Even the static outline of legs and haunch does not inhibit the implied fleeting movement of the deer. This action is a result of Bartow's application of value.

Contrast his technique with Bedia's treatment of the iconic face-to-face figures. Sparks seem to fly between the silhouetted pair. The title, which means "He acquires qualities," suggests a meeting of minds; this interpretation is reinforced by the walker who is securely traversing the linear bridge connecting the two beings. Man and deer are both faceless, yet they seem to be involved in an intense spirit communication. Bedia is a member of the Palo Monte, an Afro-Cuban religious group that recognizes the kinship between the human and animal worlds. The "electric sparks" that each figure emits are conveyed by the paint splotches and are symbolic of the intensity of shared knowledge. Both artists achieve expressive goals through value patterns befitting their mythic subjects.

4.2. RICK BARTOW. *Deer Hunt II.* 1993. Pastel, charcoal, and graphite on paper, 2'2" × 3'4" (66 cm × 102 cm). Francine Seders Gallery Ltd., Seattle. Photograph by David Browne.

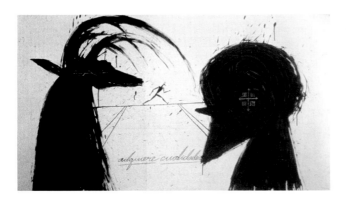

4.3. (**above left**) JOSÉ BEDIA. *Adquiere Cualidades.* 1994. Acrylic on paper, 2′7¼″ × 4′7¼″ (79.4 cm × 1.403 m). Jean and George Adams, New York.

Kiki Smith's *Two Deer* is in a different mode (figure 4.4). The gentle, life-size deer are drawn in reversed values on two panels made of saturated red and maroon papers. Smith's drawings, an engagement with wildlife and landscape, are "her personal view of Eden" (Posner, *Kiki Smith*, p. 27).

In addition to its emotive or expressive appeal, value is a concern of many graphic artists whose subjects are themes of social injustice (figure 4.5). What better means than stark contrasts to carry a message of protest! Ed Paschke presents the archetypal military strongman in his political print. An eerie light surrounds him. Are we seeing him on a television screen? The dictatorial, inhumane figure seems out of focus, impervious to light. Value

4.4. (**above right**) KIKI SMITH. *Two Deer.* 1996. Ink on paper, 4′6¾″ × 7′7¾″ (1.34 m × 2.33 m). Photo by Ellen Page Wilson. Courtesy of Pace Wildenstein. © 2004 Kiki Smith.

4.5. ED PASCHKE. *Kontato.* 1984. Lithograph printed by Landfall Press, Chicago. Printed in color, 34¼ × 24″ (87 cm × 61 cm). Lent by the Publisher, Chicago.

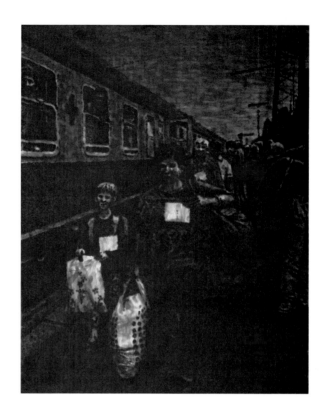

4.6. JIRI GEORG DOKOUPIL. *Bosnian Refugees Arriving in Germany.* 1992. Candle soot on canvas, 4′2″ × 3′4¼″ (1.27 m × 1.02 m). Tony Shafrazi Gallery. © 2003 Artists Rights Society (ARS), New York / VG Bild-Kunst, Bonn.

reversal is a major component in Paschke's message. This term "value reversal" takes on a double meaning in the artist's social satire. Paschke reminds us of the nightly news with horrific reports of military coups and martial law. The message is enforced by the exaggerated use of light and dark values. (This sharp contrast of light and dark is called *tenebrism*.) The face seems flattened out, devoid of affect.

The technique of creating gradual value transitions without using line is called *sfumato*, a process used by the Renaissance artist Leonardo da Vinci. Jiri Georg Dokoupil bases his technique on the literal definition of *sfumato*, "in the manner of smoke," using candle soot as his sole medium in the work entitled *Bosnian Refugees Arriving in Germany* (figure 4.6). Dokoupil, whose work deals with emigration, displays an amazing level of control using a demanding and unconventional medium. The value patterns built up from the residue of smoke from a burning candle create a realistic style that brings to mind old black-and-white newsreel documentary images. The work is compelling on a formal as well as a conceptual level.

Like Dokoupil's work, the elaborate three-part composition *Big Girl Lie #1* (figure 4.7) attracts the viewer through its unorthodox materials. This massive piece (9′ × 17′ × 3″) is made with conté crayon on Formica and sandblasted steel. The central image traces its source to the long-honored tradition of seventeenth-century Dutch still life, or *pronkstilleven* as they were called— sumptuous or ostentatious still life. These luxurious arrangements did not simply display the artist's skill, but pointed up a moral theme. How different were the European patrons, famous for their prosperity and conspicuous consumption, from the art consumers of today? Can we assume the Big Girl is Mother

4.7. KARIN BROKER. *Big Girl Lie #1.* 1992. Conté crayon on Formica with sandblasted steel, 9′ × 17′ × 3″ (2.74 m × 5.18 m × 8 cm). Gerhard Wurzer Gallery, Houston.

Nature herself? Then what is her first lie? Something about fecundity, decay, and mortality, no doubt. The abundance depicted in Karin Broker's monumental work is a result of virtuoso control over a wide value scale used to convey the stunning textures of the flowers, vase, leaves, nest, and eggs.

The central image and its accompanying close-up view of the bouquet on the right are visually and conceptually distanced from the panel on the left with its two lone, concentric target shapes. The left segment, defined by a simple overall value, contradicts the explosive richness of its companion panels. Their gaudiness, splendor, and lavishness seem to be canceled by the insistent blankness of the first segment. Is it the contradiction between the two styles and images that makes the center-stage drama a lie? Frequently, Dutch still lifes were called *vanitas*, still lifes that underscore not only the transitory nature of the prolific blooms but of life itself. Broker's descriptive skill holds its own with the early Dutch artists. Her keen observation, accuracy, and expressiveness in depiction of the natural forms along with the intrigue of the message itself keep the viewer's attention firmly fixed.

As we have seen, artists can base their work on actual appearances or they can create their own value patterns, their own kind of order, illustrated in the two drawings of rabbits in the accompanying figures. Wayne Thiebaud's sleeping rabbit (figure 4.8) is centralized in an otherwise empty space. It is tied to the ground by a dark semicircular shadow at its tail; it is strangely isolated, its forms generalized. Value is gently modulated from white to gray. Repeating, undulating shapes ripple across the surface. The rabbit seems to be sitting in a pool of light; its cast shadow is the darkest, most clearly defined shape in the composition. The value patterns are theatrically exaggerated by this intense light. As if to point out how crucial value is to the composition, the shadow cast by the ear reads as a value scale. Whether Thiebaud actually set

4.8. WAYNE THIEBAUD. *Rabbit* (from *Seven Still Lives and a Rabbit 1971*). Lithography in color, 1′10¼″ × 2′6″ (57 cm × 76 cm). Brooklyn Museum, National Endowment for the Arts and Bristol Meyers Fund. Acc. 72.121.1. © Wayne Thiebaud/ Licensed by VAGA, New York.

4.9. LYDIA MARTINEZ. *Negotiations.* 1986. Pastel on paper, 1′9″ × 1′7″ (53 cm × 48 cm). National Multiple Sclerosis Society juried exhibition "Shared Visions: Artists With MS." Courtesy of the artist.

up artificial lighting or invented it in the drawing, his manipulation of lights and darks is an intense and personal one.

A different approach, by style, technique, and subject matter, is taken by Lydia Martinez in her invented scene inside the rabbit hutch (figure 4.9). Two dark, looming, cringing, and gesticulating rabbits with human hands dominate the foreground space. Their dark forms merge with one another so that it is difficult to tell where each separate body begins and ends. What we assume to be two more anthropomorphized rabbits appear in the background, heads and upper torsos cut off by the top of the picture plane. Some dramatic event is in progress. The rabbit on the right seems to be conspiring with, or at least enlisting help from, the viewer. A sense of impending disaster is conveyed by the darkness of the figures. A raking light washes out the table and creates cast shadows behind the standing figure and the table legs.

The kind of observation and value decisions made in Thiebaud's work has not been employed here. In this imagined scene with nonhuman actors, the darkness of the forms carries a weight and seriousness that conflicts with whatever humor one might find in the setting. Again, it is the use of value that lends a conceptual weight to our interpretation of this drawing.

Value describes objects, the light striking them, and their weight, structure, and spatial arrangement. Value can also be expressively descriptive. So value has two functions: It is objectively as well as subjectively descriptive. Susan Hauptman's drawing (figure 4.10) is a study in representational clarity. The composition is built with a full range of values, all visually accurate, from the wrinkled, lightweight scarf to the glass, shell-shaped vase. Values cross over positive shapes and empty space in the upper third of the drawing; the white

4.10. SUSAN HAUPTMAN. *Still Life.*
1985. Charcoal and pastel on paper,
2′7½″ × 3′7¾″ (80 cm × 1.11 m). Private
collection. Allan Stone Gallery. Courtesy
Allan Stone Gallery, New York.

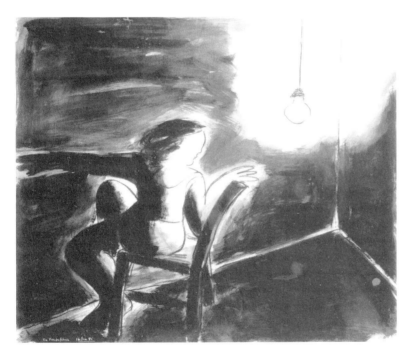

4.11. DIETER HACKER. *Die Fremdenführerin*
(*The Guide*). 1985. Charcoal and watercolor
on paper, 3′3⅜″ × 3′11¼″ (1 m × 1.2 m).
Arkansas Arts Center Foundation Purchase,
1986. 1986.047

tabletop disappears, reappears, and disappears again in the background space. The texture, or tactile quality, of the drawing is a result of a masterly handling of values. Although Hauptman's drawing is unquestionably representational— illusionistic, both spatially and texturally—it is highly subjective; an atmosphere of mystery pervades the work.

The charcoal and watercolor drawing by the German artist Dieter Hacker embodies the artist's involvement with the theater (figure 4.11). Like Hauptman, Hacker presents a scene of mystery—theatrical and ominous. A faceless woman, trapped in a cell or in a solitary, confined space, seems startled;

she twists her torso (leaving her elongated arm extended in space) to look back at the corner of the room brilliantly lit by a single lightbulb hanging from the ceiling. The drawing could be a scene from a play written by the existentialists Samuel Beckett or Jean-Paul Sartre. A writer admired by Hacker wrote that an artist can recapture creative power through a "second naivety." This seems to be a fit description of Hacker's artistic stance. Obviously, the artist invented the scene; it depicts an interior moment of great drama. The message is conveyed by contrast of the dark, threatening room, the glaring burned-out flash of the light, and the expressionistic quality of the marks.

WAYS OF CREATING VALUE

In the graphic arts there are two basic ways to define a form—by line or by placement of two values next to each other. Most drawings are a combination of line and value, as we have seen in the previous illustrations.

In his drawing (figure 4.12), Gregory Masurovsky has created value shapes by density, or closeness, of dots and lines and by pressure exerted on the drawing tool. This method of creating value is called *stippling*, a drawing or painting technique that uses dots or short strokes. Masurovsky's drawing seems to glow in imitation of the moon. The translucent surface is activated by nearly indiscernible marks, short squiggly lines and dots that congregate as if attracted by the magnetic force of the moon. The shapes created by a light range of values surge and dissolve like waves washing over the forms "in a dance of heavenly light." A meticulous handling of the medium and a pale value range combine to produce a poetic work. The repetitive action of long duration required to make the drawing encourages the viewer to make a slow, lingering inspection of the forms.

4.12. GREGORY MASUROVSKY. *Les Phases de la lune.* 1991. Pen and ink on paper, 2'2" × 3'3⅜" (66 cm × 1 m). Lent by the artist. Arkansas Arts Center. © Artists Rights Society (ARS), New York/ADAGP, Paris.

4.13. ROBERT KOGGE. *Untitled.* 1989. Graphite on canvas, 2′ × 3′ (60.9 cm × 91.4 cm). O. K. Harris Works of Art, New York.

A drawing may be exclusively tonal, as in Robert Kogge's compact still life (figure 4.13), in which the objects' actual or local values are carefully observed and translated onto the picture plane. A light source (from left front and slightly above the still life) creates minimal shadows, and, while suggesting the curvature of the rounded containers, the ultimate effect of the even lighting is to flatten the objects in their tense proximity on the picture plane. Kogge sets up an interesting spatial paradox in the work: First, a uniform texture created by graphite on the canvas tends to flatten the otherwise illusionistically three-dimensional objects; second, although the forms are modeled from light to dark to depict rounded volumes, the space from foreground to background is extremely compressed. Note that the baseboard in the lower right of the picture plane seems to exist on the same level as the small objects on the lower left. Kogge's tightly knit composition is held together by a meticulous handling of values; this spatial tension results in a contemporary look.

Tonal quality can also be made by smudging, by rubbing and erasing as in Michael Mazur's massive, realist charcoal drawing (figure 4.14). The dense tropical landscape with its moss-laden trees and palmettos lends itself to a layered technique. The whites in the sky and the mottled highlights on the trees and on the ground have been created by erasure; the moss hanging from the trees is suggested by rubbing and smudging. The powdery medium of charcoal is ideal for these techniques since it lies on the surface of the paper rather than soaking in like a wet medium; therefore, it can be moved about by smudging and lifted from the surface by erasing. These methods are suitable for modeling objects in space; they resemble the actual modeling or manipulation of a three-dimensional object. You have the sense of "reaching into" space and "digging out" forms. Mazur's technique results in a dense, congested, illusionistic space. Visually we have to fight our way through the undergrowth and overhanging trees to the background areas of light. Texturally rich value patterns of light and dark organize the complex composition.

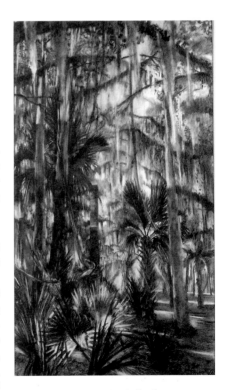

4.14. MICHAEL MAZUR. *Landscape— Ossabow.* 1975. Charcoal with smudging and erasing on ivory weave paper, 5′11½″ × 3′5″ (1.816 m × 1.041 m). Jalane and Richard Davidson Collection, Art Institute of Chicago.

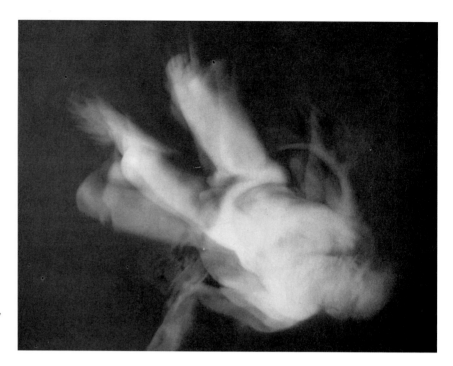

4.15 DAVID MCMURRAY. *Evidence* (detail). 1993–1994. India ink on paper, 4'2" × 5'7" (1.27 m × 1.7 m). Courtesy of the artist. Photo: Richard Nicol.

The oversize ink drawing by David McMurray exhibits blurred values to capture the notion of movement (figure 4.15). The background is both flat and deep space (that is, it is an ambiguous space; conceptually we read the space as three-dimensional, but visually it is an unmodulated black). The figure seems to be in the act of falling, and from the title of the work *Evidence*, we surmise that a crime has taken place. The scene appears to be illuminated by a strobe light, an effect achieved by the blurred values surrounding the prone figure. It is interesting to learn that McMurray works meticulously from photographic images. His use of tenebrism, the extreme change in value from light to dark, is a powerful means of relaying disturbing content.

Crosshatching is another means of creating value. A contemporary adaptation of a traditional technique is found in Sol LeWitt's Conceptual art projects from the 1960s in which LeWitt gave instructions for drawings to be made directly on gallery walls. It was not necessary that the artist make the drawings; the idea, the concept, took precedence. Lewitt took Marcel Duchamp's teaching from earlier in the century and made his ideas manifest. LeWitt's conceptual drawings have great attraction—even beauty—not only for their coherence and order but for their totally contemporary presence. The pencil marks create a shimmering quality that is quite unexpected in such a mechanically produced work. The subjective, personal mark of the artist's hand is bypassed in LeWitt's Process art; he describes the relationship of the draftsman and wall as a dialogue. The lines, according to the artist, are meaningless. LeWitt's work, simultaneous with the Pop art movement, refocused on the contemplative, logical, and rational role of art.

The work shown here (figure 4.16), a four-square grid, makes use of horizontal, vertical, and crosshatched lines. You can see that a broad range of values can be created simply by grouping lines. The direction, the spacing, the overlap, the width, and the weight of the lines are all factors in creating value.

4.16 SOL LEWITT. *Untitled* (black 4-square of crosshatch lines). 1968. 6⅘″ × 6⅞″ (17.3 cm × 17.5 cm). Fine Arts Museums of San Francisco, Crown Point Press Archive, Gift of Crown Point Press, 1991.28.785. © 2003 Sol Lewitt/Artists Rights Society (ARS), New York.

You will remember that twentieth-century art made a steady march toward calling attention to the flatness of the picture plane. LeWitt's minimal drawings were very effective in reaching this goal; the drawings are coexistent with the wall; integrated into the surface as they are, they create no illusion of depth. Think of the contrast in LeWitt's uninflected lines and those of Pollock made by sweeping gestures and flowing paint. The inner expression, conveyed in the work of the Action Painters, is completely denied in LeWitt's cool conceptual approach. His lines are the process and the product, each one as important as the next. (Or as unimportant as the next!)

In a more traditional yet still modern setting, in a life-long occupation with still life (figure 4.17), the Italian artist Giorgio Morandi constructs an ordered arrangement using crosshatching. Background and foreground are uniformly crosshatched, flattening the space. The bottles are defined by groups of angled lines, which indicate planar change; the still life contours are strengthened, and thereby flattened, by outline. Morandi's value patterns create an otherworldly effect; the objects seem strangely isolated and lonely. Morandi's work is contemporaneous with that of the Surrealists. There is a

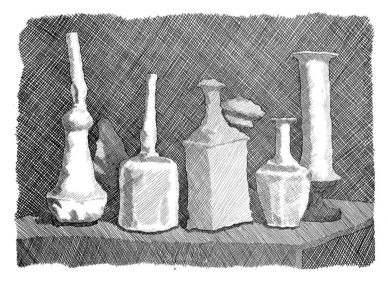

4.17. GIORGIO MORANDI. *Nature Morte au Gros Traits.* 1931. Etching, 9⅝″ × 1′1¼″ (24 cm × 34 cm). Harriet Griffin Gallery. © 2003 Artists Rights Society (ARS), New York/SIAE, Rome.

suggestion of the surreal in Morandi's work, although his calm, classically stated compositions take precedence over a more psychological approach. His images were drawn from life, unlike the Surrealists, whose source of imagery was the subconscious.

ARBITRARY USE OF VALUE

Artists sometimes ignore the natural laws of value, such as the way light falls across a form, and use value arbitrarily—to create a focal point, to establish balance between parts, to call attention to a particular shape, or otherwise to organize the composition. These uses of value are based both on the artist's intuitive responses and the need to comply with the demands of the design. In other words, *arbitrarily stated values* are light and dark patterns that differ from local values (actual values one sees in real life).

Andy Warhol, in one of his many iconic portraits of Marilyn Monroe (figure 4.18), has used a totally arbitrary arrangement of values completely divorced from values as seen in the real world. Value shapes cross over both positive and negative space. Some segments of the face are left blank and other areas are defined in a value reversal; in other words, Marilyn's eyes, nose, and mouth look like they are taken from a photographic negative. The black band that crosses the face from the bottom right to the upper left is integrated with the negative shape at the top of the picture plane that lies behind the head. If you block out the eye and mouth, the composition becomes an abstract arrangement of blacks, whites, and mottled grays. Arbitrary value patterns both integrate the work and confound a logical spatial analysis.

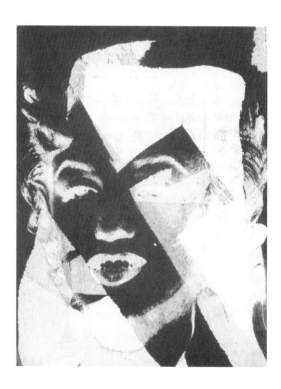

4.18. ANDY WARHOL. *Marilyn.* 1978–1979. Ink silkscreen on paper, 1′10½″ × 1′5½″ (57.1 cm × 44.4 cm). Vrej Baghoomian Gallery, New York. © 2003 Andy Warhol Foundation for the Visual Arts/Artists Rights Society (ARS), New York.

PROBLEM 4.1
Using Value Arbitrarily

Choose a still life or model as your subject, from which you are to make two drawings.

In the first drawing fill the page using background shapes. (Remember, continuous overlapping lines will create some repeated shapes.) Using black, white, and two shades of gray, arbitrarily distribute values within the defined shapes. Continue using values to enclose shapes, and keep the values flat and unmodulated. Lead the viewer's eyes through the picture plane by the location of dark shapes. Add grays, establishing a secondary pattern. Base your decisions according to compositional demands, not on the actual appearance of the subject.

In the second drawing, rather than using only flat shapes and values, model some of the shapes to give them a more volumetric appearance. Again, direct the eyes of the viewer through the picture plane by the distribution of these modeled areas. You should have a major focal point and minor focal areas. A combination of flat shapes and modeled volumes in the same drawing results in ambiguous space.

DESCRIPTIVE USES OF VALUE

Value can be used to describe objects in physical terms of structure, weight, light, and space.

Value Used to Describe Structure

Value can describe the structure, or planar makeup, of an object. Light reveals structure but values can be distributed according to an analysis of an object's planes; that is, value describing structure need not depend on the natural laws of light. A structural analysis is a type of abstraction; it is not related to imitation. It is a means of seeing the whole by separating the parts. In addition, a planar analysis gives us a better understanding of how to build volumes in space.

In the drawing of his mother by the Italian artist Umberto Boccioni (figure 4.19), the artist has analytically simplified the concrete form of the mother's head. He has indicated volume in terms of interconnecting planes. Lines define the intersection of planes; planes indicated by a darker value— by closely grouped lines—signify the planes turning from our view, into space. A planar drawing is a sort of diagram that plots the most essential planes and their junctures. Planar analysis is a step toward abstraction; it does not imitate, it analyzes. An analytical drawing takes things apart to discover basic structures.

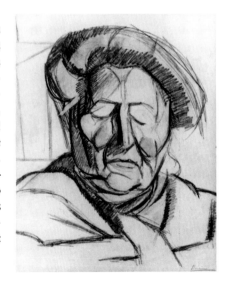

4.19. UMBERTO BOCCIONI. *The Artist's Mother.* 1915–1916. Black chalk and red, green, and blue watercolor on buff paper, 2'1" × 1'8¾" (63.5 cm × 52.7 cm) Collection Lydia Winston Malbin, New York.

PROBLEM 4.2
Using Value to Describe Structure

In this drawing from a model you are to reduce the figure to two values—black and white—and to two basic planes—front and side. Carefully examine the figure to determine where head, arms, legs, and upper and

lower torso face you and exactly where these forms turn away from you at a 90-degree angle. In other words, imagine the figure to be composed of only two planes, front and side. Draw a line separating the planes, placing a flat value within the planes that recede, leaving the rest of the figure white. Here you are using value to describe both the structure of the figure and its recession into space. The Bogomazov drawings (see figure 3.32) are examples of this approach.

PROBLEM 4.3
Using Value to Describe Planes

Use a skull or head as subject and make a drawing that emphasizes the planar aspects. Do you remember the drawings on planar analysis in chapter 3? In this drawing, group lines within the planes to create value. A change of line direction indicates a change of plane. Make your marks change directions just as the planes change. Make the strokes run vertically for those that are parallel to you and diagonally for planes that turn into space. This change in direction will emphasize the juncture of planes and will be more dimensional than the drawing in the preceding problem.

Value Used to Describe Weight

The weight, or density, of an object can be defined by value. We sense the pressure of gravity in all objects in real life. The artist frequently enforces this sense by placing darker values at points of greatest pressure or weight, or at places where the greatest tension occurs. Artists use weight or density even when they are not drawing objects in the real world. A completely nonrepresentational drawing can convey the idea of weight and mass.

Reread the quote by the artist Richard Serra at the beginning of this chapter. Looking at his work in relation to his comments on the importance of black will amplify our discussion (figure 4.20). Serra says "shapes refer to their internal masses. . . . Objects have weight because of the character of their geometries." This is well illustrated in a series of works that he calls *out-of-round* drawings, in which he uses a metal screen as a registration device for the massive circles. He places handmade paper facedown on compacted oil stick. Applying pressure on the back of the paper with a piece of metal, he forces the paper into the pigment. He doesn't see the finished drawing until he removes it from the screen. Serra says he works on the drawings on the floor and from all sides in order to achieve a "compression of the material with a gravitational load that is bearing down on them." He adds that he is "interested in the stasis of them" and "in the compactness of the spread," in addition to how "they cover the field as they are being made from the inside out" (R. Eric Davis, "Extend Vision: Richard Serra Talks about Drawing." *Art on Paper*, May–June 2000, p. 63). The drawings are so heavy they have to be stabilized on the back before they can be framed.

In *Female Model on Ladder* (figure 4.21), Philip Pearlstein gives volume to the shapes by depicting the effects of light and shadow, which in turn adds to the sense of weight and gravity. Key areas in which a heavy, darker-value line creates the illusion of weight are where the hand presses into the leg, where the thigh spreads on the ladder step, and in the folds of the stomach and the sag of the breast. There is one area where value could be used to create weight

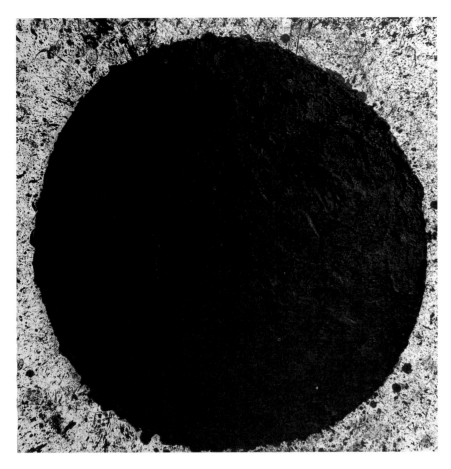

4.20. RICHARD SERRA. *out-of-round VI.* 1999. Paintstick on Hiromi paper, 6′7″ × 6′7¼″ (2 m × 2.01 m). Courtesy Gagosian Gallery, New York. © 2003 Richard Serra/Artists Rights Society (ARS), New York.

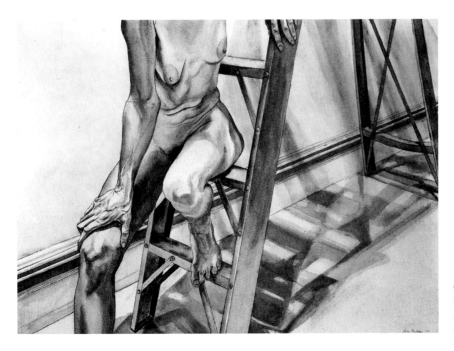

4.21. PHILIP PEARLSTEIN. *Female Model on Ladder.* 1976. Sepia wash on paper, 2′5½″ × 3′5″ (75 cm × 1.04 m). Robert Miller Gallery. Courtesy Robert Miller Gallery, New York.

and gravity: The foot of the ladder between the model's legs seems to float. The back foot of the ladder is tied to the floor by the use of value connecting the ladder to its cast shadow.

Now is a good time to introduce an important point: Sometimes one can draw things exactly as they appear, but if the light, arrangement of objects, or point of view are not properly composed, the drawing will look wrong. Sometimes the artist has to juggle elements in the drawing for it to appear visually correct. This license to rearrange and alter is an important lesson for the beginning student to learn. A typical problem area for the artist can be where a background edge intersects a foreground edge, such as at the corner of an object. In his drawing Pearlstein maintains the clarity and separation of the figure, ladder, and baseboard by controlling the intersection of foreground and background shapes. Pearlstein's interest in the structure of the human figure is conceptually fortified by the ladder, with its complex pattern of cast shadows. Figure and ladder are analogous forms; the pose of the model reiterates the triangularity of the ladder shapes. The ladder becomes a visual metaphor for the framework of the figure. The expressive quality of the work is conveyed primarily by means of value—a cool, detached, analytical approach to a figure in an environment. The headless figure reinforces the impersonal theme of model in a studio.

PROBLEM 4.4
Using Value to Describe Weight

Make a first drawing of the model beginning in the imagined center of the figure. Revolve your drawing tool to make a heavy, weighty mass of tangled line, moving outward from the central core. Exaggerate the model's weight; double the mass. The outside edge of the figure should be fuzzy and ill defined, whereas the center should be darker.

Make a second drawing of the reclining figure using pencil, wax crayon, or pen and ink, along with an ink wash. Compose the drawing with the figure at a sharp diagonal to the picture plane; for example, place the head in the foreground, the torso in the middle ground, and the legs and feet in the background space of the drawing. As in the last drawing, use value to describe weight and mass. Begin lightly filling the form from the inside out. As you reach the outer edge of the figure, use a sharper, defined line to make contact with the horizontal contours of the figure. Imagine that you are coating the figure with a thin webbing or that you are wrapping it in line, as you would a mummy. The line conforms to the body's contours. Your intent is to create volumetric forms in a three-dimensional space.

An artist who uses this technique to promote a sense of weight and mass in his drawings is Henry Moore (figure 4.22). *Row of Sleepers* is from a large series of air-raid shelter drawings done during World War II. Moore was a British sculptor whose drawings had autonomous yet parallel relationship to his sculpture. In both disciplines he explored the idea of weight and mass; his subjects seem to emerge from the earth itself. Moore concentrates on the sculptural aspects of a form in his drawings; the lines wrap around the forms, encasing them as if they were cocoons. The figures, both sculpted and drawn, have a roundness and solidity that make them resemble mountains.

In Moore's drawing there is pressure and weight in the lower half of the drawing; the sense of mass diminishes as the bodies move away into space. The

lines encasing the figures in the foreground are more distinct than those describing forms in the background. The watercolor wash conveys the idea of an underground, dimly lit space.

In the third drawing from a model—you may choose to crop the figure, drawing only a segment of the figure—the technique will be fingerprint; using black acrylic, make a stippled drawing by applying the paint with your thumb. Lightly establish the figure on the page, keeping the initial thumbprints small and widely spaced. After you have lightly established the figure in its proper scale, proportion, and placement, begin applying darker, larger prints. Imagine that your paper has depth and that you are applying slabs of clay to an armature. This technique is related to a sculptor's building up a mass of clay. Use greater pressure in the areas where you perceive the greatest weight, gravity, and distance, creating a buildup of value. Lighten the pressure and use less paint in areas where weight and gravity do not play a role, such as at the top of the shoulder or the top of the arm. You will be more successful in your depiction of weight if you imagine that you are literally constructing a three-dimensional figure. Do not simply dab the paint; try to imagine that you are pushing clay against the armature of the figure; you can both push against the body and at the same time feel the body as it turns into space.

Going back to chapter 1, look at the large-scale image of the human face by Chuck Close (see figure 1.21). The visual force of the drawing stands in contrast to the intimacy of the technique. Close maps the surface variations of his subject. He has taken the pointillistic technique, so closely identified with the Post-Impressionist Georges Seurat, in a new direction.

Value Used to Describe Light

Light falling on an object creates patterns that obey certain rules. If light falls from one direction onto the object, the value patterns created can reveal the structure of the object and its volumetric and planar aspects; for example, a sphere under a single light source will have an even change in value over its surface. In the graphic arts, modeling—the gradual transition from light to dark to create spatial illusion—is called *chiaroscuro*. This technique can be seen in Gérard Titus-Carmel's alteration of a sphere (figure 4.23).

4.22. HENRY MOORE. *Row of Sleepers.* 1941. Pencil, wax crayon, watercolor wash, and pen and black ink, 1′9¼″ × 1′⅝″ (55 cm × 32 cm). Collection British Council, London. © The Henry Moore Foundation.

4.23 GÉRARD TITUS-CARMEL. *17 Exemples d'Alteration d'une Sphere. 12eme Alteration.* 1971. Pencil, 1′7½″ × 2′4″ (52 cm × 74.7 cm). Private collection. © 2003 Artists Rights Society (ARS), New York/ADAGP, Paris. Photo: Andrew Morain.

4.24. Light on rounded and angular forms.

Cylinders, cones, and organic volumes change gradually from light to dark over their surfaces, whereas cubes, pyramids, and other angular forms change abruptly from light to dark on their surfaces; that is, their planes are emphasized by light (figure 4.24).

Generally, light as it falls over a form can be reduced to six categories: highlight, light, shadow, core of shadow, reflected light, and cast shadow (figure 4.25). Within a single form or volume we may see parts of it as light against dark and other areas as dark against light. Some areas may seem to disappear into the background; that is, if a light-valued object is set against a light background, the edge of the object will disappear. Values can cross over both objects and negative space, causing the edge of the object to seem to disappear.

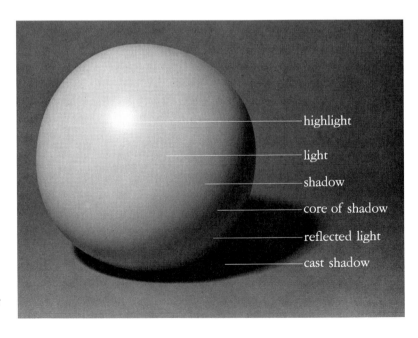

highlight
light
shadow
core of shadow
reflected light
cast shadow

4.25. Six categories of light as it falls over a form.

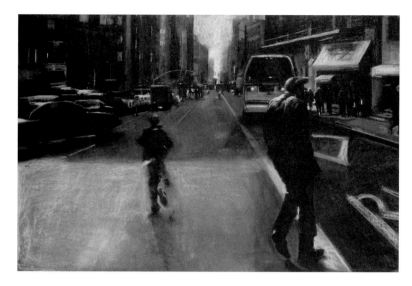

4.26. SUSAN GROSSMAN. *Lexington Avenue.* 2000. Charcoal on paper, 5′ × 7′6″ (1.52 m × 2.29 m). DFN Gallery, New York.

Susan Grossman's charcoal drawing *Lexington Avenue* (figure 4.26) illustrates these effects. Buildings, cars, and people meld into their background values. The close darker values in the middle ground absorb the objects, leaving only highlights to indicate individual forms. The light source comes from the left front of the picture plane; the progression of light is from front to back, light/dark/light. The edges of the running figure are dissolved into the large white space of the pavement. The upper torso of the striding figure on the right disappears into the darker values surrounding him. An intriguing aspect of Grossman's depiction of space is that the most blurred and imprecise contours appear in the foreground.

Multiple light sources can result in ambiguous space because the form revealed by one light may be canceled by another. Manipulation of light sources can produce striking effects that result in a very different mood from that produced by natural light. In a self-portrait (figure 4.27), the artist employs a stark underlighting to create a sense of drama. A tense, apprehensive effect is gained by an unexpected reversal of values. The stylized hair and shirt contrast with the visual accuracy of the facial features; the hair seems to be electrified by the intense raking light that illuminates the head. Note the spatial ambiguity between neck and chin where the light has washed out the shapes that normally differentiate the two.

PROBLEM 4.5
Value Reduction

Set up a still life of several objects with non-reflective surfaces. Study the subject carefully, and on a value scale from one to ten (see figure 4.1), find its midpoint value. Squint your eyes to reduce color effects so that you see only patterns of light and dark. This drawing is to be a value reduction. You are to reduce all values in the subject to either black or white. Note both the actual values of objects and the light patterns on them, and classify these values as either black or white: Values from one to five will be white, from six to ten, black.

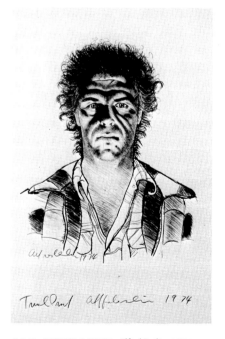

4.27. ALFRED LESLIE. *Alfred Leslie.* 1974. Lithograph, 3′4″ × 2′6″ (1.02 m × 76 cm). Published by Landfall Press, Inc., Chicago.

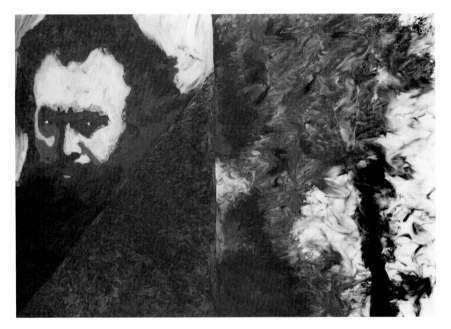

4.28. RUPERT GARCIA. *Manet Fire.* 1987. Mixed media (chalk, oil paint, pastels) on canvas, 3′9¾″ × 5′6″ (1.16 m × 1.68 m). Collection Oliver Stone, Santa Monica; courtesy of the artist, Rena Bransten Gallery, San Francisco, and Galerie Claude Samuel, Paris. © Rupert Garcia, 1996.

Draw the subject lightly in pencil; then use black acrylic or ink to make everything that is darker than the midpoint value a flat, unmodulated black. Erase the pencil lines, leaving the rest of the drawing white. Values will cross over objects and negative space; value will not necessarily be confined to an object. The finished drawing will be spatially flat, very dramatic, and somewhat abstract.

Make a second drawing, this time a two-part drawing; on one side use only two values to create a high-contrast study as in the diptych, or two-part drawing, by Rupert Garcia (figure 4.28). The subject can be drawn from memory, it can be invented, or it can come from a photographic source. Aim for expressive content as in *Manet Fire,* Garcia's homage to the nineteenth-century artist Edouard Manet.

In the accompanying panel, expand the value range to four or five, and create an abstract, nonobjective surface that will give added expression to the other half of the drawing with its recognizable imagery.

Use a wet medium such as ink or acrylic, or use a medium that can be dissolved by wash, such as grease pencil and turpentine or pastel and turpentine. Loosely handling the implement and layering the values will result in a richer, more expressionistic surface.

PROBLEM 4.6
Four Divisions of Value

Carefully observe the light patterns on a still life. Coat your paper evenly with charcoal of four or five on the value scale (see figure 4.1). If necessary go over the paper twice to create a smooth-textured drawing surface.

Choose four values—the gray of your paper, a darker gray, white, and black. The actual light patterns on the subject will govern your decisions. Try to divide accurately the values in the subject according to the light patterns on

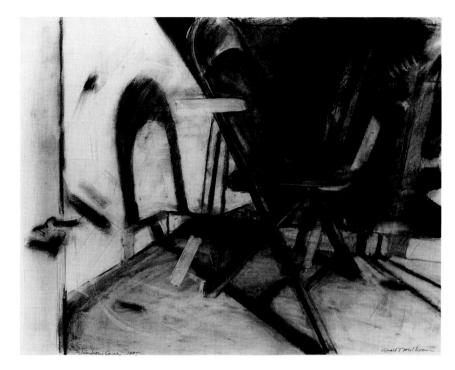

4.29. RONALD MILHOAN. *Windowcase.*
1975. Pastel, 1′ 11″ × 2′ 6″ (61 cm × 76.2 cm).
Collection of Pensacola Junior College,
Pensacola, Florida.

it. Indicate the blacks and dark grays with compressed charcoal and erase the
whites with a kneaded eraser. Now begin to model the values. Values should
again cross over objects and negative space.

To refresh your memory concerning modeling and overlapping, refer to
Problem 3.11 before beginning this exercise.

Ronald Milhoan's pastel drawing (figure 4.29) is informative to study for
use of erasure and modeled values. Note that values are not confined within a
single object; they cross over both positive and negative shapes. A rich tex-
tural surface results from applying the media in varying directions and using
the eraser as a drawing tool. Try to imagine that the eraser can actually model
forms, can reach inside the picture plane to the various levels of space. You can
use the eraser to soften the edge of shadows and to create white negative
shapes. (Note the odd floating shapes in Milhoan's drawing; they give the work
a sense of immediacy. What could have been a static composition is activated
by the small, active shapes.)

PROBLEM 4.7
Categories of Light

In this drawing, use a value range of six to depict the categories of
light referred to in figure 4.25. Set up lighting conditions using only one light
source, so that you have a highlight, light, shadow, core of shadow, reflected
light, and cast shadow. After carefully observing the actual light patterns on
the still life, make four value scales of six values each, using these techniques:
scribbling, stippling, crosshatching, and grouping parallel lines. Density, or
closeness of marks, and amount of pressure exerted on the tool are the means
of value change. Now choose one of the value techniques and draw the still

life with six values. Use no more than six values, and make the transitions gradual and smooth; try to match accurately the actual values in the still life in your value scale. In Morandi's still life (see figure 4.17), you can see how density, or closeness of marks, can be the means of value change. Since Morandi maintains the sameness of the direction of the marks within a shape creating a linear buildup, the resulting space is ambiguous. The flatness of the picture plane is reinforced by the sameness of the lines, despite the objects' overlap and their slightly different baselines. The Italian artist achieves a classical calm and presence by his sensitive balance of shapes and his unique capacity for rendering an enveloping atmosphere in which the timeless objects exist.

It is taxing to train the eye to see actual patterns of light and dark, but it is a rewarding exercise. Your ability to see will be enhanced, and your power of concentration will be intensified in doing these problems.

PROBLEM 4.8
Tonal Drawings

Using a still life or a figure in a room as your subject, make two all-tonal drawings. In the first use a light value scale to organize your drawing; in the second expand the value scale to include more darks. In your drawing indicate the change of light across each object and allow values to cross over both objects and negative space. Occasionally the edges of objects should seem to disappear into their adjacent negative shapes or shadows.

In Sidney Goodman's charcoal drawing (figure 4.30), value shifts in intensity from the bottom to top. In the lower half of the drawing the legs and lower torso dissolve into the background walls of the room. The lower arms are lost in the gray haze, and the upper arms are in relief against the densely black torso. The man's black skull contrasts with the white ceiling, or empty

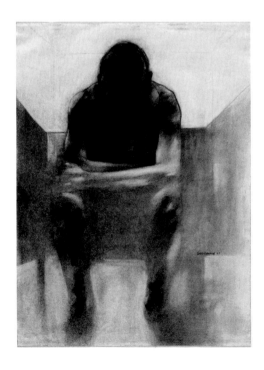

4.30. SIDNEY GOODMAN. *Man Waiting.* 1961. Charcoal on paper, 2′1⅝″ × 1′7⅛″ (65 cm × 49 cm). The Museum of Modern Art, New York. Gift of Mr. and Mrs. Walter Bareiss (143.1962). Digital image © The Museum of Modern Art/ Licensed by SCALA/Art Resource, New York.

space of the picture plane; the jaw line and chin are lost in the dark value indicating the chest. Goodman seems to have stopped time with the static symmetrical pose and the dissolution of forms in the lower half of the drawing. The figure is in the act of dissolving in spite of the weight of the upper torso bearing down on the legs.

Value Used to Describe Space

As in depicting light, artists may comply with nature to describe space as it actually appears, or they can promote the feeling of space by the use of value. Spatial depiction has many manifestations; there is no single way to indicate space. The handling of space is a result of the artist's view tempered by culture and personality.

One approach to the depiction of space is to use a progression of values from dark to light or light to dark. In Sharron Antholt's charcoal drawing (figure 4.31), we see a depiction of the hallways and cells of a Buddhist monastery, a physical means to a metaphysical purpose. Space and light are used symbolically as metaphors for a world where being takes precedence over action. The atmospheric work is one of solemnity and sublimity. The spiritual dimension Antholt invokes is a result of a masterful control of value. A deep space and carefully modulated values set the stage for a contemplative response.

PROBLEM 4.9
Using Value to Describe Space

Focus on a spatial progression in a drawing that has three distinct levels of space: foreground, middle ground, background. Keep in mind that you are trying to describe a deep, illusionistic space. For your subject, arrange

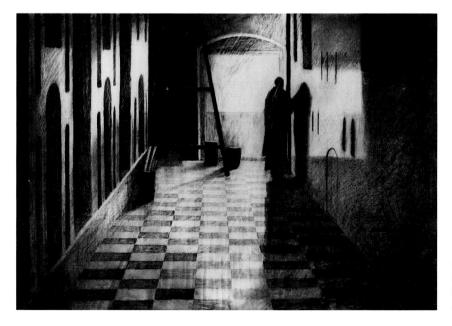

4.31. SHARRON ANTHOLT. *Tracing a Stranger Self.* 1988. Charcoal on paper, 3'3" × 4'8" (99.1 cm × 1.422 m). Courtesy of the artist.

objects on a desk into three distinct levels of space. Think of them as monumental objects in a landscape setting. Exaggerate the scale of the various objects in order to create a deep space. Assume a low eye level rather than looking straight down onto the objects; this will help deepen the spatial field.

Manipulate the lighting to cast strong shadows; long, raking shadows can lend an air of mystery. You might imagine the scene as taking place at night, so that the space behind the objects and beyond the desk will be dark and atmospheric. Keep in mind a progression of values either from light to dark as the objects extend into space, or from dark to light as they meet the horizon, the edge of the desk. Try to establish a mood through your use of space and through your selected value range. Aim for a gradual transition of values. Before you begin to draw, spend several minutes looking at the objects, and in your mind's eye transform them to objects in a landscape. This concentration will provide an imaginative beginning for the drawing.

EXPRESSIVE USES OF VALUE

The most exciting aspect of value is its use as a forcefully expressive tool. You have read about the principles of value, the observation of natural appearances, and the way this observation can help you use value. Your attitude as an artist and your intellectual and emotional responses are the primary determinants of how you use value. Actual appearance can be subordinated to expressive interests. Value is a strong determinant in the depiction of emotions. An example is pathos. Striking contrasts of light and dark help to achieve the special *angst* of Howard Warshaw's *Red Man* (figure 4.32). Fluid lines and layered washes envelop the somewhat transparent form.

Warshaw's expressive style contrasts with Ellen Soderquist's gently modeled figure (figure 4.33). Here the white paper sets off the tonal gradations of natural light on the smooth skin of the model; the controlled modeling results in a classical detachment. The artist's sensitive eye and confident drawing technique encourage the viewer to inspect the forms closely. A limited high-value range is used for describing minute anatomical detail; especially important is the white space surrounding the figure. The outer edge of the torso from armpit to hip is implied; the white negative space crosses over into the positive form. By this subtle device, a conceptual contrast is established. Even though the negative space is empty, we interpret the space surrounding the hand to be a deeper space than the space adjacent to the hip. Soderquist's drawing is a good example of the issue of figure/ground relationship. One of the distinguishing characteristics of drawing is the way the paper surface, or developed atmosphere of a drawing, becomes the space out of which the image emerges or, as is the case with the Soderquist drawing, dissolves.

Review the illustrations in this chapter and analyze how value has been used as an expressive element in each drawing. There are as many expressive uses of value as there are felt expressions. It is up to the artist to determine mood and content and how best to use value to convey intent.

A final look at the way value can create mood is through the use of *value reversal*. This technique creates unusual spatial effects. In Dmitri Wright's stencil print (figure 4.34), the emphasis shifts from the positive to the negative in a series of double-takes. The work has the look of a photographic negative.

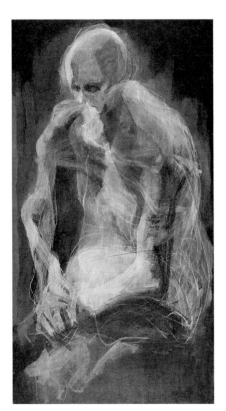

4.32. HOWARD WARSHAW. *Red Man.* 1967. Acrylic on paper, 5'5" × 3' (1.65 m × 91 cm). Courtesy Francis Warshaw, Carpinteria, California.

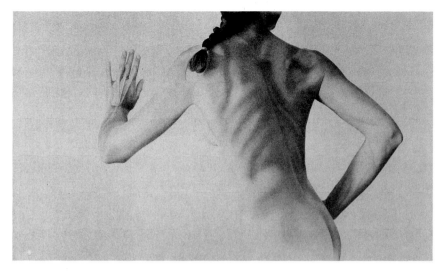

4.33. ELLEN SODERQUIST. *Fragment I: She Went This Way.* 1982. Pencil on paper, 2'7" × 4'5" (78.7 cm × 1.346 m). In the collection of Joel and Wendi Holiner, Dallas. Courtesy of the artist.

Reverse values and spatial dislocation contribute to a feeling of loss or emptiness. As a base for the stencils, Wright has used a blueprint that you can see through the transparent figures. The blueprint's geometric shapes and words lying behind the figures and implements create a second level of space that further enhances and complicates the interpretation of the work. Space has been mysteriously reversed; commonplace objects have become ghostlike and supernatural. We are presented with an eerie vanishing act. It is interesting to unravel Wright's technique. It appears that he has cut out stencils and, along with real objects, has placed them on the blueprint. By airbrush or spray he has created a "memory" of the original objects. As a result of the sprayed paint, a halo encircles the shapes, further contributing to the idea of absence and loss. Wright uses an odd assortment of implements in his composition. What could be their relationship to the heart on the string in the central figure?

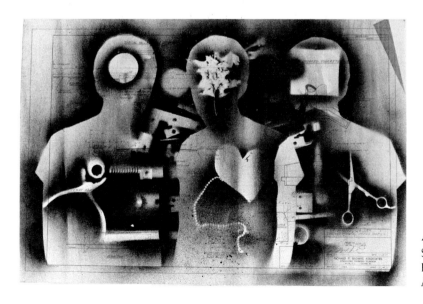

4.34. DMITRI WRIGHT. *Untitled.* 1970. Stencil print, 1'11" × 3'1⁄8" (61 cm × 92 cm). Brooklyn Museum, gift of the artist. Acc. 74.183.

PROBLEM 4.10
Value Reversal

Using a subject of your choice, make a drawing in which the value patterns are reversed. Use stencils or actual objects and spray paint, or draw on a found surface or toned paper. A colored paper, gray, tan, or black would work well with a white medium such as conté, crayon, chalk, pastel, or white ink. This is a good problem for mixed media; use both spray paint and drawing media in the same drawing. Think in terms of reversing values, using white for black. You can achieve a range of whites by layering washes or by varying the amount of pressure placed on the drawing tool. Try for the effect of a photographic negative, as in the Wright stencil print.

PROBLEM 4.11
Value Used Subjectively

In this project, make a series of related drawings in which you subordinate visual appearances to emotive content. Project a strong feeling onto your subject using a value pattern that will underscore your attitude. Draw from your imagination, choosing a subject that is emotionally charged, toward which you have strong feelings. Mythic themes are a good source for drawings with expressive content. You can combine recognizable imagery with abstract shapes using value to tie the forms together. Dark, heavy marks create emphatic statements. You may abrade the surface by erasure, smearing, or smudging. Look through the text to find drawings that elicit strong feelings. Note especially how value contributes to their expressive content.

In his intimately scaled and sensitively drawn watercolor (figure 4.35), Michael Flanagan promotes a lyrical feeling using toned paper with bands of washes (darker on ocean floor and sky, lighter in the center portion of the drawing), over which he imposes a delicate line drawing of three images—man, fish, and boat. The subtly drawn figures of man and fish seem at home in their gently washed background space. The ocean's silence is reinforced by the symbolic use of pale washes. Both action and quiet attention seem to be contained in that silence—the twisting action of the fish and the respectful attitude of the man holding his hat while attending the fish's performance.

A subtle, conceptual, spatial change is effected by the slight separation of the two parts of the picture plane. We read the smaller upper segment to be above water whereas the larger lower section seems to be underwater. The tiny sailboat that appears in the upper segment is a double spatial indicator: It represents a distant space and it appears to be floating on the surface of the water against a high horizon line, thus suggesting that the larger segment is taking place on a lower level, closer to the viewer, on the ocean floor. We therefore seem to be witnessing an underwater, or better said, metaphorical, interior event.

Poems or song lyrics can provide ideas for this project.

4.35. MICHAEL FLANAGAN. *Ocean Silence.* 1980. Watercolor and pencil on paper, 10⅞″ × 8½″ (28 cm × 22 cm). Arkansas Arts Center Foundation Collection; the Museum Purchase Plan of the NEA and the Barrett Hamilton Acquisition Fund, 1981. 81.24.

PROBLEM 4.12
Value Used to Create a Nonobjective Drawing

In this project, use value to create abstract, nonobjective shapes. Use the same media and techniques in a series of related drawings. Read all of the instructions for this problem before beginning.

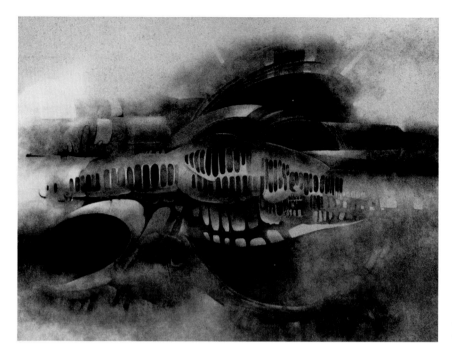

4.36. LEE BONTECOU. *Amerika.* 1966. Pencil and charcoal, 1'7¾" × 2'3⅛" (50 cm × 69 cm). Albert J. Pilavin Collection, Museum of Art, Rhode Island School of Design.

We have seen that drawings dealing with non-recognizable subjects need not lack in expressive content. Formal development does not rule out a subjective approach. Use simple, repeated, related abstract shapes as your subject. Make the forms occupy an illusionistic space. Using a shift in scale, overlap, and value, establish a foreground, middle ground, and background. In spite of the image being nonobjective, create an illusion of volume. You can use smudging, rubbing, and erasure to activate the drawing. Note: Areas of fingerprints seem right at home among other values. Aim for an interesting textural surface. Depending too much on rubbing to control value transitions is not a good idea; you need to learn to create value changes with the medium with which you are working. Rubbed values have a textural quality that is not interesting. The immediacy of the medium and the way the artist controls it gives a freshness and spontaneity to a drawing that rubbing cannot. Rubbed areas in drawings can create a textural contrast if used discriminately.

In her abstract drawing (figure 4.36), Lee Bontecou has used a simple ovoid form that she enlarges and reverses from white to dark. Image, scale, and structure combine to give her work its essential powerful character. Larger shapes loom behind the smaller ovoid forms in the foreground. Small, repeating elongated ovals resemble openings. They even transform to what looks like a row of teeth. It is as if we are looking into the mouth of a monstrous space insect. Convex and concave shapes activate the spatial tension in the work. Cavities, voids, sockets, and valve-like forms suggest the workings of an animated machine. Differing values of light and dark encompass the forms that weave through the eerie space. Bontecou is known for her three-dimensional work, assemblages made of found materials such as iron, welded steel, canvas, zippers, rivets, small machines, and other war surplus materials. Her sculptural reliefs make reference to images of violence and destruction along with organic overtones, allusions to the processes of growth and transformation.

Bontecou's abstract images in her drawings are variations on the theme of the found images in her sculpture.

Washes made by turpentine and pastel can produce gradual value transitions. A reminder: The viewer is led through the picture plane not only by value patterns but by the attraction of like shapes, as in the Bontecou drawing.

Since this is to be a related series of drawings, you will be working in the same style and medium, using a similar vocabulary of shapes, lines, textures, and values. Compositionally, shape, placement, size, or scale should vary from one drawing to the next. Before undertaking this set of drawings you should complete the Sketchbook Projects found at the end of this chapter. Also read "Summary: Spatial Characteristics of Value," which follows.

SUMMARY

Spatial Characteristics of Value

Of all the art elements, value has the greatest potential for spatial development. When value defines light, structure, weight, or space, it is being used three-dimensionally. A combination of these approaches may result in ambiguous space.

If more than one light source is used, each source may cancel volumetric qualities revealed by another. As a result, the drawing may have a sense of ambiguous space. A combination of flat value and modeled value also produces ambiguous space.

Flat patterns of light and dark confined within a given shape make the space seem shallow. Uniform lines within a shape keep the shape flat. In the same way, a uniformly textured surface pattern has a tendency to flatten.

On the other hand, volumes with gradual transitions from light to dark are seen as three-dimensional. When value defines the edges of planes and these planes behave according to the rules of perspective, the resulting space is illusionistic. Movement from the foreground in a stepped progression of value planes produces a three-dimensional space. Irregular lines used to build lights and darks make a drawing more dimensional than do uniform patterns of line.

SKETCHBOOK PROJECTS

Now is a good time to begin using the sketchbook for *thumbnail sketches*, preparatory drawings in which you jot down ideas and options for final drawings. This practice is an economical one: It saves you time, materials, effort, and, additionally, it serves as a memory bank for ideas that come at odd times when you are out of the studio. Often these inspirational jolts are the most valid ones, so having a record of them can be a great help.

PROJECT 1
Using Thumbnail Sketches

As in Sketchbook Project 1 in chapter 3, you should draw several differently proportioned formats or picture planes for your compositional ideas. Quickly note both visual and verbal ideas; for example, if you do not

have colored media handy, you might write some descriptive words concerning the color or set of color or value relationships that will revive your memory later. Visually indicate the placement of various elements; try several compositional arrangements. When you have settled on one or two that particularly appeal to you, develop them further.

At this stage you are not interested in details; it is the broader, more general issues that concern you. (This is not to suggest that details cannot be isolated and developed in your sketchbook: The sketchbook is expansive enough to hold all sorts of ideas, big and small, important and trivial. All could be helpful at some later date.) Do not, however, expend all your creative and imaginative energies developing the drawing in the sketchbook. Learn when to stop and move on to the more involved drawing, but don't bypass the vital initial stages of compositional juggling and visual thinking.

A look at some thumbnail sketches by Piet Mondrian will be instructive in seeing how visual ideas develop. Mondrian, an early Modernist (1872–1944), was absorbed with the reduction of the image to its barest essentials (figure 4.37). He aligned the basic elements of flat areas of pure color and geometric forms along a strict horizontal and vertical axis (see figure 1.34). For Mondrian this venture into reductive forms was not simply a Modernist design exercise; it was rather a mystical search for the Absolute. He regarded abstract art as prophecy of an ideal social order.

In the quick sketch shown here, the rigidly straight lines of his paintings are rendered in freehand squiggles to indicate broad, flat color shapes. Mondrian continued to search throughout his career for the perfect composition in which no single element asserts itself over the others, a visual manifestation of his hope for a utopian, egalitarian social order in which no group dominates.

4.37. PIET MONDRIAN. *Composition.* c. 1925. Pencil on paper, 8¾″ × 11⅝″ (22 cm × 29.5 cm). Arkansas Arts Center. Stephens Inc., Little Rock. © 2003 Mondrian/Holtzman Trust/Artists Rights Society (ARS), New York.

PROJECT 2
Applying Thumbnail Sketches to Actual Subject Matter

Working on site and using landscape as subject, make a series of thumbnail sketches. Concentrate on reducing the composition to simple value shapes. Use no more than three or four values. Squint your eyes to assess the actual landscape subject. This helps you see the larger shapes and most prominent value patterns. After you have made four or five quick thumbnail sketches, make another series of sketchbook drawings in which you juggle the elements in relation to the size and shape of the format, such as a horizontal rectangle, an oval, a square, a tall rectangle, a diptych, or two-part format. This exercise is one that should be regularly employed, whatever your subject matter. The size and shape of the picture plane is a decisive one in any work of art.

COMPUTER PROJECT

PROJECT 1
Converting Color to Value

The appropriated image is one that is taken from another source and recontextualized; that is, used in a different context or setting. Appropriation is a distinctive feature of Post-Modern art, so you will be right in the

mainstream with this project. Images to be used for sketchbooks, collage, and other drawing projects can easily be found in such sources as family photographs, magazines, old books, newspapers, postcards, and posters, all of which can be inexpensively purchased at used book stores, or even found at no cost. Another source for images is the Internet; many personal computers come with encyclopedias that have illustrations; or clip-art software can be purchased or even found free on the Internet. Images from printed material can be scanned into the computer. Once in your computer system, all of this imagery can be accessed, manipulated, and printed for your own art purposes. This resource material can serve as a physical base for your drawings or to use in making collages. You can draw on old letters or on paper from old ledgers, for example, and then scan and print the drawing on new paper if you have access to a good quality printer; otherwise, you can have both colored prints or black-and-white copies made at a copy center. You should always opt for the best quality paper in your reprints.

Using Adobe Illustrator, find a color image that has a full range of values. Choose an image that holds particular interest for you, such as a reproduction of an old masters painting, a favorite postcard, or a photograph of family or friends. Before finally settling on which image to use, search the Internet and your computer's picture files—many computers have image files ready to use for screensavers or other uses. This exercise can be done in a number of programs. Import the selected image into the desired program.

1. Print an unmanipulated color version to keep as a reference.
2. Go to the color control for the particular program in use. In Adobe Illustrator color control is in the *filter* pull-down menu. Convert the color image to *grayscale*. This will reduce the image to a range of blacks, whites, and grays. Print this version. Notice how some detail has disappeared because certain colors and tonalities are the same value. (Remember the exercises done earlier in this chapter where value crosses over objects and negative space? Keep in mind that values need not be confined to an object; they can begin and end independently of an object. This will be apparent in the color conversion you have just done.) The computer has replaced the function of intense looking and decisionmaking in transforming color to the black and white value scale.
3. Experiment with the color and value controls in your program; create several variations on the value theme. Lighten and darken the image, changing the range of values. Reverse values; in Adobe Illustrator this is done under *filter>color>adjust color>invert color.* Midvalues can be changed to darker values, and the image can easily be reduced to two values—black and white, or any other two values on the value scale you choose. Print all your experiments and add to your computer drawing file.

Even though the computer has done all the hard work in this project, you should learn from careful comparison of the original color source and the converted image how to see color as value. It will stand you in good stead not only in drawing but in painting and design as well.

Line

Between a line and a smudge lies a bridgeable gap, a shift of the eye.
A line is a trajectory; too close or too far, too slow or too fast, it's a smudge and a blur.
A smudge is a trace of what was or is to come. But a line is here.
MAY STEVENS

Line drawings are the most elemental and purest form of drawing. They can convey elegance or raw energy, poignancy or exuberance, outrage or wit; they can be rude or polite. Drawings are like graphs; they can track the artist's physical and mental energies as in the drawing by Gordon Matta-Clark (figure 5.1). As described by critic Ken Johnson, "Matta-Clark focused on existing architecture as a medium for large-scale, site-specific carving. Working on derelict buildings, he performed more or less elaborate surgical procedures. . . . [H]e 'drew' through the fabric of a building, cutting rhythmic curvilinear shapes out of rigid horizontal and vertical planes, admitting lyrical patterns of light" (Ken Johnson, "Playful Deconstruction of Urban Space," *New York Times,* July 24, 1998, B36). Matta-Clark converted the ugly, the discarded, and the unused to artworks, invigorating them with a new aesthetic. Although he died prematurely in the late 1970s, he is still cited as one of the forerunners of Conceptualism. He was an avid draftsman,

5.1. GORDON MATTA-CLARK. *Untitled (Energy Tree).* 1972–1973. Ink. Photo: P.S.I. Contemporary Art Center, Long Island City, Queens, NY. © 2003 Estate of Gordon Matta-Clark/Artists Rights Society (ARS), New York.

leaving more than 840 notebooks of "anarchitectural" (his term) projects and drawings.

In figure 5.1 we can imagine that the line is cut into the paper and that its energy spirals out to encompass us. Matta-Clark did, in fact, make incised linear drawings out of stacked paper, into which he delineated the same shapes he cut through floors of buildings. The artist put into action the function of line, what the critic Barry Schwabsky defined as "the virtual 'cut' that carves a volume out of the inchoate matter of the ground" (*Art on Paper,* Sept.–Oct. 1998, pp. 66–67).

Line is the element most associated with the graphic arts. The installation artist Ann Hamilton, whose work frequently deals with threads and weaving, describes the relationship between a thread and the written or drawn line: ". . . it's about the origin of things, about a really fundamental act of making" (Storr et al., *Art: 21,* p. 17). Line is valued both for its simple reductive power and for its expansive potentiality for embellishment. Of all the elements it is the most adaptable. Drawing is open-ended and experimental, an ideal discipline for formative thinking and for idea generation, and line is most often the means to uncovering new ideas and motifs. Line can be put to analytical use; it is a means to converting abstract thinking into visual form.

Line can be an economical indicator of space; it is a key element in establishing the relationship between the surface of the paper and the emerging or dissolving images on it. No better means can be used for translating the world of three dimensions into one of two dimensions or to translate a line of two dimensions into one of three dimensions. The Chinese-born artist Niu Bo uses skywriting planes to draw linear forms in the air over well-known monuments such as the Statue of Liberty. Although our experiments with line cannot be as extravagant as one drawn in the sky, we can put line to a playful use—everyone enjoys doodling.

John Alexander's drawing is an unorthodox compilation of images and ideas. His allegorical conflicts are set in the swamps of East Texas. The hyper-

5.2. JOHN ALEXANDER. *Birds of a Feather.* 1981. Ink on paper, 1′ × 1′2″ (30 cm × 36 cm). Courtesy of the artist.

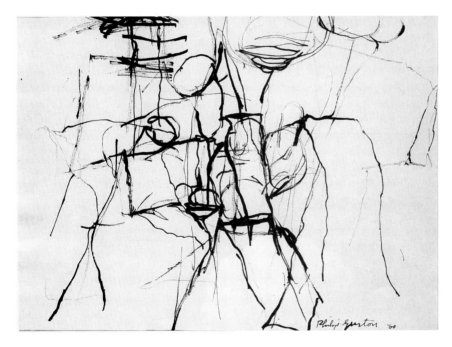

5.3. PHILIP GUSTON. *Untitled.* 1960. Ink on paper, 1′6″ × 2′ (46 cm × 61 cm). Stephens Inc., Little Rock. © eeva-inkeri.

active forms come from a mind and hand bursting with energy (figure 5.2), whereas Philip Guston's drawing uses line to communicate ideas and feelings without reference to recognizable imagery (figure 5.3). The kinetic marks have a somewhat disquieting physical presence; they are in an uneasy equilibrium with each other. The force and directness with which they are stated make them appear to be crowding against one another, pushing and pulling at the same time. We can sense the physical movement that went into their making, at times tentative, at other times assertive, feeling around the space, moving both laterally and in depth from back to front.

You have had considerable experience already in using line in problems in the preceding chapters. You have used gestural line, structural line, organizational line, analytical measuring line, directional line, outline, scribbled,

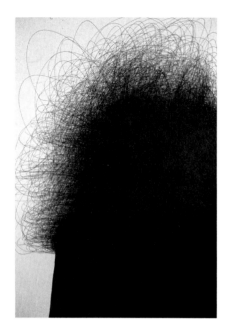

5.4. IL LEE. *Untitled #9616.* 1996. Ballpoint pen on Arches paper, 2'5¾" × 3'6" (75.6 cm × 1.067 m). Courtesy of Art Projects International (API), New York.

tangled, and wrapping lines, continuous overlapping lines, automatic lines, crosshatched lines, and lines grouped to make value. This chapter deals with line quality, with the ways line can be used both objectively and subjectively as a carrier of meaning.

DETERMINANTS OF LINE QUALITY

A first step in becoming sensitive to line is to recognize the inherent qualities of various linear drawing tools. Although materials sometimes can be made to work in ways contrary to their nature, recognizing the advantages and limitations of a medium is an important first step in learning to draw. From everyday experience we are acquainted with some linear tools that move effortlessly to create line: pencil, felt-tip marker, ballpoint pen, and pen and ink. We have used some media that produce a grainy, abrasive line: charcoal, chalk, and conté crayon. China markers and lithographic pencils contain grease and can easily be smudged or dissolved. (See Guide A on materials for further discussion of drawing media.)

Using humble, ordinary media does not necessarily diminish the impact of a drawing, as can be seen in the ballpoint drawing by the Korean artist Il Lee (figure 5.4). The dense mass created by compiling line upon line results in a simple shape. The slow process of creation is conveyed by the density of the tangled, overlapping lines. The wispy lines that have escaped the confines of the weighted form are testament to the gestural activity disguised in the lower part of the drawing. The shape with its aura of spiraling energy reminds us of the activity of the sun, a cosmic force held in by a creative mind.

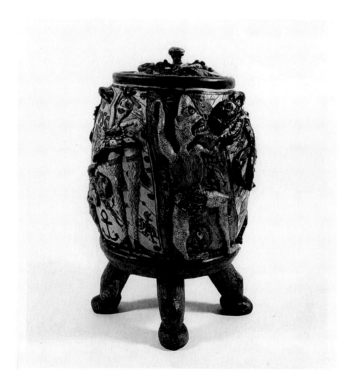

5.5. MICHAEL GROSS. *Be Smart, Buy Art.* 1986. Stoneware with slip and molded decoration, 2'6" × 1'1½" diameter (76 cm × 34 cm). The Arkansas Arts Center Foundation Collection. The Decorative Arts Museum Fund, 1986.

The surface on which a line is drawn is another strong determinant of the quality of that line. The character of an incised line, one scratched into a surface, is different from a drawn line, and a drawn line on paper is different from one on clay, as can be seen in figure 5.5. Michael Gross's all-over designs are not preplanned; he explains, "I'm driven to minute detail, like covering surfaces with tiny ghosts, skulls, ticks. . . . Whatever is working in my subconscious is what you'll see" (Wolfe and Pasquine, *Large Drawings and Objects*, p. 104). Gross's seemingly naïve modeled shapes and incised line make for a highly tactile surface in keeping with his zany subject matter.

Lines can be created in experimental ways, as seen in the installation created by a tangled environment of lines by Cathleen Lewis (figure 5.6). The work is called *Extensions (Ethnic Signifiers)*. The word "extensions" refers to hairpieces, and the title in parenthesis refers to the ability of hair (through color and texture) to relay information identifying a person's ethnic origin. Lewis has wrapped thin millinery wire with synthetic hair of various colors and textures; the cursive quality of the wires is a result of their being shaped to spell out descriptive terms for hair, although the words are not easily decipherable. Lewis's work is an example of how hidden intent and meaning can be in a work of art; without "program notes," or without reading the press release accompanying the installation, the viewer would, no doubt, interpret these loops, squiggles, coils, and knots as gestural lines in space.

Line quality is affected by the surface that receives the mark as well as the tool that makes it, so it is important to learn to assess both implement and surface. It is difficult, for example, to make a clean, crisp line with pen and ink on newsprint because of the paper's absorbency. On the other hand, good use can be made of ink on wet paper when it is in keeping with the artist's intent, as in Paul Klee's whimsical drawing of a fishing scene (figure 5.7). Here the dampened paper has caused the ink lines to bleed, and a rather scratchy, yet

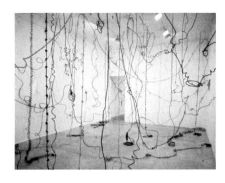

5.6. CATHLEEN LEWIS. *Extensions (Ethnic Signifiers)*. 1995. Synthetic hair and millinery wire. Dimensions variable. Photo courtesy of CRG, New York.

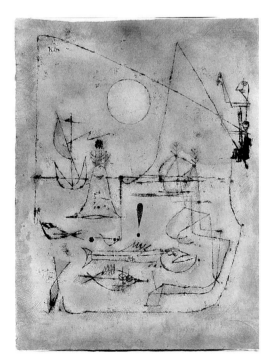

5.7. PAUL KLEE. *They're Biting.* 1920. Pen and ink and watercolor on paper, 1'1¼" × 9¼" (31 cm × 23.5 cm). Tate Gallery, London. 5658 © SPADEM. © 2003 Artists Rights Society (ARS), New York/VG Bild-Kunst, Bonn.

5.8. GEORGE GROSZ. *Exploiters of the People* from the series for *The Robbers* by Friedrich von Schiller. 1922. Photolithograph. 2′2⅜″ × 1′6⅜″ (67 cm × 47 cm) (sheet); 1′7⅛″ × 1′2¾″ (49 cm × 37 cm) (image). Print Collection, Miriam and Ira O. Wallach Division of Art, Prints, and Photographs, New York Public Library, Astor, Lennox, and Tilden Foundations. 83.9. © Estate of George Grosz/Licensed by VAGA, New York.

fragile, line quality is the result. The wet medium supports the water theme. Klee, a teacher at the Bauhaus in the 1920s, wrote a short text entitled *Taking a Line for a Walk,* and he did just that in his prolific art production. He is well known for his distinctive line quality and for the incorporation of line into his paintings.

The British painter Bridget Riley notes that "Klee was the first artist to point out that for the painter the meaning of abstraction lay in the opposite direction to the intellectual effort of abstracting. It is not an end, but the beginning. Every painter starts with elements—lines, colors, forms—which are essentially abstract in relation to the pictorial experience that can be created with them" (quoted in Alan Riding, "The Other Klee, the One Who's Not on Postcards," *New York Times,* March 10, 2002, Art/Architecture 22). Klee's interest was line itself. He wrote, "The original movement, the agent, is a point that sets itself in motion (genesis of form). A line comes into being. It goes out for a walk, so to speak, aimlessly for the sake of the walk" (ibid.). In studying Klee's work one finds ample proof that the strongest determinant of line quality is the sensitivity of the artist. An artist's linear style is as personal as handwriting; just as we are able to identify a person's handwriting, familiarity with the artist's style makes the work identifiable.

Other major determinants of line quality and drawing style are the times and societies in which we live. This is most apparent in the works of artists who deal with social commentary, such as George Grosz, a savage satirist of the social conditions in Germany during World War II (figure 5.8). His powerful visual indictments make use of exaggerated lines to convey incisive commentary. Grosz's linear style is the carrier of his passionate convictions.

There are no heroes in Grosz's work. His caustic accusations are conveyed by his crabbed line. The dominant "willful possessors" fill the composi-

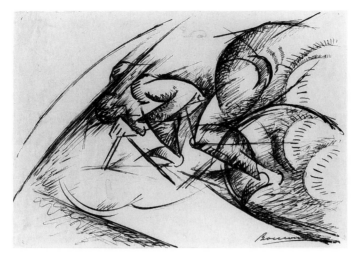

5.9. UMBERTO BOCCIONI. *Study I for Dynamism of a Cyclist.* 1913. Ink wash and pencil. 8 1/16″ × 1′ (21 cm × 31 cm). Yale University Art Gallery; gift of Collection Société Anonyme. © Joseph Szaszfai, 1941.354.

tion, crowding out the common people. Disparity in size (note the difference in scale between the crippled veteran and the bankers in the foreground) and disparity in line quality (in the depiction of the "bad guys" and "good guys") are extreme. The child is insubstantial; the table edge cuts through its foot, rendering its form transparent. The regimentation of society is shown in the geometric, severely ordered cityscape. Even the background figures are statically placed along a horizontal-vertical axis. The idea of a world gone askew is reinforced by the angularity of the three figures at the table. Grosz's subjects do not invoke sympathy; indeed, he presents them for condemnation. Grosz said of those years, "I felt the ground shaking beneath my feet, and the shaking was visible in my work." Grosz's quaking line is the identifying characteristic of his drawings.

The technology of a given period exerts influence on contemporaneous drawing style and line quality. Many artists have recognized the relationship between art and technology as a major issue in their work. Pablo Picasso and the Cubists, the Italian Futurists Umberto Boccioni, Giacomo Balla, and Gino Severini, the Soviet avant-gardes Vladimir Tatlin, Naum Gabo, and Pavel Filonov, and the American artists Robert Rauschenberg and John Cage are only a few twentieth-century innovators whose work used technology as a springboard.

Early in the century, members of the Soviet avant-garde were products of modern scientific thinking; they were particularly influenced by new discoveries in biology, in the microscope, and in X-ray technology.

The Italian Futurists were dedicated to putting into practice the ideas promulgated in their *Technical Manifesto.* In 1909, the sculptor Medardo Rosso proclaimed, "The movements of a figure must not stop with the lines of contour . . . but the protrusions and lines of the work should impel it into space, spreading out to infinity the way an electric wave emitted by a well-constructed machine flies out to rejoin the eternal force of the universe" (Rye, *Futurism,* p. 27). New ideas in physics were quickly claimed by the Futurists. Light and speed took precedence over solid, static material forms.

Boccioni developed a means to express the group's "new absolute, velocity" in his innovative style, which can be seen in *Study I for Dynamism of a Cyclist* (figure 5.9). The abstracted figure merges with the bicycle and becomes one

5.10. VICTOR NEWSOME. *Untitled.* 1982. Pencil and ink on paper, 1′1½″ × 1′5¼″ (34.3 cm × 43.8 cm). Arkansas Arts Center Foundation Purchase, 1983. 83.9.

with the machine itself. Lines, which the Futurists called "force lines," convey the idea of speed and space, which so fascinated these artists. What a sharp contrast their mechanistic worldview is to the naturalistic view of the nineteenth century!

Just as scientific discoveries early in the century affected art styles, in today's world the computer explosion certainly has had an equal effect on art. On a daily, even hourly basis, we are bombarded with computer-generated graphic images; it is no surprise that artists have exploited this new technology. Victor Newsome's gridded drawing of a head (figure 5.10) is an example of such influence. Unmistakably a contemporary drawing, its lines resemble those generated by a computer; the grid lines themselves are another reference to a mechanically generated surface. The line quality derives from technological influence.

LINE IN OTHER ART DISCIPLINES

Another contemporary art phenomenon determining line quality is the relationship drawing shares with the other disciplines of art—painting, printmaking, sculpture, and photography. Drawing, especially the linear element, extends to other disciplines and other media. It is perhaps commonplace to say how the distinctions among the various art disciplines have been blurred. The very marks that define drawing are now incorporated into work by sculptors and photographers.

In Bernar Venet's sculpture, the welded steel elements are presented in linear form; the drawings are exact replicas of the sculptures. (Or the sculptures are exact replicas of his drawings.) Venet exhibits drawings and sculptures as companion works (figure 5.11). When one thinks of sculpture, one generally thinks of mass and solidity; Venet, in his linear strategies, confounds that expectation.

A final example of the parallel relationship between two art disciplines can be found in a combination photo-drawing by Ian McKeever (see

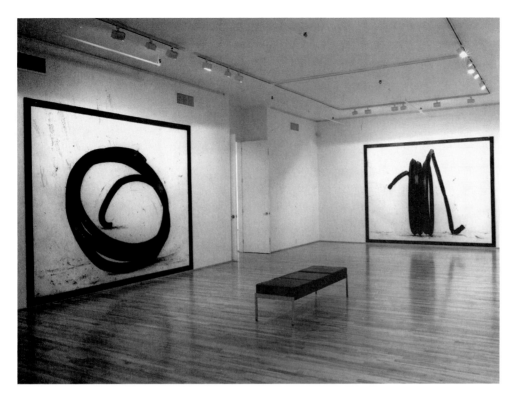

5.11. BERNAR VENET. *Indeterminate Line. Drawings.* 1990. Oil stick on paper, 9′ × 11′ (2.74 m × 3.35 m). Installation at Leo Castelli Gallery, NY. Photo: Leo Castelli Gallery, NY. © 2003 Artists Rights Society (ARS), New York/ADAGP, Paris.

figure 2.8). His work unites two different techniques in a body of work whose subject is the processes of erosion and rebuilding in nature. McKeever compares drawing and photography to the landscape itself in their ability to cover and uncover, to break down and rebuild. He notes that photography is closed whereas drawing is open; two opposite types of representation coalesce in his work, which presents a world in the process of change.

Artists from Paleolithic times to the present have left a rich storehouse of various types of line. In today's art a reinvigorated use of line has been introduced. Let us now turn to some uses of line peculiar to contemporary art.

LINE IN RECENT DECADES

Minimalist artists such as Sol LeWitt focus on reductive means. Their work is a "deflation" of art activity. Art is stripped down with a concentration on one or two of the elements that go into its making. LeWitt is particularly important to our discussion of line because his works are pared down to this prime element. His work has no literary focus; it is reductive, intellectual, and analytical in character. He, like other Process artists, establishes a procedure laying down rules for the execution of the art piece. He conceptualizes the organization of the work, then follows his own preset directions. We might call his finished pieces responses to simple commands. Artists such as LeWitt see this conceptualized approach as a viable organizational factor equal, if not superior, to traditional visual, pictorial means of composing a work of art. In Process art the viewer is able to re-create intellectually the process or action that

5.12. PHILIP GUSTON. *Untitled.* 1980. Ink on paper, 1′6¾″ × 2′2⅜″ (46.4 cm × 67 cm). McKee Gallery; collection of Mr. and Mrs. Harry W. Anderson.

went into the making of the work. Actually, anyone could carry out the instructions; the artist is not actually required to execute the work. The work is finished when the instructions have been carried out. LeWitt's wall drawings have a visual presence that is elegant in its clarity (see figure 4.16).

Artists who occupy the opposite end of the scale from the Minimalists come from the Neo-Naive, Bad Painting, and New Imagist styles. Such work is often characterized by crude figuration and expressionistic handling—they reject accepted norms of the "right" way to paint or draw. Philip Guston's drawings exemplify one approach; his images are drawn with an exact crudeness, a calculated dumbness, somewhat grotesque, but honest (figure 5.12). It is, in fact, their clunkiness and naïveté that elicits our response. The objects themselves are the accoutrements of his studio, personal symbols of the artist's struggles, and, as odd as it may seem, they are in dialogue with the art of the past over which Guston has such a command.

Guston had been involved in Social Realism in the 1930s, but turned to abstraction during the 1940s. In 1961–1962, he said he felt "the urge for images" (Dabrowski, *Drawings of Philip Guston,* p. 11). His belief that art should have a social message was the impetus to move away from abstraction. Iconographic motifs come from conversations, biographical events, and books. Guston said, "It is the bareness of drawing that I like. The act of drawing is what locates, suggests, discovers. At times it seems enough to draw, without the distractions of color and mass" (Dabrowski, p. 9). A self-taught artist, his blunt, crude line reflects his interest in the comic strip. In addition to giving life to a style that is now called New Figuration, he revived narrative content in visual art as well. Guston's work hailed art's move from Modernism to Post-Modernism. In his new figuration, the Klansmen are the main characters—

5.13. AL SOUZA. *Arc de Triomphe.* 1986. Oil on canvas, 1'10½" × 3'5" (57.2 cm × 1.041 m). Courtesy of the artist.

Guston calls them self-portraits—hooded, in the guise of a painter; they have an evil yet ambivalent identity. (Guston was very concerned with racial repression.) The artist was well aware of the many masked characters in art history, for example, in the work of Goya and Picasso.

Drawings such as Guston's offer a suggestion of what they are; it is the viewer's responsibility to sort through emotions and intellect and find meaning. Guston's method of work is revelatory; Guston's line quality is in tune with his subject matter, a sort of groping, uncertain search for personal meaning in his life. (See also figure 11.3.)

Line is an indispensable element, whether used abstractly, as in Guston's earlier drawing style (see figure 5.3), or to depict recognizable subject matter, as in the Post-Modernist piece by Al Souza (figure 5.13). A technique that has found much favor with Post-Modernist artists is that of overlaid images. In Souza's work *Arc de Triomphe,* we see three separate overlays: the golf players, the rocking chair, and a series of tree limbs. It is impossible to assign a definite location in space for all three layers, although the golf scene (which appears to have been appropriated from an older source) forms a field for the other images. The images are not integrated by color, style, or scale. This layering of images runs counter to traditional perspective ways of representing objects and the space they occupy; it is a strategy distinctive to Post-Modernism.

In the last two decades of the century, line seems to have been given an even more important role in artists' development of space. We have seen how adaptable line is in conveying ideas and how suited line is for generating intellectual and visual thinking. Now let us begin our investigation of the many types of line available to the artist.

TYPES OF LINE

We have looked at only a few of the many functions of line. In our study of line we will categorize some line types and learn to use them as well as recognize them in other artists' work. A reminder: An artist seldom confines the use of line to one particular type. This statement is attested to by William T. Wiley's humorous drawing (figure 5.14). Wiley, in his tongue-in-cheek drawing, even points out the role of line for an artist with a sign in the upper left of the drawing: "Suite out a line, sweet out a line" (Sweet Adeline). Wiley's works are filled with both visual and verbal puns. His dual roles as artist-magician and artist-dunce are underscored by his line quality.

Contour Line

In chapter 2 we discussed the two basic approaches to drawing: the quick, immediate, gestural approach that sees forms in their wholeness, and the slower, more intense contour approach. Contour involves an inspection of the parts as they make up the whole. Contour, unlike outline, is spatially descriptive. It is plastic; that is, it emphasizes the three-dimensionality of a form.

Juan Gris's *Portrait of Max Jacob* (figure 5.15) is a masterly example of contour; every line is fluently drawn. Slow and accurate observation is the key. The composition is subtly unified by a sidewise figure-eight shape; the clasped hands find their echoes in the bow tie and in the eyes. The form builds from

5.14. WILLIAM T. WILEY. *Mr. Unatural Eyes the Ape Run Ledge.* 1975. Colored pencil and wax on paper, 3′ × 2′4¾″ (91 cm × 73 cm). Collection Robert and Nancy Mollers, Houston. Walker Art Center, Minneapolis, Minn.

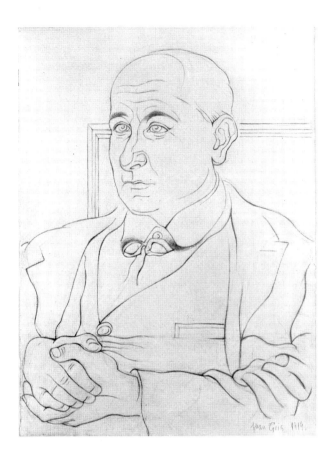 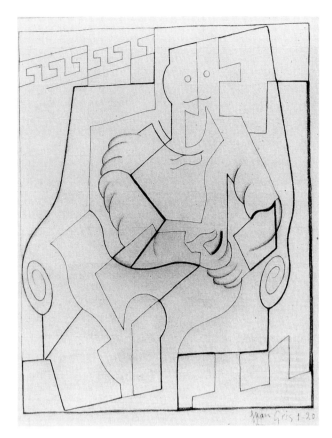

5.15. (above left) JUAN GRIS. *Portrait of Max Jacob.* 1919. Pencil, 1'2⅜" × 10½" (36.5 cm × 26.7 cm). Museum of Modern Art, New York; gift of James Thrall Soby. Photograph © 1997 The Museum of Modern Art, New York.

5.16. (above right) JUAN GRIS. *Personnage Assis.* 1920. Pencil on paper, 1'1½" × 10⅝" (34.3 cm × 27 cm). Arkansas Arts Center Foundation Collection, The Tabriz Fund, 1987. 87.47.2.

the hands to the head. The geometric framework of a background shape interrupts further upward movement. The lightly stated, sensitive curve of the head directs us back to the ears, where yet another set of curving lines leads us to the tie; the V of the vest points to the hands. We are again at our starting point.

Not only is the composition contained, we feel that the sitter himself is assured and self-contained. Contour line is used to describe change of plane, change of texture (between shirt, vest, coat, for example), change of value (note the ridge line of the nose), and change of color (between eye and pupil). This pure contour has been drawn with sensitivity and precision. Gris has used a contour of varying width. Heavier, darker lines create accents (usually where the line changes direction the mark is darker); lighter lines describe the less dominant interior forms.

Not all contour drawings are drawn from life, however. An interesting pairing with the portrait of Max Jacob is another Gris drawing, the abstracted, mental construct *Personnage Assis* (figure 5.16). In the first drawing Gris used intermittent dark lines; in the second one, the darker lines are not accents; in fact, they play the dominant role in the composition, and spatially they set up a series of interchanging foreground, middle ground, and background planes. It would be impossible to assess a definite location for nearly any shape in the drawing. It reminds us once again of that ever-present issue in the drawing: figure/ground relationships.

Five variations of contour line will be discussed: slow, exaggerated, quick, cross-contour, and contour with tone. The same general instructions given in chapter 2 for blind contour are applicable for all types of contour.

REVIEW: STEPS IN CONTOUR-LINE DRAWING

1. Use a sharp-pointed implement (such as a 2B pencil or pen and ink).
2. Keep your eyes on the subject you are drawing.
3. Imagine that the point of your drawing tool is in actual contact with the subject.
4. Do not let your eyes move more quickly than you can draw.
5. Keep your implement in constant contact with the paper until you come to the end of a form.
6. Keep your eye and hand coordinated.
7. You may begin at the outside edge of your subject, but when you see the line turn inward, follow it to its end.
8. Draw only where there is an actual, structural plane shift or where there is a change in value, texture, or color.
9. Do not enter the interior form and draw nonexistent planes or make meaningless lines.
10. Do not worry about distorted or inaccurate proportions; they will improve after a number of sessions dedicated to contour.
11. Use a single, incisive line.
12. Do not retrace already stated lines, and do not erase for correction.
13. Keep in mind line variation in weight, width, and contrast.
14. Keep the drawings open and connected to the ground.
15. Draw a little bit of everything before you draw everything of anything.

PROBLEM 5.1
Slow Contour Line

Using a plant or figure as subject, begin on the outside edge of the form. Where the line joins with another line or where the line turns inward, follow, imagining that you are actually touching the object being drawn. Exactly coordinate eye and hand. Do not look at your paper. You may only glance briefly for realignment when you have come to the end of a form. Do not trace over already stated lines. Draw slowly; search for details. Try to convey spatial quality through variation in pressure and in width of line. Make several drawings, spending as much as an hour on a single drawing. With practice, your drawings will become more accurate in proportion and detail.

If you find a particularly worrisome detail, move to another part of the paper and isolate an extended study of the problem area.

Line width and variation have been mentioned throughout the book. In a second drawing, experiment with different found implements, creating contour lines of various widths by turning the implement as you draw and by changing pressure on the implement. Keep in mind the spatial differentiation that comes from the use of thick and thin or dark and light lines. Note that a

line of varying width is generally more subjective than a line of maintained, or unvarying, width. Make two slow-contour drawings, one in which you keep the line the same all along its length, and another in which you vary the line. The manner in which an artist varies the line is very personal; the line quality will change from artist to artist.

PROBLEM 5.2
Exaggerated Contour Line

In the blind contour exercises in chapter 2 you were warned to avoid intentional distortion; however, exaggerated contour line takes advantage of these distortions, intentionally promoting them. It is the preferred technique of caricaturists, whose drawings make pungent or even poignant commentary on our cultural heroes. There is a long line of distinguished caricaturists, beginning in the modern period with Honoré Daumier. (Here is a historical fact that is surprising to us who are so accustomed to the conventions used by caricaturists: In the seventeenth century, the Baroque sculptor Bernini is said to have been the first to caricature such elevated figures as popes and cardinals. When descriptions of Bernini's drawings were first mentioned at court in Paris, the idea of caricature itself had to be explained since the genre was unknown in France. Today it is nearly a universal language owing to political caricatures in the news media.)

David Levine, the adroit cartoonist for *The New York Review of Books,* is an accomplished draftsman whose drawings depict the major cultural and political figures of our time. In figure 5.17, Levine depicts Clement Greenberg, often hailed as the most influential art critic in American history, in the costume

5.17. DAVID LEVINE. *Clement Greenberg.* Ink on thin board. Lescher and Lescher, Ltd. © 1975 by David Levine. Originally appeared in *The New York Review of Books.*

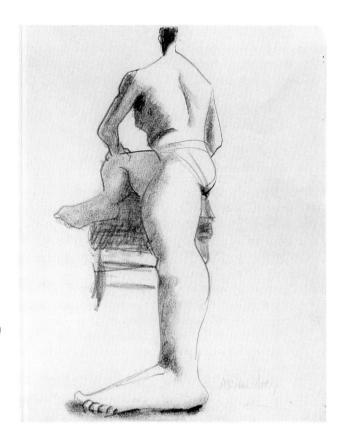

5.18. MILTON AVERY. *Untitled (Male Figure)* from *Eleven Provincetown Sketches.* n.d. Pencil on paper, 11″ × 8½″ (28 cm × 22 cm). Collection of the Modern Art Museum of Fort Worth; gift of Sally Michel Avery. © 2003 Milton Avery Trust/Artists Rights Society (ARS), New York.

of a pope. Not only is Greenberg shown as the ultimate arbiter of art and culture but Levine slyly points to Greenberg's near-religious fanaticism on the subject of modern art; in fact, "Greenbergian Formalism" and "Greenbergian Modernism" were bywords in critical writings on Abstract Expressionism during the 1950s and Color Field painting in the 1960s.

In Levine's caricatures, the scale of the head dominates the picture plane; the remainder of the body is drawn in a highly reduced scale. Certain salient features of the subject's physiognomy are also exaggerated. Levine captures the very essence of his targets' physical shape as well as their cultural roles.

In this exaggerated contour exercise we will reverse Levine's procedure by enlarging the lower half of the model's body and reducing the scale in the upper half of the figure. Your subject in this problem is a model standing or seated on a high stool. Lightly dampen your paper before you begin to draw. Use pen and ink. Begin by drawing the model's feet. Use a contour line. Draw until you have reached the middle of the page (you should be at knee level on the figure). Now you must radically reduce the scale of the figure to fit it in the remaining space. The resulting drawing will appear as if made from an ant's-eye view. There should be a monumental feeling to the figure. Milton Avery has employed this technique in his *Untitled (Male Figure)* (figure 5.18), using an extreme shift in scale from foot to head.

Note the different kind of line quality that results from the dampened paper. You will have a darker line along the forms where you exerted more pressure or where you have lingered, waiting to draw. This line of varying width is one you should intentionally employ from time to time.

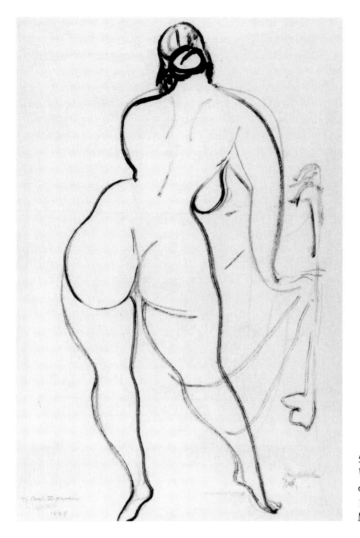

5.19. GASTON LACHAISE. *Back of a Nude Woman*. 1929. Drawing, pencil preparation, quill pen and India ink on brush wash, 1′5⅞″ × 1′ (45.5 cm × 30.9 cm). Brooklyn Museum of Art, Gift of Carl Zigrosser.

PROBLEM 5.3
Quick Contour Line

The quick contour line technique is a variation of basic contour drawing. It requires less time than the more sustained contour drawing, and you may look at your drawing more frequently than in a slow contour. The inspection of forms, however, is just as intense. Quick contour drawing might be considered a shorthand version of slow contour drawing. A single, incisive line is still the goal; however, the movement of the line is faster, less determined. In quick contour drawing you are trying to catch the essence of the subject.

In Gaston Lachaise's quick contour drawing (figure 5.19), the speed with which the figure was drawn is apparent. No more than a few seconds were required to make the sketch that is complete in essential information. Note the lines of varying width and how they serve as spatial indicators that would be absent in a contour line of maintained width. The line emphasizes the figure's repeating circular forms from head to hip; the body's masses are lyrically stated.

Make several quick contour drawings in your sketchbook and in your drawing pad. Experiment with scale, size, and different media. Keep in mind the importance of a single, informative line. Make multiple drawings of the same subject; combine several quick studies on a single page; make several single-page drawings. Alternate the time: 15 seconds, 30 seconds, 45 seconds, 1 minute, and 2 minutes are adequate lengths of time to make a quick contour drawing.

Your subject matter can be anything. Animals are good subjects for beginning quick contours. Simplify their shapes and try to capture the essence of their poses.

PROBLEM 5.4
Cross-Contour Line

Cross-contour lines describe an object's horizontal contours, or cross contours, rather than its vertical edges. They emphasize an object's turn into space. You are familiar with contour maps which describe the earth's land surface with their undulating lines that rise and recede. A quick look at an etching by Diana Jacobs will give you a visual definition of cross contour (figure 5.20). The warped center of the drawn weaving is made up of cross- and vertical contour lines. Isn't it amazing how little it takes to create a spatial illusion?

In chapter 4 we studied Henry Moore's air-raid shelter cross-contour drawing as an example of a technique for conveying weight and mass (see figure 4.22). In another drawing by Moore you can see that cross contours are particularly effective for learning to see the complex spatial changes that occur across a form (figure 5.21). Moore's lines are loosely stated, yet they economically map the contours of the elephants, even giving the suggestion that the charcoal lines "stitch" the animals to the supporting surface. Moore's familiarity with the underlying structure comes from his many drawings of elephant skulls. In this drawing, the cross contours give the elephants dimension so that they seem to be emerging from a dark space. The shapes are densely built from charcoal and chalk; the white chalk provides the highlights for this dramatic drawing.

5.20. DIANA JACOBS. *Event.* 2001. Etching, 2′6″ × 2′6″ (76 cm × 76 cm). Goya-Girl Press, Baltimore, Md.

5.21. HENRY MOORE. *Forest Elephants.* 1977. Charcoal, chalk on white heavyweight wove, 1′1¹⁄₁₂″ × 1′3⁷⁄₁₂″ (30.7 cm × 39.6 cm). Acquired by The Henry Moore Foundation.

Make a cross-contour drawing using a model as subject. Imagine the line as a thread that wraps the body horizontally, encasing its mass. Detailed studies of arms, legs, and front and back torso using cross contour are recommended. Combine several studies on a page, changing views from front to back to side. Refer to the Newsome drawing (see figure 5.10) to see how reductive cross and vertical contours can be teamed to build a three-dimensional illusion.

Cross-contour drawings of draped fabric will enhance your skills. Keeping your implement continuously in contact with the surface of your paper, carefully observe the drapery's folds and try to indicate its undulating shape. By grouping the cross-contour lines either far apart or close together, you can control the value changes across the form. You might lighten the lines for the forms that rise and use darker, grouped contours for the recessed folds of the fabric.

PROBLEM 5.5
Contour with Tone

After you have had some practice with contour drawing, you can add value or tone. Be selective in your placement of value. Don Bachardy's poignant drawing of his dying friend Christopher Isherwood (figure 5.22) is a good example of contour with tone. In fact, this drawing is a compilation of

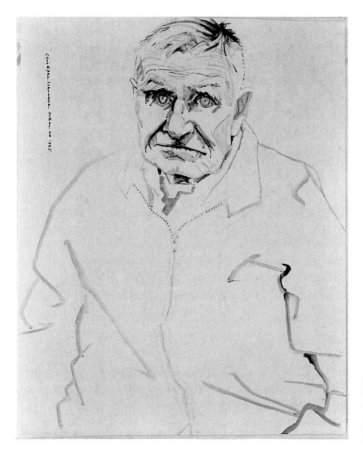

5.22. DON BACHARDY. *Christopher Isherwood, October 20, 1985.* Black acrylic wash on ragboard, 3'4" × 2'8" (1.01 m × 81 cm). Collection of the artist. Photo by Dale Laster.

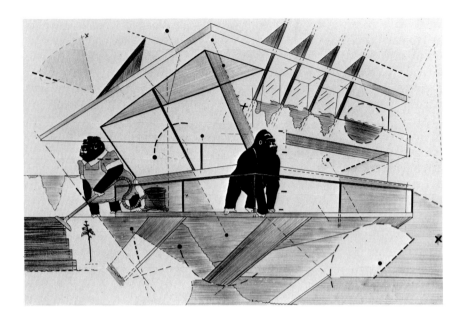

5.23. STEVE GIANAKOS. *Gorillas #10.* 1983. Ink and colored pencil on paper, 3′4″ × 5′ (1.02 m × 1.52 m). Barbara Toll Fine Arts, New York.

the various types of contour we have been discussing in the preceding exercises. Bachardy has used a pale line, a quick contour, to indicate the body's mass, slow and exaggerated contour to depict the sorrowful face, cross contour to convey Isherwood's wrinkled brow, and a limited value scale to heighten the facial features. The artist leads the viewer through the drawing with an economical use of value; three or four values are ample to convey a world of information and sympathy. This powerfully simple graphic document, quickly stated, emphasizes how fleeting life is. The faded line is symbolic of Isherwood's fading body and elicits an empathetic response.

Mechanical Line

Mechanical line is an objective, nonpersonal line that maintains the same width along its full length. An example would be an architect's ground plan in which various lines indicate different materials or levels of space. Steve Gianakos, who studied industrial design, uses a number of drafting techniques in his work (figure 5.23). The carefully plotted arcs and angles are a source of humor in the work; no doubt they are intended to make some tongue-in-cheek remark on architectural drawings. Gianakos has said that gorillas have a satirical, autobiographical significance for him. Note the mechanical application of line; each individual line is unvarying, deliberate, and controlled.

PROBLEM 5.6
Using Mechanical Line

Draw multiple views of an object—top, bottom, and sides—using mechanical line. You may keep the views separate, or you may overlap and superimpose them. Keeping in mind that mechanical line remains the same throughout its length, use a drawing tool that will produce this kind of mark, such as a pencil, felt-tip marker, ballpoint pen, or lettering pen. It would be

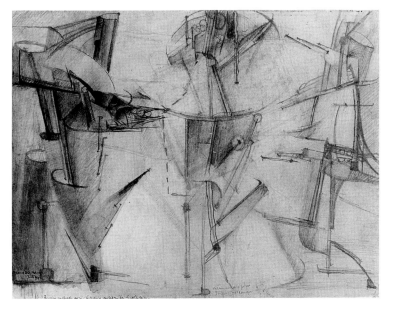

5.24. MARCEL DUCHAMP. *La Mariée Mise a Nu Par Ses Celibataires.* 1912. Pencil and wash, 9⅜" × 1'5⅛" (23.8 cm × 32.1 cm). Musée National d'Art Moderne, Paris. © 2003 Artists Rights Society (ARS), New York/ADAGP, Paris/Estate of Marcel Duchamp. Photograph Philippe Migeat, Centre G. Pompidou. © 1992 ARS, NY/ADAGP, Paris.

amusing to convert an unexpected object, such as a teddy bear or article of clothing, to a mechanical drawing.

Structural Line

Structural lines indicate plane direction and reveal planar structure. Structural lines build volume and create a three-dimensional effect. Although a drawing can be made using only structural lines, these lines are usually found in combination with either organizational line or contour line. Structural lines can be grouped and are then perceived as value. Structural line can also be put to more abstract use, as in Marcel Duchamp's pencil-and-wash drawing (figure 5.24). Here an idea of simultaneity and sequential motion is conveyed by the use of structural and diagrammatic line. Change, the recurring theme of this highly esteemed artist, is given graphic form.

PROBLEM 5.7
Using Structural Line

Make several studies from the figure using structural lines to indicate changes of planes, to create values, and to build volume. You can use parallel lines, cross-hatching, or grouped contour lines. Structural lines can be grouped and will then be perceived as value; they can be either angular or curved.

In the print by the Canadian artist Cecil Buller (figure 5.25), we see how suited structural line is to woodcut. The reduction of values to black and white and the interchange of white and black lines result in a spiritual and aesthetic work. Black line and closed contour are distinctive of French engravings of the 1920s and 1930s. The abstract patterning remains flat within a plane but the overall effect is one of interlocking volumes, both within the figures and in the print as a whole.

5.25. CECIL TREMAYNE BULLER. *Je suis à mon bien-aimé et mon bien-aimé est à moi, lui qui se nourrit parmi les lis.* 1929–1931. Wood engraving, 10¹¹⁄₁₂" × 7⁴⁄₉" (27.8 cm × 18.9 cm). Courtesy, The Montreal Museum of Fine Arts. Photo: The Montreal Museum of Fine Arts.

Use scratchboard for the drawing. Scratchboard is a clay-coated paper; its surface is made to be scratched into. Sharp implements make white lines. The final result will resemble a print, since the line looks chiseled. Find a variety of tools with which to make linear marks. Cut a 2-inch strip from the paper to experiment with various implements before beginning the drawing. You should make several quick drawings on paper before beginning the final drawing. Lightly transfer the basic shape of your composition onto the scratchboard before you start making the heavier incised structural lines.

Lyrical Line

Lyrical drawings have an intimate, subjective character and reflect a sensitivity of expression. We connect a certain exuberance with lyrical drawings. Lyric verse is akin to song, and its forms include elegies, hymns, and odes. The earliest ones were written to be accompanied by the lyre, from which the word *lyric* is derived. In art, lyrical lines are ornate, intertwined lines that flow gracefully across the page like arabesques.

Contour line and decorative line are frequently combined to create a lyrical mood. Lyrical drawings reinforce a mood of lightness and gaiety. Repeating curvilinear lines establish rhythmic patterns fitting for a relaxed theme.

Generally, the more deliberately controlled a line, the more objective it is. The more spontaneously a line is stated, the more subjective it is. Lyrical line falls under the subjective category and is characterized by sensitivity of expression.

Artists who are known for using lyrical, decorative line are Pierre Bonnard, Raoul Dufy, Edouard Vuillard, and that graphic master, Henri Matisse. Lyrical line and the drawings of Matisse are synonymous. In Matisse's distinc-

5.26. HENRI MATISSE. *Nude in the Studio.* 1935. Pen and ink, 1′5¾″ × 1′10⅜″ (46 cm × 57 cm). Location unknown. © 2003 Succession H. Matisse, Paris/ Artists Rights Society (ARS), New York.

tive pen-and-ink drawing (figure 5.26) the line flows effortlessly across the page. The white ground of the paper is activated by the forms that weave across the surface. Matisse's line is the manifestation of his wish to make art that is as "comfortable as an armchair." He effects a relaxed mood, and at the same time builds a compendium of spatial information. In fact, references to space reverberate throughout the composition. We see a model, her back reflected in a mirror in the background, a door to another space, another room, a window to an outside space, and in the lower-right-hand corner a shorthand description of the scene just described, an even more abstract handling of space than in the dominant composition—and a notation of the artist's hand holding a pen, a reference to another space. What a rich source of spatial ideas this single, seemingly simple, lyrical drawing contains!

PROBLEM 5.8
Using Lyrical Line

Choose a room interior as subject of a lyrical drawing. Create decorative linear patterns, using a free-flowing implement: either brush and ink or pen and ink. Try drawing while listening to music. The goal is spontaneity. Take a playful, relaxed attitude.

Constricted, Aggressive Line

A constricted line makes use of angular, crabbed, assertive marks. Such marks are aggressively stated. They may be ugly and scratchy, carriers of a bitter expression; they can convey the feeling of tension as in George Grosz's work (see figure 5.8).

PROBLEM 5.9
Using Constricted, Aggressive Line

An incised line is a good choice for this problem, as cutting or scraping can be aggressive acts. Note the abraded surface and rugged line quality in Jean Dubuffet's drawing (figure 5.27). The images are scratched into the surface, a technique called *grattage*. The French artist was intent on a return to expressionistic, fetishistic, primitive art that he tagged Art Brut. Destructiveness plays a large role in contemporary art; it is rough, full of pent-up energy, and obsessed with psychology. Dubuffet was instrumental in collecting art by the mentally disturbed and in creating a museum featuring their work. His interest and promotion of work by untrained makers of art presaged the popularity of what is known in the United States as Outsider art. In his own work Dubuffet aimed for the same immediacy and obsessiveness—aggressive, constricted marks, thickly applied paint, abraded surfaces, grotesque imagery, fearful subjects, destruction of previously held ideals: primitive means for primitive intent.

For this drawing, you may use black scratchboard (a clay-coated, prepared paper), or, like Dubuffet, you may coat a piece of bristol board with a layer of gesso over which you then apply a coat of black ink. The drawing implements can be a collection of found objects or discarded drawing tools, such as old pens, palette knives, or mat knives. Razor blades can also be used as scrapers; any sharp implement will serve.

5.27. JEAN DUBUFFET. *Subway.* 1949. Incised ink on gesso on cardboard, 1'5⁄8" × 9⁷⁄8" (32.1 cm × 23.5 cm). Collection, Museum of Modern Art, New York. The Joan and Lester Avnet Collection. © 2003 Artists Rights Society (ARS), New York/ADAGP, Paris. Photograph © 1997 The Museum of Modern Art, New York.

5.28. ISAMU NOGUCHI. *Untitled* (from the *Peking Drawing Series*). 1930. Pen and ink on paper, 4′ × 3′ (1.22 m × 91.4 cm). Perimeter Gallery, Chicago. Photo by Michael Tropea.

Make an abstract drawing depicting an event or situation toward which you feel great antipathy. Use constricted, aggressive lines to convey a strong, negative feeling. Aim for a drawing style and a line quality that will underscore a bitter message.

Handwriting: Cursive and Calligraphic Line

In the Orient artists are trained in calligraphic drawing by first practicing the strokes that make up the complex characters of their writing. Subtleties of surface, value, and line quality are promoted. The marks can range from rigorously severe to vigorously expressive, as in the calligraphic drawing by Isamu Noguchi (figure 5.28).

Ink and brush is the traditional medium of calligraphy where instrument, media, surface, and technique all play crucial roles. The technique is related to gesture; the variations of the line encompass the full range from bold to delicate, from thick to thin. Noguchi's lines are sweepingly graceful; it is as if the figure itself created the drawing by a simple movement of the arms. A Chinese saying sums up the drawing: "A line is a force."

5.29. DAVID HOCKNEY. *Celia—Inquiring.*
1979. Lithograph, 3′4″ × 2′5″ (1.016 m ×
73.7 cm). Ed: 78. © David Hockney.

PROBLEM 5.10
Using Handwriting or Calligraphic Line

Practice writing with ink and a bamboo-handled Japanese brush.
Hold the pen near the end, away from the brush, and at a 90-degree angle to
the paper. (Your paper should be on a horizontal surface.) Change scale, mak-
ing the transitions of the marks gradual and graceful. Apply different amounts
of pressure to create flowing motions. Turn the brush between your fingers as
you write. Experiment with the way you hold the brush and with the amount
of ink loaded onto the brush.

After you have practiced and have the medium under some control,
make a composition using written words, layering them, obscuring their legi-
bility, only occasionally allowing them to be read. Choose a text that is ap-
pealing to you—a poem, a passage from a novel, or your own original writing.

To differentiate the layers, use black, white, and sepia ink on a light gray
or buff paper. Or you may tone your paper with a light valued wash before be-
ginning to write.

Implied Line

An implied line is one that stops and picks up again. It can be a broken con-
tour; the viewer conceptually fills in the breaks. We discussed implied shape
in chapter 3. Refer to the Magee drawing (see figure 3.6) to freshen your
memory.

In David Hockney's lithograph (figure 5.29), the artist makes use of a
fragmented, or implied, line. This approach is more concentrated in the lower

5.30. DAVID HOCKNEY. *Henry in Candlelight*. 1975. Crayon, 1′5″ × 1′2″ (43 cm × 35.5 cm). Private collection, France. © David Hockney.

half of the drawing where hand, dress, and chair dissolve into a series of accent marks; the individual shapes are not clearly defined. Hockney's line is a weighted, broken contour line.

Implied line results from an interchange between positive and negative shapes. It brings the negative space into the implied positive shapes, creating spatial ambiguity. This lost-and-found line requires a viewer's participation since missing lines and shapes must be filled in mentally.

PROBLEM 5.11
Using Implied Line

Choose a still life as subject for an implied-line drawing. Alternate drawing between the left and right side of the still life; leave the opposite side empty. Create implied shapes. Be conscious of the pressure on your drawing tool, lightening the pressure as the line begins to break. The lines should change from light to dark along their length. Use a minimal amount of line to suggest or imply shape.

Blurred Line

Blurred lines are smudged, erased, or destroyed in some way, either by rubbing or by erasure. They are frequently grouped to form a sliding edge; they are not as precisely stated as implied lines. Blurred and smudged lines are much fa-

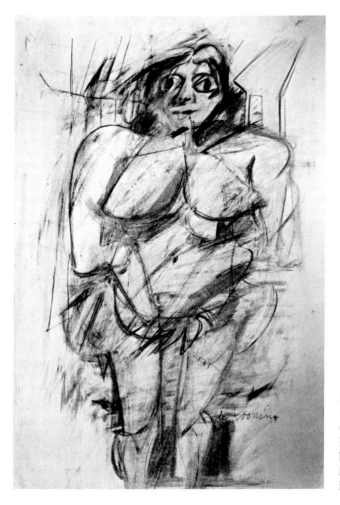

5.31. WILLEM DE KOONING. *Woman.*
1952. Pastel and pencil, 1′9″ × 1′2″
(52 cm × 36 cm). Private collection,
Boston. © 2003 The Willem de Kooning
Foundation/Artists Rights Society (ARS),
New York. Photograph Barney Burstein,
Boston.

vored by present-day artists because they create an indefinite edge, thereby re-
sulting in an ambiguous space.

David Hockney, in the study of a friend (figure 5.30), uses blurred and
erased lines to build the figure. Lines are grouped in a single direction to cre-
ate a buildup of plane and volume, binding the figure to its space. There is an
unfinished quality to the drawing, owing to the disruption of the contours.
The strokes seem to emerge from the surrounding space; they both anchor
and attack the seated figure at the same time. Hockney's technique of using
blurred line is especially appropriate when we note the title, *Henry in Candle-
light.* The flickering and shimmering quality of the light is translated into the
drawing by means of the blurred line, and the fading out of the drawing in the
bottom of the composition imitates the fading power of the candlelight.

We have mentioned several artists who have a distinctive line quality, a
signature by which we recognize the artist. The Abstract Expressionist Willem
de Kooning is one such artist. Blurred, erased, repeated gestural marks signify
his work (figure 5.31). He creates a spatial ambiguity through a textural sur-
face of built-up and erased line in both his drawings and paintings. His style
gives us a strong clue as to why the Abstract Expressionists were called Action
Painters. De Kooning was a master draftsman, yet he found it necessary to rein

in his natural facility to hone his pictorial skills. One of the techniques he devised, a variation on the Surrealist exercise of automatism, involved drawing with his left hand while watching television. De Kooning's women walk a tightwire between abstraction and depiction. His work suggests an ambivalence toward women; their simultaneous attraction and revulsion for him are a continuing theme in his art. De Kooning's marks not only create a spatial ambiguity, they are the carrier of ambiguous feelings.

Our discussion of erased and blurred line would not be complete without mention of what is arguably the most discussed drawing of the century, Robert Rauschenberg's 1953 *Erased de Kooning Drawing*. Rauschenberg was interested in disintegration, in obliterating the artist's hand and artistic presence from his own work, so he devised a project that would be a perfect vehicle for implementing his theories: Rauschenberg requested that de Kooning give him one of his drawings, one that de Kooning would not like to part with; the other stipulation was that it should be a drawing that would be difficult to erase. De Kooning gave the request long and serious consideration before complying. After the drawing was exchanged, Rauschenberg spent two months trying to eliminate all traces of de Kooning's marks by carefully erasing the entire drawing. The remaining texture or surface was persistent in retaining both memories of de Kooning's original gestural marks and shades of his composition.

PROBLEM 5.12
Using Blurred Line

With a soft pencil or graphite stick and a white plastic eraser, make a drawing in which you use blurred, smudged, and erased line. Use the eraser as a drawing tool, making sweeping motions that go counter to the pencil marks. Erase and blur the already established lines. Alternately redraw and erase until the drawing is finished.

A toned ground is a good surface for a blurred-line drawing. Develop clusters of line (using both erasure and lines created by charcoal or conté crayon) where the forms converge. By this means the positive and negative shapes will merge; the positive shapes will dissolve into the ground of the toned paper. Allow some of the connections to be implied. You might compose your drawing so that a light, positive shape adjoins a light, negative shape; a dark, positive shape adjoins a dark, negative shape. This will ensure an ambiguity of edge. This problem is related to our discussion of implied line and shape.

Whimsical Line

A playful, whimsical line quality is appropriate for a naive, childlike subject. This subjective line is both intuitive and directly stated. The whimsical line may change its width arbitrarily. Whimsy is more a feeling than a technique, but we find numerous examples of line used lightheartedly. Exaggeration and unexpected juxtapositions play a major part in creating a whimsical mood. Paul Klee is the master of whimsical line (see figure 5.7). Although his drawings are appealingly naive, they incorporate sophisticated, formally organized devices. In a distinctive style he combines geometric abstraction with fantasy in many of his works.

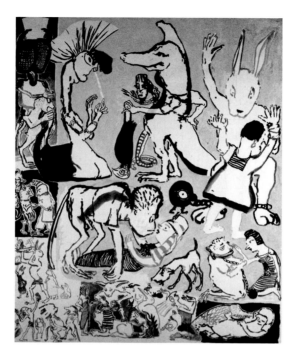

5.32. PAULA REGO. *Aïda.* 1983. Acrylic on paper, 7'10½" × 6'7¹¹/₁₂" (2.4 m × 2.03 m). Collection of the artist.

In a drawing rooted in the humorous vein by the Portuguese-born artist Paula Rego (figure 5.32), we see how effective an appropriate line quality can be in conveying a whimsical mood. Quick contours, simple outlines, insets, shifting scale, sketchy characters, exaggerated proportions, and odd costumes—all add up to a droll account of the nineteenth-century opera *Aïda.* Ever on the lookout for stories onto which to hang her elaborate expressive content, Rego hit on the idea of opera. What better source of murderous intrigue, fatal flaws of judgment, insidious competition, and quarrels between lovers and parents—opera has them all! Rego plots the narrative in both vertical and horizontal registers (note the inserts); she interrupts the theatrical flow with her subversive imagery and compilation of riotous activity. Like other artists (Walt Disney among them!) Rego uses animals to underscore human foibles and idiosyncrasies, a zoomorphic approach that has hilarious and touching results. A synchronic presentation replaces the linear unfolding of the opera scene by scene; in Rego's drawing the whole story is squeezed into a single, action-packed page. Not only is Rego's reenactment of *Aïda* fun to look at, it must have been fun to make. A full-hearted entering into the game is the first requirement of working with whimsical line.

PROBLEM 5.13
Using Whimsical Line

Choose a subject toward which you can adopt a humorous attitude. Like Rego, you might interpret a serious novel or play, giving it a humorous twist. Use a line that reinforces a playful mood. Aim for caricaturelike distortions, using a line that is boldly and quickly stated. Exaggeration is always a good choice for humor. You might use brush and ink like Rego, or pen

and colored ink, or felt-tip markers. By turning the drawing tool between your fingers as you draw you can create a line quality that is unpredictable and playful. Have fun.

SUMMARY

Although each problem in this chapter has generally been confined to the use of one kind of line, most artists do not limit their line so severely. You should experiment, employing several linear techniques in the same drawing. In figure 5.33 Rico Lebrun focuses attention on the subject's face by use of value and deft handling of line, whereas the massive bulging shapes of the body are re-

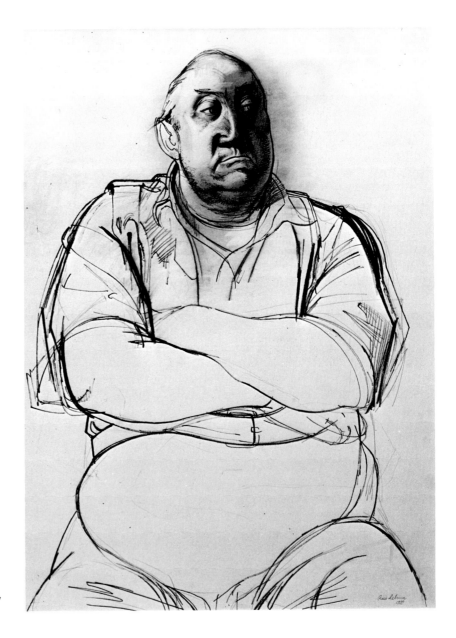

5.33. RICO LEBRUN. *Portrait of a Man.* 1939. Ink and chalk. Private collection. Constance Lebrun Crown, Santa Barbara, Calif.

layed by gestural, scribbled, quickly stated lines. Darker, heavier lines convey the message of gravity, weight, and tension. The black marks press down on the shoulder on the right side of the drawing; at the same time they narrow as they reach the neck, directing the viewer's eye back to the focal point of the head. Lines enclosing shapes build overlapping masses from the bottom of the drawing to the top—lower legs, belly, overlapping crossed arms, chest, neck, and back to the assertive face. Occasionally a simple contour line is sufficient; at other times Lebrun uses congested lines to create abstract shapes within the body, which we read as wrinkles in the man's clothing. On the left side of the drawing, lines seem to be searching their way around the curvature of the elbow. The variety of lines in the body is an intriguing foil to the treatment of the head. The faint smudged area to the side of the sitter's head takes us back to the opening quote by May Stevens, "A smudge is a trace of what was or is to come. But a line is here."

SPATIAL CHARACTERISTICS OF LINE

Subjective lines are generally more dimensional than objective lines. This is because a subjective line changes width, changes from light to dark, and is more suggestive of space than a flat line of maintained width. Outlining makes shapes appear flat; contour line is more dimensional than outline.

A contour line of varying width and pressure is more dimensional than one of uniform weight. A discontinuous, or broken, line is more spatial than an unvarying one.

When line is stated primarily horizontally and vertically, that is, when it remains parallel to the picture plane, a shallow space results. If, however, lines penetrate the picture plane diagonally, a three-dimensional space is produced. Generally, a buildup of lines is more volumetric than a single line.

When lines are grouped in a single direction to create value, the resulting space is flatter than if the lines are not stated uniformly. Lines that create a repeating pattern of texture make a flatter space than those stated less predictably.

Again, a reminder: You must analyze all the lines in a drawing to determine the entire spatial effect. Look at the line's spatial characteristics. Is it dark, light, thick, thin? Analyze the line quality in terms of contrast, weight, thickness, and movement, and determine what information concerning edge the line defines.

Finally, line is the most direct means for establishing style. It is, as we have said, as personal as handwriting. And like handwriting, it should be practiced, analyzed, and refined throughout your drawing career.

SKETCHBOOK PROJECTS

All of the problems in this chapter are appropriate for working in your sketchbook; in fact, daily contour drawings are strongly recommended. They are ideal for the sketchbook since they can be done with any subject matter and in the shortest time periods. Keep your sketchbook handy and fill it with the various types of contour drawings.

The more lines you draw, the more sensitive you will become to line quality. Being involved in simple mark making will improve your sensitivity to line. Line used abstractly as well as concretely to describe an object in the real world requires practice on a regular basis. You will begin to find possibilities for new line applications the more you draw. Now, let us look at some contemporary applications of line.

PROJECT 1
Conceptual Drawing

Sol LeWitt has claimed that it is the idea that makes the art. In his work instructions are explicitly stated before the drawing begins. The person making the marks simply follows the requisites laid down by the person who conceived of the idea, so the drawing will vary according to who actually completed or "performed" the instructions.

Here are instructions for two wall drawings made by LeWitt:

"Within a six-foot square 500 vertical black lines, 500 horizontal yellow lines, 500 diagonal (left to right) blue lines, and 500 diagonal (right to left) red lines are drawn at random."

"Ten thousand straight lines at random."

In this exercise write instructions for a drawing to be completed at a later date. The instructions should involve line and repetition; you might use permutations where a certain type of line is run through several variations, such as right to left, left to right, top to bottom, bottom to top. Write each set of rules at the top of a page in your sketchbook; leave three or four blank pages after each set. After you have composed a drawing using this highly rational approach, go back and follow your directions. Make three or four drawings for each conceptual drawing idea. Do not, however, make the drawings one immediately following the other. Rather, allow a lapse of several hours, or even overnight, so that your eye and hand are not conditioned by the type of marks made in the previous drawing. The appeal of the resulting drawings will be their order and coherence. You may be surprised at how much difference there can be from drawing to drawing even though you are employing the same set of rules.

You might enjoy working with a friend on this project. Trade instructions, thereby making the separation between concept and drawing even more removed.

PROJECT 2
The Cadavre Exquis *(The Exquisite Corpse)*

The *cadavre exquis* was a drawing technique devised by the Surrealists in which a group of artists work on the same drawing, each unaware of what the others have drawn. In the same drawing there will be different styles, different ideas, and mixed images. The result can be surprisingly coherent, funny, and strange at the same time.

The person who begins is to cover the beginning segment of the drawing by taping a piece of blank paper over the initial image. A line or two can be left visible so that the second person can attach the second part to the first part. Continue the process of drawing and concealing until the third person has finished. Unmask the drawing and reveal the visual message.

This project is in contrast to the conceptual drawing in the first exercise where you knew in advance what the elements of the drawing would be. You might want to make a few rules beforehand, although this is not necessary. You could, for example, restrict what kind of imagery is to be used: parts of the body, animals, still life objects, no nonobjective shapes, all nonobjective forms, and so on. You might limit what kind of medium is to be used; this will make for a more visually coherent drawing. Because this exercise is designed to make you more comfortable in working with line, you should make several exquisite corpse drawings that employ line only.

COMPUTER PROJECT

PROJECT 1
Computer Drawing and Line Quality

Like the other computer exercises, much depends on the particular programs available to you. Most graphic programs allow the user to control line by width, and sometimes the user can control line quality (figure 5.34). Programs are increasingly responsive to artists who require line quality to resemble physical drawing and painting media. The twelve examples shown here are from Adobe Illustrator Brush Library. The names are: Fountain Pen, Dry Brush—Thick, Dry Ink, Calligraphic Round, Calligraphic Flat, Charcoal, Fude, Fire Ash, Scroll Pen, Chalk, Train Tracks, and Dashed. Experiment with the programs available to you and create your own catalog of line quality.

5.34. COMPUTER DRAWING CREATING LINE. Courtesy of Tom Sale.

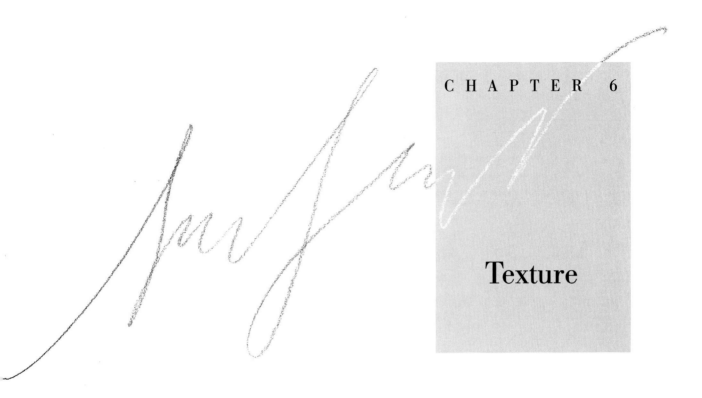

Texture

Oil, watercolor, pencil, fabric, paper, photographs, metal, glass,
electric light fixtures, dried grass, steel wool, necktie, on wood structure
with four wheels, plus pillow and stuffed rooster.
CATALOG ENTRY DESCRIBING MEDIA USED
IN RAUSCHENBERG'S COMBINE *ODALISK*, 1955–1958

THE ROLE OF TEXTURE
IN CONTEMPORARY ART

IF ANY ONE ELEMENT CAN SHOW HOW far apart are the worlds of contemporary art and traditional art, it is the texture used. The predominant role of texture in drawing before the twentieth century was illusionistic, imitating textures in the natural world. The rich array of textures in the pen-and-ink drawing by Pieter Bruegel the Elder in 1560 is a real tour de force; every shape in the drawing has been defined by texture (figure 6.1). A range of techniques—cross-hatching, cross contour, grouped parallel lines, stippling, line-and-dot, and scribbled line—has been used to

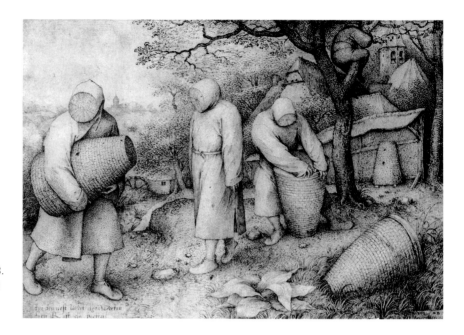

6.1. PIETER BRUEGEL. *The Beekeepers.* 1568. Pen and brown ink, 8″ × 1′1/6″ (20.3 cm × 30.9 cm). Staatlich Museen zu Berlin, Kupferstichkabinet (B.P.K.)

convey the tactile world of the beekeepers, whose vision seems to be blocked by protective hoods and masks; their contact with the world is a tactile one.

Compare the Renaissance drawing with a Post-Modern one by Julian Schnabel, *Dead Drawing*, in which he incorporates an actual cowhide (figure 6.2). In this frenetic drawing explosive lines burst from the boxlike form at the bottom of the paper, which Schnabel describes as "a plunger for dynamite." Branched lines that extend from a second box at the top of the drawing

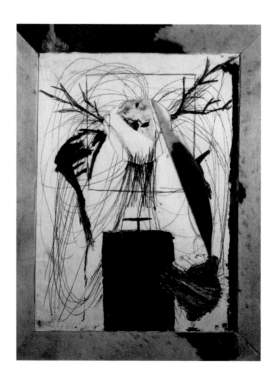

6.2. JULIAN SCHNABEL. *Dead Drawing.* 1980. Pencil and oilstick on paper with cowhide, 4′2¼″ × 3′4″ (1.275 m × 1.015 m) (with frame). Ross Bleckner Collection, New York.

can be interpreted as electrified antlers. Slicing across the scribbled picture plane are cowhide arcs, and holes (blown out by the explosion?) reveal the underlying cowhide support. The drawing has a hide frame with mitered corners, in imitation of a traditional wooden frame.

Schnabel's work emphasizes actual texture, the cowhide as well as the undisguised texture of the media, pencil and blood-red washes. In Bruegel's drawing we register that it has been drawn with pen and ink, but the medium does not insist on being forefronted as in the contemporary work. In addition to actual texture, Schnabel uses symbolic texture to convey the action of the explosion, while the antlers read more as pencil-scribbled, branched lines. He sees his art as constituting a field of activity that generates energy processes. The bond between figure and ground is a crucial concern for Schnabel, best known for his large-scale paintings with surfaces laden with broken crockery.

Of all the art elements, texture has undergone the most radical changes in today's art. Two examples will furnish insight into the extremes to which texture has been taken—the first by the conceptual artist Richard Long (figure 6.3) and the second by the sculptor Janine Antoni (figure 6.4). Both artists employ quirky materials and innovative methods. Long, extending the landscape tradition established in the last century, evokes a romantic response even in enclosed gallery spaces. On long walks he creates temporary sculptures of mud, rock, and dirt. In gallery settings, using materials taken from specific locations, he evokes memories of past treks and the ephemeral art produced on them; both time and place are important components in his work. In a recent body of work Long uses the silt of famous rivers as a medium for large drawings; in the example shown here the rivulets of actual mud flowed over Japanese rice paper bring to mind the ebb and flow of the Mississippi itself.

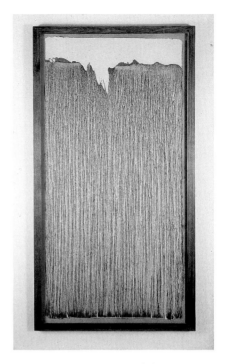

6.3. RICHARD LONG. *Untitled.* 1992. Mississippi mud on rice paper, 6'6" × 3'7" (1.98 m × 1.09 m). Modern Art Museum of Fort Worth; gift of the Director's Council.

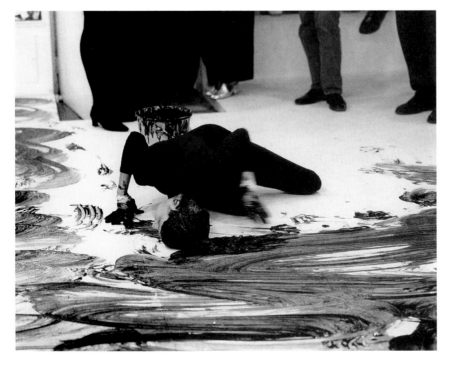

6.4. JANINE ANTONI. *Loving Care.* 1992. Performance (detail). The artist soaked her hair in hair dye and mopped the floor with it. Anthony d'Offay Gallery, London. Prudence Cuming Associates Limited.

Antoni approaches her work with a somewhat perverse sense of humor. In performance art using her own body as the medium, she calls attention to the parallels between what women suffer for beauty's sake and the methods used in making art. This body involvement is a feminist stance used for serious purposes by many contemporary women artists. In a performance piece, *Loving Care*, Antoni uses her hair as a brush for making a drawing on the floor of the gallery; the title refers to a commercial hair product with which the artist paints. The strokes create a texture that is another reference to the high Modernist art style, Abstract Expressionism (associated primarily with male artists), and with its painterly individualistic gestural marks. Many artists since the Abstract Expressionists have tried to establish a distance between the artist and the work; Antoni reestablishes the connection in a particularly feminist manner; she pays tribute to women's work, reminding viewers that "mopping the floor is the opposite of ballet" (Kay Larson, "Women's Work (or Is It Art?) Is Never Done," *New York Times*, January 7, 1996, Art 35).

Antoni also makes a critical reference to the sexism embodied in the work of the French neo-Dadaist and performance artist, Yves Klein, who painted *with* models. (Klein used women as "paintbrushes," covering their bodies with paint and then having them transfer the paint to large floor surfaces through their body movements.) Antoni's performance presents multiple interpretations using simple actions.

An art-poking-fun-at-art parody is Roy Lichtenstein's *Little Big Painting* (figure 6.5), in which the artist has isolated the Abstract Expressionist brush stroke and transformed it in his signature cartoon style. The humor comes from the conjunction of the two styles; the impersonal, flat, commercial technique with its static symbolic texture has little in common with the texture of the sweeping, dripping, gestural, and autographic mark to which it refers. Lichtenstein's penchant for transforming art historical styles from Classical art to Minimalism never fails to intrigue. Using Ben Day dots, flat paint application, and lines of maintained width to create textural effects, he incorporates a progression of styles that furnish him an unending supply of subject matter.

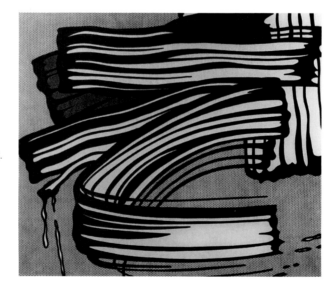

6.5. ROY LICHTENSTEIN. *Little Big Painting.* 1965. Oil and synthetic polymer on canvas, 5′8″ × 6′8″ (1.727 m × 2.032 m). Collection of Whitney Museum of American Art, New York. Purchased with funds from the Friends of the Whitney Museum of American Art. © Roy Lichtenstein. © 1996 Whitney Museum of American Art, 66.2.

And it is their conversion to a disjunctive texture that serves as an in-joke to the informed.

A quick summary of how texture has been used historically will emphasize how dramatic textural experimentation has been in this century. Until the mid-nineteenth century, texture was primarily tied to the transcription of local or actual textures of the subject depicted. In the Renaissance the ideal for painting was to be a "window into space"; this meant that a smooth surface with imperceptible individual brush strokes was the goal, so that the spatial illusion of the picture plane was not disturbed. The brushwork of Romantic artists of the last century became more flamboyant in order to relay emotional and expressive content; mood and settings overrode surface illusion. (Lichtenstein's iconic brush stroke upstages them all!)

Even more radical textural transformations of the picture plane took place with the Impressionists and Post-Impressionists. Texture was released from its limited function of illusionistic veracity and was thereby a major tool in creating various kinds of pictorial space. The uniformity and texture of broken brush strokes were a major means of flattening forms and reasserting the two-dimensionality of the picture plane (see figure II.15).

The twentieth century saw a number of influential developments in artists' use of texture, beginning in the years before World War I, when the Cubists invented the technique of *collage*—the addition of flat material to the surface of a work (see figure 6.23). These avant-garde artists also introduced the idea of adding sand and other substances to paint to create a more pronounced surface texture. Other innovations were followed by the development of the technique of *assemblage* (added dimensional material resulting in either high or low relief).

More recently, technology has offered artists new options for texture, such as transferred and photocopied images. Formal and technical developments in collage and construction have been amplified by contemporary artists. Textural possibilities have been broadened, allowing for a wider range of expressive and material options. Think of the way the camera has modified the way we see things; often we cite the photographed images as a substitute for the "real thing." In Photo-Realism the textures that are conveyed are mediated through the camera; it is the surface of the photograph that is relayed rather than the texture of the objects depicted.

Many artists consider the camera as essential as the sketchbook. An investigation into how Lichtenstein arrives at his final image is informative. Diane Waldman describes his method: Lichtenstein "selects motifs from illustrations and other secondhand sources and recomposes these images, small in scale, into equally small sketches by means of an opaque projector. . . . The sketch is enlarged to the scale of the canvas and transferred; it is [then] subject to a series of changes—of drawing shape and color sequences" (Rose, *Drawing Now*, pp. 40, 43). Lichtenstein deals with depersonalized stereotypes using parody and irony to present his seemingly straightforward images. He says, "I want my painting to look as if it has been programmed. I want to hide the record of my hand" (Rose, p. 43). Ironically, the anonymous comic-strip style has become Lichtenstein's signature style (figure 6.6). Texture is symbolically represented; the reflective glass is actually created by a series of static vertical lines that contrast with the symbolic, invented texture that represents the fizzing tablet. The background space is filled with the artist's trademark

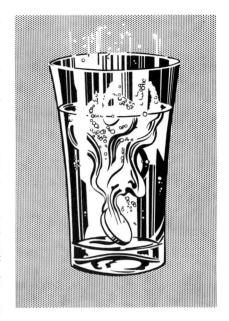

6.6. ROY LICHTENSTEIN. *Tablet.* 1966. Graphite and lithographic crayon pochoir on cream woven paper, 2′6″ × 1′10″ (76.3 cm × 56.7 cm). © Roy Lichtenstein. Photograph © 1995, The Art Institute of Chicago. All Rights Reserved. 1993.176. Photo: Robert E. Mates and Paul Katz.

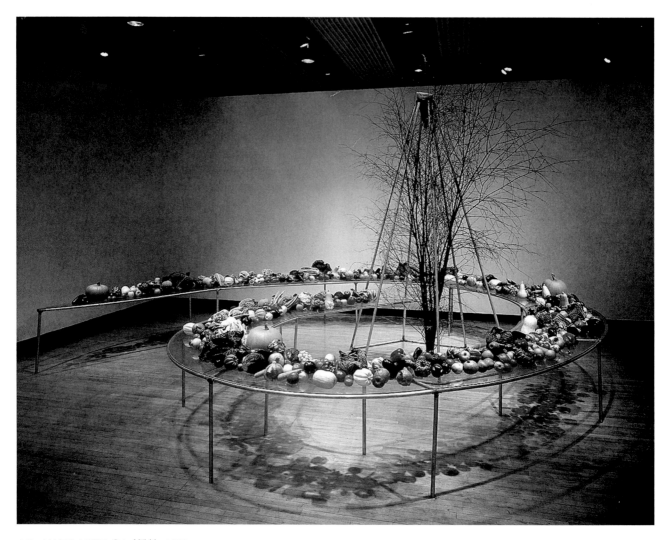

6.7. MARIO MERZ. *Spiral Table.* 1982. Aluminum, glass, fruit, vegetables, branches, and beeswax, 18′ (5.486 m) diameter. Installation view, Hayward Art Gallery, London, 1997. Courtesy Sperone Westwater, New York.

Ben Day dots; the glass is isolated, floating against a uniformly patterned negative space. The object casts no shadows; there is no context given in which to place the glass. The spatial and textural clues are symbolic conventions; we know how to read them from lessons learned in interpreting symbolic textures in comic strips.

In contemporary art, texture is the primary element in establishing meaning and in organizing the work on a formal level. Contemporary artists, especially the Neo-Expressionists, have broken all textural constraints in their art. They incorporate materials and actual objects that are either embedded in the paint or affixed to the surface. In Mario Merz's installation (figure 6.7), the artist uses actual objects to create a texturally rich effect. Two geometric forms, a pyramid enclosing a tree and a spiral set on legs, contrast with a lavish display of fruits and vegetables. For Merz—as well as for Matta-Clark (see figure 5.1)—the spiral symbolizes an energetic life force. The spiral is a schematic geometric form for a cornucopia, the horn of plenty. The tree can

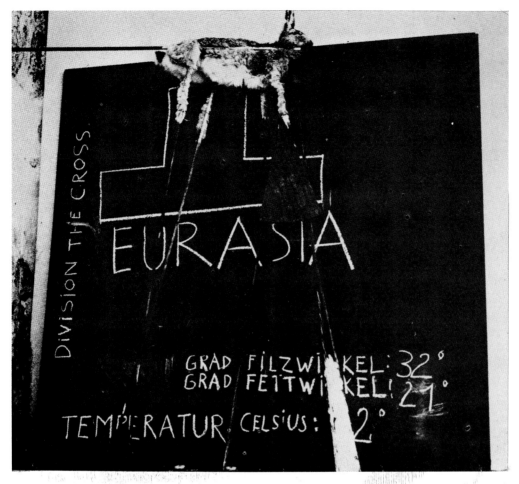

Within image (chalk drawing): DIVISION THE CROSS · EURASIA · GRAD FILZWINKEL: 32° · GRAD FETTWINKEL: 27° · TEMPERATUR CELSIUS: 2°

6.8. JOSEPH BEUYS. *Eurasia,* from *Siberian Symphony.* 1966. Mixed media performance with action tool: board with chalk drawing, wedges of felt, fat, hare, and rods. Private Collection. Photo: © 2003 Artists Rights Society (ARS), New York/VG Bilde-Kunst, Bonn.

be interpreted as dormant, not dead, and is a symbol of transcendence. Merz uses texture as a key to understanding symbols. The texture in his work is both physically and psychically dense.

It is the shaman's role to mediate between the forces of the world and the forces of the unknown to ensure the life force of the community. Anthropologists see the initial impulses of art in shamanistic activities. The German artist Joseph Beuys was such a leader for a new generation of artists in the last quarter of the twentieth century. He confirmed art as a socially useful act, and in his teachings he promoted a healing role for art. Beuys uses mythic imagery to express a state of transition through ephemeral materials, such as honey, wax, grease, and felt. Younger artists saw Beuys's work as revelatory with its primitive quality; in his drawings a pencil mark or a stain become a magical catharsis. Beuys was shot down in the Crimea during World War II, and nomadic tribesmen saved his life by wrapping him in grease and felt. This event provided impetus for his ritualized performances, the goal of which was transformation and healing (figure 6.8).

The German artist Sigmar Polke plays an art game with "pictorialness," with not only how but what is being depicted. His work has a randomness and

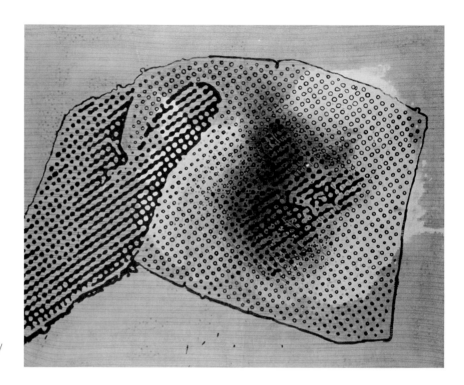

6.9. SIGMAR POLKE. *Untitled.* 1985. Acrylic on canvas, 5′10⅞″ × 4′11″ (1.8 m × 1.5 m). Photo: Christie's Images/ Corbis.

lack of fixity, as can be seen in figure 6.9. He has been called "a gambler with visual meaning variables." Readability of image and intent are discouraged; his goal is not to be pinned down. Polke does not stick to one style; he creates a farcical mix. In the work shown here the blurry image seems to be the result of a bad printing job. In fact, Polke is interested in painting and printing devices and codes, especially in the results of mistakes in the process. Unlike those found in Lichtenstein's work, Polke's dots (yes, the pun is intentional; Polke uses dots as a reference to his name) switch from positive to negative across the surface of the picture plane, occasionally connecting, like pixels (the smallest image-forming units in a video or computer screen display). In fact, the flat plane resembles a digital screen more than a handmade art piece. Polke works at the very boundaries of convention. Viewers must engage their own sense of playfulness and try to interpret the meager pictorial offering, to connect the dots, so to speak. In this work texture is the only game in town.

A significant impulse that began in the latter part of the century and that continues today is the emphasis on decorative patterning, as seen in a book by Miriam Schapiro using acrylic paint, paper cutouts, and fabric glued on paper (figure 6.10). The book tells a visual story and is bound in the Japanese tradition using an accordion fold. Nine feet by twelve feet, it is too large to fit in most rooms. Each panel uses a different set of patterns. The invented textures enliven the pages; their relationship to each other resembles a group of quilts laid end to end. Schapiro took the lead in a movement that is called Pattern and Decoration, developing new strategies for women's work and opening the art world to new images, content, techniques, and materials. Autobiographical issues, particularly those related to women's sensibilities, have now been legitimized as vital subjects for art; ideas of what is appropriate imagery for art have

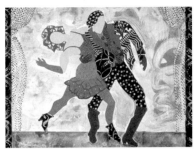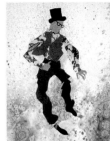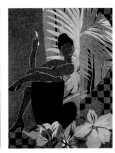

6.10. MIRIAM SCHAPIRO. *Rondo* (excerpt). 1989. Artist's book, acrylic paint, paper cutouts, and fabric on paper, 9′ × 12′ (2.74 m × 3.66 m) per page. Published by Bedford Arts Publishers. Courtesy of the artist.

been greatly expanded since the 1970s. In her own work, which she calls "femmages," Schapiro uses sources for both imagery and materials that come from women's crafts. Her work, which combines "high" and "low" art, presents personal iconography with political implications. Pattern and Decoration artists challenged the art world's prejudices of elitism, racism, and sexism, as well as cultural and economic biases.

Of course, using pattern and decoration for textural enrichment is not a twentieth-century innovation; the most ancient and honored art forms make use of these methods. Pattern and Decoration artists are not the only artists who have established ties with much older decorative sources. Patterns can convey conceptual and cultural associations; they are not simply decorative, patterned motifs but are references to systems, to various types of organic, scientific, and mathematical organizations; they are the core of crafts such as weaving, quilt making, embroidery, beadwork, and ceramics.

In another vein, the German artist Rosemarie Trockel presents knit panels, clothing, sculpture, drawings, photographs, and video art that are distinctly political and feminized. Trockel says of her work, "Irony appears when I have to get malicious. It's a vice that keeps me from ending up a cynic" (Neville Wakefield, "Rosemarie Trockel," *Elle Décor*, August/September 1997, p. 58). One of her ironic drawings is shown here (figure 6.11). What a surprise

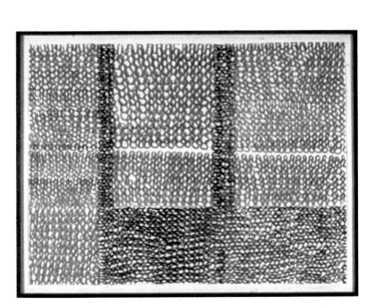

6.11. ROSEMARIE TROCKEL. *O.T 1996.* 1996. Acrylic on paper, 2′3¾″ × 2′8⅜″ (62.9 cm × 82.2 cm). Photo courtesy of Barbara Gladstone Gallery, New York. © Artists Rights Society (ARS), New York/VG Bild-Kunst, Bonn.

6.12. HELENA HERNMARCK. *Talking Trudeau-Nixon.* 1969. Wool and nylon weft on horizontal linen warp, 4'3" × 11'2" (1.3 m × 3.4 m). End panels gift of the artist to the American Craft Museum, 1990. Center panel promised gift of Jack L. Larson to the ACM, 1990.

to discover the panels are drawn, not knitted! Trockel's trick-the-eye-texture flies in the face of Modernism's ban on crossover categories and representational subject matter. Who would think that such an unimposing image could make such big waves? The confounding of genres is both a Post-Modern strategy and a source of delight for the viewer.

Compare Trockel's drawn knitting with Helena Hernmarck's woven drawing (figure 6.12). In both artists' work texture takes the lead. Hernmarck's interest in newsreels and in black-and-white dot patterning resulted in the unusual subject of her weaving, a newsphoto, Photo-Realism in fiber: President Richard Nixon and Canada's prime minister Pierre Trudeau.

A development in late twentieth-century art dealing specifically with actual texture was the emergence of the *object* as a distinct genre. This novel development introduced a new kind of art formulation. Although art objects are three-dimensional, they are not strictly sculpture; they do not deal primarily with volume, mass, intervals, and voids. Artists' one-of-a-kind books fall into this category, a crossover between drawing, painting, printmaking, photography, and sculpture. In this new genre of objects—cubes, boxes, trays, containers, books—real texture on real objects has displaced the illusionistic function of texture. Dottie Love's book, *Hard Choices/All There Is* (figure 6.13), is made of materials associated with neither books nor art but out of more base materials that avoid connotations of art. Pages are formed of layered pieces of glass, acetate, and mirror, which are held together by soldered lead and encased in a glass container. These dimensional pages are then embedded in another glass case filled with dirt clods. Love's theme, as the book says, is "Ashes to ashes, dust to dust. . . ." Blurred, confusing words and images are photographed and drawn—incised—on the layered sheets, backed by crazed and pitted mirrors, and are legible only when held up to the light. Actual, real-life texture plays a leading role in all of Love's work: the dirt clods, the leaded holders, the double, blurred images resembling photographic negatives, the mirrors. All function on a formal, design level, but more important, these textures are crucial to the work for their symbolic role. At first look, the viewer sees confusing double images; it is only by holding the pages and looking through them, having them illuminated by real, literal light that we can decipher the message. The viewer

6.13. DOTTIE LOVE. *Hard Choices/All There Is.* October, 1986. Glass, lead, dirt, photocopies on acetate, 4 1/16" × 5 1/2" (10.3 cm × 14 cm) each. Museum of Fine Arts, Houston. © The Museum of Fine Arts, Houston. Museum purchase with funds provided by Len E. Kowitz.

is also illuminated, so to speak, and given a tactile reward by actually handling the work.

We have seen only a few examples of the heightened role of texture in contemporary art. Let us now explore the role of texture in the graphic arts, where the emphasis in drawing is on visual textural effects. The contrasts between rough and smooth, coarse and glossy, or soft and hard can be communicated without actually using glossy or rough media. Jeanette Pasin Sloan's still life is a masterful rendering of reflective glasses and bowls (figure 6.14); using pencil on board the artist has created a symphony of texturally imitative forms. Each object is richly patterned by reflections that echo the striped cloth on which they have been placed. The reflected verticals undergo a series of transformations owing to the curvature of each particular piece. On the convex shape of the black goblet, in an image worthy of Van Eyck, the reflected space of the room has been drawn in miniature. The drawing succeeds both as an illusionistic duplication of a still life and as an abstract composition of contrasting and repeating forms. First and foremost on display is texture. What a contrast in texture are the two drawings of glassware by Sloan and Lichtenstein!

6.14. JEANETTE PASIN SLOAN. *Chicago and Vicinity.* 1985. Colored pencil on paper, 2′10″ × 1′10½″ (86.4 cm × 57.2 cm). © Jeanette Pasin Sloan.

6.15. DIANE SALFAS. *Jonathan I.* 1996. Graphite pencil, 4⅞″ × 4¼″ (12.4 cm × 10.8 cm). Courtesy of the artist. Photo by Nathaniel Salfas.

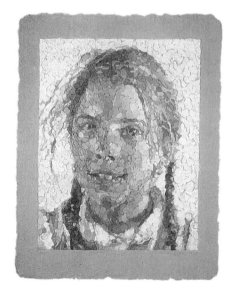

6.16. CHUCK CLOSE. *Georgia.* 1984. Handmade paper, 4′8″ × 3′8″ (1.42 m × 1.12 m). Edition: 35, plus 8 artist's proofs. Printed by Joseph Wilfer. Published by Pace Editions, New York 172-24.

Textural quality in a drawing depends on the surface on which it is drawn, the inherent character of the medium, and the artist's control of that medium. Dianne Salfas crafts an elaborate, overall surface texture with a buildup of continuous, overlapped, pencil lines (figure 6.15) in a tiny drawing that is self-assured and has the presence of a life-size portrait. The overall texture calls attention to itself; the actual texture of the marks, not an imitated or symbolic texture of the subject, gives the work its visual impact.

In addition to reinforcing the content of a work, texture gives information about materials and media. In this role it surpasses the other elements. Some basic categories of texture, beginning with the traditional ones of actual, simulated, and invented, will lead us to a clearer understanding of this element.

TRADITIONAL CATEGORIES OF TEXTURE

Actual Texture

Texture in its most literal meaning refers strictly to the sense of touch. This is the category of actual texture. For the artist, however, the visual appearance of a work, its surface quality, is most important. Although the actual texture of surface and medium may have a subtle tactile quality, the visual quality is what contributes to the textural character of the work. Chuck Close's paper pulp portrait (figure 6.16) demonstrates how important both the visual and tactile element can be in a work of art. The print can be read on two levels—one referring to the face of a child, the second as a formal means of ordering the picture plane through the use of modules of paper pulp in a range of values. Close is not involved with the traditional means of seeing and rendering normally associated with portraiture; he is concerned as much with how an image is represented as with the subject itself. Although Close's image originates with a photograph, the surface texture is a result of his stated intent of revealing the personal identity of his hand. The uniformity of the dabs of paper creates a textural pattern that tends to compress the space; Close's contemporary pointillistic technique results in a shimmering, flickering image that activates the surface like a handmade dot matrix.

Actual texture refers to the surface of the work (smooth or rough paper, for example), the texture of the medium (such as waxlike crayons, which leave a buildup on the surface), and any materials, such as fabric or paper, added to the surface.

Dokoupil's drawing (see figure 4.6) is an example of actual texture of an unusual medium, one not easily identified without knowledge of the technique used. Texture was created by holding the paper above a candle flame and controlling the carbon deposits that collect on the paper. This technique is called *fumage.* A stencil or piece of paper can be used to block out the white areas. By shifting the stencil and by controlling the thickness of the carbon deposits, a range of values can be created. The texture of the soot is soft and velvety; the imprecise edges of forms suggest they are emerging from darkness.

Texture, as we have seen, not only conveys information about the artist's medium but also gives information about subjective and expressive intent. Fi-

nally, any real material added to the surface of the work is, of course, actual texture; but for our purposes we have created a new category for this additive material, which we will discuss later.

Simulated Texture

Simulated texture, as its name implies, is the imitation of a real texture. It has traditionally been used to represent actual appearance, and many contemporary artists continue to use texture in this way. Simulation can range from a suggested imitation to a highly believable *trompe l'œil* (trick-the-eye) duplication. Remember Rosemarie Trockel's trick-the-eye knitting? Leo Joseph Dee employs contemporary handling of the *trompe l'œil* technique where verisimilitude is the goal (figure 6.17). A torn segment of an envelope is realistically rendered; an isolated detail of the crumpled paper emerges from the blank picture plane. By the title we are given directions to interpret the drawing as a metaphorical stand-in for a landscape. Careful control of the tool, silverpoint on prepared board, and a concentrated observation result in a trick-the-eye texture.

The achievement of an imitation of real textures usually results in the illusion of a three-dimensional image. This simulation, however, can result in a more abstract, two-dimensional space, as in Sylvia Plimack Mangold's drawing of the wooden planks of her studio floor (figure 6.18). The Post-Minimalist artist was struck by the revelation, learned from Eva Hesse, "that studio activity could comprise simply occupying the work space and investigating one's immediate surroundings" (Butler, *Afterimage*, p. 103). Plimack Mangold's work, which conflated a domestic space and work space, presented a transitional moment of paramount importance for feminist artists of the 1970s; it presented a way that more personal, feminist subject matter could be used to promote the same theoretical concerns that concerned male artists who were dealing with process, conceptual art, minimal means, and antiform.

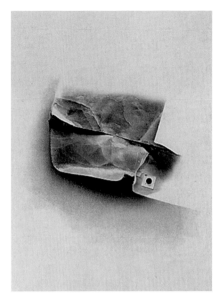

6.17. LEO JOSEPH DEE. *Paper Landscape.* 1972. Silverpoint on gesso-coated museum board, 2′11⅛″ × 2′2″ (88 cm × 66 cm). Yale University Art Gallery, New Haven, Conn. Purchased with the Aid of Funds from the National Endowment for the Arts and the Susan Morse Hilles Matching Fund. © Joseph Szaszfai.

6.18. SYLVIA PLIMACK MANGOLD. *Untitled (Wide Planks).* 1973–1974. Acrylic and pencil on paper, 2′6″ × 3′4″ (76 cm × 1.02 m). Courtesy Alexander and Bonin, New York.

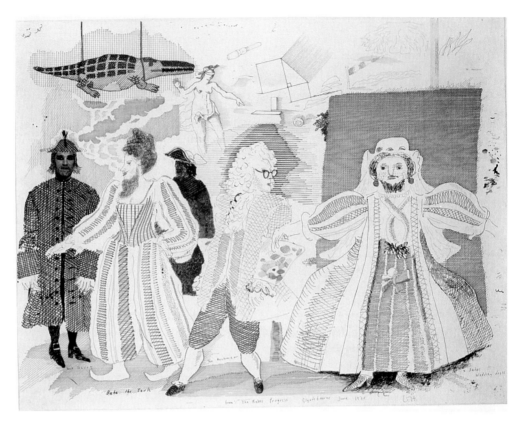

6.19. DAVID HOCKNEY. "An Assembly" from *The Rake's Progress.* 1975. Pen, colored inks, cut and pasted paper, 1'7¾" × 2'1⅝" (49.9 cm × 65 cm). Museum of Modern Art, New York; gift of R. L. B. Tobin. © David Hockney. Photograph © 1997 The Museum of Modern Art, New York.

Invented, Conventional, or Symbolic Texture

Invented, or decorative, textures do not imitate textures in real life; the artist invents the textural patterns. Invented or conventional textures can be used as nonrepresentational patterns, as in David Hockney's sketch for the stage designs for *The Rake's Progress* (figure 6.19). Or they also may be abstracted, conventional textures symbolizing actual textures; for instance, Hockney uses symbolic notations for hair, fabric, and crocodile skin.

James Rosenquist's work is a concise compendium of texture, a good choice to conclude our discussion of actual, simulated, and invented texture. In his lithograph *Iris Lake* (figure 6.20) he combines all three categories of texture—actual, simulated, and invented. Texture is, in fact, the subject of the work. The image on the left is an example of invented texture; the image in the center simulates crushed paper; and the third image makes use of actual texture in the marks and rubbings. The pictorial space is ambiguous because the illusionistically three-dimensional elements are placed in a flat, white field. Are the shapes on top of the plane or are they holes in its surface? The black vertical lines reinforce this ambiguity.

Of course, texture is a critical element whether used referentially or independently of the subject depicted. Just as we could make a scale of artistic choices with realism at one end and nonobjective art at the other, there are gradations in the use of texture, too. Texture, although it can be used to record the observed phenomenon of external reality, always relays information concerning media and surface.

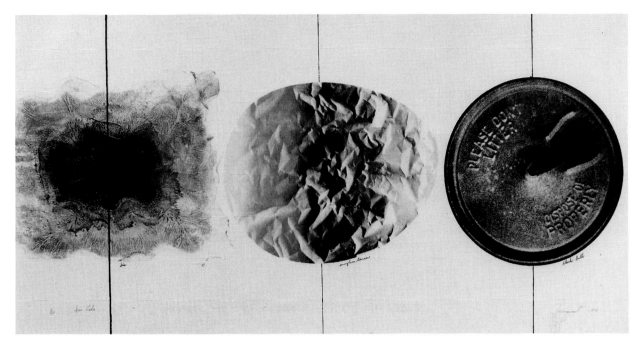

6.20. JAMES ROSENQUIST. *Iris Lake.* 1974. Lithograph, 3′½″ × 6′2″ (93 cm × 1.88 m). Marian Goodman Gallery. © James Rosenquist/Licensed by VAGA, New York.

PROBLEM 6.1
Using Actual Texture

In this problem, focus on the texture of the drawing medium itself, its inherent qualities. Cut several sheets of 18-inch-square cardboard or mat board. Use several media such as pencil, chalk, pastel, charcoal, or a combination in conjunction with a flat, water-based house paint. Begin with a gestural network of lines using various media; then overlay some sections with paint. You can use scumbling, drips, abrasion, drawing, redrawing, and repainting until you have achieved an interesting surface. You might think in terms of a wall with scaling paint, or some weathered surface. You are not copying or imitating a found surface; you are involved in a process in which the surface is a record of your activity. Do not develop a focal point; the texture should vary from section to section but there should be no focal point. The transitions between one area and another should be subtle. Your goal is to make an interesting textured plane.

At a later time you might want to use this technique for building a surface on which to draw.

PROBLEM 6.2
Using Simulated Texture

Choose as your subject a textured, two-dimensional surface, such as a weathered piece of wood, a textured piece of wallpaper, a piece of fabric, or a carpet sample. Photocopy several of these textures, and make studies of both the actual texture and the photocopy in your sketchbook. After making a number of sketches, make a finished drawing in which you incorporate several kinds of simulated texture.

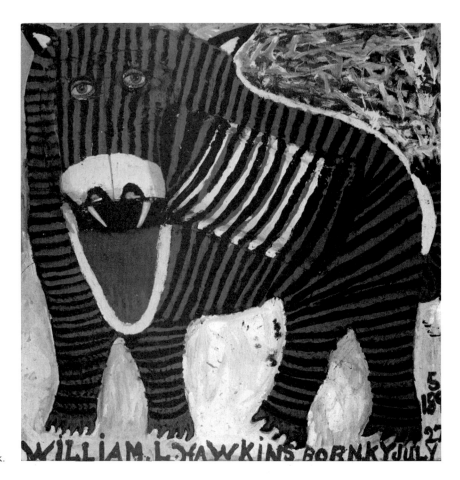

6.21. WILLIAM L. HAWKINS. *Tasmanian Tiger #3*. Ricco-Maresca Gallery, New York.

PROBLEM 6.3
Using Invented Texture

For this drawing invent a mythological creature. Once you have decided on a subject, draw your conceptualized character by using enclosed shapes in both positive and negative spaces. Fill the entire page with enclosed shapes that you define by invented textural pattern or outline. Use pen and ink or black-and-white acrylic on fabric. The absorbent quality of the cloth will provide a softer and much different texture from paper. Experiment with several kinds of fabric; a tighter weave will allow you more control. Suggested fabrics include muslin, duck, sailcloth, or canvas.

You may change the scale of the textural pattern within a shape to indicate a spatial progression or you may choose to use an ambiguous space, as in the drawing by the African artist Michael Abyi (see figure 1.6). This lively ink drawing on fabric deals with a mythic subject, *The Twins Who Killed Their Father Because of His Properties*. Every inch of space is activated with bulging biomorphic shapes defined by decorative line-and-dot patterning; textural variations fill the composition, crowding out empty space. The compact design is made up of invented textures and fantastic shapes that reveal the artist's fertile imagination.

Outsider art, art made by untrained artists, is a particularly rich source for textural inventions. The fantastic red, black, and white Tasmanian tiger

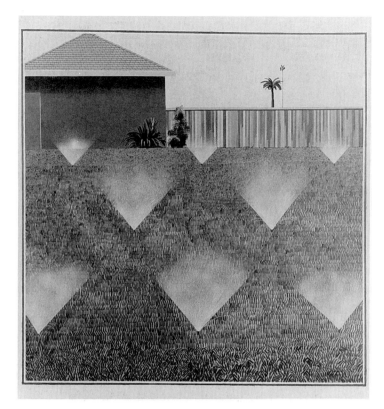

6.22. DAVID HOCKNEY. *A Lawn Being Sprinkled.* 1967. Acrylic on canvas, 5′ × 5′ (1.524 m × 1.524 m). Collection of the artist. © David Hockney.

made by William L. Hawkins (who provides his date and place of birth along with his signature) presents a wonderful, uninhibited use of invented texture (figure 6.21). Repetition builds the body of the beast, which has seductive collaged eyes. A white line separates the tiger from a scumbled background shape; the whites are distributed throughout the drawing in varying shapes and sizes. There is an obsessive quality to the work that contributes to its charm. Textures are totally unrelated to the real world—except that maybe Tasmanian tigers really are striped. Hawkins has created an active, energetic surface texture by using a lively application of paint and repetition.

PROBLEM 6.4
Using Conventional or Symbolic Texture

Represent various surfaces in an imaginary scene by means of conventional or symbolic texture. You may choose to draw an imaginary scene or landscape or you might try drawing your room from memory. Use a variety of textures and aim for a symbolic interpretation (see figure 6.18). A comic-strip style would be appropriate for this problem.

In David Hockney's depiction of a backyard scene (figure 6.22), symbolic or conventional texture dominates the composition. Repeating rows of diminishing marks indicate grass; inverted triangles of spray paint represent sprayed water; alternating stripes of random value suggest a fence; rectilinear shapes predictably describe roof tiles. Hockney's commitment to invented texture has remained a constant throughout his career. Like many artists,

Leonardo da Vinci among them, Hockney has always been interested in the depiction of water. Subjects such as pools, fountains, and showers continue to elicit inventive responses to the numerous ways moving water can be drawn.

TWENTIETH-CENTURY TEXTURES

Additive Materials to Create Texture

Earlier in the text we mentioned the Cubists' innovations of including collage and other additive materials in their art (figure 6.23). In distancing themselves from the confines of tradition, Pablo Picasso and Georges Braque found that collage gave them increased formal and technical freedom. Through the medium of collage the Cubists found they could introduce the space of their public social life into their art. Café- and urban-inspired motifs—smoking accessories, wine bottles, and newspapers—set the table, so to speak, for a new order of still life. Using ordinary, daily, commonplace objects, the Cubists developed a new pictorial syntax, and their innovations with space and texture—actual, invented, and symbolic—played a decisive role in the development of later art of the nineteenth century. Philosophically, these additive nonart materials expanded our ideas of what art can be.

To see how flexible additive materials can be in retaining a sense of their previous identity while functioning compositionally within the work, look at Rauschenberg's combines (see figure II.22).

We can divide such additive materials into two classifications: *collage* and *assemblage*. Collage is the addition of any flat material, such as paper or fabric, to the surface of a work. Assemblage is the use of dimensional material attached by any means—glue, nails, wire, or rope, for example.

In the visual arts a major development by the Dadaists was *montage*—the combining of photographs, posters, and a variety of typefaces in startling new

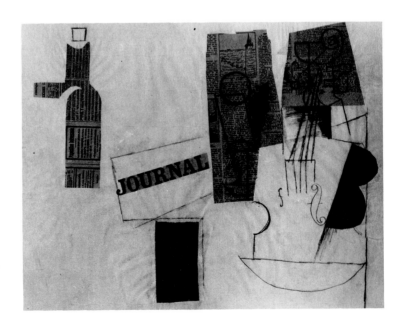

6.23. PABLO PICASSO. *Bottle, Glass and Violin.* 1912–1913. Paper collage and charcoal, 1′6½″ × 2′⅜″ (47 cm × 62 cm). Moderna Museet, Stockholm. © 2003 Estate of Pablo Picasso/Artists Rights Society (ARS), New York.

juxtapositions. The aim was to jolt the viewer; shock was the motive. These raffish antiart artists began their campaign in 1918. They attacked the status quo, both in art and in politics. Artistic chaos paralleled political chaos. The Dadaists needed a disjunctive art form to hold up as a mirror to a world out of control. Montage became their primary means.

One of the best-known artists to emerge from this movement was Kurt Schwitters. His collages are made up of tickets, newspapers, cigarette wrappers, and rubbish from the street (figure 6.24), resulting in rich textural surfaces. An important element in Dada is randomness or chance as a compositional principle. The informality and looseness of Dada compositions along with a use of perishable materials had a lasting effect on later art in the century. Schwitters's engagement in everyday life resurfaced in the 1960s with the Pop artists' choice of banal, everyday subject matter. His famous claim to be a painter who nailed paintings together could be made for many of today's artists.

Several definitions of terms will be useful here in talking about texture. *Papier collé* is a term for pasting paper to the picture plane; *photomontage*, as its name implies, uses only photographs; *collage*, like *montage*, is any flat material put together to create a composition. Works using papier collé, collage, montage, and photomontage usually remain flat, although they can be built up in relief.

6.24. KURT SCHWITTERS. *Merzzeichung 75 (Merz Drawing 75)*. 1920. Collage, gouache, red and black printer's ink, graphite on wood-pulp papers (newsprint, cardboard), and fabric, 5¾″ × 3¹⁵⁄₁₆″ (14.6 cm × 10 cm). Peggy Guggenheim Collection, Venice. The Solomon R. Guggenheim Foundation, New York. © 2003 Artists Rights Society (ARS), New York/VG Bild-Kunst, Bonn.

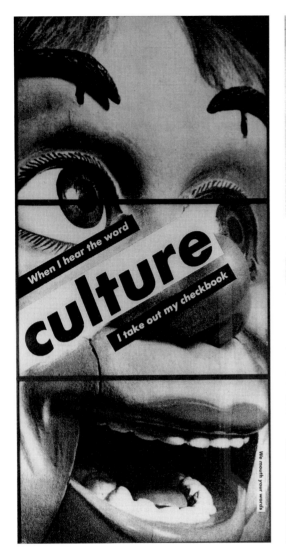

6.25. (above left) BARBARA KRUGER. *Untitled (When I Hear the Word Culture I Take Out My Checkbook).* 1985. Photograph, 11′6″ × 5′ (3.51 m × 1.52 m). Mary Boone Gallery, New York.

6.26. (above right) JACQUES DE LA VILLÉGLÉ. *Metro Saint-Germain.* 1964. Torn posters, 1′7″ × 1′1½″ (48.3 cm × 34.3 cm). Zabriskie Gallery, New York. © 2003 Artists Rights Society (ARS), New York/ ADAGP, Paris.

These techniques are alive and well in contemporary art, and nowhere are they more evident than in Barbara Kruger's work with its pointed exposé of establishment values (figure 6.25). Kruger has a moral mission in her work. She uses a visual method of deconstruction in demanding a reassessment of accepted ideas; she presents the underlying mechanisms of society and asks us to recognize how much we are controlled by them. Her method is to overlay a terse statement on a photographic image. In the work shown here, it is at the junction between the two lines that we find a biting admission. Near the puppet's mouth is a line of tiny print that says, "We mouth your words." The message is clear, and the billboard size is not an easy one to ignore. Kruger's work begins with photographs and typography and is then mechanically reproduced; so the resulting image, although resembling a montage, is actually a single, unlayered plane. Kruger uses images appropriated from popular media to underscore her sociopolitical message. Appropriation may be used as a

means of deconstruction; the appropriated image is given the task of revealing or exposing a hidden or underlying bias.

One final update on collage before we move on to our discussion of assemblage—Jacques de la Villéglé's work (figure 6.26) is an offshoot of collage. He calls his work *décollage* (unpasting); he pulls down and reveals hidden, layered posters from Parisian walls, executing his art without scissors or paste. This idea had already been suggested as a possibility by Dada artists. Villéglé stresses the impersonal character of his work; he describes himself as an "anonymous lacerator."

Assemblage, firmly in place in the 1960s, has held a continuing attraction, not only for Pop artists, but for artists of the Post-Modern period as well. Consumer culture and its mechanisms are designed to make objects appealing and seductive; Pop artists used the same mechanisms as the basis of their consumer-object parodies. The acquisitive instinct is both encouraged and made fun of in Pop art. A more coded, ambivalent message is inherent in the work of European artists who were working contemporaneously with their American counterparts. Arman, a French assemblage artist, makes use of accumulation or quantity for its own sake (figure 6.27). The critic Margit Rowell says that "these victimized objects [have been] transposed according to new systems of representation [and] are not assembled as a eulogy to modernity" (Rowell, *Objects of Desire*, p.167). She sees them as a "nostalgic ode to almost obsolete humanistic values."

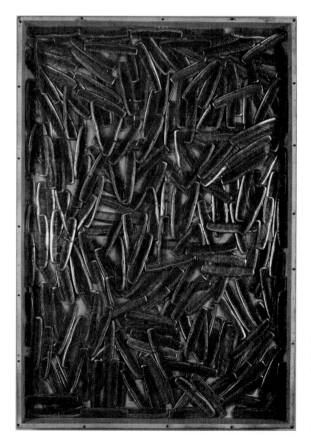

6.27. ARMAN. *The Gorgon's Shield.* 1962. Accumulation of silver-painted dog combs, 4′5″ × 3′1″ × 5″ (1.35 m × 94 cm × 12.5 cm). APA #8002.62.023. Collection Armand P. and Corice Arman. © 2003 Artists Rights Society (ARS), New York/ ADAGP, Paris.

Arman's reiteration of the same object has the effect of repeating a word so many times you lose the sense of its meaning and retain only the sound. His assemblage of painted dog combs is a visual enactment of this phenomenon. It becomes a formal design of texture, line, and value, that is, until you read the title and try to unscramble clues to meaning. In Greek myth the heroic Perseus was sent to destroy the Gorgon, Medusa, a terrible monster whose hair was writhing serpents; so frightful was her aspect that any living thing that looked at her was turned into stone. Perseus, who was able to see Medusa's image reflected in the bright shield given to him by the goddess Minerva, cut off her head. Now that we have all the missing pieces, we can unravel the meaning in Arman's assemblage. The dog combs refer to Medusa's ringlets of snakes; the silver paint with which they have been painted converts them to Minerva's bright, reflective shield that guided Perseus to the Gorgon. A contemporary update of an ancient myth is retold with an improbable image that carries multiple symbolic references.

Depending on the dimensional items added to the surface, an assemblage can range from a low relief to a freestanding, three-dimensional composition. It can combine both two- and three-dimensional elements in the same work. The object as a work of art had two major influences: Cubist collage and Dada, which opened art to include heretofore nonart objects. Perhaps the American artist best known for his objects and for his assemblages is Joseph Cornell. His intimately scaled, beautifully crafted, poetic works are shadow-box glimpses into a private, intense world (see figure II.12)

A logical development of assemblage is the blurring of categories between two- and three-dimensional art. In earlier times the separation of sculpture, painting, and drawing was readily determined. Today the demarcation is less precise. Installations, such as the chaotic environment created by the Soviet artist Ilya Kabakov in *The Man Who Flew into Space from His Apartment* (figure 6.28), use drawing, painting, and photography with real objects. The diorama of a grim communal Moscow apartment is accompanied by an extravagantly fantastic narrative written by the artist. In his fictive account the lonely inhabitant of the room realizes his dream of a flight into space by catapulting himself through the attic with his vault. The ceiling is ripped away by the explosion, leaving the squalid room in shambles. Kabakov absurdly concludes that in all probability the project was successfully realized. Even this turbulent and illogical piece does not measure up to the dramatic chaos experienced by the Soviet states in recent years.

In collage, montage, photomontage, assemblage, and installations, bizarre and unlikely combinations press the viewer to interpret, to find meaning in the disparate pieces. The breakdown of conventional categories and predetermined rules for art has helped close the gap between art and life, a steadfast goal of the artists of our era.

PROBLEM 6.5
Using Papier Collé

For this problem, reassemble old drawings to create a new work. For example, you might tear up old figure drawings and rearrange the pieces to make a landscape. Pay attention to the shapes of the torn paper and to the marks drawn on them. Paste the torn paper on a piece of heavy supporting paper and redraw, integrating the papier collé into the work.

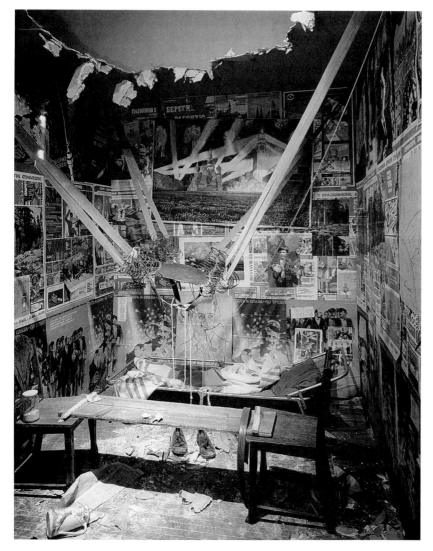

6.28. ILYA KABAKOV. *The Man Who Flew into Space from His Apartment.* 1981–1988. From *Ten Characters.* 1988. Installation, six poster panels with collage, furniture, clothing, catapult, household objects, wooden plank, scroll-type painting, two pages of Soviet paper, Diorama; room 8′ × 7′11″ × 12′ (2.44 m × 2.41 m × 3.73 m). Ronald Feldman Fine Arts Inc. © 2003 Artists Rights Society (ARS), New York/ VG Bild-Kunst, Bonn.

You should take into consideration not only the shapes of the piece of collage but the marks on them and how they relate to each other. Try to integrate the torn paper and the fragmented lines before adding more drawing.

PROBLEM 6.6
Using Collage

Make an arrangement of real objects directly on a photocopy machine. Flat objects copy better than dimensional ones, although objects of low relief work well too. You need to be able to close the cover of the copier to get a good print. Make several different compositions, altering placements of the objects until you have a good selection. Choose one of these to develop into a final drawing. Take care in choosing the objects; try for a wide range of textural variety. You may draw on the surface, using such media as colored pencils, grease markers, pencil, or ink. You might make a grid of several of the

copies backing them with mat board to support the weight. The result could be an odd amalgamation of seemingly realistically rendered textures in illogical relationships. If you include collage pieces of different sizes, the disorientation will be even greater. Your goal, however, is not disorientation; it is to integrate a number of disparate textures on a single surface.

PROBLEM 6.7
Using Assemblage

Make an assemblage that takes into account some aspect of history. You might find photographs, illustrations, and three-dimensional objects that relate to a particular historical event to use in making a bas-relief or shadow box. Reacquaint yourself with Joseph Cornell's boxes (see figure II.12). Cornell not only made boxes, he produced refined collages using old prints and engravings that embody the same poetic sensibility as his three-dimensional work.

Transferred Texture

Related to both actual texture and simulated texture is the transfer of a texture from one surface to another, a technique called *frottage*, reinvigorated by the Surrealists in the 1920s. This transfer can be made by taking a rubbing from an actual textured surface or by transferring a texture from a printed surface onto the drawing. Transferred textures cannot clearly be categorized as actual texture or simulated texture because they possess elements of both; they belong to a crossover category.

The technique of stone and bronze rubbing is an ancient one, popular in earlier times for making transferred images of tombstones and low-relief sculptures found in churches and churchyards (figure 6.29) In a complete reversal

6.29. ANN PARKER & AVON NEAL. *Timothy Lindall. Salem, Massachusetts . . . 1698/9.* 1963. Stone rubbing, 1′6½″ × 1′11¾″ (47 cm × 60.3 cm). Amon Carter Museum, Fort Worth, Tex.

6.30. JACK WHITTEN. *Studio Floor #1.* 1970. Carbon stick rubbing on paper, 1′1″ × 1′8″ (33 cm × 51 cm). Collection of Jack Whitten.

of intent and effect of the traditional rubbings are the process works of Jack Whitten (figure 6.30). The puzzling questions that faced the Post-Minimalists were how to construct a drawing or painting that is not a representation, how is a drawing made, and how it functions in terms of the space of a painting. Whitten found a solution by making rubbings of the walls and floors of his studio; he found a way to condense and summarize his studio activity through marks that record his time and labor.

Transfer from a printed surface is a widely used contemporary technique. The image to be transferred is coated with a solvent, then laid face down onto the drawing surface and rubbed with an implement such as a wooden spoon, brush handle, or pencil. The directional marks made by the transfer implement provide additional textural interest in a drawing. Robert Rauschenberg developed the technique of transfer from a printed surface in the 1950s as a means of reintroducing representational imagery different from other realist techniques (see figure II.22). He used secondary sources taken from the mass media in his transferred imagery in drawings and prints. In an illustration for Dante's *Inferno, Canto XXI, Circle Eight, Bolgia 5, The Grafter* (figure 6.31), Rauschenberg made his earliest experiments with transfers, combining them with gouache, collage, graphite, red pencil, and wash. The marks made by the implement in transferring the images provide textural unity for the composition. The overall sameness of line direction has the effect of flattening out the images. At the same time the streaked lines build on one another to make an agitated surface, creating a nervous movement throughout the work. Dante's *Inferno* is given a modern interpretation; war, quite literally, is hell. Texture reinforces the drawing's bleak message.

Another technique claimed by artists is the photocopy. It is an accessible and speedy solution to providing multiple images so prized by contemporary artists. Photocopied images are a rich source for collage. The readily available process depends on the texture inherent in the medium of the copy and the texture of the object being photocopied. Photocopies lend themselves easily to the process of transfer.

6.31. ROBERT RAUSCHENBERG. Illustration for Dante's *Inferno: Canto XXI, Circle Eight, Bolgia 5, The Grafter.* 1959–1960. Red and graphite pencil, gouache, cut-and-pasted paper, wash, and transfer, 1′2⅜″ × 11½″ (37 cm × 29.3 cm). Collection, Museum of Modern Art, New York. Given anonymously. © Robert Rauschenberg/Licensed by VAGA, New York. Photograph © 1997 The Museum of Modern Art.

PROBLEM 6.8
Using Rubbing

Using a graphite stick, a litho stick, or a china marker, make rubbings of several textured surfaces, combining them into one image or into one composition. By changing pressure on the drawing implement and by controlling the line direction, you can create a range of values. In addition to creating interesting textures, aim for some spatial tension in the work. Line direction and change in value will help establish a sense of space. The resulting space will, of course, be ambiguous since the rubbing technique creates a uniform texture within a shape.

Oriental papers are good for rubbed drawings. They are strong and can withstand the friction without tearing, and they are texturally interesting. Consult the Practical Guides for a list of papers.

PROBLEM 6.9
Transfer from a Printed Surface

Read this problem in its entirety before beginning. For this project you may use images from magazines or newspapers or photocopies of images. If you choose photocopies, duplicate several images to be used in one composition. You may wish to copy the same image several times, either enlarging or reducing the scale on the copy machine. Use a machine that produces a good value contrast.

Create a drawing made of transferred images. Alcohol can be used for transferring photocopies, turpentine or Nazdar for magazine images. Lightly brush the solvents on the back side of the image to be transferred, and let it set a minute so that the ink will soften before beginning to rub. Lay the image face down on the picture plane and rub with a wooden spoon, brush handle, ballpoint pen, or pencil. Work in a well-ventilated space.

After having decided on placement, distribute the transferred images throughout the picture plane. You can keep all the lines going from right to left, across, or up and down; pay attention to the patterns the lines themselves make regardless of the image. You can turn your paper and work from all sides for a different effect. You may find that the transferred images need no additional drawing, or you may integrate the composition by using gouache, graphite and turpentine, watercolor, or ink wash. Graphite sticks and pencils make more subtle additions to the transferred images. Be selective in your additive marks. The very nature of transfer is its rather blurred and indistinct quality. The negative marks, the white marks that show between the intermittent rubbed lines, allow the paper to come forward and to create an interesting ambiguous space. You may choose to draw over certain areas to unify the work so that the images emerge from and dissolve into the background space. Rather than adding colored or textured elements, transfer them from another surface.

Work on several drawings at a time, creating a thematic relationship between them by using related images in each piece. You might base your theme on a favorite novel, poem, or song. Use images from current publications for your transfers. The newer the print (such as today's newspaper), the better the transfer, because the ink has not yet set. More recently printed magazines are easier to use than older ones.

Familiarize yourself with Rauschenberg's prints and drawings, where this technique is used extensively. You will find a number of books on his work in the library.

A heavier paper, a good quality rag paper, is ideal for this problem. You can even transfer images onto silk, cotton, or other fabrics. Consult the paper list in the Guide to Materials.

While Sigmar Polke has not used transfer in his wall-sized painting, it might be informative to analyze his work before beginning this project. In Frau Herbst und ihre zwei Töcher (*Mrs. Autumn and Her Two Daughters*) (figure 6.32) Polke has imitated and vastly enlarged images taken from nineteenth-century wood engravings; the theme is an allegory in which Mrs. Autumn, the seasonal Mother, cuts up pieces of paper that her daughters strew over an abstract landscape in imitation of a snowstorm. On the formal side, the deft control and scale of the mimetic copy in conjunction with the experimental abstraction in the remaining space set up a deliberate dissonance of textures, styles, images, scale, and media. The compression of time and sensibility between the images and styles is a suitable foil for Polke's attack on the coherence of Modernism and the cult of the personality of the artist.

SUMMARY

We will conclude our discussion of texture with a description of Robert Morris's project that has spanned over three decades. Morris's *Blind Time Drawings* involved the body's implication in making a work of art (figure 6.33). By blocking his vision, he separated it from the normal hand-eye coordination so essential to art making. Not only could he not see the marks he was making, he could not see the geometry of the sheet he was working on. The drawings were made directly with his hands; no implement intervened between his hands and the paper. He made an initial series of 98 drawings that were "task oriented" and were to be made within a preset time period. There is a legend in the corner of each drawing that records the activity by type and time. His aim was "to relinquish control and distance, authorship and ego." A catalog entry from his retrospective show at the Guggenheim reads ". . . the black velvet of the powdered graphite reading less as a trace or imprint of the hands'

6.32. (above left) SIGMAR POLKE. *Frau Herbst und ihre zwei Töchter (Mrs. Autumn and Her Two Daughters).* 1991. Artificial resin and acrylic on synthetic fabric, 9′10″ × 16′4¾″ × 1⅝″ (3 m × 5 m × 4 cm). Collection Walker Art Center, Minneapolis; gift of Ann and Barrie Birks, Joan and Gary Capen, Judy and Kenneth Dayton, Joanne and Philip Von Blon, Penny and Mike Winton, with additional funds from the T. B. Walker Acquisition Fund, 1991.

6.33. (above left) ROBERT MORRIS. *Blind Time XIX.* 1973. Powdered graphite and pencil on paper, 2′11″ × 3′10″ (89 cm × 1.17 m). Virginia Wright Fund. The Washington Art Consortium: Henry Art Gallery, University of Washington, Seattle; Museum of Art, Washington State University, Pullman; Northwest Museum of Arts and Culture, Spokane; Seattle Art Museum; Tacoma Art Museum; Western Gallery, Western Washington University, Bellingham; Whatcom Museum of History and Art, Bellingham. Photo by Paul Macapia, © 1977. © 2003 Robert Morris/Artists Rights Society (ARS), New York.

passage over the page than as a mirror surface for touch itself—the drawing touching back the artist's hands" (Butler, *Afterimage*, p. 97).

Texture, the touch of the drawing's hands and touching the viewer's eyes, is an element that pays rich rewards in both making and viewing.

SPATIAL CHARACTERISTICS OF TEXTURE

Generally, uniform use of textural pattern and invented texture results in a relatively shallow space. A repeated motif or texture that remains consistent throughout a drawing tends to flatten it.

The use of simulated and invented texture in the same drawing results in arbitrary space, and so does a combination of simulated texture and flat shapes.

Simulated texture is more dimensional than invented texture. If sharpness of textural detail is maintained throughout the drawing, space will be flatter. Diminishing sharpness of textural detail results in a three-dimensional space. Objects in the foreground that have clearer textural definitions than those in the background usually indicate an illusionistic space.

In summary, simulated texture is generally more three-dimensional than invented texture. Repeated patterns or textural motifs result in a flatter space. Spatial ambiguity can result from a use of simulated and invented texture in the same work.

SKETCHBOOK PROJECTS

PROJECT 1
Identifying Textural Techniques Used in Depicting Water

This assignment goes beyond the actual sketchbook. In the library look at some work by artists who use images of water in their work. Be sure to look at the notebooks of Leonardo da Vinci with their scientific and visual investigations of the properties of water.

In your sketchbook take verbal and visual notes of how the various artists have approached the problem of depicting this symbolically loaded element. Classify the textures according to the various categories discussed in this chapter. Note the scale of textural variety from photo-realistic to illusionistic to symbolic to abstract. Describe the kinds of marks, styles, and media used to achieve various textural effects.

PROJECT 2
Transcribing Textural Techniques

Make a list of different kinds of water images—for example, swimming pools, waterfalls, natural pools, lakes, oceans, droplets, water running from spigots, bathtubs, showers, sprinklers, birdbaths, boiling water, ice water in a glass, steam, fog, rain, splashing water, standing water, turbulent water, and so on—the list should be as comprehensive as possible. Write verbal descriptions of the characteristics and properties of each item on your list.

Choose a minimum of seven kinds of water to transcribe into drawn textures in your sketchbook. The size of each textural notation should be at least

four inches square (10.16 × 10.16 cm), or it can fill a full page. Experiment with different kinds of media and with different kinds of marks. Scale is an interesting aspect of this project. In some of your transcriptions try for an accurate description; in others synthesize the information in a nonconventional approach. Make five drawings for each category.

Variations on this problem can be done with an endless number of textural challenges: urban textures, manufactured surfaces; natural, organic textures, such as animals, plants, or minerals; secondhand textures drawn from found printed surfaces, such as photographs or illustrations. You might want to devote a special notebook to textures for reference in later work.

Both transcribing visual textures and inventing ways to symbolize texture will sharpen your perceptual and conceptual skills. Finding the appropriate textural notation for the message in the work is a lifelong challenge for the involved artist.

COMPUTER PROJECT

PROJECT 1
Creating Texture on the Computer

Paper selection is the only control the computer graphic artist can exert in regard to the actual physical texture of a computer drawing. However, the computer has limitless possibilities for simulated and invented textures. Use the computer to generate texture samples for a collage.

There are many ways to create textures on the computer: Actual textures can be photographed with a digital camera and downloaded to your computer; objects can be scanned directly into the computer; textural images can be found on the Internet and printed; and finally, textures can be created via graphics programs, such as Adobe Illustrator and Photoshop.

Here are some ideas for creating texture samples on the computer. They may be printed in black and white or color. Use the controls in your scanner program to manipulate color and value. Scan the following into your computer:

A towel
A piece of wrinkled aluminum foil
A printed, textured fabric
A weathered piece of wood

Using a digital camera, photograph:

Grass
Pebbles
Rusty metal
Animal fur
Skin (your hand, for example)

Try to fill an entire frame with your chosen texture. Now try to create your own textures in Adobe Illustrator. Use various line qualities available to create a network of interesting lines. Make at least five samples, ranging from light to dark and from organized to chaotic. Again, fill the entire page with this texture. (This can be done quickly with *cut-and-paste tools.*)

Bring all of your samples to class and install a wall of textures using samples from the entire class. Look at the examples for interesting ways to create texture.

Using sample textures, cut and tear shapes to create a collage. Pay attention to contrasting values and to contrasting textures, such as smooth and rough. Use a spray adhesive or glue stick to attach the shapes to the picture plane. You may add some actual texture (such as string) to the finished piece.

Color

Color is a vital necessity. It is raw material indispensable to life, like water and fire.
FERNAND LÉGER

FUNCTIONS OF COLOR

Our language is filled with references, analogies, metaphors, descriptions, and allusions to color. Kandinsky described his city scenes as "yellow enough to cry" (Eleanor Munro, "Where Postmodern Art and Schizophrenia Intersect," *New York Times*, March 31, 2002, Art/Architecture 34). Whether shrill or cacophonous, sweet or somber, saturated or pale, color speaks in an evocative voice. Cy Twombly calls attention to the emotive, expressive, symbolic, and associative powers of color in his work that, except for its size, resembles a discarded page from an intimate diary (color plate 7.1). In mute, stuttering handwriting he scribbles the heart-wrenching message, "In his despair he drew the colors from his own heart"; and that color from the heart is red, quite a contrast to the dark and somber mood of the scarcely legible written fragment. This work would carry a

different meaning and emotive content if it were made in another color. The scale of the handwriting, enlarged to the nearly five-foot-high format, makes us confront the drawing and its message as something more than a discarded sheet of paper. Twombly's scrawled writing evokes a visceral response, and being aware of that, he chose the most powerfully loaded symbolic color of all—red—to carry the impact of the message.

More than any other element, color has a direct and immediate effect on us, on the emotional, intellectual, psychological, even the physiological level. It evokes associations and memories; it can provoke the full gamut of physical responses, such as anger, excitement, sadness, peacefulness, and joy.

In daily language we use color in our descriptions of objects in the real world. In addition, we use color to describe such phenomena as a musical instrument's timbre or distinctive sound quality by referring to its tone color; a chromatic scale in music refers to a scale using all twelve semitones. In language color is used to describe an ornate style or one that has particularly vivid descriptiveness. "Colorful characters," "colorless situations," "things take on a different color," "alibis are colored," "anger colored her decision"—expressions such as these give vitality to our language and underscore how deep-seated our human response to color is. In our everyday conversations adjectives relating to color are legion: gaudy, bright, intense, fresh, deep, gay, brilliant, lustrous, florid, flashy, glaring, soft, subdued, tender, dull, lifeless, leaden, muddy, pale, sallow, faded, lackluster—we could go on for pages. Color lies at the very core of our sensual, visual, and conceptual experiences.

Children intuitively seem to understand not only the aesthetic function of color but its symbolic significance as well. Exciting and unexpected color combinations are also found in the work of self-trained artists. Color can reach from the intuitive to the sophisticated, as seen in the work by Jessy Park (color plate 7.2). In spite of her autism, Park is an amazingly gifted colorist and artist. The scientist Oliver Sacks writes that she is obsessed with enormously intricate complex "systems," in which "weather, mood, flavors, colors—a dozen variables—are all interconnected and correlated with one another." For over twenty years Park has transformed her obsessions into art, in which an "uncanny accuracy of line is combined with colors of surreal brilliance." Park's mother writes that her obsessions include "Stars, Rainbows, Clouds, Weather phenomena. Quartz heaters. Odometers. Street lamps. A strange process of obsessions, eliciting for a year or two an intensity of emotion approaching ecstasy"(Oliver Sacks, "Leaving Nirvana," *New York Review of Books*, March 29, 2001, pp. 4, 5). Through her art her obsessions have been elaborated, transformed into architectural images whose colors transmit an intense feeling in the viewer as well. The "migraine-type lightning" symbols in the drawing seem to have coalesced into an architectural construction that emits a fluorescent light. The high-keyed pastel colors are electrified by the diagonal yellow band and red stripe in the lower right-hand corner. The insistent attention to detail results in an elaborately patterned surface. Park gives us a look into a different reality, and we are richly rewarded by it.

Culture is a determinant of how color is viewed; for example, the color of royalty in Eastern cultures is green, whereas in European cultures it is purple; black is symbolic of death in European cultures, while in many African cultures white signifies death. There are as many ways of looking at the world as there are people in it. Space and time are experienced differently by different cultures, so it comes as no surprise that color should not be exempted from

cultural interpretation. One of the positive benefits of art is that it may lead to acceptance of differences in people and cultures when other efforts fail. Viewing art from other cultures and trying to understand its bases are ways to expand our humanity.

Attitudes toward color are culturally and historically revealing. Born in Pakistan and now living in Texas, Shahzia Sikander was trained in the traditions of Indian and Persian, Mughal and Pajput, miniature painting. Using the format and formal devices of miniatures, Sikander uses vegetable color, dry pigment, and watercolor tea on hand-prepared wasli paper to make drawings (some only inches high) that echo the vibrant colors and expressive subjects of their predecessors (color plate 7.3). Miniature painting is a convention-bound art form that demands the use of hand-prepared pigments and burnished paper to give the colors their distinctive luminescent quality. Sikander places the much-used image of traditional miniatures—women awaiting the arrival of a lover—in a chaotic contemporary condition. Although the subcontinent is the subject of her work, India is transformed into a political and personal symbol rather than a specific geographical location. Color, technique, format, and formal devices point us to a world that is more distant than miles would indicate.

Juan Sánchez, an American-born artist of black and Puerto Rican descent, creates work that reflects his ethnically diverse background (color plate 7.4). His work combines religious, mythical, and cultural symbolism with a strong social consciousness. He uses both *barrio* and Anglo sources for ideas and images. Sánchez describes his efforts as "Rican/structions" ("reconstructions") forging a relationship between his homeland and his Brooklyn neighborhood. His sensuous palette is emotionally charged; we can feel the island's climate in his color choices. The colors from the tropical landscape unify Sánchez's work, and they provide a symbolic underpinning of his visual ideas. He uses large-scale, altarlike formats on which he combines photos, newspaper clippings, and religious artifacts with handwritten texts inscribed over and around the images. The textural surface of the paintings reminds one of urban walls with graffiti and torn posters. Sánchez combines abstract shapes with religious icons and photographs, fragments from everyday life. Layered, hot colors, actively applied, connect the disparate segments both conceptually and formally.

At certain periods of time people have expressed decided color preferences; for example, in the 1960s Americans generally preferred clear, intense colors associated with advertising and television. In the 1980s Victorian color schemes for houses made a popular return, a break from the preference for all-white houses that prevailed for many years. In the 1990s, more subtle and complex color combinations found favor; layering colors on walls is a revival from historic periods. Even geography plays a part in color preference; certain colors seem to be right for specific climates, such as pastel colors for the tropics or the rich range of grays in New York City.

COLOR MEDIA

The importance of materials in the use of color cannot be overestimated since the work is as much a product of what it is made of as how or why it is made. Involvement, practice, and experimentation with color media will give you new respect for the integral nature of each medium. Pastels are dry and chalky;

watercolors are transparent; gouaches are opaque; acrylic and oil can be used as thin and fluid washes or they can be applied in a thicker, flatter, more opaque state; pen-and-ink drawings can be scratchy; ink-and-brush drawings can be fluid, stippled, rubbed, or dabbed; oil crayons leave a waxy buildup. This is not to say that materials cannot be handled in ways contrary to their basic nature but that their inherent characteristics should first be understood.

Certain media are preferred over others in any single work; it is, as we have seen, the fusion of materials and idea that makes for a successful drawing. In some contemporary work, the medium can literally be the message.

Color evokes often visceral, instinctual, or intuitive responses. We respond not only to the color but also to the medium itself. In art the very signs of spontaneity are directional marks that signify the speed of execution. They signify the singularity of a particular, unique moment; they are a mirror of time, a conjunction of action and material.

In their continuing efforts to expand the role of drawing and to overturn accepted practices, many artists have considered the properties of paper as an end in itself. Rather than using the paper merely as a ground or field for the action of drawing, they have treated the manipulated paper as the finished work of art. In many contemporary drawings lines or marks on the surface are a scaffold that holds a suspended, disembodied background wash in check, or the ground can be a textured surface that forms an underpinning for linear elements (see color plate 7.1). Washes can provide subtle colors—blues, sepias, umbers, and grays are traditional wash colors.

In his subtle work (color plate 7.5), David Jeffrey has stacked several sheets of paper of various sizes on top of each other and cut them into distorted, squarish shapes. Rather than pressing the papers flat, he has allowed them to warp and bulge. From being folded and refolded both vertically and horizontally, the surface of the paper eventually rips, exposing the underlying layers. The paper at this point is very fragile. Jeffrey manipulates the paper mass through the use of wax, charcoal, and rust, which is applied in irregular tints. The surface resembles stain or mold. Jeffrey's actions are akin to those of the Antiform artists, who used studio walls and floors as subjects of drawings in dealing with modernist explorations of pictorial support. Jeffrey's worked surfaces are a product of time; they reveal the process of their own making. Color, in spite of its subtle, fleeting appearance, is an essential element in the final drawing (or sculpture, since the paper has mass and weight); color is a result of the "marks of time," rather than an intentionally applied element.

Before beginning the problems, carefully examine the color plates in this chapter; note what medium is used in each work, how it is applied, and what effects are achieved with various color media. Remember that your experiments with color application should be based on the knowledge and experience you have already gained from working with various wet and dry media.

Here are some suggestions to follow when working with color.

GUIDELINES FOR WORKING WITH COLOR

1. Avoid filling a shape with a single color unless you desire a spatially flat effect.
2. Experiment with layering colors, combining multiple colors to build a rich surface.

3. Think not only in terms of color but value as well.
4. Combine media—incorporate charcoal, pencil, conté crayon, china markers, oil crayons, and ink with any or all of the color media.

Because color is such an eye-catching and dominant element, do not forget what you have already learned about the role of shape, value, line, and texture. Color can be used to develop a focal point in an otherwise achromatic drawing; it can be used to direct the eye of the viewer through the composition; and it can be an effective tool for creating spatial tensions in a drawing. Give consideration to your personal response to color and try to broaden your color tastes.

PROBLEM 7.1
Using Color Media

Choose an old drawing to recycle as a base for this problem. On top of the drawing use a number of colors of oil pastel to build a surface. Try overlapping the colors, drawing directly over the already established image. Try to create an interestingly colored and textured surface. Notice that even though you may have used only five or six colors, your palette seems to be more extensive; this is because of the color mixing, one color modifying another. Take advantage of these color effects.

Use a wash such as turpentine, gesso, or ink in several places to create focal points or to unify the drawing. Allow the underdrawing to reappear in certain places; redraw the image, incorporating some of the medium used in the original background drawing in combination with the color. Continue to layer images and color until you have achieved a satisfactory effect.

COLOR TERMINOLOGY

Our discussion of color begins with some definitions and terms. Color has three attributes: hue, value, and intensity.

Hue is the name given to a color, such as violet or green.

Value is the lightness or darkness of a color. Pink is a light red; maroon is a dark red. As noted in the chapter on value, a change of values can be achieved by adding white, black, or gray. A color can also be heightened, darkened, or modified by mixing or overlaying two or more hues. Color media can be built up, layered, and modified. Paper can be toned with an overall colored value on which marks of various hues and values can be overlaid to build a richly dense colored surface. Intense colors can be modified to darker values by such overlays. Dulling and modulation of a color can be achieved by applying color on top of color. Unexpected "no-name" colors can result from this technique.

Intensity refers to the saturation, strength, brilliance, or purity of a color. You are familiar with intense colors in adjusting a color television; hues can be turned up to a high level of intensity or brilliance (see color plate 7.2).

The *Munsell Color Wheel* (color plate 7.6) is a circular arrangement of twelve hues, although one can imagine an expanded gradation of color. These

twelve colors are categorized as primary, secondary, and tertiary. The *primaries* (red, blue, and yellow) cannot be obtained by mixing other hues, but one can produce all the other hues by mixing the primaries. *Secondaries* (green, orange, and violet) are made by mixing their adjacent primaries; for example, yellow mixed with blue makes green. *Tertiaries* are a mixture of primary and secondary hues; yellow-green is the mixture of the primary yellow and the secondary green.

Local color and *optical color* are two terms artists use to describe color. Local color is the known or generally recognized hue of an object regardless of the amount or quality of light on it, for example, the red of an apple, the green of a leaf. The local color of an object will be modified by the quality of light falling on it. Bright sunlight, moonlight, or fluorescent illumination can change a color. For example, if we imagine an intense red object under moonlight, the intense red, the local color of the object, might change to a deep red-violet, and we would call this its optical, or perceived, color. The distinction between local and optical color is that one is known (conceptual) and the other is seen (perceptual).

PROBLEM 7.2
Using Local and Optical Color

In this problem, duplicate as closely as you can the perceived color of an object. In verbal descriptions of the color of an object, it is usually enough to name a single hue, as in "a red apple." But an artist must describe the apple more accurately, using more than one hue.

The subject of this drawing will be, in fact, a red apple. Tape off a segment on the surface of the apple—a rectangle 2 inches by 3 inches (5 cm × 8 cm). Using pastels, make a drawing of this selected area, enlarging the section to 18 inches by 24 inches (46 cm × 61 cm). Use a buff-colored paper: Manila paper is a good choice. The drawing will be a continuous-field composition, focusing on color and textural variations.

Very carefully examine the portion of the apple to be drawn, analyzing exactly which colors are there. You may see an underlying coat of green, yellow, maroon, or brown. Tone your paper accordingly and build the surface of your drawing using layers, streaks, dabs, and dots of pastels. The longer you draw and look, the more complex the colored surface will appear. Sustain this drawing over several drawing sessions. If you extend the drawing time to several days, you will find the apple itself has undergone organic changes and will have changed colors as a result. Adjust your drawing accordingly.

COLOR SCHEMES

Color schemes require a special vocabulary. Although there are other kinds of color schemes, we will discuss only monochromatic, analogous, complementary, and primary color schemes. A *monochromatic color scheme* makes use of only one color with its various values and intensities. An artist known for his monochromatic works is Mark Tansey. His images are allegories, or "painted texts," which promote his ongoing concerns with representation in contemporary art. He favors blue, red, violet, terra-cotta, and gray in his single-colored

7.1. MARK TANSEY. *Triumph over Mastery II.* 1987. Oil on canvas, 8′1¼″ × 5′8¼″ (2.47 m × 1.73 m). Emily Fisher Landau, New York (Amart Investments LLC).

works (figure 7.1). Tansey's technique is both additive and subtractive: He applies a color over an area, then removes some of it. Textural variety is created by using brushes, string, cloth, carved wood, and crumpled paper. In *Triumph over Mastery II*, we see a man painting over Michelangelo's *Last Judgment* in the Sistine Chapel. (Michelangelo is still seen as a "tortured genius" in constant struggle with his powerful patrons. Tansey, in a clever painted act, makes the famous fresco disappear, and along with it Michelangelo's genius.) Tansey says his aim is not only to deconstruct but to construct.

An *analogous color scheme* is composed of related hues—colors adjacent to one another on the color wheel, for example, blue, blue-green, green, and yellow-green. (Here the shared color is blue.) In Lance Letscher's collage (color plate 7.7), an analogous color scheme predominates. Note the larger boat shape in the upper third of the picture plane; it is built, as are the other boats, of strips of analogous color. (The strips themselves resemble a color scale.) The background surface is built of aged, yellowed papers that support the colors used in the overlaid images. Letscher occasionally adds strips of green as accents—green is a complement to the overall reddish-brown tones. The viewer is led through the picture plane by the repetition of colors, as well as the repetition of shape—variation of size plays a dominant role in organizing the picture plane. The support for the boats, built of found papers with printing and handwriting on them, plays a role in activating the surface. At times the leaf-shape images seem to float on the surface, and at other times they seem to have been cut out of the background papers and to lie behind them. Analogous colors, analogous shapes, and analogous sizes furnish the structure for the drawing.

Complementary color schemes are based on one or more sets of complements. Complementary colors are contrasting colors that lie opposite each other on the color wheel. Blue and orange, red and green, and yellow-green and red-violet are complements. Complementary colors in large areas tend to intensify each other. Small dots or strokes of complementary hues placed adjacently neutralize or cancel each other. The viewer blends these small areas of color optically and sees them as a grayed or neutralized tone. (Note these effects in Letscher's drawing with the accented areas that make use of green and red complements.)

Not only does a color scheme organize a work by directing the eye of the viewer (like attracts like), but a color scheme is also the carrier of meaning in a work. California artist William T. Wiley uses a primary color scheme in *Your Own Blush and Flood* (color plate 7.8). In addition to a primary color scheme and a primary triad (yellow, red, and blue), we find triads abounding in the work. Triangular forms are everywhere: three-pronged forked limbs, a triangular tabletop; on one of the three central blocks are three symbols, one of them a triangle. There are three cut logs behind the bucket. Are we to surmise, then, that the triadic color scheme has symbolic meaning? Much of Wiley's work relies on paradox, on something being two things at once. Wiley learned from Zen Buddhism that opposites are reconciled when seen as a part of a continuous chain. (Are not the fans and spirals a visual metaphor for this chain? And since the palette has an analogous shape to the fans, can Wiley be giving us a clue as to the important role of art in the continuity of life?) Wiley's work is full of contradiction, complexity, humor, and metaphor. His work is so engaging that we don't escape easily; he traps us into attempting to interpret the allegory.

Wiley directs us through his allegorical maze by both shape and color; the reds call our attention from one object to the next, whereas the complicated blue value patterns unify the jumbled composition. The crystalline colors are in keeping with the fragmented, broken quality of the images. The brittle, jagged edges echo the fragmentation inside the picture plane. Is Wiley saying this is just a part, a fragment, of the greater picture, metaphorically speaking? He presents clues for interpretation grounded in the triangular forms; he offers reconciliation through the triad.

We have by no means exhausted the number of color schemes available to the artist. The chosen color scheme contributes to the overall mood and meaning in a work. Although a color scheme in a given work is related to aesthetics and psychology, it must suit the demands of the artist's personal vision.

PROBLEM 7.3
Using a Monochromatic Color Scheme

From a magazine or newspaper, choose a black-and-white photograph with at least five distinct values. Enlarge the photograph to a drawing with no dimension smaller than 12 inches. You may use a copier to make the enlargement. Convert the photograph to a monochromatic drawing, duplicating the original values; for example, you might choose an all-blue or an all-red monochromatic color scheme. Take note of the value variations within a given shape and try to match them in your chosen color. A close inspection of Tansey's monochromatic paintings will be informative. Make a photocopy (red orange) of Tansey's painting to approximate the original.

Coat your drawing surface (paper or board) with gesso, and use acrylic paint. You will need to apply the paint in varying consistencies to achieve a range of values. Begin with a light wash to lay out the composition, then by adding and subtracting, brushing and rubbing, try to imitate the original value patterns. You can wipe off the paint to create lighter values and use a buildup of paint for the darker ones. Tansey uses a variety of implements to achieve various textures; you, too, should experiment with found implements.

Color photocopy machines can convert black-and-white images to a monochromatic color. After you have completed your drawing, photocopy the original black-and-white photograph using one of the primary colors; then compare the two versions.

Heide Fasnacht is an artist whose monochromatic drawings are based on photographic sources of explosions, detonations, and natural phenomena such as geysers and volcanoes (color plate 7.9). She is interested in subjects that seem impossible to stabilize that are at the border of visibility. Her drawings capture a split second in time. She even makes sculptures of "events" such as sneezes. Although the finished work depicts a flash of the eye, the work may take several months to complete. Using a colored pencil, Fasnacht makes her monochromatic images of smoke and clouds built up of crosshatched and parallel lines.

PROBLEM 7.4
Using a Complementary Color Scheme

For this project use as your subject a still life by a window; combine an interior view with an exterior view. You may draw from life or you may invent the scene. This was a favorite subject of Matisse and the Fauves. Before you begin your drawing, go to the library and look at some books on these artists; note their use of color and how it contributes to the spatial effect in each work.

Use a complementary color scheme, a color scheme of opposites, with no fewer than three values of each complement. You can mix the opposites to change intensity and use white to change value. You should use color arbitrarily; that is, do not use color to imitate local color and value.

Arrange your composition so that in some areas the complements intensify each other; for example, the view through the window might frame an intense color scheme. In other parts of the drawing, by using dabs of color, try to make the complements neutralize each other. (Analyze a large, full-color reproduction of Georges Seurat's *Sunday Afternoon on La Grande Jatte* for an understanding of how this technique works.)

Using adjacent dabs of color complementaries might be an appropriate approach to describe fabric, drapes, or wallpaper in the interior space. Experiment with various intensities and values and their relationships with their opposites.

By making changes in value and intensity, you can make a color appear to advance or recede, expand or contract. Can you reverse the expected function of color? For instance, can you make a red shape appear to recede rather than come forward as you would expect? Matisse is a particularly good artist to study in this regard (see color plate 7.11).

WARM AND COOL COLORS

Colors can be classified as warm or cool. Warm colors, such as red, orange, or yellow, tend to be exciting, emphatic, and affirmative. In addition to these psychological effects, optically they seem to advance and expand. We can readily see some of these effects in the Sánchez work (see color plate 7.4). His warm (better said, hot) colors promote an active, excited response in the viewer. Even the greens and blues are warm tones. The work is organized by the broad expanse of the background colors. Try to imagine the effect of this work if the background spaces were white, black, or a cool blue; symbolic and psychological meaning would undergo a radical change.

Cool colors—blue, green, or violet—are psychologically calming, soothing, or depressive, and unemphatic; optically, they appear to recede and contract. These characteristics are relative, however, since intensity and value also affect the spatial action of warm and cool colors. Intensely colored shapes appear larger than duller ones of the same size. Light-valued shapes seem to advance and expand; dark-valued shapes seem to recede and contract.

PROBLEM 7.5
Using Warm and Cool Colors

In this problem use two sources of light, one warm and one cool. Seat the model in front of a window from which natural, cool light enters. On the side of the model opposite the window, place a lamp that casts a warm light. Alternate the light sources; draw using the natural light for three minutes, then close the window shade and draw using the warm artificial light for three minutes. Continue this process until the drawing is completed.

Use colored pencils or pastels and no fewer than three warm colors and three cool colors. There will be areas in the figure where the warm and cool shapes overlap; here you will have a buildup of all six colors. Work quickly, using short strokes, overlapping colors where appropriate. Focus on drawing the light as it falls across the form. Draw the light in the negative space and on the figure. Do not isolate the figure; draw both negative and positive forms. Try to imagine the light as a colored film that falls between you and the model. Do not use black for shadows; build all the value changes by mixing the warm colors, cool colors, or both.

Note how the short strokes unify the drawing and limit the space. By concentrating on the quality of light, you will find that you can achieve atmospheric effects.

HOW COLOR FUNCTIONS SPATIALLY

The spatial relationships of the art elements and the ways each element can be used to produce pictorial space are a continuing theme in this book. Color, like shape, value, line, and texture, has the potential to create relatively flat space, illusionistically three-dimensional space, or ambiguous space.

When unmodulated flat shapes of color are used, when colors are confined to a shape, a flatter space results. But when colors are modeled from light to dark, a more volumetrically illusionistic space results.

Colors contribute to a three-dimensional illusion of space not only when they are modeled from light to dark but when brighter colors are used in the foreground and less intense ones in the background.

When flat color shapes and modeled color volumes are used in the same composition, an ambiguous space results. Further, when bright colors occur in the background of an otherwise three-dimensional shape, an ambiguous space results. In Michael Heizer's colorful work on paper (color plate 7.10), we see a complicated progression into space. The stacked blue boxes with textured white tops occupy a logical, perspectival space, with their edges forming flat color planes. The space surrounding them is atmospheric, somewhat diffused. There seems to be a transparent plane, like a piece of glass, that intervenes between the slabs and the foreground space. On this imagined glass wall are scribbles, drips, and notations. The vivid red and yellow marks advance; the blue and turquoise marks occupy a second level, and the gray and black marks appear to be located on yet another level. The diffused orange, green, and pink airy film made with spray paint looks as if it is suspended, hanging in space; sometimes it seems to advance and at other times it appears to recede. Heizer has carried the spatial behavior of color to its limit; in fact, it is the very essence of this complex drawing. Color is both the means and the subject.

When color crosses over shapes, a flattening can take place, making space ambiguous. You can see this effect in Heizer's work in the areas where the blue crosses over the edges of the cubes and melds with shadows and negative space in the background forms. Sprayed color areas, colored marks, and drips all occupy an ambiguous space; they are not confined to a shape. In spite of the abstract nature of this work we sense a spontaneous physical immediacy and presence. A mood, an odd sense of place such as found in some fantastic mind travel, is the result of Heizer's exuberant use of color.

SOME EARLY INFLUENCES ON CONTEMPORARY ATTITUDES TOWARD COLOR

Because our current attitudes toward color have been shaped by earlier artists, a quick survey of some innovations in their treatment of color during the past hundred years is in order.

We might begin with what has been called the "revolution of the color patch," the revolutionary way the Impressionists applied color. With Impressionism in the late nineteenth century, artists began to depend on more purely visual sensations. Their concern was the way light in its multiple aspects changes forms, and their approach was scientific in many respects. Recording the stimulation of the optic nerve by light, they began working outdoors directly from nature, using a new palette of brighter pigments and purer colors, applying them in broken patches. Dark shadows were eliminated, local color was ignored, and local values or tones were abstracted to create atmospheric effects.

The Impressionists were innovators in color application, applying it in perceptible strokes unlike the smooth, brushed surface that characterized earlier works. The outlines of objects were blurred to make them merge with their backgrounds. Volumes were diminished in favor of describing the effect of light over a form. These quick, broken strokes, suggesting the flicker of light, resulted in a sameness or uniformity in the overall texture that flattened the image and created a compressed space. Such strokes had the added bonus of allowing the artists to work more directly to keep pace with the changing light. The Impressionists saw that color is relative; when light changes, color changes.

The Post-Impressionists continued their predecessors' investigations into color. They used complementary colors in large areas to intensify each other and in small dabs to neutralize each other. They interpreted shadow as modified color, not simply as black or gray, and they made use of optically blended color. The viewer blends colors visually; a dab of red adjacent to a dab of green will be blended by the eye to appear gray. These complementary hues in small contrasting areas also made for greater luminosity and greatly enlivened the surfaces of the paintings.

Early in the twentieth century a group of painters called the *Fauves* (Wild Beasts), who were familiar with the color advances of the Impressionists and Post-Impressionists, renounced the pretense of re-creating reality and began a subjective and symbolic investigation of color. They sought a heightened reality more exaggerated than actual appearances. The Fauves used flat, pure, unbroken color to further limit traditional perspective, depth, and volume. Fauvism, Matisse said, meant construction by color, which was the source of everything that followed in Matisse's long and illustrious career. Color, freed from tonal modeling, was used to convey the artist's response to the subject matter. Color was immediate, fundamental; it was the means of "orchestrating the surface with complex harmonies and dissonances" (Elderfield, *Henri Matisse*, p. 133). *The Red Studio* (color plate 7.11) is made up of spatially dislocated images and suspended objects in a color field of red. Color was the primary element in Matisse's art; the interaction of adjacent colors determined form. Matisse was greatly influenced by Persian miniatures, by their profusely patterned surfaces used to organize the picture plane and by their non-Western perspective. Although he rejected Western perspective, he did not follow the spatial innovations of his contemporaries, the Cubists, with their multiple perspectives and fragmented images.

The different periods of Matisse's long career were all involved with what he spoke of as "the eternal conflict of drawing and color" (Elderfield, p. 29), the reciprocation between the two fundamental pictorial elements. In the early 1940s he saw the way to integrate these two elements. "Instead of drawing an outline and filling in the color . . . I am drawing directly on color," he said. He began "drawing with scissors" (Elderfield, p. 413) by cutting shapes from paper he had prepainted. Eventually, owing to his crippling arthritis, cutouts formed virtually his only means of expression (figure 7.2). His last style, from 1950 to 1954, culminated with an outpouring of brilliant large-scale cutouts that served as designs for the Vence chapel, for stained-glass windows, and for large ceramic tile murals—Matisse spoke of the Vence chapel as the culmination and summation of his life's work.

Wassily Kandinsky, a contemporary of the Fauves, carried freeing color a giant step forward into abstraction. In placing emphasis on composition and

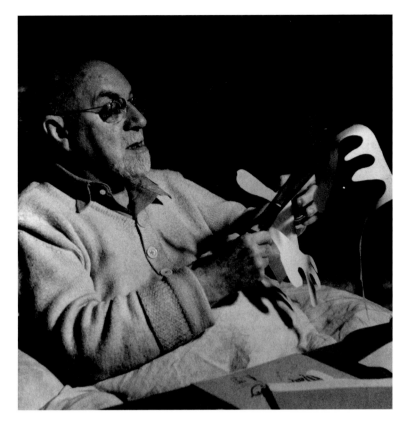

7.2. Matisse at work on a paper cut-out.
© Bettmann/Corbis.

color, he left representation of objects behind (see figure II.17). His goal was to infuse shapes that had no reference to recognizable objects with a symbolic and metaphysical intensity, and he saw that the most direct means of achieving that goal was through the use of color. His memoirs open with the sentence, "In the beginning was color."

The Abstract Expressionists continued Kandinsky's freedom of paint application, but it was Hans Hofmann who was the teacher and theoretician for the advancement of Modernist ideas concerning color and space. Fundamental perceptions led Hofmann to his rules concerning the flatness of the picture plane and the necessity for preserving its two-dimensionality. Foremost among his teachings were those dealing with color tensions to create spatial dynamics, his famous "push-and-pull" concept. Hofmann's art rules of pictorial grammar dealt with the distinction between positive and negative space, the autonomy of the picture plane, and the visual interaction of warm and cool colors to create pictorial spatial illusion.

Hofmann's theories concerning colors' perceptual retreating and advancing in pictorial space laid the groundwork for many of the color experiments in art later in the century. They had special influence on Color-Field artists and on modernist attitudes toward color in general.

Expressionists throughout this century—the German Expressionists before World War I, the Abstract Expressionists in the 1940s and 1950s, and the Neo-Expressionists in the 1980s—all have used color to underline their own emotional responses. Strong contrasting colors applied in thick slashing strokes give urgency to a charged content.

Color-Field artists in the 1960s saw that they could communicate essentially through color alone. Reducing their formal means and limiting shape, line, value, and texture, they depended on color to carry the weight of the work both in form and in content. Certainly the Color-Field painters can be said to be dealing with the physiological effects of color noted at the beginning of this chapter. The scale of these artists' works is so large that the viewer's peripheral vision is encompassed. Envisioning the difference between a spot of red on a wall and an entire wall of red will enable you to understand better the concept of enveloping color. The viewer is absorbed by the expanse of color in a Color-Field painting; experience and vision are one.

The strategy of the Pop artists in the 1960s and 1970s was to use technology and common objects in a man-made environment as sources of technique and imagery. They used advertising techniques and established a new palette based on color television and advertising layouts. Colors were intensified, often garish.

Photo-Realists use film colors to establish their color. Taking their color schemes directly from the photograph, they present the viewer with an alternate means to establish reality or verification. Image, color, and technique are derived from photography.

In contemporary art, color maintains its decisive role. All the earlier uses of color are exploited—the representative, emotive, psychological, and symbolic impact—for their subjective and objective functions. Technology has provided new impetus for dealing with color as seen in the drawing by Tom Burckhardt, *Geisha Hair* (color plate 7.12). Burckhardt makes digital scans of images; he then prints them onto pages of old books, adding his own drawn images in colored ink. Two dissimilar categories of images appeal to the artist: industrial equipment and Eastern decorative objects. In the drawing shown here it takes a while to realize that the zany biomorphic shapes are actually part of the headdress piled on the head of a Japanese geisha. Burkhardt deals in contradictions, between found images and drawn additions, between hand-drawn forms and digitized scans, between East and West, between the industrial and the decorative. Color enriches and ties together the disparate techniques, images, and ideas.

The overriding lesson that contemporary artists have learned is that color is relative. Through a lifetime of experimentation Josef Albers investigated the relativity of color. In his theoretical writing and in his work he offered ample proof that color is not absolute but interacts with and is affected by its surroundings. Since colors are always seen in a context, in a relationship with other colors, artists must make use of this knowledge of color relationships.

PROBLEM 7.6
Studying Influences on Contemporary Color Attitudes

In the library find several examples of the historical styles that have formed our attitudes toward color (Impressionism, Post-Impressionism, Fauvism, German Expressionism, Abstract Expressionism, Color-Field, Pop art, Photo-Realism, and Neo-Expressionism). Study at least one book on Matisse, Kandinsky, Hofmann, and Albers.

Pay special attention to color relationships and to color application. Reread this section while looking at the artwork from the period. You need not

limit your search to drawings because artists use color in much the same way whether the work is a painting, a drawing, or a print.

PROBLEM 7.7
Using Symbolic Color

Make a drawing in which you use color symbolically. Invent an imaginary scene or event as your subject. Use color to enhance the subject both visually and symbolically. Consider not only the universal symbolic significance of your chosen palette, but think of personal associations the colors have for you. Try to weld message and color; aim for a formal and conceptual integration of color.

You might look at some work by Paul Gauguin and Vincent van Gogh, both of whom used color in new and unexpected combinations. Gauguin's *Yellow Christ* is a good example of the use of symbolic color. Van Gogh is well known for his impetuous use of color. His color choices are emotionally based and symbolically powerful.

A contemporary artist who uses dynamic, symbolic color is the Italian artist Francesco Clemente.

PROBLEM 7.8
Using Color-Field Composition

On a large format, one that is twice as wide as it is tall, divide the picture plane in half. On one side of your paper make a drawing using a recognizable subject (you may use local color or arbitrary color); on the other side use a continuous field of color. Aim for the same feeling on both sides. On one side you can convey your message by using images and color; on the second side you are limited to color as the carrier of the meaning.

Using media of your choice, give careful consideration to the exact color you need, not only to the hue but to its proper value and intensity. You may layer the color in washes, you may build the color in overlapping strokes, or you may use a saturated single color. Try to achieve the effect you want by this continuous field of color. Consider the textural quality of the finished surface. There can be very subtle changes across the field. Think of the color in psychological and symbolic terms; determine what you think the physiological effects might be.

Look at some work by Color-Field painters such as Mark Rothko or Barnett Newman. Make a list of adjectives describing the moods or feelings the works elicit.

SUMMARY

SPATIAL CHARACTERISTICS OF COLOR

In the twentieth century we find artwork that gives the illusion of three-dimensional space, works that are relatively two-dimensional, and works that are spatially ambiguous. Color is one major determinant of spatial illusion.

When flat patterns of hue are used, when colors are confined to a shape, the shapes remain relatively parallel on the surface of the picture plane. On the

other hand, when colors are modeled from light to dark, a more volumetric space results; and when bright colors are used in the foreground and less intense values are used in the background, color contributes to a three-dimensional illusion of space.

As a general rule, warm colors come forward and cool colors recede. This rule, however, is relative since the intensity and value of a hue may affect the spatial action of warm and cool colors.

When flat-color shapes and modeled-color volumes are used in the same composition, an ambiguous space results. When bright colors occur in the background of an otherwise three-dimensional work, the background will seem to come forward, flattening the picture plane to some extent. Also, when colors cross over shapes, a flattening takes place, making space ambiguous.

SKETCHBOOK PROJECTS

PROJECT 1
Using Color for Quick Landscape Sketches

Pochade is a French term for a rapidly made sketch, a shorthand notation. The Impressionists were famous for working outdoors on site; their *plein-air* practices are clearly apparent in their work. For this exercise, make a series of landscape sketches, or *pochades*, using various color media.

Choose a convenient site, one you can visit easily and frequently over the period of a week or so. Visit the setting at various times of the day (or night), and, if possible, under different weather conditions. Make a series of quick, abbreviated sketches using color to convey both the quality of light and the feel of the place. In the initial drawings let the optical color determine your palette. As you familiarize yourself with the actual setting and its compositional relationships, expand your color choices.

Use only dry media for one session, wet media for another, and combinations of wet and dry at other times. In spite of being quickly drawn, colors can be layered. You might make several drawings simultaneously, especially if you are working with wet media; then go back over them as they dry. This series can develop into some very interesting color relationships and changing values, hues, and intensities from one wash to the next.

Stay with the same subject in order to free yourself for color experimentation within self-set limits. At the end of the time designated for this project, choose one of the more successful sketches or combine elements from a number of sketches in a larger, finished drawing that you complete in the studio. By this time your familiarity with the scene and your memory of it will enhance the preparatory sketches.

Acrylic or oil paint, colored inks, watercolor, and gouache are wet media that can be used for this project. Oil-based crayons, colored chalks, pastel sticks, pastel pencils, and colored pencils are suggested dry media. Water-soluble colored pencils are a good choice. Oil-based crayons are soluble in turpentine. Do not strictly limit the media to color media; the combination of pencil, conté, charcoal, and black ink with the color media can be very effective. Color can be used for the development of a focal point or it can be used more extensively throughout the drawing. Think of it in descriptive, structural, and expressive terms.

PROJECT 2
Using Color to Convey Emotive Content

Bring your *pochades* back to the studio and make a second-stage series of color sketches from them.

Using color to carry the message of emotional intensity, make at least three different sketches. Each sketch should use color to convey a specific emotion such as joy, anger, or fear.

COMPUTER PROJECT

PROJECT 1
Using the Computer to Create Matisse Cutouts

The Internet can be a quick and accessible way to research ideas for your projects. This color exercise is based on Matisse's cutouts discussed earlier in the chapter. Before beginning this project, use the Internet to research Matisse's work and to find examples of his paper cutouts. The computer skills needed for this project are similar to those used in the computer problem on shape in chapter 3.

1. Using a program such as Adobe Illustrator, create a variety of shapes using Matisse as inspiration. (His cutouts included figurative as well as biomorphic, abstract shapes.) Simplified figures, flowers, and stars, as well as the negative shapes created between them, can be used along with shapes of your own design.
2. Choose a color scheme to work with based on those discussed in this chapter. You may add black and white if needed.
3. Fill the shapes with solid colors and arrange them on a colored picture plane. Experiment with several compositions and print them out. Be selective in your self-critique. You may find that certain shapes work better than others or you may prefer certain color arrangements over others. Mix and match shapes and colors. Save your file so you will be able to make changes based on suggestions that arise during a class critique.
4. If the printout quality is not good, make a construction paper version or a painted paper version for your finished drawing. In reconstructing the computer version you will probably want to change the scale of the finished drawing.

Color plate 7.13 is an example of what can be done with this project using Matisse-like shapes and colors.

Since you are using modern technology to pay homage to an earlier artist, can you think of contemporary subject matter on which to base your computer cutouts? Burckhardt (see color plate 7.12) based his images on industrial equipment such as "shelving, steel drums, electric fans, and hand trucks." These sources are not recognizable in the finished work, yet they fuel the artist's creative ideas.

How did the computer help or hinder your creative decisions in making the drawing? Can you think of other ways the computer could be used to create interesting color relationships?

Before we conclude our look into ways to use computer software in developing color and shape, let us look at a contemporary abstract painter who uses the computer as a compositional tool. Monique Prieto uses Painter 3 to develop her "confectionary-colored shapes" (*Art in America*, September 1998, p. 97), which she places flat against raw, unprimed canvas (color plate 7.14). Cadmium orange, pale green, and faded blue anthropomorphic shapes lean against one another on the large picture plane (6 feet by 12 feet). They seem to be held upright by the thin, irregular, orange line that bisects the picture plane; it in turn is buttressed by a darker, rust-colored line that could be read as a side view of a woman with bent knee. The five smaller shapes on the right side of the painting—lavender, blue-violet, lemon yellow, a darker purple, and magenta—lean away from the central lines. Although Prieto's shapes are nonobjective, they evoke human presences and psychological responses. The colorful, modular forms seem to ask the viewer to rearrange them and create other nonverbal narratives. Each color plays a spatial game with its adjoining color; the complex relationships between the colored forms build an exciting pictorial space. Color and shape elicit an ebullient reaction from the viewer.

PLATE 7.1. CY TWOMBLY. *Untitled.* 1985. Oil, oil/wax crayon, and water-based paint on board, 5′4¹⁄₁₆″ × 3′10⁹⁄₁₆″ (1.627 m × 1.259 m). Cy Twombly Gallery, Houston. Gift of the artist. © Hickey-Robertson, Houston.

PLATE 7.2. JESSY PARK. *St. Paul's and St. Andrew's Methodist Church with the Migraine Type Lighting and the Elves.* 1998. Acrylic paint, 2′ × 1′6″ (61 cm × 46 cm). Courtesy of the artist.

PLATE 7.3. SHAHZIA SIKANDER. *Riding the Ridden.* 2000. Vegetable color, dry pigment, watercolor tea on hand-prepared Wasli paper, 8″ × 5½″ (20 cm × 14 cm). Courtesy of the artist and Brent Sikkema Gallery, New York.

PLATE 7.4. JUAN SÁNCHEZ. *Bleeding Reality: Así Estamos.* 1988. Mixed media on canvas, 3′8″ × 9′½″ (1.12 m × 2.76 m). Courtesy Exit Art, New York.

PLATE 7.5. DAVID JEFFREY. *Untitled.* 1995. Wax, charcoal, and rust on two sheets of translucent vellum paper, 2′5″ × 2′7½″ (73.7 cm × 80 cm). Fogg Art Museum, Cambridge, Mass. Gift of Sarah-Ann and Werner H. Kramarsky, 2001.241.

PLATE 7.6. The major elements of color: hue (as expressed in the Munsell Color Wheel), value, and intensity.

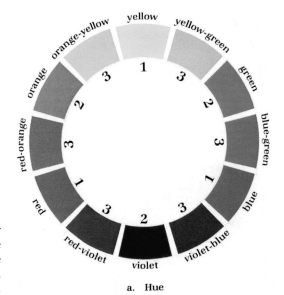

a. Hue

b. Value

c. Intensity

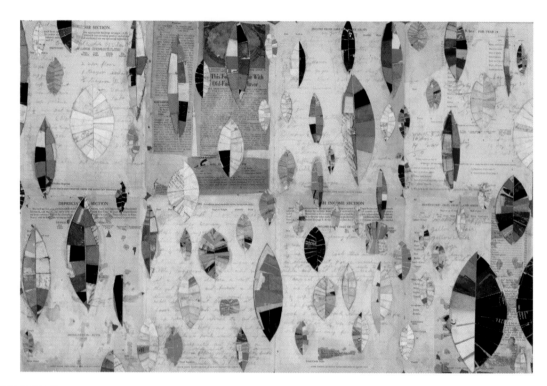

PLATE 7.7. LANCE LETSCHER. *Boats.* 2002. Collage on Masonite, 1′9⅛″ × 2′7¼″ (53.6 cm × 79.3 cm). Private collection, courtesy of Howard Scott Gallery, New York.

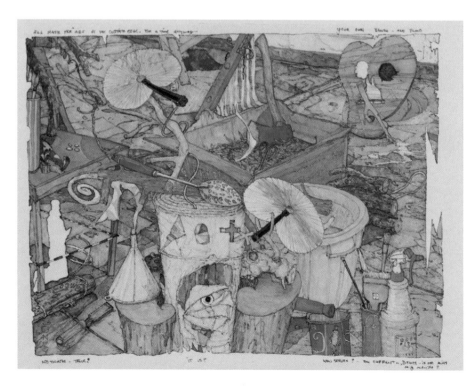

PLATE 7.8. WILLIAM T. WILEY. *Your Own Blush and Flood.* 1982. Watercolor on paper, 1′10″ × 2′6″ (55 cm × 75 cm). Collection Byron and Eileen Cohen, Shawnee Mission, Kansas. © Photo by Schopplein Studio SFCA/Morgan Gallery, Kansas City, Mo.

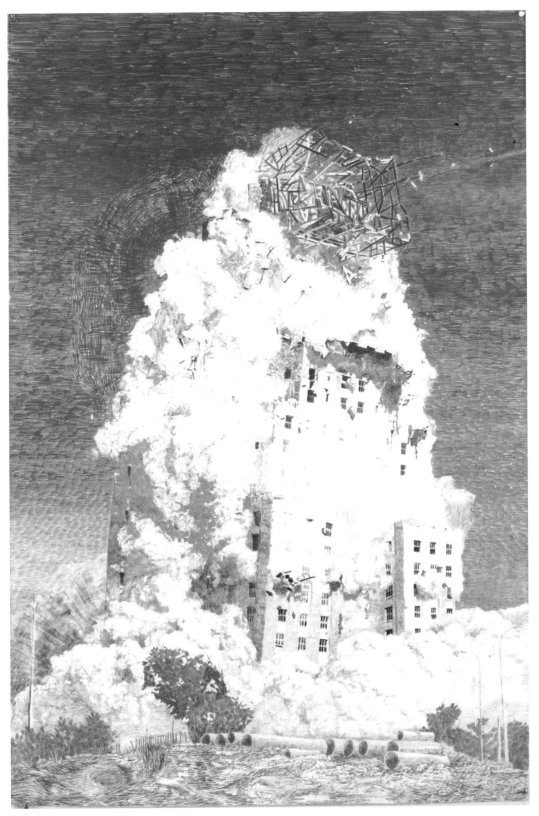

PLATE 7.9. HEIDE FASNACHT. *Hotel Demolition.* 2000. Colored pencil and paper, 5′ × 3′4″ (1.52 m × 1.02 m). Courtesy of the artist and Kent Gallery, New York.

PLATE 7.10. MICHAEL HEIZER. *45°, 90°, 180° Geometric Extraction Study #1*. 1983. Silkscreen, watercolor, crayon, ink on paper, 4′2″ × 4′2″ (1.25 m × 1.25 m). Private collection. Courtesy M. Knoedler and Co., New York. Photo © Douglas M. Parker Studio.

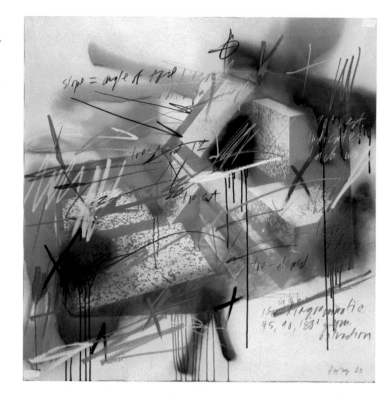

PLATE 7.11. HENRI MATISSE. *The Red Studio*. 1911. Oil on canvas, 5′11¼″ × 7′2¼″ (1.81 m × 2.19 m). The Museum of Modern Art, New York, Mrs. Simon Guggenheim Fund. © The Museum of Modern Art/Licensed by SCALA/Art Resource, New York. © 2003 Succession H. Matisse, Paris/Artists Rights Society (ARS), New York.

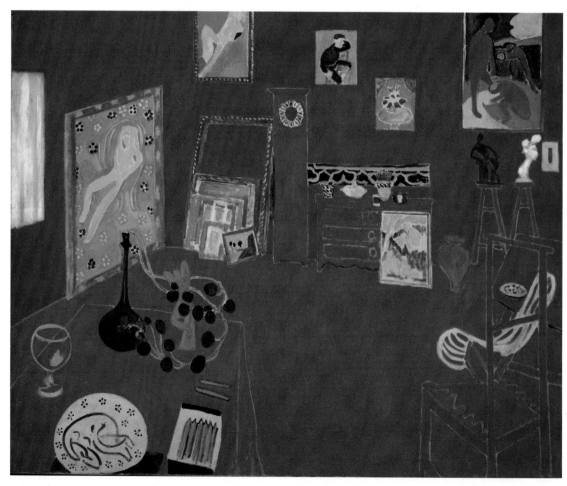

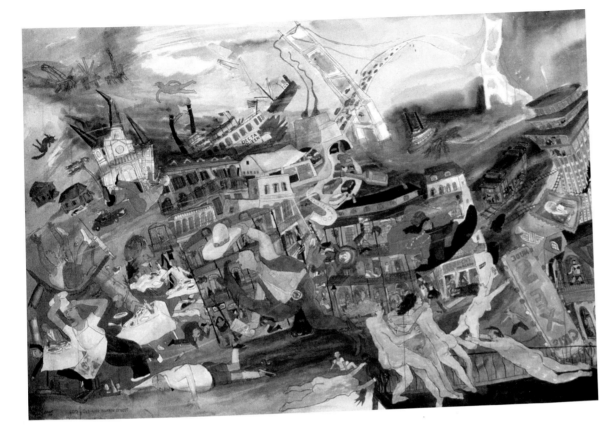

2. WARRINGTON COLESCOTT. *God*
troys Bourbon Street. 1995. Watercolor
paper, 3'4¼" × 4'11¾" (1.02 m ×
m). Arkansas Arts Center Foundation,
Rock. Purchase: '94 Tabriz Fund.
.001.

conceptual and the material, the real and the imagined in a kaleidoscopic mix of motifs and imagery. Turbulent forms explode and bulge from the picture plane; delicate notations recede into space. Line, value, shape, texture, and color cannot be contained; space itself seems to contract and expand at the same time.

In translating three-dimensional visual data from the real world onto the constraints of a two-dimensional surface, the artist must make a number of choices about how to express the experiences and ideas of the phenomenal world. Some of these choices are made intuitively and others consciously. Some are personally determined; others are culturally influenced. Optical appearance is frequently insufficient for the artist who wants to express more about an object than a strict visual description taken from one particular viewpoint, as in the work by the Argentinian artist Guillermo Kuitca (figure 8.3). His work, which conveys a social and cultural anxiety, has been called "an architecture of allusion, in which humanity is relegated to memory" (Benezra and Viso, *Distemper,* p. 71). The presence of people in his prisons, theaters, city maps, cemetery plots, and genealogical charts is merely implied. He calls his maps "silent theaters of human interaction" (ibid.). Kuitca sees them as a means of probing human nature; they are painted from unusual viewing angles— Kuitca describes his fluid and constantly changing angle of vision as "panoptic," like the vantage point of a guard who oversees a prison yard, a vantage point encompassing all. (A panopticon is an optical instrument that combines

PLATE 7.13. TOM SALE.
Computer Color Cutouts.
Courtesy of the artist.

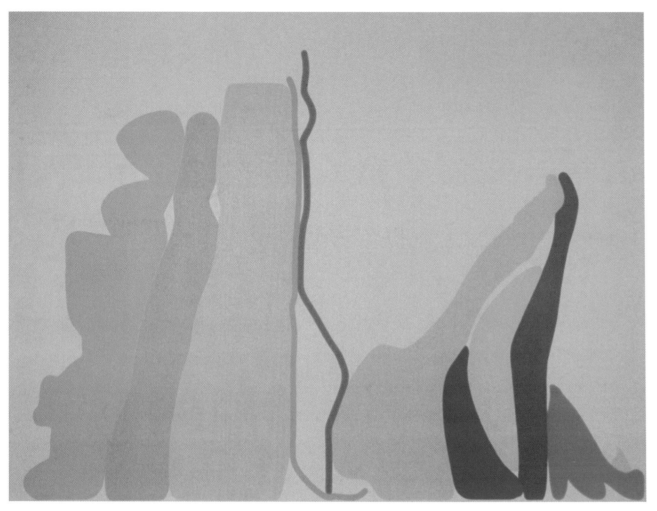

PLATE 7.14. MONIQUE PRIETO.
On the Other Side. 1997. Acrylic on canvas,
6′ × 8′ (1.82 m × 2.44 m). ACME,
Los Angeles.

Antiperspective:
The Triumph of the
Picture Plane

Perspective: Just another lie invented by dead European white males.
CHARLES BARSOTTI

T HE ARTIST WAYNE THIEBAUD SAYS HE IS
amazed—and amused—that a city's massive apartment complexes are de-
signed to have "100 views rather than several . . . it's really rather silly—or
sublime—depending on your point of view" (Beal, *Wayne Thiebaud Painting,*
p. 5). We could call Thiebaud's structures "buildings with 100 eyes." And that
image can serve as a metaphor for multiple ways of seeing the world, each
from a different stance. In art since the beginning of the twentieth century—
for over a century now—artists have rejected the fixed-focus vision and have
opted for new ways to "wring from the visual world" their spatial images.
 One artist can present 100 views simultaneously in a single work
can be seen in figure 8.2 by Warrington Colescott. *God Destroys Bourbon S*
a satirical melange, it is a compendium of New Orleans's famous si
activities, with a hurricane thrown in for dramatic effect. The artis
his comic interpretations on these topics through multilayered i
multiple standpoints. Colescott is antiperspective, antiacademic
genius, and antitradition. He combines the abstract and the

8.1. CHARLE
New Yorker M
© 2002 T
cartoonb

8.3. GUILLERMO KUITCA. *Untitled (Red and Blue Theater)*. 1994. Acrylic and graphite on canvas, 5′4½″ × 5′4½″ (1.64 m × 1.64 m). Private collection, Italy. Courtesy Galleria 1000 Eventi, Milan, Italy.

the function of a telescope and a microscope.) Kuitca's maps are "intense psychological spaces that chart human experience far beyond topographical realities" (ibid.).

Any single expression of our multiple experiences in the world is limited and partial. Advantages gained in one spatial system must be weighed against possibilities lost by not choosing another system. In chapters 3 through 7 we saw how the spatial relationships of the art elements can be used to create pictorial space and how that space may be relatively flat, illusionistically three-dimensional, or ambiguous, depending on how the various elements of shape, value, line, texture, and color are used. We have looked at a broad spectrum of spatial approaches in the illustrations in this text: some images seem to jut out toward the viewer, other objects appear to recede into space, and yet other objects and figures seem to occupy a jumbled, fragmented, illogical space.

Space is an essential ingredient in all the visual arts. In the performance arts, drama, and dance, the performers are contained by a designated space activated and transformed by the performers. In sculpture the viewer moves around the work to see it in its entirety; in painting and the graphic arts where space is pictorial, we are presented with an illusion of space. Although architecture provides the spatial environment for our daily lives, architectural drawings present an illusion of space, as can be seen in the site plan drawing by Zaha Hadid (see figure 1.19). In drawings for her innovative designs, Hadid looks back to Suprematist art as a basis for her drawing and then extends those ideas beyond contemporary architectural conventions. Implicit in her drawings are her ideas that social and technological changes demand visionary new uses of spaces. She employs radically new methods of architectural representation, presenting a building from conflicting angles, from above and below simultaneously. Her visual language results in a narrative process. An explosively

energetic setting is created by using distorted perspective, shifting eye levels, changing planes, and implied dynamic movement.

Our ideas about space changed dramatically in the twentieth century as scientific exploration of space exceeded the most active speculations of the previous century. New knowledge and discoveries in an expanding universe, along with new ideas in physics, such as quantum mechanics and chaos theory, have resulted in an ambiguous notion of space; so it is no surprise that the ways in which artists depict space also have changed.

This is not to say that an artist always predetermines the kind of space used in a work. Space can be intuitive, but not accidental. This intuitive response comes not only from a cultural base but from a private, personal one as well. Other considerations, such as subject and intent, also enter into the decision.

You, as an artist, must have an understanding of space to analyze both your own work and the work of other artists. This understanding gives you wider choices in meaning and technique; knowing which techniques give the effect of two-dimensional, three-dimensional, or ambiguous space keeps you from making unintentional contradictions in your work. Knowledge of how the elements function will help you carry out your intention.

In this chapter we will discuss eye level and baseline, aerial perspective, linear, multiple, and stacked perspective, and foreshortening. Through the eyes of contemporary artists we will look at various perspectival conventions of representing three-dimensional objects as they appear to recede into space on a two-dimensional surface. The word *perspective* comes from the Latin *prospectus*, which means "to see through or into." In traditional art, perspectival relationships that exist in the real world are transcribed onto the confines of the two-dimensional picture plane. In looking at a work of art that employs traditional perspective, we as viewers can project ourselves through our imaginations into that imitation, or simulacrum, of real space.

Linear perspective, a theory developed in the Renaissance, is a quasi-mathematical system based on the observations that parallel lines seem to converge as they move into space and that all lines going in the same direction into space appear to converge or meet at a single point on the horizon. This discovery of perspective provided art with a forceful and exciting impetus at a time when many former ideas and ways of interpreting the world were being replaced with new observations and theories. (In Baroque church art, artists' use of perspective served a doctrinal purpose; it required the viewer to stand in the center of the nave of the church for the ceiling painting above to make sense. This act reinforced the teachings of the Church during the Counter-Reformation that the world made sense only when viewed from one particular vantage point. So religious indoctrination was reinforced by one-point perspective.)

We have an automatic tendency to interpret depth or spatial organization in any visual arrangement. This tendency is natural and fundamental; certain perceptual principles have been shaped by natural selection by our operating in a three-dimensional world. Humans' ability to make pictures goes back many thousands of years. Drawings, of course, are particularly well suited to recording objects in space. We employ many clues to indicate space; dimunition in size, occultation (where a closer object blocks the view of a more distant object), and overlap are devices that even young children use in their drawings. According to the conventions of perspective, objects appear larger

8.4. JAMES CASTLE. *Untitled (farm scene with road).* n.d. Found paper, soot, 9¼″ × 1′2″ (23.5 cm × 35.6 cm). Collection of the Whitney Museum of American Art, New York. Courtesy of AC Wade Castle LP.

or smaller in relation to their distance from the viewer. This recession into space can be relayed by the artist according to certain rules. Of course, perspective is based on what the eye sees; it is not simply a mathematical rule. Some knowledge of perspective can be helpful for the artist, but it also has limitations. Perspective can be used as an aid in seeing, but it should not be a formula to be substituted for visual acuity.

People can draw objects as they appear in space perfectly well without ever having heard of perspective; a case in point is the work by James Castle (figure 8.4). Castle was a deaf mute who refused to learn to read or write. He drew obsessively throughout his life, recording and animating the world around him. His images make use of a "knotty, perspectively inventive architectural realism" (Stephen Westfall, "Touched into Being," *Art in America,* June 2001, p. 86). His self-taught perspective skills developed over time, but he employed other techniques and imagery during his lifetime. His media—homemade ink made from soot, saliva, and ground-up colored paper, and string and found papers—are peculiar but well suited to his texturally rich drawings.

Figure 8.5 is a drawing by a three-year-old savant named Nadia. Nadia was an unresponsive two-year-old, but at age three she began making detailed drawings from memory, not at all like normal young children who use line to designate major features, head, eyes, and legs, based on a concept rather than actual physical details. Allan Snyder, a vision researcher, physicist, and director of the Center for the Mind at the University of Sydney and the Australian National University, explains such talents: "Each of us has an innate capacity for savantlike skills, but that mental machinery is unconscious in most people." Snyder says that in savants "the top layer of mental processing—conceptual thinking, making conclusions—is somehow stripped away. And without it, they have an amazing capacity for other processing abilities" (Douglas S. Fox, "The Inner Savant," *Discover Magazine,* February 2002, p. 46). Unlike Nadia, we are not born with such startling ability, but practice does enhance skills over time.

8.5. NADIA. *Drawing of Horse and Rider.* (Nadia at 3 years old.) Reprinted from *Nadia* by L. Selfe © 1977 by Academic Press, with permission from Elsevier.

Keep in mind that linear perspective is only one of many systems of representation and is not always the most appropriate choice for a particular idea. In different time periods different systems have been dominant. In non-Western art, in children's art, in the art of the Middle Ages, and in the art of the twentieth century, the dominant system of representation has not been linear perspective.

EYE LEVEL AND BASELINE

8.6. (below left) ANN PARKER. *Sturgeon Stake Out.* 1991. Linocut, 4′2″ × 2′6″ (1.27 m × 76 cm). Courtesy of the artist.

8.7. (below right) ANN PARKER. *The Prize* from "Northern Sports Series." 1991. Linocut, 4′2″ × 2′6″ (1.27 m × 76 cm). Courtesy of the artist.

A drawing of a scene from real life differs from the actual scene; it is a two-dimensional translation from a three-dimensional subject. It *re-presents* the scene as viewed from a particular position. This viewing position taken by the artist is an inherent part of the depiction, or representation. The viewing position determines not only how the scene is composed by the artist, but it also

determines how the picture is perceived by the viewer. The first important matter that the artist must consider in the treatment of space is the use of eye level. An *eye level* is an imaginary horizontal line that is parallel to the viewer's eyes. When we look straight ahead, this line coincides with the horizon. If we tilt our heads, if we move our angle of sight to a higher or lower position, this eye-level line will also change on the picture plane, thereby making the horizon line seem higher or lower.

Two extremes of eye level, the ant's-eye view and the bird's-eye view, are amplified in the exuberant works by Ann Parker from her *Northern Sports Series* (figures 8.6 and 8.7). The first print is from an ant's-eye view, or better said, from a sturgeon's view. The fish in this linocut are lures, or decoys, ornately carved and decorated to attract real sturgeons. From beneath the ice we look to the surface where the frigid fisherman is patiently staked out, trident in hand. We perceive the fish and sportsman as occupying two different levels of space, and two different states of mind: the decoys seem more animated than their owner.

Parker's second print, titled *The Prize*, makes use of an overhead viewpoint; forms diminish in size as the space recedes from top to bottom of the picture plane. The ice fisherman proudly displays his catch while the lures seem to share in his achievement; the "prize" itself seems somewhat skeptical. A conceptually deeper space is indicated by the dark hole in the ice occupied by the sturgeons who witness the boast; this inset does not make use of the bird's-eye perspective; it is indicated by a more normal head-on perspective, a penetration of space from front to back. A third, and very clever, kind of space is used in the sketchy background; Parker has distorted the space to wrap around the fisherman and his catch. This circular notation of Lake Winnebago and its surrounding woods holds the key to a visual pun. In photography the lens that compresses a 360-degree view onto a rectilinear format is called a "fish-eye lens." So it is the fish that has the last laugh; there is no doubt the prizewinner is posing for a documentary photograph, but who is behind the camera?

Artists since the Renaissance have been occupied with the problem of how to re-create a distorted image as it might be found in the real world, as in a convex mirror, for example. In the twentieth century this distortion takes on new connotations. In *The Inertia of Night (Self Portrait as a Slat)* by the Australian artist Mike Parr (figure 8.8), the oblique figure on the left reminds us of the distortion that occurs when a slide is projected at an angle, when the parallax is not true. We feel we are not parallel to the drawing, and if we could shift our viewing angle, the distortion would disappear. Parr makes reference to space and flatness in his use of the word *slat* in the work's title. The scale of the drawing (9 feet by 6 feet) relates more to a projected slide or film image than to the human figure. It is the unsettling eye level or point of view that manipulates the viewer's sense of space, making this work both disturbing and intriguing.

We have seen several examples of highly subjective manipulations of vantage point; eye level is much more than a spatially descriptive tool for these artists; it is a major means of conveying conceptual, psychological, and emotive ideas.

Another important consideration is *baseline*, the imaginary line on which an object sits. Baseline and eye level are closely related. If all the objects in a given picture share the same baseline, that is, if the baseline remains parallel to

8.8. MIKE PARR. *The Inertia of Night (Self Portrait as a Slat).* 1983. Charcoal and Giroult on paper, 8'11⅞" × 6' (2.74 m × 1.83 m). Collection of Roslyn and Tony Oxley, Sydney, Australia. Photograph from Sherman Galleries.

8.9. JIM DINE. *Five Paint Brushes.* 1973.
Etching and drypoint on paper, 2′5″ ×
2′11¼″ (73.7 cm × 89.5 cm). Collection
of the Neuberger Museum of Art, Purchase
College, State University of New York.
Gift of Mr. and Mrs. Werner Kramarsky.
Photo by Jim Frank. © 2003 Jim Dine/
Artists Rights Society (ARS), New York.

the picture plane, space will be limited as in the print by Jim Dine (figure 8.9).
If objects sit on different baselines, and if these lines penetrate the picture on
a diagonal, the resulting space will be deeper.

In Judy Youngblood's etchings, *Foreign Correspondents,* horizon lines, eye
levels, and baselines play a crucial role. The horizon is placed progressively
lower in each print in the series. In figure 8.10 bundles of twigs are distributed
in a random fashion. In figure 8.11 the bags have sprouted legs. These striding
anthropomorphic figures occupy different baselines on a low horizon. The
figures seem to be standing on the rim of the horizon. Cast shadows connect
the animated sacks in a series of diagonal lines that penetrate the picture plane.

The images in the two prints were drawn from manipulated objects
that are intimately associated with both the artist and her environment. Tab-
leaux are arranged from which drawings and photographs are made. Spatial
manipulation—variations in eye level and baselines—is of the utmost impor-
tance in Youngblood's work.

Keep in mind that eye level is only one determinant of pictorial space.
The space an artist uses is relative; it is not possible to determine the spatial
quality of a work by eye level alone. In fact, the same eye level can result in a
shallow or deep space, depending on other determinants in the work such as
scale, proportion, texture, value, and color.

PROBLEM 8.1
Using Eye Level and Baselines

Before beginning this problem, complete Sketchbook Project 1,
found at the end of this chapter.

Make a diptych, a two-part drawing, using the invented forms and ideas
taken from the preparatory work in your sketchbook. Refer to Youngblood's

etchings (see figures 8.10 and 8.11) to see how simply the negative space can be handled. You may use different invented forms from one panel of the drawing to the next or you may keep the forms consistent. (In Youngblood's work she uses the same image within each individual work, but changes images from print to print.) Use two different horizon lines; however, the two drawings should work as a pair. You might have one side take place in daylight, the other at night. You might use a distant view of a group of images combined with a close-up, magnified view of the same images. Like Youngblood, you might combine objects using various household items as subjects for the diptych — sacks, balloons (deflated), kitchen implements, sticks, pencils, and brushes are some suggestions.

Give real consideration to how the two sides of the drawing relate to one another. Keep the negative space simple; focus on the relationship of the objects within that space. The diptych can be either horizontal or vertical, depending on the demands of the subject.

8.10. (above left) JUDY YOUNGBLOOD. *Foreign Correspondents #1.* 1979. Etching with aquatint and drypoint, 11¾″ × 1′2¾″ (30 cm × 37 cm). Courtesy of the artist. Photo by Danielle Fagan, Austin, Tex.

8.11. (above right) JUDY YOUNGBLOOD. *Foreign Correspondents #4.* 1979. Etching with aquatint and drypoint, 11¾″ × 1′2¾″ (30 cm × 37 cm). Courtesy of the artist. Photo by Danielle Fagan, Austin, Tex.

AERIAL PERSPECTIVE

There are two distinct types of perspective, linear and aerial. *Aerial perspective* is the means by which the artist creates a sense of space through depicting the effects of atmospheric conditions. Various atmospheric conditions affect our perception of shape, color, texture, value, and size at different distances; compare your memory of a bright, sunny summer day and a cold, drizzly winter night. Long before linear perspective was developed, artists used aerial perspective to promote a sense of depth in their work.

Depicting atmospheric conditions can convey a sense of depth. *Aerial perspective* is one means by which the artist creates spatial illusion: objects in the foreground are larger and their details are sharp; objects in the background are diminished and less distinct. As the objects recede into space their color and value become less intense and their textures less defined (see figure 8.10).

8.12. CHRISTOPHE CHÉREL. *Meander.* n.d. Ink on paper, pasted on canvas, 1′1⅖″ × 2′1⅗″ (34 cm × 65 cm). The Gallery, Paris.

Christophe Chérel has employed aerial perspective in his ink drawing *Meander* (figure 8.12). A dark, brooding, diffused light bathes the scene, while a river (or other waterway?) meanders from the bottom of the picture plane to disappear in the fog above the horizon line. The horizon line is high; it lies slightly below the top of the picture plane just at the point of the disappearing zigzag shape that we interpret as a river. The reductive, natural landscape offers three vital forms: earth, air, and water. The light is barely perceptible; an ominous mist clouds the landscape; we can nearly picture the water particles in the air softening the distant landscape. Chérel's mysterious and disquieting depiction suggests a sense of exile and absence; the landscape seems tinged with sorrow. To establish this mood, he uses a very limited, close value range, one texture only, and four simple shapes—the shape of the sky, the river, and the two shapes bordering the winding path of the waterway. What a masterful effect with such simple means!

Normally aerial perspective demands that as the distance increases textural definition decreases; this is not the case with Chérel's drawing. The textural surface is constant throughout; it is by the amazingly simple image of the river as it weaves through space (literally as it diminishes in size from the bottom of the picture plane to the top) that space is defined. The drawing is both abstract and illusionistic at the same time, a contemporary evocation of an age-old theme.

PROBLEM 8.2
Using Aerial Perspective

Make a landscape drawing on site. Try to depict a particular atmosphere, a specific time of day or night and season of the year. What atmospheric clues can aid you in establishing a mood? Your main subject might be the sky, in which case you could use a low horizon line. Or you might focus on a field of grass with a high horizon line. Pay particular attention to the size, value, and scale of your marks; make them smaller and closer together as they near the horizon line.

Some other devices by which you can control space and create a sense of atmosphere are diagonals penetrating the picture plane, overlapping forms,

diminution of size as the forms recede, gradual value changes, blurring in focus from front to back, and changes in texture from foreground to background.

Select a medium that can be combined with a wash in order to achieve a blurred focus.

In a second drawing create a scene from a 1950s *film noir*. In that genre emptiness, bleakness, mystery, and obscurity apply. The scene could take place at night, either in a darkened room or in an abandoned cityscape. Try to convey an ominous feeling; threat and mystery are the subject. Think of a movie set in which a streetlight, a shaded backlit window, or car lights faintly illuminate the scene. Long shadows help create a sense of mystery. You might opt for an enveloping fog as seen in the Chérel drawing. Urban, back-alley scenes or interior, dingy, dark, half-lit spaces such as stairways or hallways would make good settings for your dramatic interpretation.

Charcoal on toned paper with erasure would be a good choice for media. Or you could fill a spray bottle with an ink wash and manipulate layers of spray to create an atmosphere of foreboding.

LINEAR PERSPECTIVE

Filippo Brunelleschi, the Italian Renaissance architect, is credited with the invention of perspective, the system of translating three dimensions into two. The critic Michael Kimmelman describes Brunelleschi's method: the Florentine architect painted a view of the Baptistry of San Giovanni on a wooden panel, then he drilled a hole in the center of the panel; by standing directly in front of the baptistry and viewing it from the back of the panel, he could see the church. With a mirror held in front of the reverse side of the panel, he could see the painted version. The mirror blocked Brunelleschi's vision of the church and presented the painted image; removing the mirror allowed him to see the actual three-dimensional image. By this simple "trick" Brunelleschi proved that a microcosm of the world could be re-created on a flat surface (Michael Kimmelman, "Everything in Perspective," *New York Times Magazine,* April 18, 1999, p. 86).

M. C. Escher, the master of perspectival games, mixes the rational with the antirational in his spatially ambiguous work. In figure 8.13 he has maintained an extreme bird's-eye view in the upper half of his drawing, aptly named *High and Low*. In keeping with his unwavering involvement with spatial ambiguity, in the lower half of the drawing he has abruptly changed eye level to an equally extreme ant's-eye view. Within each segment the eye level is strictly maintained. Escher employs contour line along with a rigidly controlled one-point perspective to set up an exaggerated spatial contradiction.

Perspective assumes a fixed point of view, so it is important to remain relatively stationary in order to make a consistent drawing.

To use perspective it is necessary first to establish a horizon line. Place a pane of glass (or more safely, a pane of clear plastic) at a fixed distance directly in front of you. Ideally, the pane should be the size of your drawing paper. If you do not maintain a fixed, stationary distance from the pane, the measurements change. Attach the pane to the edge of your easel, or on a tripod. Be careful to keep it perfectly perpendicular to the ground and directly in front of your eyes. The glass is perpendicular to your sight line; that is, if you drew

8.13. M. C. ESCHER. Study for the lithograph *High and Low*. 1947. Pencil, 5′8¾″ × 4′ 2½″ (2.71 m × 1.99 m). © 2003 Cordon Art B.V. Baarn-Holland. All rights reserved. ARCO Center for Visual Art, Los Angeles.

a line from the center of your eyes, it would intersect the plane of glass. If you look up, the horizon line is below the direction of your sight; if you look down, the horizon line is above your sight line. The pane of glass is always perpendicular to your line of vision; in other words, your line of vision will always intersect the clear plane at a 90-degree angle.

This pane of glass represents the picture plane; you are transferring the visual information seen through this imagined plane onto your drawing surface. The see-through plane is identical with the picture plane. The information you record on the glass is the same as the information you draw on your paper.

Your viewing position is of the utmost importance in perspective. Two relationships are crucial: your distance from the subject being drawn and your angle in relationship to the subject. Are you directly in the middle front and parallel to the subject, or are you at an angle to it? Manipulate the distance between you and the subject by looking through the glass at various different viewing angles and from various different stances.

Always locate the horizon line, even if it falls outside the picture plane. Its position will describe the viewer's position—whether the viewer is looking up, down, or straight ahead. (On the pane of glass, using a water-soluble felt-tip marker, draw the horizon line. The water-soluble marks can be wiped clean with a damp rag.)

Perspective hinges on the fact that lines that in reality are parallel and moving away from us appear to meet at some point on the horizon. That meeting place is called the *vanishing point*, or the point of convergence. Parallel lines of objects above the horizon line will converge downward; those of objects below the horizon will converge upward. Lines perpendicular and parallel to the picture plane do not converge unless the viewer is looking up or down, tilting the picture plane. Draw those lines on the glass plane.

In Escher's drawing, the vanishing point is in the exact center of the picture plane; all parallel lines both above and below converge at the mark. Compare the two views of the tree, stairs, and passageway connecting the buildings on either side of the composition and trace their converging lines.

Once the horizon line has been determined, finding the vanishing point is relatively easy. Simply point with your finger, tracing the direction of the receding lines until you reach the horizon line (or more graphically, draw the receding lines on the clear glass). The vanishing point is located at the juncture of the traced line and the horizon line. True *one-point perspective* will have a single vanishing point in the middle of the picture plane. One-point perspective is useful chiefly in situations in which subjects are parallel or perpendicular to the picture plane, as in the Antholt drawing (see figure 4.31). Antholt's use of aerial and one-point perspective is the means to represent an esoteric idea. Her formal technique is a means to a metaphysical end with symbolism as its "point of departure"; her subject is "the conditions of spirituality within a house." A strict use of one-point perspective is a means to promote "an appreciation of sterner, more eternal conditions." Antholt's use of aerial perspective lends a tone of solemn purpose to the work; as one reviewer has written, "An atmosphere of sublimity pervades every picture like a fragrance" (J. W. Mahoney, "Sharron Antholt at Franz Bader," *Art in America*, March 1989, pp. 155, 156).

If you are standing in front of a building parallel to the picture plane and you move to the right or left so that the building is seen at an angle, you will have changed to a *two-point perspective*. There are now two sets of parallel lines,

each with a different vanishing point. There may be multiple vanishing points in two-point perspective; any number of objects set at an angle to the picture plane can be drawn, and each object or set of parallel lines will establish its own vanishing point. All planes that are parallel share the same vanishing point. (Take your pane of glass outdoors in your neighborhood or on campus, and trace a number of one-point perspective scenes. You can lay the glass on your sketchbook or on a clean sheet of paper and you will easily see the various angles to be drawn; the conversion of angles, or the angles of the parallel lines as they move into the distance, have been indicated accurately on your "window into space.")

Objects in *three-point perspective* have no side perpendicular to the picture plane, so there will be three sets of receding parallel lines, which will converge to three vanishing points, two sets on a horizon line and one set on a vertical line.

PROBLEM 8.3
Locating Vanishing Points

Cut six strips of stiff paper ¼ inch by 11 inches (.6 cm × 28 cm). Use them to determine where the vanishing points fall on the horizon. Locate vanishing points and horizons in each illustration in this chapter by laying the strips along the converging lines. Note that horizon and convergence points frequently fall outside the picture plane. Note whether the artist has taken liberties with a strict perspective in each drawing.

One-Point Perspective

Many artists, such as M. C. Escher, Ann Parker, David Macaulay, Ed Ruscha, and Wayne Thiebaud, point explicity to perspective as a subject in their work in tongue-in-cheek references to the traditional, long-honored spatial device. Throughout the text we have spoken of the modernist characteristic of self-reference—of the artwork referring to how it is made. A humorous case in point is the sketch by David Macaulay, *Locating the Vanishing Point* (figure 8.14), taken from his book *Great Moments in Architecture*. It certainly was a great moment in art when Renaissance artists discovered this new means of describing the

8.14. DAVID MACAULAY. Final preliminary sketch for Plate XV, *Locating the Vanishing Point* (Macaulay's intentionally misplaced horizon line), from *Great Moments in Architecture*. 1978. Ink and felt marker. Copyright © 1978 by David Macaulay. Reprinted with permission of Houghton Mifflin Company. All rights reserved.

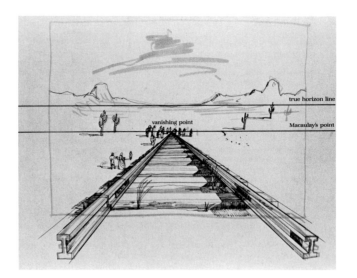

8.15. Diagram—One-point perspective superimposed on David Macaulay's final preliminary sketch for Plate XV, *Locating the Vanishing Point* (Macaulay's intentionally misplaced horizon line).

visual world, but in the world of contemporary art it is frequently seen as a cliché.

One-point perspective is the device in which parallel lines (lines parallel in actuality) located diagonally to the picture plane converge at a single point on the horizon (figure 8.15). This convergence point is called the vanishing point. The humor in Macaulay's drawing stems from the fact that the railroad tracks converge before they reach the horizon. This contradiction sets up a complicated response in the viewer who tries to explain (both logically and visually) the paradox.

In addition to a point of convergence, other devices—overlapping, reduction in the size of objects as they recede, and blurring of detail in the distance—contribute to the sense of spatial recession. In many drawings, especially cartoons, these devices are exaggerated.

Figure 8.16 shows us an example of one-point perspective with a fixed, straight-on eye level in a page from the comic book *The Sarcophagus* by Enki Bilal. There is nothing "comic" in his pessimistic comic strips; they deal with political concerns: the individual in conflict with monolithic powers, the question of memory and the search for identity beyond national and ethnic labels. In collaboration with the writer-journalist Pierre Christin, Bilal is at work on experimental graphic novels that deal with a kind of "docu-fiction."

In Bilal's drawing one-point perspective is the ideal choice for a rigid, ideological subject.

Perspective is a code, just as the conventions of a comic book are a code, and it is through intelligent looking that one learns to interpret the code in a personal, subjective way.

PROBLEM 8.4
Using One-Point Perspective

In this problem and those following, it is important to position yourself so that your angle of vision encompasses both the height and width of your subject. Use your transparent pane to help you track vanishing points and horizon line.

8.16. ENKI BILAL. A page from *The Sarcophagus*. 2000. Drawing, 6′8⅚″ × 8′8⅓″ (2.05 m × 2.65 m). © Dargaud, Paris.

Station yourself directly in the center of a house, a building, or a room; your angle of vision will be the center of the drawing. If you place the picture plane too close to your line of vision, the objects in the foreground will be so large that they will crowd out the objects in the distance. First, locate the horizon line, even if it is off the paper. Establish the height of the verticals nearest you. Draw them, and then trace the parallel lines to their vanishing point on the horizon line.

Use contour line. Create a center of interest in the center of the drawing. The depth of space is flexible; you may either create an illusionistically deep space or one that is relatively flat. Remember to maintain a fixed point of view. It will be helpful to close one eye to rid yourself of the problem of binocular vision in tracing vanishing points.

A second device that is helpful in perspectival drawings is a viewer for sighting, for taking measurements. Cut a 5- by 7-inch opening in a larger rectangle of mat board. (Make several of these viewers, cut to the proportion of your drawing paper; that is, a square and a longer rectangle to be used in long, horizontal, or vertical formats.) Attach two taut strings (either with glue or tape), one vertically from top to bottom, and the other horizontally from side to side, exactly bisecting the opening both horizontally and vertically. This "crosshair divider" or grid is helpful in marking reference points for placement in the initial stages of a composition. It offers you a plumb line to check verticals and horizontals and their relationships to each other. It is helpful in taking proportional measurements; for example, a head might be the unit of measurement to determine the height or width of a particular pose. You can make measurement marks along the sides, indicating quarter-inch intervals to help you more correctly determine heights and widths. This sighting viewer is a convenient way to determine how to crop a composition. Remember in sighting and in using the glass pane to use only one eye because binocular vision interferes with a single sight line. Keep the glass pane and the sighting device in your drawing kit for checking proper size and scale.

Two-Point Perspective

A picture that uses two-point perspective has two vanishing points on the horizon, rather than the single point of convergence in one-point perspective. Two-point perspective comes into use when objects are oblique to the picture plane, that is, when they are turned at an angle to the picture plane. This is clear when we look at Edward Ruscha's *Double Standard (Collaboration with Mason Williams)* (figure 8.17). The verticals all remain parallel to the vertical edges of the picture plane, but the two sides of the service station lead to two vanishing points, one to the right and the second to the left (figure 8.18). The vanishing point on the right is at the exact lower right corner; the one on the left falls outside the picture plane. The horizon line coincides exactly with the bottom edge of the picture plane. (For two-point perspective, any number of objects may be oblique to the picture plane, and each object will establish its own set of vanishing points on the horizon line.) Conceptually, the form is well suited to the meaning in Ruscha's work. What better way to present a double standard than an X shape! Further, there is a play on words: "double standard" is equated with "moral dilemma," and certainly Ruscha indicates we have had a standard response to the question. The looming form of the build-

8.17. EDWARD RUSCHA. *Double Standard (Collaboration with Mason Williams)*. 1969. Color silkscreen printed on mold-made paper, 2′1¾″ × 3′4⅛″ (65 cm × 1.02 m). Edition of 40. © Edward Ruscha/Licensed by VAGA, New York.

8.18. Diagram—Two-point perspective superimposed on Edward Ruscha's *Double Standard*.

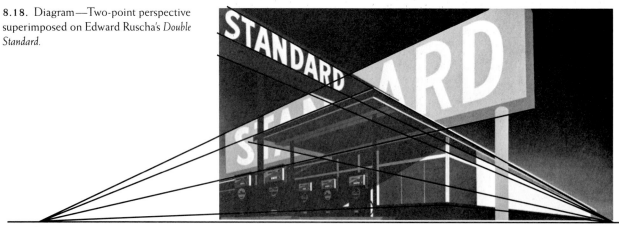

vanishing point 1 horizon line vanishing point 2

ing takes on mythic proportions, matching the scale of our profligate misuse of nature's petroleum. The baseline is at the exact bottom edge of the print. The scale of the building and the extreme upward view emphasize the ant's-eye view and diminish the scale of the implied viewer.

It would be informative to make a visual comparison between Ruscha's linear perspective and Chérel's aerial perspective (see figure 8.12). What extremely different sensibilities and ideas are conveyed in these two works! You can readily see how important the choice of spatial systems can be to both the perceptual and conceptual development of an idea.

PROBLEM 8.5
Using Two-Point Perspective

Before beginning this problem, carefully examine the drawing by Ron Davis in which he has left traces of all the lines of measurement used in making the drawing (figure 8.19). He has left in the drawing extended verticals, horizontals, and angled parallel lines moving into space; these multiple lines trace vanishing points of every angle of the multifaceted forms of his subject. They make up a lively spatial grid into which the objects are logically fitted. The encompassing space is further activated by splotches of wash that serve as a foil to the rigid geometric forms. Davis has made use of an overhead light source to differentiate the planes of the forms and to further enhance the spatial quality of the drawing. His overhead view actually results in a three-point perspective with three vanishing points falling outside the picture plane.

In much contemporary art, rather than disguising spatial devices such as linear perspective, artists forefront them, as seen in work by Ruscha and Davis. This self-conscious approach is modern, where spatial illusion is not meant to penetrate the picture plane. Everything that happens in contemporary art happens on the flat surface of the drawing or painting.

For this project, make an arrangement of various size boxes or geometrically shaped containers. Experiment with placement. If you arrange the still

8.19. RON DAVIS. *Bent Vents & Octangular.* 1976. Acrylic on canvas, 9'6" × 15' (2.9 m × 4.57 m). The Museum of Contemporary Art, Los Angeles. Photo by Squidds & Nunns.

life on the table, the horizon line and vanishing points will be different than if you place them on the floor. Give real consideration to eye level and baselines. Rather than positioning yourself so that you are drawing from a one-point perspective, change your position either to the right or to the left, so that you will be at an angle to the subject. (Remember that in two-point perspective, the subject must be seen obliquely; that is, you must be able to see both the front and side of an object.) Before beginning the perspectival drawing, execute several quick freehand sketches, depending on your visual acuity and your perceptual ability rather than the glass pane aid.

Now draw the same view. Using two-point perspective, register the horizon line by checking your angle of vision. Estimate the height of the vertical nearest you, and draw it. This first step is crucial; it establishes the scale of the drawing, and all proportions stem from this measurement. Next trace the vanishing points. Remember that you may have several sets of vanishing points (all facing on one horizon line) if you are drawing a number of objects that are set at an angle to the picture plane.

After you have finished the drawing, look through the glass from the same perspective you made the drawing. Hold the glass at a fixed distance from your eyes; close one eye and trace the scene, concentrating on the objects in perspective. Establish the horizon line and lightly extend the diagonals to their vanishing points on the horizon. Place the glass on which you have traced the horizon line and diagonals on top of your drawing and compare the two. This device will help serve as a corrective to clarify the angles and points of convergence. Using a transparent picture plane will help you solve some problems in seeing. Do not, however, use this as a crutch to prevent you from developing your own visual acuity.

Three-Point Perspective

In addition to lines receding to two points on the horizon, if you are looking up (at a building, for example), parallel lines that are perpendicular to the ground appear to converge to a third, a vertical, vanishing point. In Hugh Ferriss's dramatic study for a skyscraper (figure 8.20), we can easily trace the vertical vanishing point. Each tower has its set of stacked parallel, horizontal lines receding downward to two points on the horizon line, whereas the vertical lines of each tower converge at a single point above the central tower (figure 8.21). The angle or speed with which the lines converge produces a sense of vertigo on the part of the viewer, not unlike the effect the tourist experiences in New York City looking upward at the vertical architectural thrusts. Ferriss counters this pyramidal effect with rays of beacon lights, which converge downward. The cleanly modeled forms change in value, from light at the base to a flat, dense black at the top, further emphasizing the building's verticality.

PROBLEM 8.6
Using Three-Point Perspective

Assume an ant's-eye view and arrange several objects on a ladder. Position yourself at an angle to the ladder so that your view is looking upward. Again, trace with your finger the vanishing points that will fall on the horizon

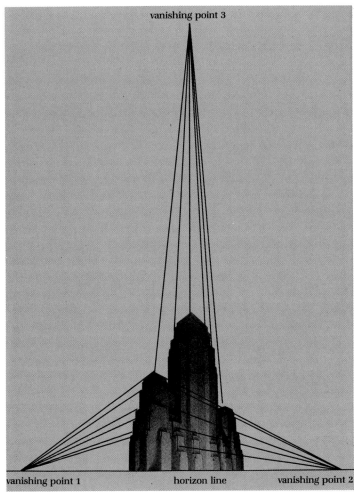

line, and then trace a third vanishing point, the vertical one. Remember to keep in mind all three vanishing points even though they may fall outside the picture plane. The forms will be larger at the bottom of the ladder (and at the bottom of the picture plane). When you reach midpoint on your paper, check the scale and draw in the remainder of the ladder and objects. Employ some aerial perspective to further enhance the feeling of space.

MULTIPLE PERSPECTIVES

Since the beginning of the twentieth century, artists have felt that traditional perspective is lifeless, that any fixed, single viewpoint is too limiting, too narrow, too isolated to adequately render our ever-changing, interconnected world.

The extremely disorienting effect that can be achieved by changing eye level and perspective in the same painting is illustrated by Giorgio de Chirico's

8.20. HUGH FERRISS. *Study for the Maximum Mass Permitted by the 1916 New York Zoning Law, Stage 4.* c. 1925. Carbon pencil, brush and black ink, stumped and varnished on illustration board, 2′2³⁄₁₆″ × 1′8″ (66.5 cm × 50.8 cm). Cooper-Hewitt Museum, Smithsonian Institution, New York; gift of Mrs. Hugh Ferriss.

8.21. Diagram—Three-point perspective superimposed on Hugh Ferriss's *Study for the Maximum Mass Permitted by the 1916 New York Zoning Law, Stage 4.*

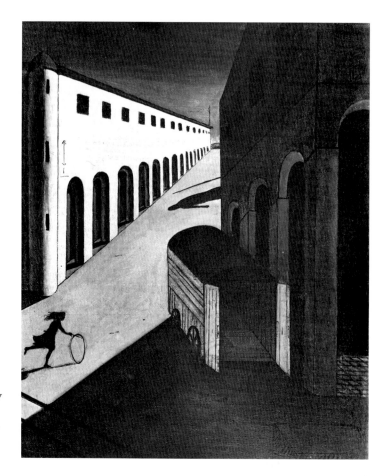

8.22. GIORGIO DE CHIRICO. *The Mystery and Melancholy of a Street.* 1914. Oil on canvas, 2′10⅜″ × 2′4½″ (87 cm × 72 cm). Private collection. © 2003 Artists Rights Society (ARS), New York/SIAE, Rome.

eerily disturbing *The Mystery and Melancholy of a Street* (figure 8.22). In addition to the unreal lighting, sharp value contrasts, and extreme scale shifts, which contribute to the surreal, otherworldly atmosphere, the most jarring effect is produced by de Chirico's forcing the viewer to change eye levels from one part of the painting to another. One eye level is used for the cart, another for the building in the foreground, another for the building on the left, and yet another for its openings. (The top windows and the top of the arched arcade should vanish to the same point as the other parallel lines in the building, but they do not.) In the diagram in figure 8.23, you see four sets of vanishing points, which do not fall on the horizon line. The diagonals converge at dizzying rates within the picture plane. A troubling strangeness upsets what could be a classical objectivity.

In Surrealism spatial ordering follows an illogical underlying geometry. Aerial perspective is turned upside down; deviations from established norms result in distanced and spectral effects. You have seen in de Chirico's work that linear vectors do not obey perceptual logic; illusionism is defied. A particularly contemporary device (an influence from de Chirico) is to place unrelated objects together in the same picture—motifs from classical antiquity or other historical styles with more modern components. This not only has the effect of collapsing style; it collapses past and present (or in the case of de Chirico's work, past and future).

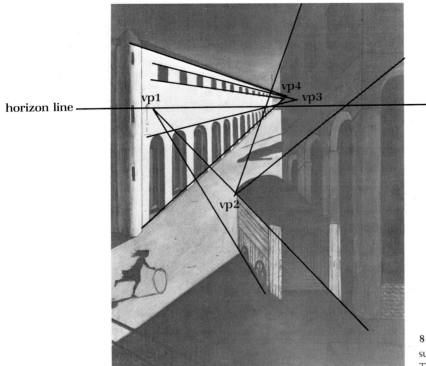

horizon line ⎯

vp1 vp4 vp3

vp2

8.23. Diagram—Multiple perspective superimposed on Giorgio de Chirico's *The Mystery and Melancholy of a Street*.

Incompatibility of images, along with conflicting sizes and scale of objects and multiple perspectives punctuate the isolation or separation between objects and space. As the critic Margit Rowell has noted, de Chirico was "instrumental in destroying the intimist parameters of the still life, taking it off the table, out of the interior, and into the infinite spaces of the world" (Rowell, *Objects of Desire*, p. 87). Note "spaces of the world," not "space of the world."

PROBLEM 8.7
Using Multiple Perspectives

Make a drawing in which you use changing, or multiple, eye levels within the same drawing. The resulting space will be ambiguous. Draw the interior of a room, using one eye level and perspective for a view through the window, another for a tabletop, and still another for objects on the table. Choose the objects with an eye toward the surreal.

Or you might choose to draw a cityscape or an urban freeway, changing eye level and perspective from one section of the drawing to another, from building to building. The roadways might vanish on an extreme diagonal into space; billboards could be out of scale and have multiple vanishing points. Keep in mind the disorienting effects of a multiple perspective with its highly ambiguous space. Use extremes of perspectival space to mirror the disorientation of city life. A look at the cityscapes of Wayne Thiebaud will give you some ideas of how to handle images from urban landscape, although his work does not employ multiple perspectives.

STACKED PERSPECTIVE

You are probably familiar with stacked perspective from reading comic books; stacked panels or frames on the same page create a space that is predominantly two-dimensional. A parallel grouping of squares or rectangles, stacked one on top of the other, encourages a reading from top to bottom across the page in a sequential order. These parallel frames reinforce the two-dimensionality of the picture plane. In comic strips there can be abrupt changes in horizon line from frame to frame and pronounced shifts in eye level, from high to low. Perspective is frequently exaggerated; extreme angles are used often to suggest a deep space.

In an earlier discussion of space in Part II, Spatial Relationships of the Art Elements, we saw how stacked space was used in the Mixtec codex from the fourteenth to the sixteenth centuries (see figure II.6). The figures share the same baseline; the blank or empty space of the background focuses attention on the hierarchical figures, priests and gods. Egyptian wall paintings also make use of hierarchical, stacked space. Both Mixtec and Egyptian paintings employ a social and religious hierarchy rather than a visual reality. Not only is space stacked, but in Egyptian art, a twisted perspective combines a frontal view of the torso with a side view of legs, a profile view of the head illogically combined with two eyes as if seen from the front—a device reintroduced by Picasso and used throughout his long career. Both Mixtec and Egyptian cultures employ a number of common devices that results in a relatively shallow space. Modeling is limited; value remains flat within a given shape. Repeated shapes organize the images. There is a limited use of diagonals; shapes remain parallel to the picture plane on a horizontal-vertical axis. Outlines and invented textures are made up of lines and dots.

In figure 8.24 we see a modified stacked perspective from an ant's-eye view in a drawing of San Francisco's topography by Thiebaud. An uphill view is combined with an extreme compression of space from bottom to top. Thiebaud's work, as one critic notes, reads more like a waterfall than a four-lane street. His work makes use of a subjective manipulation of perspective. His cityscapes deny the convention of perspective; he says, "What interests me is how an artist can interrupt that convention, orchestrate or augment it" (Beal, p. 4). So developed is Thiebaud's observation and memory that he can produce images without ever visiting a particular site. In the studio, he can assert his own sense of the landscape, borrowing from several studies. In a final work, there is morning and evening light. "It turns out to be the day stretched out," he says (Beal, p. 6). The "urban landscapes," as he calls them, allowed Thiebaud to integrate horizontal and vertical planes, like a series of stacked flat planes lined up behind one another. Landscape provided the format for this spatial involvement. A breakthrough came when he decided to juxtapose elements from drawings of different sites. He found that he could build up his images unconstrained by exact representation, that he could "take a piece here and a piece there and organize it like a stage. Working with specific information I can . . . manage the landscape" (Beal, p. 3).

Thiebaud is interested in what he calls a "concept of extremism" (Beal, p. 4), whether in dealing with color, light, or perspective. His compressed space accentuates the vertical (certainly San Francisco's extreme topographical contours are ideal subjects). Although Thiebaud has chosen a subject that

8.24. WAYNE THIEBAUD. *Down 18th Street (Corner Apartments).* 1980. Oil and charcoal on canvas, 4′ × 2′ 11⅞″ (1.218 m × 91.2 cm). Hirshhorn Museum and Sculpture Garden, Smithsonian Institution, Washington, DC. Museum purchase with funds donated by Edward R. Downe Jr., 1980. Lee Stalsworth, photographer. Acc. 80.66. © Wayne Thiebaud/Licensed by VAGA, New York.

demands a perspectival solution, he protects the surface integrity, or autonomy of the picture plane, so that we never feel we are looking through that much-cited window-into-space of traditional art. Light is ambiguous since both morning and evening light are combined. This stretched-out, or rather stretched-up, space seems to be further extended by the long freeway that dissects the picture plane. The snakelike movement of the adjoining roads weaves through the composition, leading the viewer's eyes upward. The viewer "enters" the picture plane from the bottom; unlike many other works where the reading is from left to right or from top to bottom (an encoded Western bias), in this work the reading is bottom to top.

PROBLEM 8.8
Using Stacked Perspective

Set up a still life made up of several common objects on a table in front of a window; arrange the remainder on a windowsill. Use multiple parallel baselines. Draw two or three objects on each baseline. Make use of

8.25. DAVID MACAULAY. *Fragments from the World of Architecture,* from *Great Moments in Architecture.* 1978. Copyright © 1978 by David Macaulay. Reprinted with permission of the Houghton Mifflin Company. All rights reserved.

repeated shapes, repeating values, invented texture, and outlining to create a relatively shallow space. Some of the objects may be parallel to the picture plane, others set at an angle to it. Scale and proportion may change from panel to panel. Macaulay's *Fragments from the World of Architecture* (figure 8.25) could have been made in response to this problem. For subject matter he has chosen common building materials—acoustical tiles, Formica, fake brick, Styrofoam, and AstroTurf—all "archaeological finds" from the twentieth century. They are stacked on various baselines in a two-point perspective drawing. Texture is meticulously handled. The volumetric depiction of the objects is in contrast with their strictly limited space.

Be inventive in your choice of objects. You, too, might go on an "archaeological dig" in search of subject matter for this drawing. You might even photocopy some of their textures, or go back and look at your photocopied texture file and find suitable textures and objects.

ANTIPERSPECTIVE/THE FLATBED PICTURE PLANE AND SUPERFLAT

We are introducing a new category of perspective, antiperspective, to cover more recent developments in handling space. You may remember from our discussion in Part II, Spatial Relationships of the Art Elements, Leo Steinberg's famous characterization of Robert Rauschenberg's working surface as a "flatbed picture plane." Steinberg likened it to a flat, horizontal surface on which any-

thing can be placed. (Reread that discussion to refresh your memory on that innovative spatial and pictorial development.)

Jasper Johns, with whom Rauschenberg lived and worked, made equally revolutionary advances in his work in overturning traditional attitudes and approaches to illusionistic space. In the 1950s Johns also chose commonplace objects—"things that were seen and not looked at": flags, targets, alphabets, numbers. Where Rauschenberg's work was exuberant and all inclusive, Johns's images turned in on themselves. The very choice of subject matter resulted in work that allowed "no air or empty space." Steinberg said that in Johns's work he saw "the end of illusion"; the work, he concluded, was profoundly important (Steinberg, *Other Criteria*, p. 13).

According to Johns's logic, since the surface of a drawing or painting was flat, he would only paint flat images on it. And, like Rauschenberg, if he needed something three-dimensional, he would add the actual object to the flat surface. In 1956 Johns incorporated the first objects to an otherwise flat picture plane. Steinberg says, "Within Johns's pictorial fields, all the members abide in a state of democratic equality. No part swells at the expense of another. Every part of the image tends toward the picture plane as water tends to sea level. . . . and one imagines that any part could replace any other at any point" (Steinberg, p. 46) (see figures 2.16 and 2.26). Not only did Johns dispense with perspective, he seemingly dispensed with structure. So the picture plane triumphed once more in its battle with perspectival illusionism.

A more contemporary designation of space is "Superflat," coined by the Japanese artist, designer, and critic Takashi Murakami, whose work is a mix of high and low culture. Comic books and animated movies have been a major influence on a new generation of Japanese artists. Proving that Modernist ideas have spread worldwide and are still capable of lively change, their work incorporates sculpture, videos, photographs, paintings, and digital prints—all employing a "Superflat" space. Exaggerated, abstracted shapes, flat colors with little or no modeling, flat patterning, a total absence of perspective, and a symbolic use of line (one that represents an eye or a mouth, for example) are common characteristics of the new work.

In describing the very popular work of the young Japanese artists, Murakami offers a new twist on Leo Steinberg's flatbed picture plane in his concept of "Superflat," his term for a computer-generated desktop graphic in which a number of distinct layers merge into one (Raphael Rubinstein, "In the Realm of the Superflat," *Art in America*, June 2001, pp. 111–115). Flatness can, after all, have many dimensions.

FORESHORTENING

Perspective is concerned with representing the change in size of objects as they recede in space. *Foreshortening* is the representation of an object that has been extended forward in space by contracting its forms. Foreshortening produces an illusion of the object's projecting forward into space. The two techniques are related, but they are not the same thing. Foreshortening deals with overlapping. Beginning with the form nearest the viewer, shapes are compiled from large to small, one overlapping the next, in a succession of steps. In

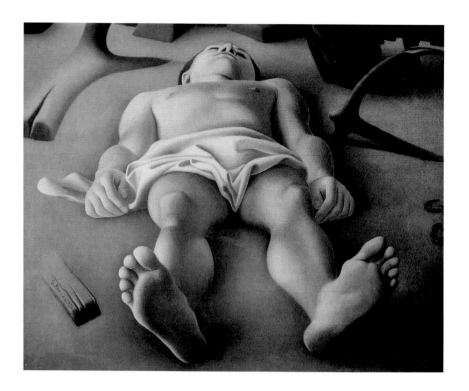

8.26. GEORGE ROHNER. *Drowned Man.* 1939. Oil on canvas, 1′11¾″ × 2′7⅝″ (60 cm × 80 cm). Courtesy Galerie Framond, Paris.

George Rohner's twentieth-century version (figure 8.26) of Andrea Mantegna's fifteenth-century Christ, we are presented with an example of extreme foreshortening. The forms are compiled one behind the other from foot to head. The leg on the left is more severely foreshortened than the one on the right, presented in a side view. The leg on the left is compressed, each unit maintaining its own discrete shape; there is no flowing of one form into the other as we see in the other leg. It is fascinating to see how conventions are adapted to their times. Perspective has certainly undergone drastic changes since its inception 600 years ago.

Foreshortening does not apply to the figure exclusively; any form that you see head-on can be foreshortened. In foreshortening, spatial relationships are compressed, rather than extended. Foreshortening heightens or exaggerates the feeling of spatial projection in a form, its rapid movement into space.

PROBLEM 8.9
Using Foreshortening

Observing a model, combine four or five views of arms or legs in a single drawing. In at least one view employ foreshortening; that is, begin with the form nearest you, enclose that form, then proceed to the adjacent form, enclosing it. Be careful to draw what you see, not what you know or imagine the form to be. For example, in drawing the leg, analyze the parts that compose the form: foot, ankle, calf, knee, thigh, hip connection. This is unlike a profile drawing where you are presented with a side view and each form flows into the next. Foreshortening describes the form's projection into space. In foreshortening a feeling of distance is achieved by a succession of enclosed,

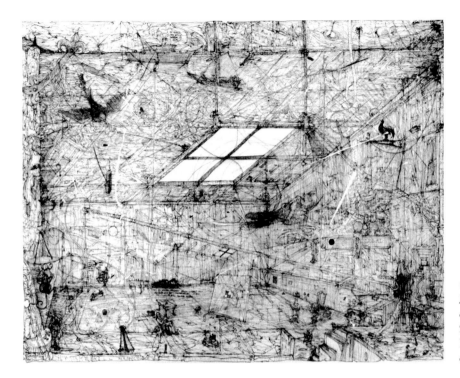

8.27. WILLIAM T. WILEY. *Slightly Hysterical Perspective.* 1979. Acrylic and charcoal on canvas, 7′5″ × 8′6″ (2.26 m × 2.59 m). Sharon and Thurston Twigg-Smith, Honolulu. Photo: eeva-inkeri. Courtesy of George Adams Gallery, New York.

overlapping forms. Make careful sightings when making horizontal and vertical measurements. Note the relationships in height and width between each level of overlap; for example, in a reclining pose such as Rohner has used, the height and width of the foot, compared to the shape immediately behind it, the calf; the length and width of the calf compared to the thigh, and so on.

SUMMARY

SPATIAL ILLUSION

The type of space an artist uses is relative; it is seldom possible to classify a work as strictly two- or three-dimensional. As a drawing student you may be required to create a flat or an illusionistic or ambiguous space in a given problem, but as an artist your treatment of space is a matter of personal choice. Mastery of the spatial relationships of the elements will give you freedom in that choice. Your treatment of space should be compatible with the ideas, subject, and feeling in your work. Along with shape, value, line, texture, and color, proficiency with spatial manipulation can help you make an effective personal artistic statement.

For students interested in the traditional treatment of perspective, see the Perspective section in "Suggested Readings" at the end of the book.

It might be a good idea to let William T. Wiley's drawing, *Slightly Hysterical Perspective,* have the final word in this chapter (figure 8.27). That proverbial window-into-space has been turned topsy-turvy; rather than "looking out," it "looks down"—down into a jumbled studio filled with a "hysterical" conglomeration of images and spaces. If we were art travelers from the Baroque period

we would view deviations of viewpoints with great suspicion, but since we are contemporary art lovers, we can view Wiley's work with a great deal of pleasure and delight.

SKETCHBOOK PROJECTS

The sketchbook projects at the end of each of the preceding chapters can be done at any time during your study of each element; the following two projects, however, should be done after you have read the introductory material to chapter 8, and in preparation for problem 8.1.

PROJECT 1
Invented Spatially Illusionistic Forms

A reminder before beginning: Although your approach in keeping a sketchbook is serious, playful invention should not be minimized. A look at the visual improvisations by Picasso, an artist known for his clever variations, will be informative. Picasso was rigorous in keeping sketchbooks, volumes of them. Figure 8.28 shows nine lighthearted variations. Some of the anthropomorphic forms are derived from still life material, from man-made objects, others from organic shapes, vegetables, and bones; many are geometric. The invented class of creatures all share a basic anatomy (hence the title of the drawings) in that they have heads, necks, upper and lower torsos, and limbs— arms and legs. Put together in wildly wacky ways, they offer insight into Picasso's never-failing inventiveness.

In your sketchbook create several pages of organic, bonelike forms; they need not necessarily be anthropomorphic. Try to imagine what they would look like from various angles as they turn in space. Concentrate on making them volumetric. Indicate front and sides either by planar connections or by volumetric modeling. Imagine a single light source casting shadows to enhance the three-dimensionality of the forms.

PROJECT 2
Employing Different Horizon Lines

In the next several pages of your sketchbook make quick drawings in which you arrange three or four of your invented shapes in an imagined space. Employ different horizon lines. (In Picasso's collection he has a horizon line of maintained height.) In the first drawing arrange the forms on a low horizon line; remember that if all the forms share the same baseline, that is, if they are lined up along a single line parallel to the picture plane, space will be limited. A diagonal or angular distribution of the forms penetrating the picture plane will result in a more spatial illusion.

In the second group of sketchbook drawings raise the horizon line, locating it somewhere in the middle third of the picture plane. Be aware that you are manipulating the viewer's stance. Are the forms being viewed from above or from below? Indicate the light source to help you achieve the spatial effect you desire.

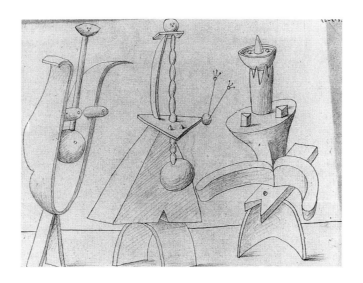

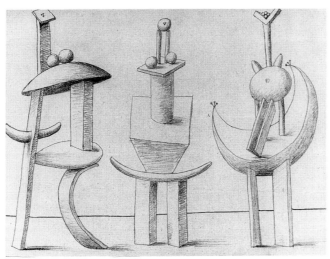

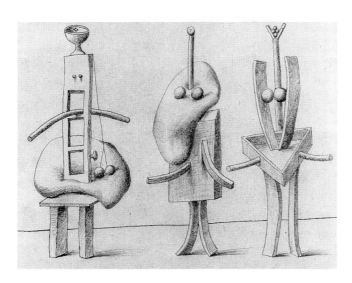

8.28. PABLO PICASSO. *An Anatomy.* 1933.
Pencil on paper. Musée Picasso, Paris.
© 2003 Estate of Pablo Picasso/Artists
Rights Society (ARS), New York.

In the final group of drawings use a high horizon line located in the top third of the picture plane. You must decide whether the point of view is from above or below. Here overlapping forms and a radical shift in size and scale of the objects distributed throughout the composition will help you achieve a greater spatial effect.

Keep the drawings fresh and immediate. Do not try for a polished, completed look. Do not overwork your ideas. This group of preparatory sketches will provide material to be used in problem 8.1, so you can save the finishing touches for that problem.

A
CONTEMPORARY
VIEW

Organizing the Picture Plane

. . . time doesn't flow, it ticks. Space is not a surface but a grid.
STEPHEN WOLFRAM, PHYSICIST

CHALLENGES TO TRADITIONAL COMPOSITIONAL APPROACHES

JOHN BALDESSARI, A TEACHER AND MA-
jor influence on conceptually based photography, directs us to *A Different Kind of Order* in his retelling of a story about the well-known jazz pianist Theolonius Monk. Baldessari framed five photographs of various disasters found in press files, matted them crooked in their frames, and hung them askew. In the sixth frame is the narrative:

There's a story about Theolonius Monk going around his apartment tilting all the pictures hanging on the wall. It was his idea of teaching his wife a different kind of

order. When she saw the pictures askew on the wall she would straighten them. And when Monk saw them straightened on the wall, he would tilt them. Until one day his wife left them hanging on the wall tilted.

There is more to this anecdote than meets the eye, so to speak. Baldessari points to our adherence to a "right" convention in art without giving consideration to why we are committed to it. The artist shows us both visually and verbally that there is more than one kind of order in the world. Even in this one work of art we find at least two different kinds of meanings, the semantic one and the visual-aesthetic one. (*Semantics* is a branch of linguistics that deals with the study of meaning and the relationships between signs and symbols and what they represent.) Visually the mounted photographs ask a question that can only be answered in a qualified way: Is it the photographs or the frames that are crooked?

We can learn a lesson from Baldessari's cautionary tale, one not only in life but in art as well. Art derives its vitality from new ideas and feelings; it challenges previously accepted conventions, styles, techniques, and definitions. So the "rules of composition" are not fixed; they need to be understood to be transcended, to be used or discarded as the visual idea requires. We have seen how important it is in some artists' work to remove the hand of the maker; in other artists' work it is that very personal, individual mark that is valued. In some works a carefully balanced, unified composition is desired; in others chance, even chaos, is the governing concept.

Many issues exist in contemporary life and art that have challenged the traditional view of composition. One example will suffice for now: Think of how the advent of cinematography with its sequential frames has changed static single-frame art. Multiple formats, such as the divided picture plane and

9.1. JAMES ROSENQUIST. *Military Intelligence.* 1994. Oil on canvas with charcoaled wood, 6'6½" × 9'10" (1.994 m × 2.997 m) (2 panels 4'11" wide). Leo Castelli Gallery. © James Rosenquist/Licensed by VAGA, New York.

especially the grid, have become the very identifying characteristics of contemporary art. Sequence and serial development lie at the heart of Minimalism, a major contemporary development. Impermanence, change, and transition in the culture are mirrored in the art of our times.

As we rethink our physical, intellectual, and emotional orientation in the world, the implications for art are that we must revise our ways of handling form. Changes in art parallel changes in culture. In recent years artists have been subverting and otherwise transforming the conventions and aesthetics of earlier times, for example, the substitution of randomness for geometric order. This is not to say that one must not be familiar with former principles of compositional organization, but it is imperative to realize that these principles of design are not locked into place. They may be turned topsy-turvy; they may even be negated.

We confront crowded, disjunctive environments in the real world, so it is not surprising to find this kind of disorder in art as well. Art today encompasses the full gamut of personal expression; we find straightforward work alongside convoluted work, the political alongside the comical, direct art statements alongside oblique ones. In other words, art, like life itself, is multidimensional. And in art the means to this diversity go beyond the conventional compositional rules.

CONTEMPORARY APPROACHES TO THE PICTURE PLANE

Part II dealt with the ways the art elements can be used to create pictorial space, a major concern of the artist. This chapter focuses on another contemporary concern, the picture plane and how to handle the problems it presents. Artists have always been aware of the demands of the picture plane—its size, shape, flatness, edges, and square corners. However, many innovations in form in contemporary art have specifically and explicitly centered around the demands and limitations of the actual physical support or surface on which an artist works.

In James Rosenquist's *Military Intelligence* (figure 9.1), the picture plane is even blasted away revealing the stretcher, or support, itself. (Note the exposed section in the lower left corner.) This exposure—which supports Rosenquist's comment on the subject of secrecy and disclosure, a particularly pertinent topic in the twenty-first century—undermines the illusion of the superscaled, hyper-realistic eyeglasses that float in a theatrical space of swirling flames. The title directs us to make connections between surveillance and vision suggested by the glasses.

The picture plane makes certain formal demands on the artist; certain compositional concerns must be dealt with in working on a flat, two-dimensional surface. *Form,* the interrelationship of all the elements, is the way artists say what they mean. In art, form and meaning are inseparable; form is the carrier of the meaning. It is the design or structure of the work, the mode in which the work exists. It is an order created by the artist. There are two overriding goals in structuring a two-dimensional work: first, it must assert its character, or presence, as a two-dimensional object; and second, at the same time it must relay a spatial tension between its internal forms—between the various parts of the work that make up the total composition.

9.2. NANCY RUBINS. *Drawings.* 2000–2001. Pencil on paper, 14′ × 24′ × 3′ (4.27 m × 7.32 m × 91.4 cm). Courtesy Paul Kasmin Gallery and the artist.

Dominance of the Edge

Perhaps the most obvious challenge to the rigidity of the perimeters of the traditional picture plane has been the breakup of its regular shape. Artists of the 1960s led the way for new forms and expressive means; the shaped canvas was one such innovation. Frank Stella gained wide recognition for his relief constructions. His early work was related to Minimalism; he employed symmetry and repetition of line. Over the years Stella has pushed his work increasingly toward a more projective three-dimensionality (see figure II.25). His work has moved from logical, serialized investigation of flatness to a flamboyant, dramatic, expressionistic involvement that he himself proclaims has affinities with Baroque art.

Nancy Rubins's large pencil-on-paper drawing resembles a Baroque sculpture more than it does a drawing, with its heroic scale and billowing three-dimensional forms (figure 9.2). Rubins uses heavy sheets of paper with the surfaces solidly covered with pencil marks; the graphite marks are so heavily overlaid that they create a leaden luster. The irregularly torn sheets of paper, which resemble sheets of metal, are crumpled, folded, bent, and twisted into giant three-dimensional shapes and attached to the wall by pushpins. In the 1970s Rubins made massive sculptures from debris from airplane parts and motor homes. She definitely has the last say on illusionistic mass and weight.

Richard Artschwager's work (figure 9.3) demonstrates the dominance of the outside edge of the picture plane. The offbeat materials he uses boldly assert their presence as two-dimensional objects—Celotex, a material used in the walls of buildings, and Formica, which the artist has called "the great ugly material, the horror of the age." (It is interesting to note that Artschwager was a commercial carpenter earlier in his career.) Artschwager intentionally wants

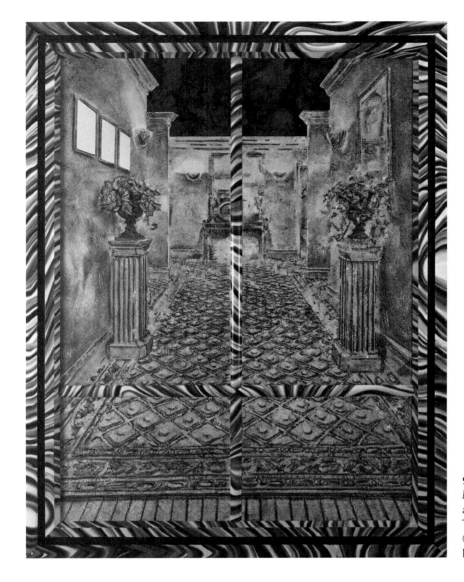

9.3. RICHARD ARTSCHWAGER. *Northwest Passage.* 1994. Acrylic, Formica, Celotex, and wood, 6′ × 4′11″ (1.83 m × 1.5 m). The Eli and Edythe L. Broad Collection. © 2003 Richard Artschwager/Artists Rights Society (ARS), New York.

to distance the viewer from an aesthetic response to his work. In spite of the use of common, ordinary materials, made popular by Pop art, Artschwager is closer to Mimimalism in his emphasis on the literal, and to Photo-Realism in his portrayal of everyday scenes taken from newspaper clippings. The *grisaille* painting—a monochromatic painting in shades of gray, shown here—could be taken from a real estate ad. The edge, or frame, is meant to be an integral part of the work and serves to call attention to the "objecthood" of the piece. Artschwager's painted faux-wood window frame not only dominates the scene drawn in one-point perspective, it dissects the scene and locks the viewer's attention on the foreground of the frame rather than the background of the depicted space. This window serves a triple function: It frames another image, it reiterates the size and shape of the picture plane, and it is a contemporary window into a contemporary space. Here the traditional Renaissance use of the picture plane as a "window into space" has been given a radically new look. In

this instance the two images, window frame and inside view, serve a contradictory function. The window border has a beginning and an end—we know where it stops and where it starts—whereas the image outside the window depicts a receding space. In spite of being presented with what should be a spatial illusion, the viewer never "gets past" the materiality of the Celotex and Formica; the faux-wood frame rivets the viewer's attention; what is inside the frame becomes secondary to the dominant, divisive, and demanding textured border.

PROBLEM 9.1
Shaped Picture Planes

In the library, look at some catalogs of art shows and books that deal with contemporary art. Focus on contemporary artists who use nontraditional shaped formats in their work. Look at the work done in the 1960s when this movement was in its early stages of development. We have already mentioned Frank Stella; other artists of the same time are Tom Wesselmann (who cut the picture plane to conform to the shape of the actual object being painted, such as a hand holding a cigarette), Ellsworth Kelly, Kenneth Noland, and Richard Smith. Note the evolution of the motif or image in Stella's work from the 1960s to the present.

Elizabeth Murray is only one of the many current artists working with shaped picture planes. Neil Jenney is associated with dominant, sometimes irregularly shaped frames that alter the look of the traditional format. Robert Morris's work makes use of eccentrically shaped frames that are an integral part of his work. Miriam Schapiro uses fan- and kimono-shaped canvases, appropriate to her work as a Pattern and Decoration artist.

The shaped picture plane is not only about edge but concerns itself with establishing the plane as an object, giving it a physicality that is different from the dematerialization sought in illusionistic work.

In your visual research pay close attention to the motif or image and how it relates to the shape of the support. You will discover a broad range of subject matter being used on these structures, from nonobjective to recognizable. Try to determine how subject, content, and support are welded in each work.

This project will not only acquaint you with the important issue of the dominance of the picture plane but will also offer you a wider spectrum of work than we are able to present in this book.

PROBLEM 9.2
Confirming the Flatness of the Picture Plane

Make a drawing that asserts the limits and flatness of the picture plane. You might choose a common, everyday object as subject for the drawing. Present the object frontally and enclose it with a drawn "frame" or patterned border. Use a conceptual approach. Combine solid value shapes, outlining, or invented texture within confined shapes, along with reverse perspective to emphasize the flatness of the picture plane. Jim Nutt is a good artist to study before beginning your drawing. Another artist who uses flat shapes but whose subject is taken from real life is Alex Katz (see figure 9.12).

Continuous-Field Compositions

One innovation contemporary artists have made in dealing with the edge of the picture plane is to negate its limitations by making a continuous-field composition; that is, if we imagined the picture plane to be extended in any direction, the image would also extend, unchanged—the picture plane would be a continuous field. There is no one place for the viewer to focus. Mural-scaled paintings afford a physical relationship to the viewer that is similar to that of a wall—again the "objecthood" of the work is emphasized. The artist Dona Nelson observed, "I understand why the Ab-Ex painters always had trouble with the edges and why they ended up doing such big paintings—literally to have more space to work with. In a 75- by 78-inch canvas you have a disk of about 40 inches across in the middle of the canvas—that's the only free part—everything else is impinged upon by an edge" (Faye Hirsch, "Abstracting the Familiar," *Art in America,* February 1997, pp. 88, 89).

Andrea Way's drawings qualify for this category (figure 9.4). Way's work deals with process, the imposition of one system of abstract patterns over another. In her drawing, *Shots,* space seems to be that of a video screen or computer game. The drawing is made by the use of overlays; small triangular shapes lie behind larger white slivers. A third system of lined rectangles provides an emphatic horizontal balance while connecting lines seem to stitch the rectangles in place. The smaller white triangles occupy several levels of space; they appear to be more free-floating than the other more stabilized units. Way's method is programmatic; she says she creates rules for her drawings so she can constructively depart from them. The merging systems seem to extend in all directions; each pattern maintains its own integrity within the picture plane yet relates with the others in a nonchaotic way. Each system is on its own wavelength.

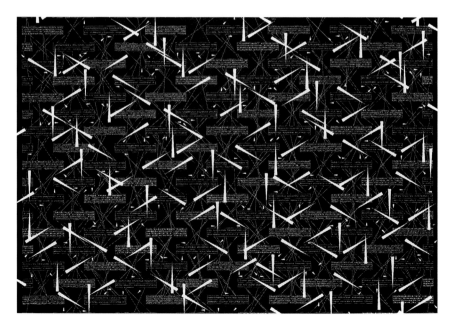

9.4. ANDREA WAY. *Shots.* 1986. Ink on paper, 3′ × 4′3½″ (91 cm × 1.31 m). Collection of George T. Moran.

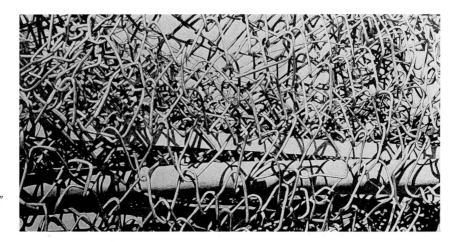

9.5. STUART CASWELL. *Chain Link Disaster.* 1972. Pencil on paper, 1′10″ × 2′4″ (56 cm × 71 cm). Minnesota Museum of American Art, St. Paul.

Although most continuous-field drawings are abstract, some artists work with an overall articulation using recognizable subject matter. Vija Celmins, in mapping the night skies, is one such artist. (Her work, with its black field and miniscule white stars, is very difficult to photograph; the night sky is exactly duplicated on a given date, from a particular geographical location.) Visualize a subject that makes use of this type of composition, for example, a continuous field of water, or grass, or a wooden floor. Images need not necessarily be taken from the real world; a continuous-field effect can be achieved easily with nonobjective forms as well. Jackson Pollock's work was less a composition than a process; the action of the artist while painting has been documented (see figure II.20). Movement and time have been incorporated to result in a richly energized surface; the limits of the final piece seem somewhat arbitrarily chosen. (Note that the paint drips go off the paper on all four sides.) Again, we can imagine the field to be continuous.

If a recognizable subject is used, as in Stuart Caswell's *Chain Link Disaster* (figure 9.5), it must be one the viewer can imagine continues beyond the limits of the picture plane. In comparing the two works by Caswell and Pollock, it is as if Pollock's drips have metamorphosed into the tangled wire of Caswell's drawing. Both works are tense with implied motion; the lines are stretched across the surface. And in both works overlapping darks and lights bind the forms to each other in a complexly layered surface.

PROBLEM 9.3
Continuous-Field Compositions

Make two drawings that deny the limits of the picture plane, one using a recognizable, illusionistic image and the second using nonobjective imagery. Create an overall textured surface so that no segment of the drawing has precedence over another. There should be no dominant center of interest. Try to create the illusion that the image extends beyond the confines of the picture plane. The use of line, value, and texture is consistent throughout the drawing. The shapes fill the picture plane with no priority of focus. We can easily imagine that the image extends beyond the edges of the paper.

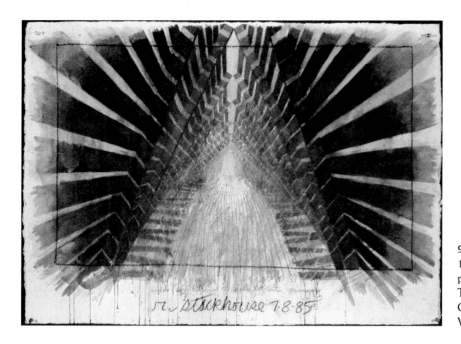

9.6. ROBERT STACKHOUSE. *Inside Shiphall.* 1985. Watercolor, charcoal, and graphite on paper, 2'5½" × 3'5½" (74.9 cm × 1.05 m). The Arkansas Arts Center Foundation Collection: Purchased with a gift from Virginia Bailey, 1987. 1987.024.002.

Arrangement of Images on the Picture Plane

The Abstract Expressionists introduced continuous-field compositions, but in the 1960s Pop artists were influential in adding new compositional options by introducing commercial design techniques into fine art. Included in their innovative approach were compositions using extreme close-ups of details or fragments; isolation of forms (such as a single image centered on the picture plane in an empty, white field); schematic simplification, eliminating modeling or shadows; stark contrasts and limited color range; color and texture applied by commercial means (silkscreen and Ben Day dots); silhouetted forms; and serial compositions. Modernist preferences for the grid, along with their concerns with the flatness of the picture plane, continue to present options for contemporary artists.

The importance of the relationship between positive and negative space has been emphasized throughout the book. In dealing with the demands of the picture plane, this relationship remains crucial. Positioning of positive and negative shapes is of the utmost importance. By placement the artist may assert or deny the limitations of the picture plane. Placement of an image calls attention to the shape and size of the plane on which it is placed. Too small a shape can be dwarfed by a vast amount of negative space, and too large a shape can seem crowded on a small picture plane.

Center, top, bottom, and sides are of equal importance until the image is placed; then priority is given to a specific area. Centralizing an image results in maximum balance and symmetry, and if that centralized image is stated frontally, the horizontal and vertical format of the picture plane will be further reinforced, as in the drawing of a monumental environment by Robert Stackhouse (figure 9.6), which has been described as "an overlapping grid composed of lines that converge, intersect and vanish on the surface of the paper

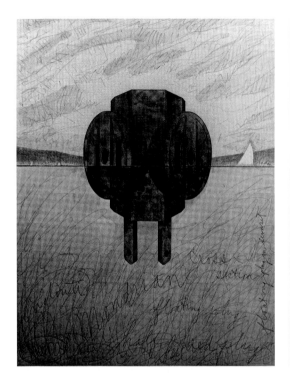

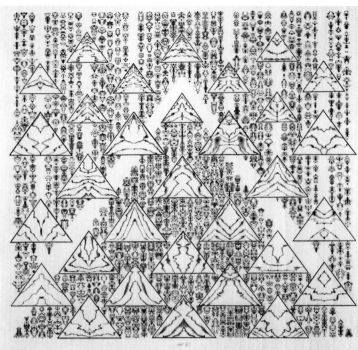

9.7. (above left) CLAES OLDENBURG. *Floating Three-Way Plug.* 1976. Etching and aquatint, 3′6″ × 2′8¼″ (1.07 m × 82 cm). Published by Marian Goodman Gallery, New York.

9.8. (above right) BRUCE CONNER. *INKBLOT DRAWING,* 8/12/1995. 1995. Ink and graphite pencil on paper, 1′7⅛″ × 1′7″ (48.6 cm × 48.3 cm); image, 1′3⅛″ × 1′4³⁄₁₆″ (38.4 cm × 41.1 cm). Courtesy Michael Kohn Gallery, Los Angeles.

[creating] a space that is both visionary and palpable" (Wolfe, *Revelations,* p. 81). Stackhouse's perspective qualifies as "antiperspectival" since the radiant pattern explodes outward to the edges. As if to contain the radiating lines, or beams, Stackhouse has reiterated the shape of the picture plane in a heavy graphite line. This illustration could qualify as employing both a centralized image and an emphatic attention to the edges.

In his print (figure 9.7), Claes Oldenburg centralizes a three-way plug. The image is made static by its placement; the stasis is further enhanced by the use of the enclosed shapes, especially the closed ovals. Such complete balance in the positioning of the image permits no movement. Oldenburg, in typical, whimsical contradiction, makes the plug seem to levitate or float by bisecting the shape with a line. So now we interpret the image as suspended between sky and water, as being submerged midway between air and water. Several hints are dropped for this reading of the image—the triangular ship sail and the cursive writing in the water, "floating plug in sunset." Scribbles radiate from the sun in the upper half. These marks activate an otherwise static space.

In some contemporary art, several compositional devices are used simultaneously in a single work. This is especially true in Bruce Conner's drawing (figure 9.8) in which inkblot shapes are the motifs. He calls these inkblots "ersatz notations that might be thought of as music" (John Yau, "Folded Mirror," *Art on Paper,* May–June 1998, p. 30). Conner begins by scoring the paper in equidistant vertical lines; he then draws the inkblot shapes on the center line, moving alternately from side to side until the page is filled. Repeating geometric shapes furnish the organizing structure. It is ambiguous whether the lines of the inkblots are pressing down on the empty space surrounding the

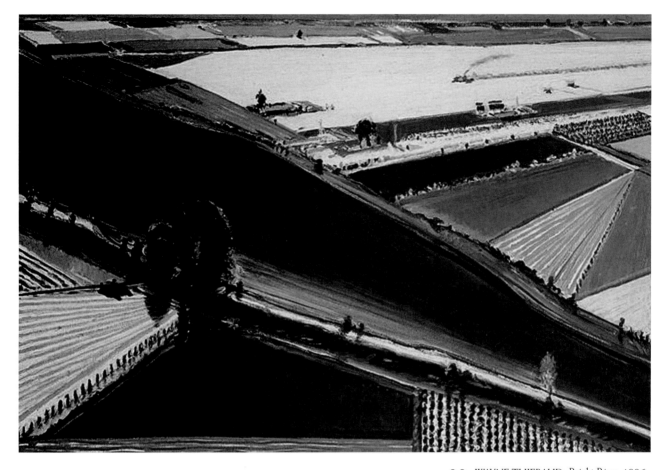

9.9. WAYNE THIEBAUD. *Bright River.* 1996. Oil on canvas, 1′11¾″ × 3′ (60.3 cm × 91.4 cm). Photo courtesy Campbell-Thiebaud, San Francisco. © Wayne Thiebaud/Licensed by VAGA, New York.

large inset triangle or whether the triangle is intruding into the linear pattern. The outlined floating triangles, which contain magnified versions of the inkblots, maintain their position in the foreground. A slight spatial progression is indicated by the smaller triangles in the top three rows. Note how spatially different are the works of Stackhouse and Conner, even though both artists are using stripes and triangles.

In *Bright River* (figure 9.9), Wayne Thiebaud has given his landscape a distinctive twist through use of a diagonally divided plane, an unusual compositional device. Spatially, the work is confounding; the composition is built up of a series of triangular and rectilinear units. The river that flows at an angle through the middle of the picture plane divides foreground from background. The larger geometric segments are at the bottom, while smaller divisions are at the top, creating a space that flips forward and progresses from bottom to top. In chapter 8 we discussed Thiebaud's penchant for extremism; this landscape displays that tendency. The diagonally divided picture plane gives Thiebaud a chance to show off his compositional daring.

Another technique for asserting the picture plane, one favored especially by Post-Modern artists, is to crowd the picture surface with a great number of images. This device eliminates a priority of focus. Seemingly unrelated images of contradictory size, proportion, and orientation announce that the picture plane is not a place for a logical illusion of reality; rather, it is a plane that can

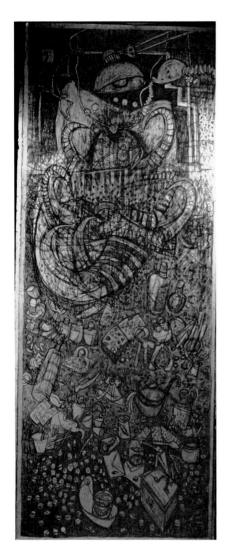

9.10. CLIVE KING. *Madre-Cariad* 2 (detail). 1996. Graphite on paper, 9' × 3'6" (2.74 m × 1.07 m). Courtesy of the artist.

be arranged any way the artist chooses, as in the work by the Welsh artist Clive King (figure 9.10). Working on wall-size paper and using graphite and eraser, King builds a dense and complex surface, layering shapes built of lines and richly textured values. The work shown here, from the series called *Madre Cariad (Mother Love)*, is based on personal responses to issues of grief and loss—grief for the death of his mother. Gnarled, writhing, convoluted organic shapes crowd the picture plane, while references to the horrors of an emergency room intrude from the edges of the drawing. The only identifiable shapes are those that symbolize the operating room with its lights, plugs, wires, and other medical paraphernalia. His dynamic process of drawing is a route to his intent to elevate the status of drawing to higher levels. His images have a mysterious resonance in spite of their very physical presence. King's confrontation with the drawing, his direct technique, results in a dynamic, physical immediacy that is conveyed in the finished work. The chaotic images and odd juxtapositions are the means to a powerful statement not only on his personal emotions but also on the human condition in general.

Throughout the text we have shown examples of Outsider art, work by untrained artists. A crowded picture plane is a favored compositional device in their work. The term *horror vacui* is often applied to artwork that leaves no empty space. The term literally means "fear of the void," and it carries psychological connotations. Adolf Wölfli's incredibly complex drawings, with their compulsively filled spaces (figure 9.11), are examples of *horror vacui*. The Swiss artist Jean Dubuffet began collecting the works of Swiss insane asylum inmates in 1945 which he called "Art Brut," literally raw or unadulterated art. Dubuffet was avidly opposed to "official" art culture; his original concept was to collect art that included children's drawings, prisoners' paintings, urban graffiti, work by mental patients, recluses, and people in trances, as well as traditional folk art—art that was not informed or adulterated by formal, academic training. In the United States the preferred terms are "vernacular" and "self-taught," although the term "outsider" is the one used most frequently.

When the Swiss artist Wölfli was institutionalized as a schizophrenic, he turned to intense, compulsive, and obsessive art making, creating a massive and original body of work (including 45 text- and image-filled books.) In his work shown here, ornate musical staves create an architectonic structure. Words and images crowd the negative nooks and crannies. Wölfli reinvented himself as the hero of imaginary exploits, transforming himself into St. Adolf II, a sort of artist-god who recreated the world. His centralized images expand and contract, like sounds reverberating against a resonant wall. He fills the corners with compact music patterns, and semi-circular figurative images press in from the top and sides. "Music of the spheres" is the analogy that comes to mind in trying to encompass this vastly expansive, rich, and convoluted work.

Going from the complex to the seemingly simple, we will now look at an artist who uses a single positive image to crowd out the negative space. Alex Katz, in his lithograph *Homage to Frank O'Hara: William Dumas* (figure 9.12), presents the far-away stare of a youthful, empty face. The figure is cropped on all four sides by the edges of the picture plane. Katz denies the limits of the paper through this close-up, blown-up view. We are forced to come to terms with the unblinking eyes in the flat, unmodulated shape of the face. Although Katz's figures are extreme simplifications of the human form, they are, nonetheless, real portraits; his work is at once a picture of a class and of a single individual.

9.11. ADOLF WÖLFLI. *General View of the Island.* 1911. Pencil and colored pencil, 3′3⅔″ × 2′4″ (99.8 cm × 71.2 cm). Kunstmuseum Bern, Adolf-Wölfli-Stiftung, Bern, Switzerland.

9.12. ALEX KATZ. *Homage to Frank O'Hara: William Dumas.* 1972. Lithograph, 2′9¼″ × 2′1½″ (84 cm × 65 cm). Edition of 90. Courtesy Brooke Alexander Editions, New York. © Alex Katz/Licensed by VAGA, New York/Marlborough Gallery, New York.

9.13. (above left) JANE HAMMOND. *Silver Rider.* 1999. Mixed media on Japanese paper, 3'6½" × 2'8½" (1.08 m × 82 cm). Private collection, N.Y. Photo by Peter Muscato.

9.14. (above right) JANE HAMMOND. *Untitled (Red Frog #2).* 2000. Ink and watercolor on gampi paper, 2'5" × 2'8" (73.7 cm × 81.3 cm). Metropolitan Museum of Art, New York. Photo by Peter Muscato.

A compositional approach that is an identifying mark of Post-Modern artists is the use of overlaid or superimposed images. Jane Hammond, who has been called the quintessential paper artist of our time, layers distinct and seemingly unrelated images in her work, an example of which can be seen in figure 9.13. Hammond's nonperspectival space also fits into our "antiperspective" category; she uses the space of a flatbed press, laying the images on top of each other and compressing the space. The viewer's job is to unscramble the various layers and relate the images to one another.

Hammond's images come from a lexicon of 276 images that she has collected from a variety of printed sources. Hammond's obsession with images originated in her childhood—she explains, "When I was a kid I cordoned off these 50-ft. square grids on our property with string, and I had notebooks, and I catalogued everything that was in there—the rocks, the trees. I mean that's the sensibility, either you have it or you don't have it." As an adult she continued her quest for images. She says she "let them associate themselves in different configurations" (Faye Hirsch, "Paper Pulse: A Conversation with Jane Hammond," *Art on Paper,* March–April 2002, p. 64).

Hammond cataloged each image, giving it a number; some of the images in her work are hand-drawn, others are printed from linoleum blocks, some are taken from rubber-stamp images, and others are photocopy transfers. Hammond says she "has a field" but "not a focus." "I'm always interested in fragmented, multipartite reality. I like art with a high degree of internal contradiction, where order is wrenched out of a huge amount of chaos" (Hirsch, "Paper Pulse," p. 69).

Hammond's mix-and-match compositional approach is indicative of two Post-Modern practices—overlay and fragmentation. In Post-Modern work

formalist concerns are in the service of content. In figure 9.14 the constitutive elements are on torn Oriental paper pieced together in a loose grid; the resulting composite, randomized collage has irregular sides, again calling attention to the edge. Images overlap and change scale illogically; they originate from different stylistic sources and different times. Hammond aims for a stream-of-consciousness interpretation; the associative powers of the viewer are completely engaged.

PROBLEM 9.4
Placing Images on the Picture Plane

Make two drawings in which placement is the prime concern. In the first drawing use a nonobjective, centralized image. Present the image frontally. You can use simple geometric motifs. The centralized form can be activated by small, related shapes located on top of and behind the main image. Think in terms of weaving. You could add threads or bits of collage to enhance the surface.

In the second drawing, using the same set of related motifs, emphasize the edges or corners of the picture plane. Position the image so that corners, sides, or both are activated. You will obviously work with a change in scale between the parts. You might reverse color and value from the first drawing. You could even block out the central area by a blank, empty shape. Even though your focus is on composition and placement, do not neglect the elements of shape, line, texture, value, and color. Try to create spatial tensions between the various images and the negative space, and between the images and the outer edges.

PROBLEM 9.5
Filling the Picture Plane

In the first drawing, use a single image that completely fills the picture plane. You may enlarge a detail or you may crowd out the negative space by filling the picture plane with an object or an image. Confront the viewer with a composition that is cropped top, bottom, and sides by the edges of the paper.

A device that is helpful in selecting an image or scene to be cropped or framed can be made by cutting a 3- by 4-inch opening in a larger piece of mat board. Close one eye and look through the opening to preview your options. If you are taking your image from a flat surface, two mat board Ls work well. With the two L-shaped pieces you can adjust the size of the image to be cropped. Keep these two aids in your drawing kit; they will be of great help in determining compositional matters.

In a second drawing crowd the picture plane with a great number of images. They need not relate in size, proportion, or orientation. You might even draw from all edges of the picture plane—top, bottom, and sides. Since you will be exploiting the spatial confines of the picture plane, you might employ modeling and cast shadows. Keep your medium limited—oil stick, or pen and ink, or graphite. You can use invented forms to create fantastic subject matter; odd juxtapositions are a means to catch the viewer's attention. Some messages require the artist to disregard accepted norms of taste and form and

to break rules intentionally. In creating your imagery you might think in terms of a personal symbolic code. This is a drawing that does not convey a logical reality. You might do some research on images from other cultures to combine in this free-for-all drawing.

Another, closer look at Clive King's drawing (see figure 9.10) is helpful for this problem. Reread the description of his sources and intent that accompanies the illustration. Rather than completing this drawing in one session, extend the drawing period for a week. Draw some every day, keeping the idea of accretion of time and images. The images will take on different meanings in each drawing session. Finally, make whatever adjustments you think the drawing needs to pull it from an overly chaotic, fragmented state.

In a third drawing use overlaid or superimposed images. For each layer you might choose a different medium, using a diffused pale value for the deepest, or first, layer; images could be loosely suggested in a pale wash. Darken the value or change colors with each succeeding layer. The final or top layer can be drawn in a more decisive manner. Like Hammond, you can use solvent transfers, rubber stamps, or drawn images. The images do not need to be related. You can combine images from various historical periods, or from various art styles; you can choose ordinary images found in catalogs or old books. Try to integrate the first level in some way—by washes or repetition of color or texture—to the top surface.

Along with Hammond, many Post-Modern artists use overlaid, superimposed images; look at their work in books and catalogs from the library. David Salle, Julian Schnabel, and Sigmar Polke are three very well-known Post-Modern artists who employ this technique. See Al Souza's composite images in figure 5.13 for another response to this contemporary approach.

DIVISION OF THE PICTURE PLANE

Another formal means contemporary artists have used to meet the demands of the picture plane is the grid, which divides the picture plane into units or segments. Just as layering images is the signature compositional approach of the Post-Modernists, the grid is the identifying format of the Modernists. In addition to reiterating the flatness of the picture plane and its horizontal and vertical shape, grid units introduce the element of sequence, which in turn brings up the idea of time. Most traditional art is viewed synchronically; that is, the composition is seen all at once in its entirety; grids, on the other hand, are viewed both synchronically and linearly. We see the entire work at a first glance, but in a more sustained look, the composition demands to be read sequentially, segment by segment.

Pat Steir's drawn-on canvas (figure 9.15) has been gridded by intersecting lines in the upper two-thirds and by horizontal lines in the lower third. The grid alternately advances and recedes in different segments of the painting. Pronounced rectangular shapes are distributed throughout the composition, again calling attention to the horizontal and vertical axes. The irregular line that divides the two major segments can be read either as the horizon or as a fluctuating graph line. The loosely stated marks and drips cancel out the

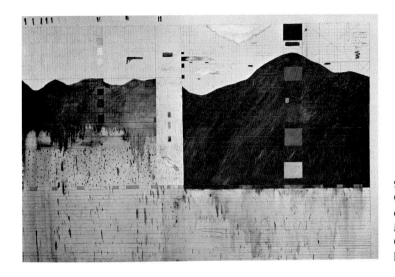

9.15. PAT STEIR. *Three Green Days*. 1972.
Oil, crayon, pencil, and ink on canvas,
6′ × 9′ (1.83 m × 2.74 m). Collection
Mrs. Anthony J. A. Bryan. Robert Miller
Gallery, New York. Photo by Bevan
Davies, New York.

otherwise rigid format. Certainly, the idea of sequence and of time is rein-
forced by the title, *Three Green Days*. Our reading of the work is both syn-
chronic and sequential.

Lynda Benglis uses an underlying, implied, irregular grid in her mixed-
media collage (figure 9.16). The grid seems bent out of shape; it is loosely di-
vided into a four-part structure. The units vary in size and shape within each
off-square segment. The interplay of positive and negative organic shapes with
their overlap creates a complex spatial tension. This unpredictable type of grid
is ambiguous, both affirming and defying the flatness of the underlying sup-
port. We feel that if each segment of the work were reassembled in a strictly

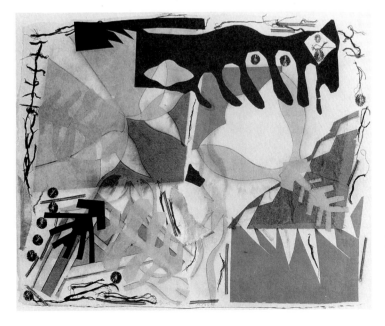

9.16. LYNDA BENGLIS. *Patang Fossil Papers,
Drawing No. 6*. 1979. Cloth, foil collage,
thread, tissue on handmade paper, 2′2″ ×
2′10″ (66 cm × 86.4 cm). Lent by Douglas
Baxter. Paula Cooper Gallery, New York.
© Lynda Benglis/Licensed by VAGA,
New York.

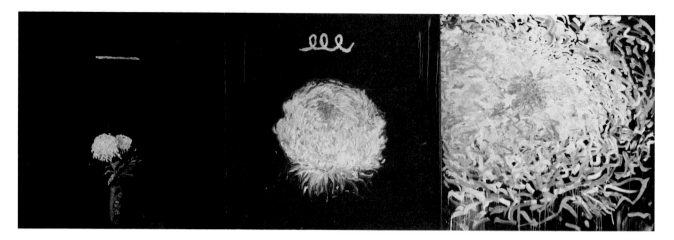

9.17. PAT STEIR. *Chrysanthemum.* 1981. Oil on canvas, 3 panels, each 5′ × 5′ (1.52 m × 1.52 m). Collection Gloria and Leonard Luria. Robert Miller Gallery, New York. Photo: D. James Dee, New York.

horizontal and vertical format the newly constructed composition would be larger than the original one.

The grid can be stated in a sequential pattern to suggest a stopped-frame, or cinematic, structure. Although grids can be read in a number of ways—horizontally, diagonally, or vertically—in cinematic structure each frame logically follows the other. There is a definite sense of time lapse and movement.

These stopped-frame compositions use a regular geometric frame (like the segment of a piece of film) as in Steir's flower painting (figure 9.17). This three-part composition is conditioned by modern technology—close-up photography. The viewer is forced to adjust to the rapid change in scale from the first, rather distantly conceived object to the disproportionately large scale of the same flower in the third section. The traditional boundaries between realism and abstraction are also called into question in this single painting. The final segment seems more closely related to a Pollock painting than to the painting of the small vase on the left. This relation is especially apparent when you realize that each segment in the Steir painting measures 5 feet (1.52 m) square.

Jody Mussoff uses a segmented picture plane related to a stopped-frame composition—gridded at the top, with one large segment at the bottom—for her drawing *Atlas* (figure 9.18). Mussoff uses the themes of passage, states of growth, and change in her work. Conceptually, then, the divided picture plane is appropriate for the content. Close-ups of the girl's face seen from different angles fill the four top units. The eyes are intently focused in each segment, whereas the figure of the kneeling girl is tentative in her pose and in her glance. The spatial relationship between the bottom segment and the four upper units is ambiguous; in one view, the kneeling figure seems to be peering from behind the "screen" of faces; in another view, she seems to be "the supporting actor." We cannot help thinking of gravity and weight with the name *Atlas*; it leads us to question what this young female Atlas is supporting. We assume that vision is another major theme—the eyes are certainly the dominant feature of the top planes. We can reasonably assume that the subject of this powerful work deals with the role of the artist, with growth, vision, support, performance, and vulnerability. Although the subject may deal with vulnerability and the

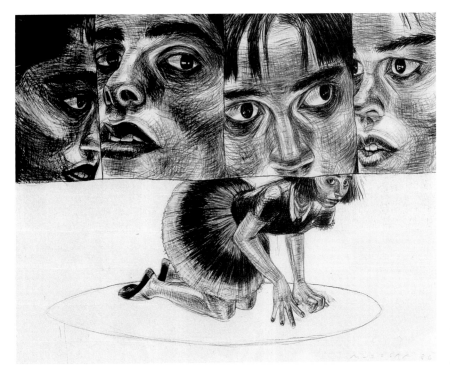

9.18. JODY MUSSOFF. *Atlas.* 1986. Colored pencil on paper, 4'½" × 5' (1.232 m × 1.524 m). Collection of Mr. and Mrs. Irving Tofsky.

pose may portray a tentative position, Mussoff's line quality is strong and as-sured; it builds a powerful structure on which to hang a world of meaning.

In cinematic grids, visual reinforcement of the picture plane comes from the contained images. Conceptual denial of a fixed format is suggested by the idea of continuation, by the idea that with a longer lapse of time come more stopped-frame images.

Most stopped-frame compositions use a regular geometric division, but a linear, sequential arrangement can be achieved by omitting the lines that di-vide the units. (See figure 2.1 in which the artist, Park Yooah, has eliminated the frames. The sense of movement is enhanced since there is no disruption in the sequence.) A long, narrow format like a film strip is appropriate for a work that requires a sequential, linear reading, or for a subject in which time is central to the meaning. Since movement and dislocation are repeating themes in contemporary art, the divided picture plane is a favored compositional de-vice, one that lends itself to narrative sequences, another thematic focus in to-day's art.

Throughout the text we have mentioned such strategies as deconstruc-tion, appropriation of images from preexisting sources, and exposés of ac-cepted norms. At the root of all these concerns is the problem of context. Meaning or interpretation must have a context in which to develop. The di-vided picture plane is a conceptually loaded formal device to aid the artist in establishing context—even discontinuity between images—that has the underlying purpose of expanding or questioning our cultural and personal attitudes.

Related both to cinematic structure and the divided picture plane is the comic strip format. In recent decades, a group of artists began working in

9.19. CHRIS WARE. A page from the graphic novel *Jimmy Corrigan, the Smartest Kid on Earth.* © 2000 Chris Ware.

a cartoon format in a more serious vein. The term "graphic novel" has emerged to describe their work. Figure 9.19 is a page from one such work by Chris Ware. In the graphic novel when text is used, it is disjointed or broken up across several frames. A shorthand convention deletes connective frames that would give the reader-viewer clues to what is going on. Ware's drawing here is a "record of nothing happening: eating, waiting, being disappointed," an indictment of our times.

Loosely related to the divided picture plane is the composition with an inset (see figure II.13). In older, more traditional work, the artist was free to draw a detail or make notations concerning the drawing on any empty space of the page. In contemporary work, this latitude has been claimed as a favored compositional device. An inset creates an opposition between itself and the primary subject and sets up a feeling of discontinuity between the two images, as we saw in Barbara Kruger's work (see figure 6.25). Kruger, you remember, overlays photographic images with terse statements meant to reveal or expose hidden or underlying biases. The inset "deconstructs" the visual image in her work.

In Don Suggs's landscape (figure 9.20), a painted image of Mount Shasta is blocked by an inset of intrusive vertical stripes. Suggs appropriates his images from photographs in books. These secondhand images (like postcards) stand between us and the real experience of nature in the same way that Suggs's vertical stripes "bar" us from the painted image. His title *Proprietary View (Mount*

9.20. DON SUGGS. *Proprietary View* (*Mount Shasta*). 1985. Oil and alkyd on panel, 1'9¾" × 3'3¾" (55.2 cm × 1.009 m). L. A. Louver Gallery, Venice, Calif.

Shasta) has a double edge: How can one "own" the earth except through images, which are feeble substitutions and reflections of the real thing? Our experience of landscape has been reduced to copies of copies. It is impossible not to see both images merge in Suggs's work. Both identities, illusion and abstraction, assert themselves; in fact, in a perverse way, the inset forces us to pay more attention to the blocked landscape. In Suggs's work we find another candidate for our antiperspective list: The striped inset blocks a perspective view of the mountain; the viewer's focus is abruptly brought back to the space of the picture plane. By means of a bold compositional device, the inset, Suggs has rearranged the visual and emotional focus of the work.

PROBLEM 9.6
Composing with a Grid

Make three drawings in which you use a grid. In the first drawing, establish a grid with each unit the same size. Papers with various sizes of printed grids are readily available; it might be interesting to use multiple grids in the same composition—grids within grids, while maintaining a master grid of the same size.

In the second drawing, lightly establish the grid; then use value, texture, line, or a combination to negate or cross over the regular divisions. Try to achieve an overall effect as opposed to a sequential reading of the drawing. (See figure 2.10 for Suthat Pinruethai's solution to this problem. Note the layered marks, the use of value to organize the sections, the use of white lines that cross over the grids, and especially take note of the two grid units that remain white. The abrupt discontinuity between what is drawn and what is omitted creates extreme tension in the work.)

In the third drawing, use a grid of irregular units. You might use a concentric grid or a grid in only one area, as in the Mussoff drawing (see figure 9.18), or you might simply imply a grid structure without rigidly defined units. You could cut up or tear old drawings into uniform pieces and "reconstitute" them by jumbling the pieces to create a collage. Add value, texture, line, or color as needed to unify the composition. (See Benglis's collage, which follows this process, figure 9.16.)

PROBLEM 9.7
Dividing the Picture Plane

Using a picture plane that is exactly twice as wide as it is high, divide the format into two equal segments. Make a diptych with an image in one half totally unrelated to the image in the other half. This is not as easy to do as it sounds, since we attempt to relate any two images seen simultaneously. For the first image you might choose a visual cliché, an icon that is well known to everyone in American culture, such as the Statue of Liberty. Try to pair another subject with the first image that is totally unrelated by form, media, technique, scale, or meaning. The result should be a disjunctive composition, one that is unsettling to the viewer.

PROBLEM 9.8
Using Inset Images

Make a drawing that employs an inset. The inserted image may or may not be related to the larger drawing.

The image in the inset could be a blowup or a detail of the outside image; the drawing inside the inset could be stylistically different from the main image; the inset could be drawn with different media from the outer drawing; or the inset image could be abstract and the outer image recognizable. You might think of a time shift between the two segments.

One approach to this problem is to attach a postcard to center of the picture plane; extend the images at the edges of the card out onto the white space of the picture plane. In extending the images, change scale, size, and medium. For example, if you have chosen a black-and-white postcard, used colored media for the extended drawing, or use black ink with a colored postcard. You may have to use some drawing within the card itself to make the transition from the inset to the outer edges. The disjunctive quality that is set up between the two disparately treated segments is a contemporary one. Consider the dichotomies that Suggs sets up in his landscape with an inset (see figure 9.20).

A second approach to this problem is to choose a black-and-white image from the newspaper, and rather than pointing out the disjunction between what is drawn and what is found, try to integrate your drawing so completely by texture, value, line, shape, and scale that it is impossible to tell the difference between the two surfaces. To disguise the printed image, do not place it in the center of the picture plane. You might place it in one corner and let the drawn segment extend from it. You might then adjust scale, making the forms change in size as they move away from the original image. Rather than using a newsprint cutout, you might use a good photocopy. The photocopied paper will blend in better than the newsprint. Use a medium that integrates with the ink of the photocopy.

PROBLEM 9.9
Using Linear Sequence

In this problem, repeat an image in a linear or cinematic sequence. The drawing may progress from left to right across the page or move in a vertical direction from top to bottom. Keep in mind the idea of a time lapse. This may be achieved by having the image undergo slight changes from frame to frame. Try to create a sense of expectation as you progress along the picture plane. You might depict the image from increasingly closer (or farther) views.

Another option for subject is a narrative sequence; for example, you might take an imaginary character through a catastrophic day. A cartoon style would be appropriate. Think in exaggerated, symbolic terms. How can you succinctly convey your visual ideas? Eliminate text or words and let the images graphically tell their story. As you saw in the page from Ware's graphic novel, the most mundane scenes and nonevents can serve as appropriate subject matter.

SUMMARY

PERSONAL SOLUTIONS/DIFFERENT KINDS OF ORDER

We have looked at and discussed a number of ways contemporary artists have dealt with the demands of the picture plane. The list is by no means comprehensive, for each time artists are confronted with the clean, unblemished surface of the picture plane, new problems arise. Out of the artist's personal and subjective experience come the solutions to these problems. For many artists the response to the demands of the picture plane is on a highly conscious level; in others the response is more intuitive. The organization of the picture plane is not only a response to formal concerns, it can be a carrier of meaning, a reinforcement of the content in a work.

In your own work, whatever approach you take, the solutions or resolutions should not be turned into formulas, for there are no pat answers to any problem in art. Involvement in your own work and familiarity with the concerns and styles of other artists will help you approach your own work in a personal and exciting way.

SKETCHBOOK PROJECTS

During one week make a collection of drawings, filling a single page of your sketchbook with multiple drawings before you move on to the next page.

PROJECT 1
Crowding the Picture Plane

This will be a composition in which you crowd the surface with a great number of images. They can be totally unrelated, recognizable, abstract, and nonobjective. Include some writing, notes to yourself, scraps of information, and quotations that appeal to you. Avoid a symmetrical or balanced distribution of images, especially in the beginning. Overlap and overlay images;

turn your paper from time to time so the orientation of the drawing is not always the same. Try not to think in terms of top, bottom, or sides.

After you have crowded the page with drawings, impose some minimal order by use of value or by connecting lines and shapes. Avoid the development of a focal point. Make several of these composite compositions in your sketchbook. When you fill one page proceed to the next. Think of these drawings as visual diaries; the imagery and thoughts contained in them could be taken from your hour-to-hour experiences, a record of your day's activities, daydreams, and thoughts.

PROJECT 2
Attention to the Edge

Choose one page of the drawings done in the preceding exercise and use some white-out, gesso, white acrylic, or white tissue or tracing paper to cover the center part of the page, leaving the images showing around the edges. The paper or white paint could be applied so that faint images from the original drawing show through; this will activate the surface. Integrate the center with the edges.

PROJECT 3
Divided Picture Plane

Using masking tape, mask off some divisions of equal size in your sketchbook. You may create a grid of four, six, or nine segments; or you may use a linear, sequential division of three or more units. Leave the masking tape intact and proceed as in project 1, filling the page with drawings done over several days or at least several drawing sessions. Do not confine the drawings to the delineated segments; draw over the full page, over the masking tape and paper. When an interesting texture develops, remove the masking tape to reveal the underlying white negative lines of the grid. Enhance the drawing with minimal additions if needed.

COMPUTER PROJECT

PROJECT 1
Using Superimposed, Layered Images

Overlaying and superimposing images is a technique that is easily done on the computer. Create three or four different compositions of linear images on the computer; use different subjects and different sizes for each composition. Print the compositions, overlaying them on the same sheet of paper; that is, run the same sheet of paper through the printer for each different composition. Use light ink for the first printing, a different color, value, and texture for the second printing, and continue to print layer after layer until you have achieved a satisfactory solution.

Printing on transparencies (using the same procedure as described above) is another way of trying out ideas for superimposed images. Print several pages of images on transparencies (check what transparencies your printer

requires). Overlay the printed sheets of acetate on a piece of white paper to see the results. You can juggle the layers for different effects; try placing the darkest images on the lower level, the lightest on top; then reverse the procedure. Scan and print several of the most successful arrangements. You can add hand drawing to the final print if needed. Felt-tip pens made for drawing on acetate are available. You might hand color some of the images or use a colored wash. Even with a black-and-white printer, successful compositions using transparent superimposed images can be made. Vary line quality, value, and texture for the various levels. You can add areas of wash either before or after printing the overlaid images. Print your final selections on a good quality, 100 percent cotton rag paper.

Thematic Development

If something is meaningful, maybe it's more meaningful said ten times.
If something is absurd, it is much more exaggerated, much more absurd if it's repeated.
EVA HESSE

DEVELOPING A BODY OF RELATED WORK

THEMATIC DRAWINGS ARE A SUSTAINED series of drawings that have an image or idea in common. Artists have always worked thematically—Rembrandt's repeated self-portraits (40 paintings and 31 etchings) attest to this truth, and concern with process has made thematic work even more in evidence today.

The emphasis in a thematic series—and the emphasis throughout the problems in this chapter—is on process rather than product. Thematic drawings present options; since they are an open-ended body of work, they provide a way to express more ideas and more variations on an idea than it is possible to

address in a single drawing. Nothing can better illustrate the number of possible compositional and stylistic variations on a given subject than a set of connected drawings. Because you will be using only one subject throughout the series, you are free to attend more fully to matters of content and composition.

Image, idea, content, and form can be juggled and transformed to create a series of work that reveals a theme and variation similar to that in music. Themes have the power of pointing out similarities and differences, they show the artistic process at work, they can uncover a broader visual logic than a single piece, and they expose patterns and explore traces of creative thought. A study of thematic development will inform you of the variety of ways artists use particular concepts so you can better understand your own options.

There are a number of reasons to develop a series of drawings based on a single theme. The most basic reason is that art involves the mind as well as the coordination between eyes and hand. Art sometimes begins with an exercise in thinking and moves to an exercise in doing. Just as frequently, the order is reversed, but the processes of thinking, observing, and executing drawings are always in tandem. A thematic series allows you to go into your own work more deeply, with more involvement and greater concentration; in addition, you work more independently, setting your own pace.

Finally, the process of working on a series develops a commitment to your ideas and thereby a professional approach. And as a professional you will begin more and more to notice the thematic patterns in other artists' work. A first step toward developing thematic drawings is to look at the way other artists have handled a theme in their works. This chapter discusses three general categories: *shared themes*, the same images or subjects used by different artists over a period of time; *individual themes*, chosen by individual artists; and *group themes*, developed within a movement or style such as Cubism or Minimalism.

SHARED THEMES

Words as Image

A thematic thread that weaves through art is the relationship between word and image. The drawn or painted image, of course, preceded the written word, but as soon as writing developed, image and word were solidly united, each serving to amplify the other.

Writing itself is among the most prized arts in both the Islamic world and in the Orient, where elegant cursive calligraphic styles have developed during centuries of practice. In the Islamic world words were power, and the ability to write them carried a special kind of status. In the sixteenth century Mir Ali wrote a treatise on how to become a calligrapher; in it he cited "good tools, a good hand, and the capacity to endure pain." Orthodox religious restrictions constraining the depiction of the human figure were more than compensated for by the development of intricate pattern and decoration. Word and image are so entwined that they are difficult to separate; together they make up the formal vocabulary of Islamic art in architecture, art, and crafts.

In figure 10.1 we see a drawing in which the entire picture plane is covered in a storm of calligraphy. The work is by Rasheed Araeen, who was born in Pakistan and now lives in London. The theme of a series of related draw-

10.1. RASHEED ARAEEN. The second of four panels from the *Ethnic Drawings* series. 1982. Felt pen and pencil on cardboard, 2′7½″ × 1′9½″ (80 cm × 54.6 cm). Collection of the Arts Council of England, London.

ings, which Araeen calls "Ethnic Drawings," is the enforced marginality of people from the Third World. Combining a self-image and text, Araeen questions how one can define oneself if one is being defined by others. For the viewer who does not read Urdu or who is not familiar with Araeen's work, the calligraphic writing is a simply a decorative overlay on a featureless face; however, for Urdu speakers the calligraphy spells out ugly rhymes, slurs, and angry satires. The critic Guy Brett observes that Araeen seems "to be seeking a personal way of bringing into critical relationship the words of fine art, of everyday language and imagery and of [contemporary] social strife"—a theme that lays bare the raw and hurtful oppositions between the "First World" and the "Third World."

In the Orient the study of calligraphy provides the foundation for training an artist. Poetic descriptions, narrative accounts, and maxims were the literary forms used in scroll painting—the scroll was a unique Chinese development, meant to be unrolled and viewed one segment at a time. Poetic imagery accompanying eloquent descriptive writing has traditionally been a characteristic of Oriental drawing and painting in which subtleties of surface, value, and line quality are promoted. Ink and brush is the traditional medium of calligraphy, used to produce sweepingly graceful variations of line that encompass the full range from bold to delicate. In defiance of tradition, the contemporary Japanese artist Yuichi Inoue makes work that has been described as

10.2. YUICHI INOUE. *Ah! Yokokawa National School.* 1978. Ink on paper, 4′9″ × 8′ (1.45 m × 2.44 m). UNAC Tokyo.

10.3. F. T. MARINETTI. Cover of *Zang Tumb Tumb.* 1914. © 2003 Artists Rights Society (ARS), New York/SIAE, Rome.

"renegade"; his marks are splintered and shattered in keeping with his theme—his memories of the firebombing of Tokyo in 1945 (figure 10.2). The wall-size text screams at the viewer while smeared, scumbled black slashes rain down a torrent of words. Across time and cultures the written (painted or drawn) word has provided a powerful thematic source for artists.

During the early part of the twentieth century the relationship between word and image grew in complexity beginning with the European movements Cubism, Futurism, and Suprematism, which introduced type and typography as image. Abstract, geometric compositions and radical designs in posters, magazines, and books disrupted the traditional way works were read, forcing the viewer's eye to move right to left, crosswise, and from bottom to top to unravel the fragmented, unconventional distribution of letters of all sizes and typefaces, which F. T. Marinetti, the Italian Futurist artist and writer, called "Words in Freedom" (figure 10.3).

The most basic connection between the traditional pairing of words and images is found in the role a title plays in a work of art; traditionally the title gives the viewer a reference point for understanding the work. The interpretive role of words merely serving as titles to direct the viewer's focus changed radically in the twentieth century when actual words or fragments of words claimed equal status as image. The inclusion by the Cubists of painted and collaged images of newsprint in their still lifes set the stage for a century-long involvement with word-as-image (see figures 1.14 and 6.23). Dadaist collages solidified the trend (see figure 6.24). In an update of the Dadaist reclamation of urban ephemera, the contemporary French artist Villéglé strips through layers of posters to reveal hidden words (see figure 6.26).

In the 1970s and 1980s, the relationship between word and image underwent explosive changes. Conceptual artists led the way in asserting the primacy of words and written documents as stand-ins for the actual art objects. Joseph Kosuth's title (used for more than one work) *Art as Idea as Idea* accompanied an enlargement of the dictionary definition of the word "idea." In Kosuth's work he presents three ways of perceiving and conceiving an object: An actual object (such as a hammer) is paired with a photographic image of the same size

10.4. RENÉ MAGRITTE. *The Key of Songs.* 1930. Oil on canvas, 2′7⅞″ × 1′11⅝″ (81 cm × 60 cm). Private collection. © Photothéque R. Magritte-ADAGP/ Art Resource, New York. © 2003 C. Herscovici, Brussels/Artists Rights Society (ARS), New York.

of the object, and with an enlarged dictionary definition of the object. Neither the isolated text nor the isolated object nor the copy of the image provide the ultimate meaning; it is the combination (or disjunction) of the three that generates new and different meanings.

The goal of the Surrealists was to subvert accepted cultural standards, and their influence is still being seen in today's art. In Surrealism the subconscious with its irrational associations furnishes grist for the artist's pictorial mill. René Magritte's practice of misnaming objects became the identifying mark of his work. In figure 10.4 he disrupts rational thinking by presenting the viewer with visual/verbal paradoxes. In the work shown here, Magritte names a hat "the snow," a shoe "the moon," and a glass "the storm."

We have seen examples of work in which facture is emphasized, where the particular handmade quality gives the viewer a clue as to who the maker

10.5. EDWARD RUSCHA. *Brave Men Run in My Family.* 1988. Dry pigment on paper, 5′ × 3′4″ (1.524 m × 1.022 m). Collection Richard Salmon, London. © Paul Ruscha.

of the art is. Look again at Twombly's work (see color plate 7.1) as an example of this phenomenon. Note how his linear configurations stem from handwriting, not from the artistic gesture. Twombly's intentionally clumsy writing style creates a tension between the written word and the often poetic response it elicits. The written word as image is a recurring motif in Twombly's work; Twombly sometimes scrawls names from classical culture (like "Virgil" or "Dionysus") across the surface of his work; these words seem to be fragments of the past barely alive in our consciousness. The effect is an ironic one of poetic spareness. The word *mute* keeps cropping up in describing Twombly's work.

Other artists such as Ed Ruscha use the word itself as image. In figure 3.28 the word *chop* has been turned into an illusionistically three-dimensional object with light and shadow giving it dimension; the word seems to be constructed from a streamer of paper folding and turning in perspectival space. We are left to puzzle the significance of this particular word. After intense concentration on the word, we finally begin to lose the sense of its meaning, and see it as an object.

A second word/artwork by Ruscha will extend our understanding of his strategy. This time word and image work together to create a visual and verbal double entendre (figure 10.5). The words are taped onto the paper and the image of the sailing ship is airbrushed over the surface. The tape is removed, leaving the words negative to the ghostly image that is now situated behind them.

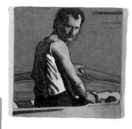

10.6. DOTTY ATTIE. *Barred from the Studio.* 1987. Oil on canvas, 11″ × 2′10″ (27.9 cm × 83 cm) overall. P.P.O.W., New York.

The statement "Brave Men Run in My Family" can be taken on at least two levels: The men are either brave or they run away. The ship supports both interpretations, but it is an absolute impossibility to hold both interpretations in mind simultaneously. The ideas are mutually contradictory. A third level that is operative in the work is the commentary on the romantic attitude with its ideas of heroism and bravery. The ghostly Ship of Romanticism seems to be fading in the fog. The idea of a life at sea (again a double meaning crops up: living onboard a ship or living "lost at sea" without meaning and direction) could be understood at a deeper level. Nearly any words one might choose to discuss this work point to sea metaphors and allusions, and from there to more personal, psychological "undercurrents." It is exactly this kind of game playing Ruscha uses in his work, and the efficacy of his seemingly simple approach is underscored when we as viewers join in the game.

Some Post-Modern artists work in a more clearly defined narrative mode. Dotty Attie insinuates encoded messages beneath the surfaces of old masters' paintings. Her goal is to expose and unveil secrets found in them through recombining segments of the painting with invented, fictional stories (figure 10.6). By focusing on details that are secondary in the actual work (such as hands, feet, and glances), Attie subverts the original meaning and implies through her texts that the old masters themselves are involved in secret schemes and cover-ups. She generally works in small, 6-inch-square units arranged sequentially, either horizontally or sometimes in grids. She painstakingly and convincingly copies not only the image but also the original brush strokes.

Combining details from two different paintings by the nineteenth-century American artist Thomas Eakins, Attie insinuates a disreputable story. She creates new and multiple contexts for the repossessed images. We are aware of the historical context from which the images are taken; the artist creates a disjunction by removing them from that frame of reference and offering us another view, another set of propositions for interpreting them.

The text in the initial frame reads: "Barred from the studio while male models were posing, female art students were placed in a corridor where a small window provided a distant view of the sitter's back." This is a fact of the actual practice of art schools of the time, but the following two narrative

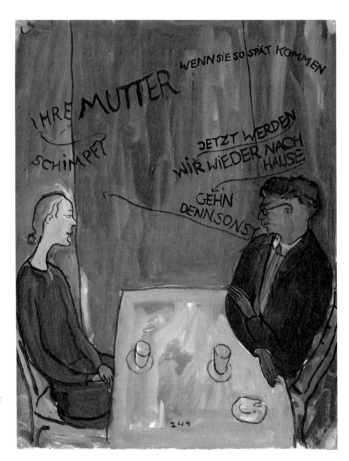

10.7. CHARLOTTE SALOMON. Drawing from *Life? Or Theater? A Play With Music.* 1940–1942. Goache on paper, 1'⅘" × 9⅝" (32.5 cm × 25 cm). Text reads, "We better go home now. Your mother will be angry if you are late." Collection Jewish Historical Museum, Amsterdam. © Charlotte Salomon Foundation.

fragments leave viewers to draw their own conclusions concerning exactly what Eakins did that was so shocking in trying to rectify the situation. The second and fourth squares are bloody details taken from Eakins's painting *The Gross Clinic;* these, combined with the famous image of Eakins's oarsman leave us in a quandary. The figure's central position and his intent gaze offer some clues to the underlying message. Looking, gazing, seeing, close inspection, close-up views, being barred from looking—these activities are either explicitly or implicitly stated in verbal and visual images throughout the six-part narrative. Can we then surmise that voyeurism itself is the subject of the work? Voyeurism operates on several levels in the images: The painted oarsman returns the viewer's gaze (or is he observing the bloody proceedings going on in front of him?); the viewer is implicated by looking at the gory close-up details and by trying to fit together a plausible explanation for Eakins's "shocking" and "impulsive gesture" that "succeeded only in further sullying his career"; both artists, Eakins and Attie, are involved in "voyeuristic" activity, that of making art. We are all implicated, viewers and artists alike. With reduced images and minimal text, Attie plants notions that keep us involved long after the actual encounter with her work.

Let us conclude our discussion on the shared theme of word and image by looking at the work—created a year before she died in 1943 at Auschwitz—by a young German woman. Charlotte Salomon was not an

artist, yet she produced a series of drawings (800 in a two-year period, from 1940 to 1942), which she called "Life? Or Theater? A Play With Music" (figure 10.7). In a review of a show of her work in New York in 1997, critic Michael Kimmelman writes that her subtext was Germany, "a Germany that not only denied not just her nationality but even her right to exist" (Michael Kimmelman, "Shaping Stories, Shaping Herself," *New York Times*, December 29, 2000, pp. B37, 39). Salomon said the goal of her fictionalized diaristic drawings was to cleanse the world. Kimmelman writes, "Art didn't save her life, obviously, but it gave her purpose and clarity about the world" (ibid.), which is the message in the drawings, a message of salvation and self-affirmation. The drawings are based on memory and employ such compositional devices as close-ups, long shots, and montage; they steadily move from a naive, innocent style to a harsh, expressionistic one. Salomon, who finished the work a year before she was shipped to Auschwitz, said, "I needed a year to figure out what this singular work is about, for many of its texts and melodies, especially in the first sheets, have slipped my mind." The work is not about the Holocaust; it is, she said, "about my whole life" (ibid.). The final drawing in the series carries this text: "And with dream-awakened eyes she saw all the beauty around her, saw the sea, felt the sun, and knew she had to vanish for a while from the human plane and make every sacrifice in order to create her world anew out of the depths" (ibid.).

In our look at word-as-image themes we have seen that modes differ from artist to artist, but the cross-circuitry between the two disparate ways of relating to the world—through language and through images—provides a spark for viewer and maker alike. Our visual and verbal abilities are called into action to interpret and relate, and to provide our own personal imprint and responses. The contemporary issue is not to make illustrative art where picture and text function in tandem to the same ends, but to create certain combinations and juxtapositions that produce resonances between the verbal and the visual that are lacking in each separately.

Appropriated Images

A second major shared thematic thread that runs through contemporary art is appropriation of preexisting images. Post-Modernism resulted in a split with authority, a rupture in historical time, a disruption of the picture plane, and even a fragmentation of language. Appropriation of images entered the art scene with a vengeance in the 1980s—a decade that was characterized as being an art about "pictures" with appropriation as the dominant mode—and the theme is still alive and strong today. Visual quotations come not only from art history but also from the mass media. Although claimed images promote associations with style and subject matter, the resulting content differs from the original. Appropriations pose questions concerning our pictorial language. Josef Levi's major theme is the combination of two figures from separate art historical periods. He appropriates and combines women from the work of Picasso, Renoir, Cézanne, Matisse, and Leonardo among others; each is depicted accurately, down to the cracked surfaces of old oil paintings. Earlier in the text we discussed Levi's double appropriation—Leonardo's *Mona Lisa* and Warhol's *Liz Taylor* (see figure II.26). Levi's pairings alter our preconceptions about both artists' work; a new meaning is produced by placing two (and

sometimes three) recognizable characters from art history, each in the style of her own period, in the same picture plane.

In addition to Levi, from our discussions throughout the book, you will remember other artists who make use of appropriation, such as Baechler, Hamilton, Hammond, Polke, and Souza (see the index to find their work shown in this book). They are among many artists who have taken subjects from earlier art and given them new meaning through jolting transformations.

The Figure / Body Art / Portraiture

The figure (or the body, as it is known in art parlance) has held center stage for artists throughout the 1990s and into the twenty-first century. The figure has been called "the still life" of contemporary art. In some work the figure is used in a narrative context, as in Jim Nutt's work (see figure II.10); in other works the figure is merely implied.

The contemporary artist can employ a number of representational strategies in portraiture. Some artists work directly from life, such as Don Bachardy in the series he made of his dying friend. Bachardy records the last days of Isherwood's life in the titles of the work, which include the date of the sitting, as seen in *Christopher Isherwood, October 20, 1985* (see figure 5.22). Some figure or portrait drawings are mediated through photography, such as the work by Chuck Close (see figures 1.21 and 6.16). Close's monumental "heads," as he calls them, of himself, his family, and friends are fixed by the camera. Although verisimilitude to the Polaroid photograph is important to Close, he approaches the painting with a detachment and a process-driven approach. Close's technique is to grid the picture plane and map each grid square by square like a topographical map of the "terrain" of the sitter's face. Seen individually, each square is a mini-abstraction; somehow the result is a complete identification with both the subject and the photograph.

The artist can combine observation and abstraction; an example of this approach is the work of Alex Katz (see figure 9.12). Katz's detached work deals with simplification, yet the result is a portrait that remains recognizable both as an individual and as a representative of a certain privileged class. Katz uses flat planes of unmodulated color with positive and negative shapes that could easily be cut out and reassembled. It is amazing that Katz achieves such remarkable likenesses to his sitters with such reductive means. Katz works thematically; over the years he has made innumerable portraits of friends and of his wife Ada.

Unlike Katz's and Close's psychological detachment from their sitters is the work by Alice Neel who works from direct observation. She seems to be looking into the souls of her subjects, who are stripped by her penetrating sight. Psychological verisimilitude was the goal of her lifelong involvement with portraiture. Neel paints people from all walks of life; her exaggerated and expressionistic technique produces the empathic feelings her work evokes.

Neel's interest in women's experiences and in motherhood furnished her with a continuing theme. The unconventional view of a mother with her ill infant is a moving portrait not only of a specific person but also of a universal condition (figure 10.8). Neel employs a high eye level so that the mother's loving face looms as a focal point of the composition. The child's awkward posture with its frail, bent legs is echoed in the mother's enfolding hand. Neel's

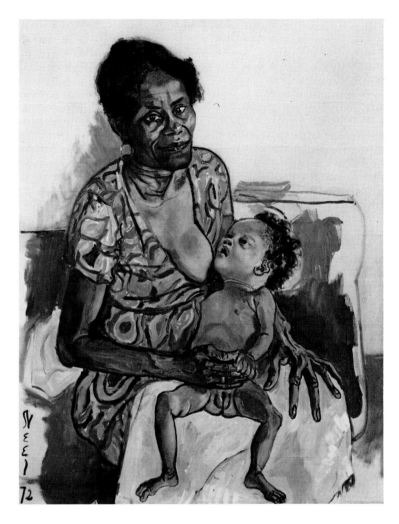

10.8. ALICE NEEL. *Carmen and Baby.* 1972.
Oil on canvas, 3'4" × 2'6" (1.02 m × 76 cm).
Private collection. Robert Miller Gallery,
New York. © The Estate of Alice Neel.

subject, her penetrating insight, her way of handling paint, all go into creating a gripping psychologically charged work.

It is interesting to compare the portrait Neel painted of Warhol (see figure 1.23) with the portrait of Marilyn Monroe by Warhol (see figure 4.18). Unlike Neel, whose work is deeply embedded in the human condition, Warhol's portraits deal with the cult of celebrity. In spite of the star's icon status, Warhol seems to have reached a deeper level in this portrait.

Earlier in our discussion of word-as-image, we saw the work of Araeen, whose self-portrait was a mirror held up to society (see figure 10.1). His image "absorbed" the verbal prejudice hurled at it; the words became a screen that hid the actual person "behind" the slurs. Araeen forefronts the damaging words; his portrait is a stand-in, a universal scapegoat. He offers his self-portrait as a means of self-reflection for the viewer. Araeen's question of how one defines one's self when one is defined by others is at the very core of the work of body artists. Women artists took the lead in redefining and revalidating the body as subject matter in the latter two decades of the twentieth century. Male-dominated mainstream traditions of how women's bodies have been

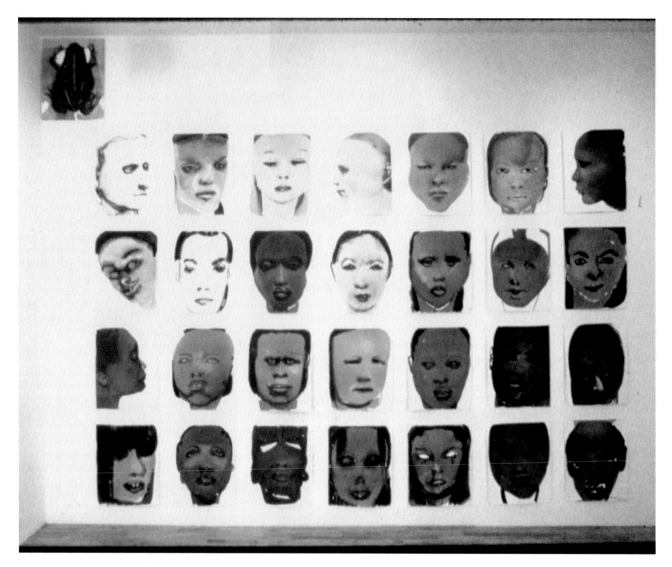

10.9. MARLENE DUMAS. *Betrayal*. 1994. 29 drawings. Ink on paper, 2' × 1'7¾" (61 cm × 50.2 cm) each. Installation view. Courtesy Jack Tilton/Anna Kustera Gallery, New York.

depicted have been challenged through women's body art. Araeen has shown in his work that it is not only women now who see representations of the body as a political battleground.

The work of Marlene Dumas also falls under the category of body art. Her interest in portraiture, like Araeen's, also has a social and political purpose. Using a camera to record individual expressions, she then transforms them into universal statements. Her work is a catalog of emotion rather than a mapping of physical likeness. Dumas uses serialization and repetition in her work (figure 10.9). The images seem to be in flux, emotion sweeping across the multitude of faces in a fleeting moment of time. Dumas sees portraiture not as a means to revealing an individual's personality or looks, but as a route to exploring relationships within a group. Close works meticulously and slowly, but Dumas relays an immediacy through an economic rather than a detailed approach.

Leslie Dill takes an alternative approach to the self-portrait. Her interest in literature carries over into her art. Her title *The Soul Has Bandaged Moments . . .* (figure 10.10) is a line from an Emily Dickinson poem. The "bandage" Dickinson speaks of becomes the "skin" of the figure; the words are literally made flesh. In an artist's statement Dill writes, "Sometimes I feel skinless. How right to slip inside words, the meaning and the shape of some emotion you're feeling, and go out into life." She adds, "Maybe we do have words on us, invisible texts we all wear" (Wolfe and Pasquine, *Large Drawings and Objects*, p. 94).

The direct frontal stance of the figure in this dark, mysterious, life-size drawing suggests vulnerability. The head disappears into the black charcoal background, leaving the body to speak for itself.

Just as in viewing and understanding other art forms, the way we look at portraiture is informed by our experiences, beliefs, and cultural conditioning. Body artists are constantly breaking down ways of looking, thinking, and identifying; body art brings into critical relationships conventional ways of depicting the body and current social, political, economic, and aesthetic changes and demands.

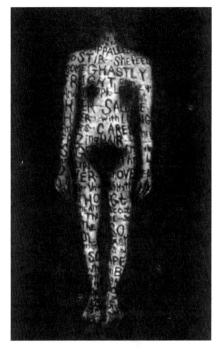

10.10. LESLIE DILL. *Untitled (The Soul Has Bandaged Moments . . .).* 1994. Charcoal on paper, 6'1" × 4' (1.85 m × 1.22 m). Arkansas Arts Center Foundation Purchase: '94 Tabriz Fund. 95.0008.

PROBLEM 10.1
Word and Image

In this problem dealing with thematic development, unify a series of drawings by media, technique, and idea, using words and images. Take your cues from the section called Division of the Picture Plane in chapter 9.

Tom Sale's *Self-Study Primer* (figure 10.11) is an informative work to study before beginning this project. Formally, this series is unified by media, technique, and image. Each segment is drawn on a blackboard, separately framed; each unit employs a limited number of images juxtaposed with a title that gives some clue as to how to interpret the drawing. In one drawing a fishing lure with an eyehook is combined with a centralized image of teeth; the single word written in a style akin to that in a handwriting manual reads "pacify." The

10.11. TOM SALE. *Self-Study Primer.* 1990. Oil pastel on chalkboard with wood, each segment 2' × 1'6" (61 cm × 46 cm), overall 2' × 4'6" (61 cm × 1.37 m). Collection of Teel Sale. Photo by Dottie Allen.

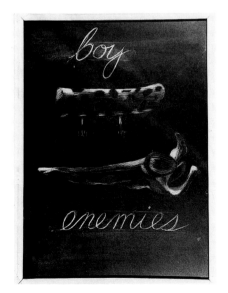

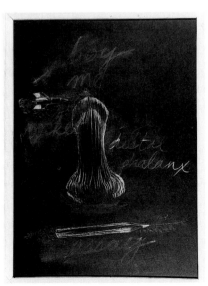

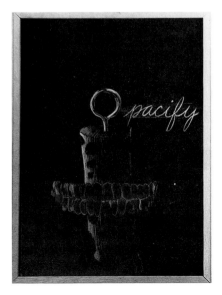

second panel in the triptych includes a rocket, a fingertip bone, a pencil, and the words "distal phalanx." How are we to interpret such disparate images? Are they connected? What, if anything, do they have in common? Artists frequently develop a personal iconography that may be difficult to comprehend. The effort to discover, to unravel their meaning is a vital part of the art experience. Subtle connections emerge, testing our interpretative and deductive reasoning.

We can approach this triptych as if it were a game. Our first major clue in unraveling the meaning comes from the title, *Self-Study Primer;* we can assume that these drawings are lessons, a symbolic self-portrait. Two of the boards contain images that refer to seeing: the eyehook on the fishing lure (two visual/verbal puns). In the third drawing, a face is made of objects: rocket-eyes, bone-nose, pencil-mouth. What are the connotations of the objects? They seem to have double functions; in the fishing lure, there is a hook; the eye can be snagged. The rocket and pencil function as arrows, directing the viewer's line of vision; they, along with the teeth, are sharp; they could be a danger. The word "pacify" defuses the danger; one of the functions of art is to blunt the hooks of existence. The shoulder blade is also a visual/verbal pun (shoulder blade/knife blade). It appears with the words "boy enemies," reminding us of the games even big boys play with knives and rockets. The "distal phalanx" is the name of the first joint in the finger—also a pointer, a means of directing attention. Pointers direct you where to look, lures intrigue, eyehooks grab or capture, rockets destroy, pencils create, teeth bite lures, and so on. We see the makings of a story in these seemingly incongruent images and words. Contradictions and oppositions seem to be contained within a single image; images and words play interchanging analogy games.

We see how an artist can look at objects outside of art and reassemble them to make new meanings. Images fade in and out like half-remembered ideas. The erased images, Sale says, indicate that there are layers of images, built from back to front; others are ready to appear to create new sets of oppositions, contradictions, metaphors for making and looking at art, and, as the artist says, for creating the self. The artist, like his art, is in the process of becoming.

Create the effect of blackboard and chalk for this drawing. Blackboard paint can be purchased in a hardware store or you can use a flat black or dark green latex paint in imitation of a blackboard. Cover a panel (wood or cardboard) with the paint and let it dry overnight before drawing with chalk or pastels. Be sure to use a spray fixative on the final drawings since chalk and pastels erase easily.

PROBLEM 10.2
Frames of Reference

For this problem, select five or six postcards with reproductions of paintings or drawings from art history.

Write captions with no more than three or four lines each. These do not necessarily need to be original. You can use found words or found fragments of texts. They can be snippets from old letters, random sentences from any book on hand; you might even ask a friend or a child to write some segments. Initially, they need not relate to each other. It is your job to create a sequence.

Form a narrative or story from the disparate words and images by combining captions and pictures.

Place the postcards face down on the table and let chance determine which text goes with which image. After you have spent some time with the combined words and pictures, alter the images in some way. You can draw over the surface; you can apply opaque paint; you can use collage; or you can cut the card into segments and rearrange the parts. You may need to do some editing and revising. Keep the spontaneity of the project alive by not intruding too aggressively with rational, logical additions.

Using the postcard series as a preliminary study, create a drawing based on the most successful effort. Incorporate the texts into the composition by overlay, by collage, or by some other means. You can enlarge the type to suit the image. A multipart format might be a good choice for this project. Look at the work of Dottie Love and Dotty Attie in relation to this problem (see figures 6.13 and 10.6).

PROBLEM 10.3
Appropriation / An Art History Homage

Choose as your subject a work from art history. Make a series of drawings with the work as a point of departure. Approach your theme through any of the methods discussed in this chapter. The original work should be altered or transformed stylistically. Use a contemporary compositional format taken from chapter 9.

In your drawings you can change the meaning of your chosen reference by transforming it from its context into a scientific, secular, or religious context. The use of grids and other contemporary devices, such as collage or photomontage, can give your subject a contemporary look.

You might crop the original image and blow up a detail of the work. In keeping with the Post-Modern technique of overlaid images, you might use this strategy in your work. In any case, keep the source of your subject apparent to the viewer. The resulting series is to be an homage to your chosen artist.

PROBLEM 10.4
Alternate Self-Portrait

Everyday objects can be stand-ins for the self. Common objects present themselves as familiar companions capable of being transformed. Find one such object that has special significance for you. Let it be a mirror of yourself. Make several drawings of the object from different viewpoints. You might impose several different views in a single drawing. In a second group of drawings turn the object into an anthropomorphic image of yourself. Combine some of your distinguishing features—your face, hands, the contour of your head—with the object, allowing the object and you to meld into a single entity.

You might use smaller paper for this series. When you have completed the related works, arrange them on a single format. Consider how you want the sequence to be read—as a cinematic strip, either a vertical or a horizontal arrangement, or as a grid. Use pushpins to attach the work to a foam-core background, or attach them directly on the wall.

PROBLEM 10.5
Self-Portrait in Different Styles

Using a photograph of your head and face, depict yourself in three different styles on the same picture plane. The picture plane can be in a ratio of 1:2 or 1:3; that is, it can be twice or three times as long as it is tall. You might make a transparent overlay of a head from the Cubist period or from Pop art; place it over your photograph and draw the composite face. Use faces or heads from three distinctly different styles in the final work. Use actual images by specific artists; do not try to concoct a style. Keep your references pure.

In art history books you will find many styles to work with. Use color; integrate the three versions by using the same colored or textured background. You can convert your photograph from black and white to color or from color to black and white. Your first image could be a Photo-Realist image. You could use a solvent to transfer the image on the three-part picture plane. (See directions for solvent transfer in chapter 6.)

PROBLEM 10.6
A Psychological Portrait

Using Alice Neel's approach to portraits—depicting "what people are like underneath how they look"—make a double self-portrait, a diptych, in which you present yourself in two different modes, in two states of being.

The constant in the work of Francesco Clemente is the body—his body—a fragile human form. Through his self-portraits, which deal with introspection and mystical intimations, Clemente leads a search for identity that binds him to himself; in other words, a search for unity. For Clemente, doubleness is a form of unity. From a group of pastel studies (figure 10.12) we see one page from a series of eleven double portraits that form a part of his quest for self-knowledge. In most of his work, and in all of this series, Clemente includes

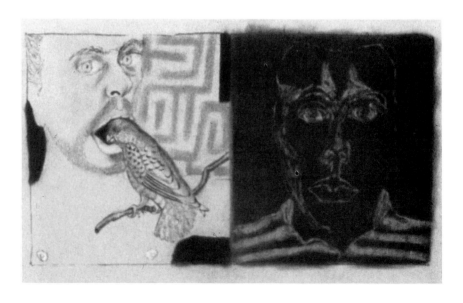

10.12. FRANCESCO CLEMENTE. *Còdice 1.* 1980. Pastel and tint, 2′ × 1′6″ (61 cm × 45.8 cm) (for all three codices). Collection of the artist, Rome and New York.

objects or animals along with his self-portraits; animals metamorphose into strange shapes, houses have mouths and noses, body parts are detached and floating—all are images tied to ideas. For Clemente they are "an endless stream of images that [seem] to generate one another" (Percy and Foye, *Francesco Clemente*, p. 21). Clemente is another male artist who could be included among the body artists.

Like Clemente, you will find that in making self-portraits you are presented with a chance to look in two directions at once as you depict your external world as well as your internal self.

Paint, pastels, or watercolor are appropriate for an expressionistic drawing.

INDIVIDUAL MOTIFS AND THEMES

An example of individual thematic development can readily be seen in the works of Jasper Johns (see figures 2.16 and 2.26). We have discussed Johns's selection of flat images as subjects for his work—images that are themselves flat such as targets, flags, and numbers. Another motif that Johns has used since the early 1970s is the crosshatch (figure 10.13). The *motif*, or recurrent thematic element, has been interpreted on a number of levels: as abstraction; as a subtle compositional structure; as symbolic of something camouflaged or hidden; as a reference to traditional pictorial elements; as a pictorial device appropriate for concerns with process and systems; as an analogy for a covering such as the stretched canvas; and as a stand-in for the artist's personal signature. In Johns's

10.13. JASPER JOHNS. *Untitled.* 1983–1984. Ink on plastic, 2′2⅛″ × 2′10½″ (66 cm × 87.5 cm). Collection of the artist. Leo Castelli Gallery, New York. © Jasper Johns/Licensed by VAGA, New York.

work in the early 1970s he used this motif in a nonobjective mode on panels of equal size, using different media on each subsection. In these works each subsection of crosshatch complied with a preset system; variations in color and scale contributed to a change in mood.

In the example shown here, the crosshatch motif has undergone a transformation. The apparently abstract patterning is more dimensional; its source (hidden from view) is a detail of the demon of the plague in Matthias Grünewald's early sixteenth-century painting, which Johns has abstracted and reversed, or turned upside down. This citation has been the subject of much critical investigation. Without clues to help locate the hidden image, the average viewer could not detect the disguised reference, but this strategy lies at the very heart of Johns's work; doubleness of meaning and of appearance is a prime concern.

In a more recent phase of his career, Johns uses more recognizable imagery. In addition to the crosshatch motif, other recurring images are the clothes hamper, the faucet, the skull, double flags (one with 48 stars; the other with 50 — again, the question of doubleness), a vase, and a rather clumsily drawn head of a woman with a feather curling out of her hat. Johns has established a theme by using the same images and the same format (the diptych) throughout the 1980s. These images and format are the language Johns uses in his visual speculations on art, and they are the means he uses to tell us that things are not what they appear to be. The idea of multiple appearances and of art as the ground of his work has its visual equivalence in the divided picture plane. (In each of the drawings, the Grünewald crosshatch always appears on the left; it is the continuing ground of the entire cycle of work.) Not only is the picture plane divided into two major sections, each section is further subdivided into planes within planes. Johns has had a continuing interest in pictorial space from his early work to the present; segmentation is one manifestation of that involvement. The right picture plane functions as a wall on which two-dimensional objects are attached (note nails and shadows), and the objects that refer to dimensional shapes in the real world, basket, faucet, and vase, are singularly flat.

Two images are especially worthy of note; they are both picture puzzles, paradoxes. The white vase can alternately be seen as a vase or as two facing profiles, male and female (again, doubleness of identity; the one on the left is Johns's profile). The drawn figure of the woman on the right is another composite, a borrowed 1915 cartoon, originally titled *My Wife and My Mother-in-Law*; she is either a young woman with her features turned away from the viewer or she is an old crone depicted in profile with a huge nose, her head lowered into her fur collar. Johns tests our perceptual quickness and requires us to form relationships and distinctions between the parts. Johns's appropriations are more subtle than other work we have looked at; what is hidden is as important to Johns as what is revealed. Contrasts are crucial to his concerns, to his continuing thematic dialogue on art and mortality.

We have discussed Johns's work at length, not only because it is so rich and full of meaning, but also because it shows how an artist's theme and variation can extend over a lifetime of work. In his art, we find a consistency of images or motifs along with continuing involvement in formal concerns, especially that of pictorial space. His work has become much more personal in the latest phase of his career, in which he uses more figurative references and recognizable images. Throughout his work he has maintained an intense investi-

gation into the ways in which pictorial space reflects and represents real space. An involved examination of Johns's work will introduce you to the many options available when you embark on your own projects of theme and variation. Media, subject, recurring images or motifs, formal decisions, technique, and style—all play a role in thematic development. The following problems will suggest points of departure for serial drawings.

PROBLEM 10.7
Individual Theme: A Series of Opposites / Transformation

We have seen how contemporary artists frequently create a feeling of disjunction by placing together two dissimilar objects. In this series you are to choose one object that will appear in each drawing. With that recurring image juxtapose another object that will either amplify or cancel the first object's meaning or function.

In Gael Crimmins's *Spout* (figure 10.14), the source of the painting within the painting is Piero della Francesca's fifteenth-century portrait of the Duke of Urbino. The small portrait is combined with a small milk carton that in some strange way is analogous to the duke's profile. By this surprising pairing we read multiple meanings into the work: the debt of modern artists to Renaissance art, the dominance of man over nature, the richness of the old contrasted with the depleted, ordinary carton full of references to a consumer world with our habits of use and discard.

A second way to develop your private theme of opposites is to have an object literally transform into another one. Crimmins has left the final stage of transformation to the viewer to perform. In preparation for choosing the objects to be transformed, it is helpful to sharpen your vision to see visually analogous forms. (The duke's nose and the spout of the milk carton are visually analogous.)

10.14. GAEL CRIMMINS. *Spout* (after Piero della Francesca, *Duke of Urbino*). 1983. Oil on paper, 1′10″ × 1″10½″ (56 cm × 57 cm). Private collection, Los Angeles. Photo by Susan Einstein/Hunsaker-Schlesinger Gallery, Los Angeles.

10.15. EDWARD RUSCHA. *Birds, Pencils.* 1965. Oil on canvas, 5'7" × 4'2" (1.7 m × 1.27 m). © Edward Ruscha.

You can graphically attribute human characteristics to an inanimate object; this is called *anthropomorphizing* the object. Or you can have two objects metamorphose into each other, as in the work by Edward Ruscha, *Birds, Pencils* (figure 10.15). Make a list for interesting pairings before you begin on this thematic series; the longer the list, the better the ideas, because you will refine your way of looking at things—visual analogies will suddenly become a part of your vision. Not only are the pencils in Ruscha's work analogous to the birds' tails, they are analogous to their beaks, which, incidentally, Ruscha also observed. Other drawings in this series depict birds with pencil beaks.

PROBLEM 10.8
Developing a Motif

For this series, choose a single motif, a recurring thematic element, a repeated figure or design, that will be the dominant image in each drawing. Use nonobjective imagery rather than recognizable objects or figures. A repeating motif in Johns's work is the crosshatch; in Rauschenberg's it is the transferred image.

In Brice Marden's work the repeating motif is the continuous overlapping line; in Lichtenstein's work it is Ben Day dots. A motif can be something as simple as a box, as in Mel Bochner's work, or as complex as Hammond's inventory of rubber stamps. A motif can be used in a single series or in a large body of work that encompasses many different thematic works.

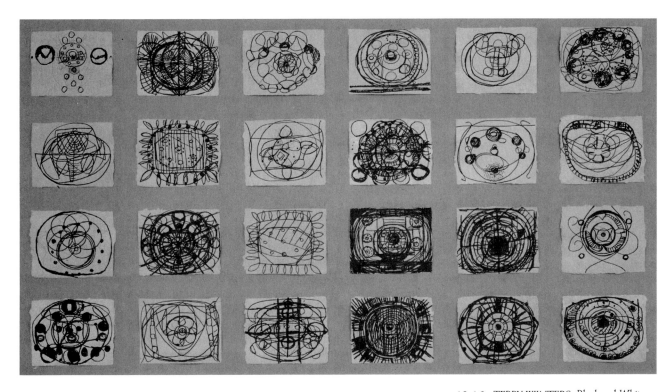

10.16. TERRY WINTERS. *Black and White Examples* (1–24). 1997. Ink on paper, 8½″ × 11″ (21.6 cm × 27.9 cm) each. Courtesy of the artist and Matthew Marks Gallery, New York.

Before beginning your search for a motif, a look at a wall full of drawings by Terry Winters will be informative (figure 10.16). In Winters's work repetition itself is a recurring motif. In the series shown here the reiterated image is the circular form. Winters's automatic, gestural style keeps what could be a rigid form flexible and varied—the technique of automatism is shown at its best in Winters's freewheeling drawing style. Winters says he is interested in "all kinds of virtualities, some electronic, some biological, some inorganic" (Nancy Princenthal, "Perfect Like a Hedgehog: The Printed Works of Terry Winters," *Art on Paper*, September–October 2001, p. 55); he speaks of an involvement with an area "where the boundaries between the natural and the artificial aren't so distinct, where the artificial and the technological are seen as newer orders of nature" (ibid.). His interest in digital, mechanical, and reproductive processes is apparent, particularly in his print series *Graphic Primitives* (see figure 1.10). Transit maps, musical staffs, double helixes, and microchips are among the sources for his imagery. Winters's work is definitely a candidate for our antiperspective category with its spatial indeterminacy. The wall of drawings resembles a set of spinning helixes; the weblike lines and oscillating forms resemble a slide seen under a microscope. Winters's interest with the physical sciences and with chaos theory feeds his voracious mind.

Now, having seen some rich examples of motifs in other artists' work, select a motif and develop it through variations of the form. Manipulate scale, vary its placement; repeat it; think in terms of compositional and spatial arrangements. Your motif can be a geometric form, a decorative pattern, or a recognizable object; it can undergo change, as in the drawings by Winters, or it can be isolated and used in a diptych, as in the work by Johns. The motif can

have a special and hidden meaning for you; the more interpretations you can attribute to it the richer your drawings will be.

Keep in mind the decisive role of the picture plane; choose a format that is suitable for a series of drawings. Use the same kind of paper and media throughout the series. The images might change gradually from drawing to drawing, so that a decided difference is apparent between the first and last drawings in the series, but only a slight change appears when the drawings are seen in sequential order.

Drawings dealing with form need not lack in expressive content. Johns and Winters have taught us that formal development does not rule out a subjective approach.

GROUP THEMES

Members of the same schools and movements of art share common philosophical, formal, stylistic, and subject interests. Their common interests result in group themes. Cubists Georges Braque (see figure II.16) and Pablo Picasso (figure 6.23) illustrate the similarity of shared concerns most readily. Their use of ambiguous space through multiple, overlapping, simultaneous views of a single object, along with a combination of flat and textured shapes, is an identifying stylistic trademark. Collage elements—newspapers, wallpaper, and playing cards—as well as images of guitars, wine bottles, and tables appear in the works of many Cubists.

Pop artists have a preference for commonplace subjects. As the name suggests, these artists deal with popular images taken from mass media, which are familiar to almost everyone in American culture. Not only do they choose commercial subjects, but they also use techniques of advertising design such as the repeated or jumbled image. In Pop art repetition emphasizes the conformity and sameness of a commercially oriented world. Pop artists manipulate subject and technique to make a comment on American life and culture.

PROBLEM 10.9
Style / Visual Research Project

Look through several contemporary art surveys. Choose three twentieth-century styles. Some suggestions are: Analytical Cubism, Synthetic Cubism, Fauvism, Dada, German Expressionism, Surrealism, Constructivism, Abstract Expressionism, Pop art, Minimal art, Photo-Realism. Find the commonalities in the work of at least three artists within each style. Pay attention to preferred medium, to shared imagery, and especially to style. (Style is the way something is done, as distinguished from its substance or content, the distinctive features of a particular school or era.) What are the distinctive characteristics of the periods you have chosen? Analyze the works according to how the elements of line, shape, value, texture, and color are used. What is the resulting space in each work?

Paul Giovanopoulos provides us with a good art history exam in his apple conversion (figure 10.17). How many artists or styles can you identify? We have discussed several of the artists whose works are parodied by Giovano-

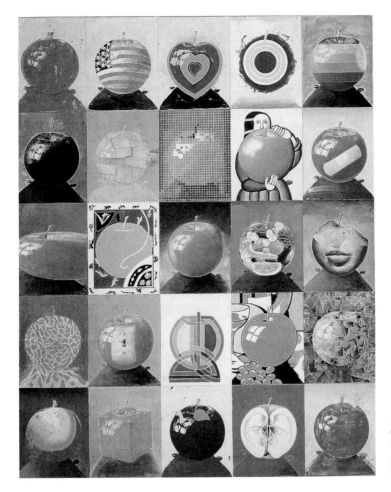

10.17. PAUL GIOVANOPOULOS. *Apple-Léger.* 1985. Mixed media on canvas, 5′ × 3′4″ (1.524 m × 1.016 m). Louis K. Meisel Gallery, New York. Photo: Steve Lopez.

poulos. In your research on the shaped picture plane, you may have seen Frank Stella's *Protractor Series*, but did it occur to you they could be combined to be analogous to an apple?

SUMMARY

DEVELOPMENT OF A THEME

An artist's style is related to imagery. Sometimes an artist works with an idea in different media and in different styles, yet the theme is constant. In other artists' work the theme is the result of a stylistic consistency, and the imagery is changed from piece to piece. Whatever approach you take, let your own personal expression govern your choices.

Here is a list of some variables that will help you in structuring your thematic series:

1. subject matter, imagery, or motif
2. media or material
3. technique

4. style
5. compositional concerns, such as placement on the picture plane
6. use of space (determined by how you use line, shape, color, texture, and value)
7. scale

It is necessary to find a theme that is important to you. Each drawing in your series should suggest new ideas for succeeding drawings. An artist must observe, distinguish, and relate; these three steps are essential in developing thematic work. After having completed several of these problems, you will think of ways of developing your own personal approach.

Here are some actions that go into making a thematic body of work. Review them in your process of making a series.

Build
Reshape
Mediate
Manipulate
Edit
Arrange
Select
Modify
Change
Reflect
Correct
Reinvent
Look
Think
Concentrate
Transform
Abstract
Describe
Focus

SKETCHBOOK PROJECTS

Collecting ideas is a continuing process for the artist. Thematic series can evolve from simple sources.

PROJECT 1
Visual and Verbal Descriptions

Over a two-week period set yourself the task of drawing single, individual objects. You are to draw from life with the object in front of you, graphically describing the object as accurately as possible. After you have made the first drawing of the object, look at it again. You no doubt have a different perception of it now than before you drew the first study.

Next, you are to write about the object. Your writing should be as descriptive as possible. After writing an objective, accurate description, introduce into your writing metaphors and allusions. What is the object like? What

does it remind you of? How does it make you feel? What associations with other objects, memories, or events does it evoke?

Your personal, unedited response is valuable in doing this project. If you want to make lists of words or use sentence fragments or try your hand at poetry, do not feel intimidated. You are trying to construct a personal, comprehensive, perceptual, and conceptual response to the object. The goal is to expand the way you look at and interpret the world. A fresh, open-ended, unexpected response is what you are after.

After drawing and writing about the object, make a second drawing of it. Compare the first and second drawings. How has the graphic concept changed? How did writing about the object inform and affect your second drawing?

PROJECT 2
Juxtaposition of Word and Image

Reverse the order of the preceding exercise. Begin with a written description, follow with a drawing, and conclude with a second written response.

Words can alter the way we perceive an image and, reciprocally, images can change the meaning of words. Juxtapositions of words and images can produce resonances between them that can jolt our perceptions. This exercise can be a reinvestment of meaning into the most common of objects.

Reduce your verbal description and responses to a single word. Pair that word with a drawn object. Word and image may or may not derive from the same object. Note the influence the single word has on the object. Try for multiple effects by changing the word but retaining the same drawn object.

COMPUTER PROJECT

PROJECT 1
Transformation Using Computer-Generated Images

The process of drawing with a computer is closely related to design; however, the distinction between drawing and design is that in design there are stated problems to solve and goals to be met. In this drawing you are to respond to what you see on the computer screen, allowing the image to govern what happens next. Do not let preconceptions interfere with the process.

Use a program that allows input from a digital camera or scanner to capture the image; alter it, converting the image to lines, dots, or value shapes. Make a concentrated search for interesting images. Old science textbooks or old magazines might be a good source. There are some good designs that come with various computer programs. A grid can be manipulated to create interesting backgrounds. Stretch, distort, enlarge, and crop your chosen image on the computer. You should include some words in your composition. Various typefaces also come with computer programs; these, too, can be manipulated, altered, enlarged, and cropped. Remember our discussion of word-as-image— even isolated letters or numbers can be used as images. You can incorporate a narrative text or simply use isolated words as a part of the composition.

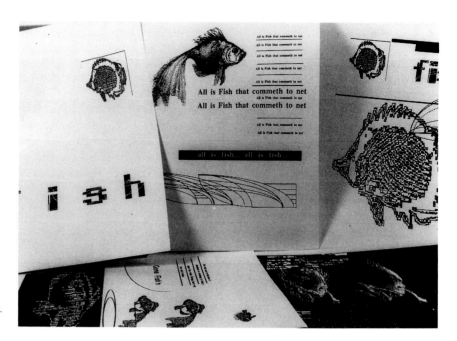

10.18. DANIELLE FAGAN. *Fish Book.* 1990.
Computer-generated book, 8½″ × 11″
(21.6 cm × 28 cm). Collection of the artist.
Photo by Dottie Allen.

Print the computer-generated drawings; then photocopy them, enlarging or reducing the composition to an appropriate scale. Consider making the drawings some size other than the standard 8½ by 11 inches. A square or long, narrow, vertical, or horizontal format might be more interesting since it is not the expected computer printout size. In addition, working with different shaped picture planes is more challenging and will sharpen your computer skills.

You can "take a page out of Danielle Fagan's book" (figure 10.18) and make a book out of your computer designs. Artist's books do not follow the traditional format of printed books; they can have a limited number of pages; each page can be on different paper, and the ink can be any color you choose. You can even dispense with a title page and end sheets, although these conventional book parts offer space for real creative manipulation. The book can be bound using a spiral binding or a plastic slip-on binding, both of which are sold in copy shops. The pages can be stapled or sewn together or they can be placed in a handmade box. You can even recycle a cover from an old book. There are dozens of options for presentation.

Figure 10.18 shows pages from a book that was produced entirely on a computer following the steps outlined above. The artist, Danielle Fagan, used an image of a fish, which she manipulated by stretching, compressing, enlarging, deleting, compiling, and combining with some found texts referring to fish. She altered a grid to become a net, which she printed in red ink on clear acetate. The gridded net image is dispersed throughout the book as if to catch the fish on the pages that lie beneath the acetate. Blue paper is used for some of the pages, an obvious reference to water.

Fagan says the fish is a metaphor for the artist who might "fall prey to the fishermen or be trapped on the outer isles." She recommends a metaphorical summer as a good time to go fishing—fishing for new ideas, images, questions, and answers.

One final comment: Computers can be helpful tools for artists, especially for beginning students because more sophisticated images can be used at an early stage of a student's career. Frequently, beginning students want to produce more involved work than their hand skills permit. Many variations can quickly be made on the computer; you do not have to imagine what an image or a composition would look like if, for example, it were bigger, blue, moved to the left, doubled, or turned sideways. The computer can turn your "what ifs" into concrete form. Computers are experimental tools; they can be freeing; they do not produce work that is "precious"; images can be discarded and retrieved easily. But computer art does have a "sneaky" aesthetic and process all its own. It is important not to buy into it completely. In the hands of an artist with a good foundation in art, computers can be helpful aids, and the resulting drawings can be exciting, creative, and personal.

A Look at Art Today

Do not define today. Define backward and forward, spatial and many-sided.
A defined today is over and done for.
PAUL KLEE

WHY LOOK AT CONTEMPORARY ART?

Now at the beginning of a new century we need to assess the world's concerns. What better discipline than art to shed light on the old and spotlight the new? Following Klee's admonition, we will not make any hard and fast definitions, rather, we will take a look at some of the major concerns of today's art and of the role drawing plays in it.

Our twenty-first-century world is immersed in images and information. It is imperative that we as artists and as viewers examine and interpret the systems that produce our images and ideas. How, why, and for whom images are made, how they are distributed, the context in which they are seen—all these

327

issues demand critical assessment. Pictures have a power over us; they make us desire—desire to know, to have, to be, to control, to own, to become. They attempt to tell us what the good life is, what our values are, what kind of people our society values. Art makes us look at pictures and styles and encourages us to rethink assumptions and attitudes toward others.

Today the work of a large number of artists from all parts of the world is being shown. The world is richer by hearing the voices of these artists. A new multicultural world is unfolding that offers new ideas and definitions that are not based on Western or Eurocentric practices. The move toward inclusiveness has revitalized the dialogue on race, ethnicity, identity, gender, generational concerns, political debate, and aesthetic standards. The current pluralism in art offers ideas and views other than those heretofore promoted by the mainstream.

In a time of political, economic, and sociological instability, when no single stylistic, aesthetic, or political model lays solid claim over another, it comes as no surprise that artists respond by employing images and strategies whose associations, references, techniques, styles, and meanings are also in flux. Since today's world is multicultural and pluralistic, we must acknowledge other ways of seeing, speaking, and thinking, and a major means of accomplishing this high priority task is through art.

Václav Havel, the president of Czechoslovakia, in his acceptance of the 1997 Fulbright Prize, summed up our role both as artists and as humans: "We are living at a time when humankind can face whatever threatens it only if we, by which I mean each of us, manage to revive, with new energy and a new ethos, a sense of responsibility for the rest of the world. What does this mean in concrete terms? It means a number of things. For example, it means a deep respect for everything that in today's multipolar and multicultural world constitutes 'otherness,' a respect acquired from understanding the positive values in other cultures."

Contemporary art challenges preconceptions; it opens us to other views and ideas than those approved and promoted by the mainstream. Familiarity with today's art will enable you to relate your work to your own experiences and to the times in which you live. An acquaintance with current issues will increase your knowledge of art and provide a reservoir of techniques and points of view that will strengthen your own work.

MODERNISM AND POST-MODERNISM / OPTIONS

Our understanding of contemporary art is of necessity tied to our understanding of Modernism. For over a century Modernism has been the cultural standard that formed our conception of what art is. The philosopher and critic Arthur Danto calls the history of modern art "a complex network of criss-crossing streams and streamlets rather than a single mighty river." Critics have tried to impose a clear-cut structure on Modernism beginning in 1880 with Manet and ending with the Color-Field painters in midcentury; yet it is generally accepted that modernism (small *m*) continued after Modernism (capital *M*) came to an end. Modernism has remained an option even now in the twenty-first century. In the catalog for the 1995 Madrid show "Codido y Crudo," critic Jerry Salz observed, "The 1990s may have been the first decade

to have left the 19th century behind." A "cultural convulsion" took place at the end of the twentieth century that signaled a change of direction for artists, leading them down new paths. Some artists still follow the Modernist aesthetic, whereas others repudiate that route; some artists have formed a continuity with the past and others have demanded a break.

What are some of the causes in art that led to such a cultural upheaval? Some obvious answers are developments in technologies, the hold that television took in the 1950s, the onslaught of computers in the 1960s, and the ever-increasing bombardment of images by the printed media. These influences caused a fundamental change in perception, in how we perceive the world. Photography and its extension—mechanical reproduction of popular images—provided the means of representing our culture. Photographic images entered into painting (as we saw in the work of Rauschenberg); it is largely through photography that the change in perception can be explained. Today's pluralism in art can also be attributed to the extent photography is used worldwide.

New ideas, attitudes, and art forms are being made now that do not conform to Modernist formalist criteria. This broad cultural shift has been named *Post-Modernism*; the term not only describes a paradigm shift in art, but also changes in culture in general, in literature, history, architecture, music, and design—changes in the very way we look at the world. It is important to keep in mind that Post-Modernism is more an attitude than a style.

Frank Stella said of Modern art, "What you see is what you see." This is not the case in Post-Modern art, where what you see is what is implied—what is not present is often as important as what is present. The Post-Modern artist is concerned with content, with signification, something beyond the actual image, something in the world of ideas. Semiotics is a program with a goal to identify the conventions and strategies by which art and literature produce their effects of meaning. In Post-Modern art, traces of over- and underlaid meanings exist in the viewer's mind. Semiotics focuses on communications and how our values are encoded in our culture. The connections between language and art compound the problem of interpretation. As we saw in chapter 10 in our discussion of thematic development, artists are drawn to words and narrative structure as a means of drawing attention to the encoded meanings in the culture.

Modernism throughout the twentieth century has been characterized by dialectical shifts in style. Analytical Cubism, Fauvism, Futurism, Dadaism, Constructivism, Purism, Abstract Expressionism, and Minimalism are only a few in a line of "isms" progressing through the century. Each "ism" responded to a different philosophical theory of what art is. Modernism has been seen as a set of codified values about art and art making whose role is to investigate the essential nature of visual art. It deals with the processes by which art is made and with the nature of pictorial space. It stresses the primacy of form; it promotes truth to the intrinsic properties of the material from which it was made; and it asserts that art is a way of thinking and seeing that is opposed to the natural appearance of objects in the real world.

In Modernism, definitions held schools together—color for the Fauves, space for the Cubists, gestural vocabulary for the Abstract Expressionists. The definitions were exclusive. Modernism is involved in how an object is made, how it is perceived, and what defines art. It focuses on the formal properties of art.

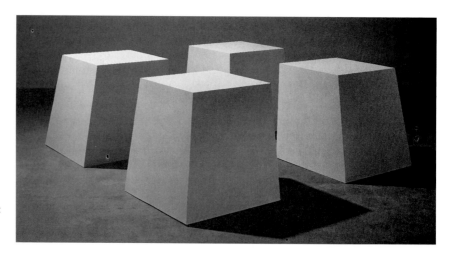

11.1. ROBERT MORRIS. *Battered Cubes.* 1965–1988. Painted steel, 3′ × 3′ × 3′ (91.4 cm × 91.4 cm × 91.4 cm) each. Leo Castelli Gallery, New York. © 2003 Robert Morris/Artists Rights Society (ARS), New York.

In contrast, formalist issues in Post-Modern art take a secondary role to other concerns, such as why an art object is made, how it is experienced, and what the object means beyond its formal compositions. Post-Modernism's syntax is images of images; it pries away at the politics of representation, focusing on the relationship between representation and content. In Post-Modernism categories are never clearly drawn; a multitude of purposes and categories exist side by side.

The two basic approaches, Modernism and Post-Modernism, are clearly evident in two periods of work by the same artist, Robert Morris (figures 11.1 and 11.2). A leading proponent in the two movements of Minimalism and Earthworks in the 1960s and 1970s, Morris was involved in material, seriality, and process—all formal concerns. In contrast, his Post-Modern work uses apocalyptic images dealing with the aftermath of nuclear destruction. A heavy Baroque-like frame encases a massive pastel drawing, with marks applied in slashing, violent strokes. The frame combines bas-relief images of skulls and dismembered body parts. Called a "mini-theater of fear and fascination," the drama Morris presents is horrific. It was inevitable that an investigation into subject matter would follow the "exhaustion of modernist forms," to quote the Minimalist-now-Post-Modernist artist.

Morris's work exploded the Modernist dictum that art should make no reference to any other order of experience, that it should confine itself strictly to the visual experience of art itself. Purely pictorial, nonillusionistic, essentially optical, and self-referential—these were the demands of Greenbergian Modernism.

Morris's new work violates categories; that is, it can no longer be strictly categorized as pure painting or pure sculpture. This blurring of categories, or hybridization, is one of Post-Modernism's distinguishing characteristics. Crossover categories along with inclusive modes of representation, especially photographically derived imagery, are at the core of Post-Modern work. The French critic Jean Baudrillard claims that media-derived images are even more real to us than reality itself. The extent to which commercial images have altered the way we look at the world cannot be exaggerated.

Canadian-born Philip Guston was a major force in redefining art. Guston's early work dealt with the formal issues of color and atmospheric

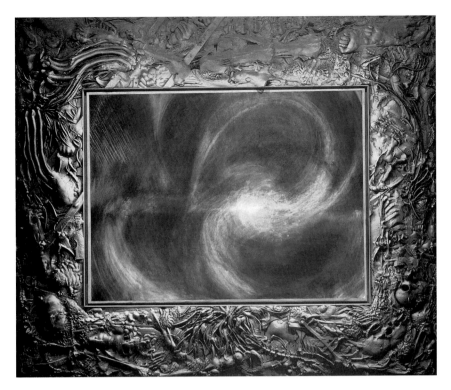

11.2. ROBERT MORRIS. *Untitled.* 1983–1984. Cast hydrocal, graphite on paper, 6'4" × 7'8" (1.93 m × 2.34 m). Courtesy of the artist and the Solomon R. Guggenheim Museum, New York. © 2003 Robert Morris/Artists Rights Society (ARS), New York.

space. Then, in the late 1960s and early 1970s, his art underwent a radical change; he began making self-portraits featuring clumsily drawn, hooded Klansmen with enormous hands and feet who were usually smoking, drinking, painting, or sleeping (figure 11.3). Justifying his radical departure from his earlier work, Guston equated creativity with a willingness to be embarrassed. He claimed that art is made in the mind of thoughts, memories, or sensations.

Along with a reintroduction of figuration, Guston incorporated complex iconography from many sources—personal, public, political, psychological,

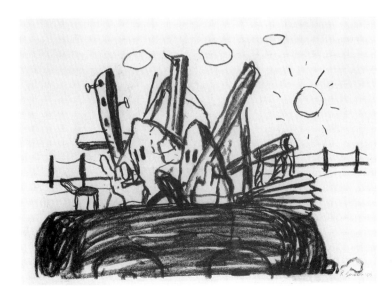

11.3. PHILIP GUSTON. *Study for Edge of Town.* 1969. Charcoal on paper, 1'2" × 1'5" (35 cm × 43 cm).

and art historical. Stylistically, he combines the rendering style of the 1930s Regionalists and Surrealists with other art historical sources, especially early Italian Renaissance painting. Drawing was Guston's primary means of developing the personal idiom that expressed his unique vision.

Guston, along with a group called the New Imagists, were the pioneers of Post-Modernism in their exploration of new subject matter and their rejection of Modernist tenets. (Among those included in this text are Neil Jenney and Jim Nutt.)

These new Post-Modern artists, like their predecessors, the Pop artists, regarded popular culture as a fruitful field for critical investigation, a mine of imagery, styles, and ideas. Commercial techniques, comic book drawing styles, and other untrained, nonart methods were claimed by the New Imagists to revitalize heretofore unacceptable ways of representation and to introduce new images into their work. This was in sharp contrast to the basic stance of Modernism, which disallowed extraneous, personal, autobiographical, and social references. Modernist abstraction is based on the belief that meaning exists outside of time, that it is eternal, while Post-Modernist representation sees meaning as situational, located in culture in a specific time. In Post-Modernism there is a tendency to read all products of culture as "texts." This in turn leads to a reconsideration of the function of representation both in art and in the broader culture as well.

One of the important influences forging change in contemporary art has been the women's movement. Feminist art is devoted to the idea of art as a direct experience of reality. Its stated goals are "raising consciousness, inviting dialogue, and transforming culture." Women have demanded new criteria for judging art. They have challenged the limitation of a singular, dominant, "right" view of experience; they defy the "remedial category" to which women artists have been relegated throughout the history of art.

Out of women's work of the 1970s came new strategies; women were leaders in the evolving art forms of performance, installation, and artists' books (see figures 6.10 and 6.13). A newly accepted gender-centered vantage point opened art to new content, new techniques, and new materials. Autobiographical issues, particularly those related to women's sensibilities, have now been legitimized as vital subjects for art.

Women artists continue to be involved in a rigorous and ongoing questioning of hierarchical conditions and the analysis of how representations of women address power and position. The critic Michel Foucault argues that what is "true" is dependent on who controls the discourse.

A seminal figure in the erosion of strict categories of art was the German artist Joseph Beuys. He embraced Performance art, the most characteristic art of the 1970s, as a means of rehumanizing not only art but also life. Performance art encompasses language, physical activity, projected slides, and three-dimensional objects—theater unbound by rules or traditions. Beuys's wartime experience (in World War II he had been shot down in the Crimea, and nomadic tribesmen had saved his life by wrapping him in grease and felt) provided impetus and techniques for his ritualized performances, the goal of which was transformation and healing (see figure 6.8).

Beuys had a tremendous influence on the developing new artists in Germany; in his teaching and in his art he revived myth as a powerful theme.

In the 1980s German and Italian artists, the Neo-Expressionists as they were called, spearheaded a new movement in Europe and claimed international

attention on two counts: their forceful use of paint and the return to the convention of representation. Enormous, heroic-scale, apocalyptic subject matter; bold, gestural brushwork; and vigorous, color-saturated, energized works announced the arrival of something very different from the prevailing art, and continental artists were in the vanguard.

Anselm Kiefer, Georg Baselitz, Mario Merz, A. R. Penck, Francesco Clemente, Enzo Cucchi, and Helmut Middendorf are names you may be familiar with—we have discussed several of their works elsewhere in the book (see index). And you know their American counterparts, Julian Schnabel and Robert Longo, among others. Anselm Kiefer has been called the quintessential Post-Modernist in his broad-ranging, wide-foraging use of appropriated images, in his conceptually loaded work made with nonart materials, and in his demanding agenda to reassess history and culture.

The Neo-Expressionists revitalized art and embraced images, subjects, and styles that had been banned by the Modernist code. By the late 1970s and early 1980s Post-Modernism took center stage in its search for a radical new content.

NEW SUBJECT MATTER, NEW STRATEGIES

Post-Modernism defies limits; even the label, Post-Modern, is challenged by some—alternate terms are Post-Conceptual, Post-Minimal, and Post-Historical. After the excesses of the 1980s, art's economic boom, matched by equally inflated artists' egos, the prevailing idea was that art had played itself out. Much work dealt allegorically with the disintegration of culture, even of civilization itself. The artificiality of art was underscored.

The relationship between representation and content is still today, in the twenty-first century, at the forefront of Post-Modernist work; it remains a vital way to invoke associations and make references to popular culture, history, and art itself. Post-Modernism aims for a reassessment of modern traditions of art and the role of art in society. Post-Modern artists see art as a means of interpreting nonart experiences, borrowing freely from the past, and using art and nonart sources, popular imagery, and cultural artifacts.

Certain discredited themes that were off-limits for art have been claimed by Post-Modern artists, themes such as the artist as social critic, literary themes, the relationship between art and language, image and concept, content and context; their work deals with issues of political, social, moral, and cultural relevance; they question class and gender structure and problems of self-identity and the role of myth in a culture, along with other psychological and philosophical investigations of import. Contemporary artists are involved with *how* we know what we know. Let us look now at a number of strategies taken by contemporary artists for whom drawing plays a critical role in the development of their art.

Appropriation and Recontextualization

The dominance of photographic images continues into the twenty-first century. Walter Benjamin's observation about our propensity to "pile up fragments ceaselessly, without any strict idea of a goal" seems to have become the

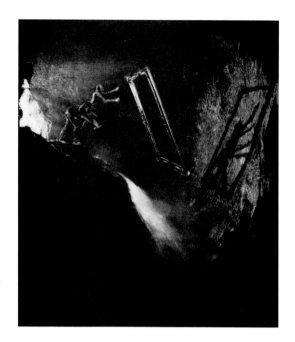

11.4. MARK TANSEY. *Literalists Discarding the Frame.* 1992. Toner on paper, image 8″ × 7″ (20 cm × 18 cm); frame 1′5¾″ × 1′2½″ (45 cm × 37 cm). Private collection, Boston. Curt Marcus Gallery. © Mark Tansey 1992. Photo: Orcutt and Van Der Putten. MT 2890.

rallying cry of Post-Modernists. The art of the 1980s was characterized as being art about pictures, with appropriation as the prevailing mode. This mode is still in effect full force, albeit with less irony than was seen previously. Throughout this book we have looked at work whose images were taken from their original context and recontextualized; by this strategy we have seen how an image sheds some of its original meaning and acquires new ones. A summary of the picture-making process of the contemporary painter Mark Tansey will be informative in our discussion of appropriation and recontextualization.

Tansey constructed what he calls a "content wheel" consisting of three concentric rings; the first lists subjects, the second verbs, the third objects. When the wheel is spun, three different levels of content can be combined: the conceptual, the figurative, and the formal. The resulting combinations are then used as supplementary motivating narratives for his work. An example of a phrase that could appear is, "Cubists [subject from ring one] suppressing [verb from ring two] other history [object from ring three]."

After this exercise Tansey selects images from a voluminous collection of photos and texts compiled from magazines, newspapers, books, his own photographs, and drawings. The archive provides lowbrow imagery for highbrow messages. The selected images are then photocopied and synthesized into a collage. A graphite drawing follows the collage process and serves as a "veritable photographic source" (Freeman, *Mark Tansey,* p. 70). Following the graphite drawing, Tansey makes a "toner drawing" by the subtractive process using erasers, brushes, and a variety of tools to remove the copier ink or toner and to produce a painterly looking drawing.

At this step in the process Tansey informs us that "the handmade and the reproduced are set in a sort of dialectical dance" (ibid.). Unlike the computer, the copier allows the hand to imprint directly onto the surface and to manipulate the toner ink. The process itself raises questions concerning the relationship between the original and the reproduced, and in so doing has bearing on the content while providing an underlying theme.

In the drawing shown here (figure 11.4), the structure of the frame is used as a metaphor of representation. In a suite called *Frameworks*, from which this illustration is taken, Tansey explores framing as a metaphor of representational content: "art production as framing, frames as transformational edges and lines, frameworks as sites of representation, frames as substitutes for subject matter" (ibid.).

Tansey's work is monochromatic (see figure 7.1), which, according to the artist, both clarifies and illuminates the subject. Texture (frequently used to carry opposing interpretations, such as rock formations built from words or texts) and value are the formal elements most pronounced in his work.

In keeping with contemporary goals, Tansey invites the viewer's involvement in an unraveling of complex meanings. The work is simultaneously metaphorical and allegorical.

Installations

The decade of the 1990s was a time of bold theatrical installations — a favorite Post-Modern genre. An installation is a hybrid form of art that uses impermanent objects in a temporary space offering the viewer a temporal and spatial experience (see figure 6.28) Installations deal with illusions. Unlike the illusions the viewer experiences when watching a film, the artificiality of the scene is ever-present in the viewer's mind. Viewers must rely on their own responses to "complete" the work and to unravel the meaning.

Ann Hamilton's work does not fall under the bold or theatrical category; however, what it offers is a sensual, mystical experience. For Hamilton making art is a social act, and "how one chooses to be social is an ethical act" (Golden et al., *Art: 21*, p. 17). The artist, whose training was in textile design and sculpture, makes installations that involve photography, video, performance, language, and sound. Hamilton often has a person physically present doing repetitive actions, such as burning words out of books or unstitching sewn threads. She attributes these actions to a Midwestern work ethic, that work is its own redemption.

This obsessive making and remaking underlies much of her work, and can be found again in *ghost . . . a border act* (figure 11.5). In this installation the

11.5. ANN HAMILTON. Installation view of *ghost . . . a border act*. 2000. Silk organza, tables, video projection, and sound. Dimensions variable. © Ann Hamilton, Photo by T. Cogill, courtesy of the Sean Kelly Gallery, New York.

11.6. ROBERT GOBER. Site-specific installation at Dia Center for the Arts, 548 West 22nd Street, New York, September 24, 1992–June 20, 1993. Courtesy of the artist. Photo © 1993 Geoffrey Clements, courtesy of the artist.

written word is reduced to a hand-drawn line; a video image of the action is projected onto translucent silk organza walls of a room installed in an abandoned textile mill. A disembodied pencil draws lines and then erases them (an effect achieved by running the projection in reverse); the drawn line is projected onto a painted "horizon line," on the borders of the walls of the textile mill. Hamilton's contemplative work is intimate with a spiritual dimension, which she achieves by making the viewer hyperaware of the space, sound, and images. The artist says her works ask viewers to "trust without naming" (Golden et al., p. 85). Hamilton, in speaking about the nature of installations, asks, "Are they like sanctuaries [when] one enters the church or mosque or the temple?" She speculates that "to cross that threshold . . . is to enter a world where something else can occur. Perhaps, for some, that something is spiritual" (Golden et al., p. 17).

The installations of Robert Gober definitely qualify for the theatrical in their ambitious and metaphorical engagement with the issue of nature and culture (figure 11.6). A sylvan glade is drawn on the walls of the installation on which are hung three-dimensional sinks; stacks of newspapers and boxes of rat poison are positioned on the floor of the gallery. A black door and barred windows penetrate the illusionistic forest walls.

Our associative powers are confounded; the complexity and confusing dichotomies between nature and culture, between the sublime and the mundane jolt our sensibilities. The environment is not what it first seems to be. The depicted representation of nature points to the "other nature," which has been turned into pulp and poison. The papers (imprinted by culture) are stacked

and tied; they seem ready to be recycled. Nature, now also imprinted by culture, cannot be restored. In this installation, in this world, what is real? What is false? What is artificial? What is salvageable? The painted pathway leading to the woods suggests a way out. What, then, is the meaning of the barred windows and the blocked, blacked-out door? Is nature dead or alive? Are we in or out? The work is even more poignant for being located on the third floor of a building in lower Manhattan, far from the rustle of leaves and the sounds and smells of nature.

To find the way through the complexity of Gober's work, the viewer can turn to his drawings, which are frequently displayed along with the installations. Gober says that for him drawing is a notational activity, rather than an end in itself. Drawings help him work out ideas; they are a manifestation of his thinking process. For example, the sink, which appears in several installation pieces, is reconfigured in dozens of ways in his drawings—none of them drawn from life. Drawings become anthropomorphic beings in Gober's drawings; he flattens them, unfolds them, abstracts them; some metamorphose into crosses or boomerangs. In some drawings Gober reveals the wealth of associations that the sink has for him—for washing clothes and babies, for baptism, for quenching thirst, for warming, cooling, heating, and of the loss of precious things—"down the drain." It is interesting to note that all of the objects—sinks, newspapers, and rat poison boxes—are meticulously handcrafted by Gober.

Leo Steinberg in his 1968 essay "Other Criteria" described the fundamental change in the practice of art as a shift in subject matter from nature to culture. You will remember that 1968 was the same year Steinberg coined the word Post-Modern, calling it "a shake-up which contaminates all purified categories." Gober's hybrid work is a powerful underscoring of Steinberg's prophecy.

Before we finish our discussion of Gober we should note another work that will give you some insight into how an artist builds a body of work. In a year-long project Gober made hundreds of paintings of mundane objects combined in odd juxtapositions—such as a huge leaf resting on a small chair—working on a single wooden panel, photographing and scraping before painting another image on the same panel. Out of hundreds of slides he chose 90 from which a projected piece called *Slides of a Changing Painting* was created and exhibited. These images formed a major source of subjects for his subsequent work. You might think of imitating Gober's approach in developing a theme, and imagine how little storage space it would require!

Film

In Post-Modern art theatrical, allegorical, mythical, spiritual, and historical content can exist alongside political, sociological, and psychological work. Nowhere is this more apparent than in the films of the Iranian artist Shirin Neshat.

Neshat's mesmerizing, dramatically intense films with their memorable images and unforgettable settings fall also under a category much debated and discussed in the 1990s—beauty (figure 11.7). Neshat's poetic response to the devastating history of her nation and to her role as both a native of Iran and now an immigrant is both insightful and powerful. In her films Neshat makes use of contrapuntal themes of sanctity and sensuality, male and female, seduction

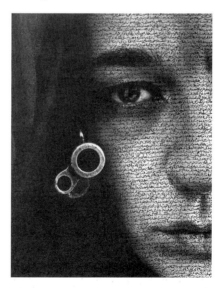

11.7. SHIRIN NESHAT. *Speechless.* 1996. RC print, 3′10¾″ × 2′9⅞″ (1.187 m × 86 cm). © 1996 Shirin Neshat. Photo taken by Larry Barns. Courtesy Barbara Gladstone Gallery, New York.

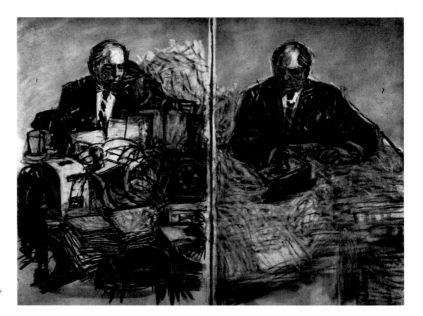

11.8. WILLIAM KENTRIDGE. Drawing from *Stereoscope.* 1999. Charcoal and pastel on paper, 3′11¼″ × 5′3″ (1.2 m × 1.6 m). Courtesy Goodman Gallery, Johannesburg, South Africa.

and sadness, the personal and the political, the public and the private, society and the individual, the individual and the community, tradition and change, and violence and serenity. Neshat presents the dichotomies facing Muslim women, the disparities between the roles of men and women in the Islamic world, the conflict between the old and the new. "It is through her extraordinarily perceptive grasp of the nature of feminine piety in an Iranian/ Islamic universe that Shirin Neshat can detect and convey the seductive energy of the clasp when the sacred and the sensual meet," writes the critic Hamid Dabashi (Dabashi et al., *Shirin Neshat*, p. 37).

Neshat makes use of various viewing techniques—a split screen, a double screen, screens placed on opposite walls of the viewing space—to reinforce the divisions in the culture. She challenges repression and denial by presenting the very borders where veiling and revealing collide. Neshat's films with their powerfully moving musical scores are mythic, sensual, and transformative. Dabashi calls her "an aesthetic tactician of uncommon precision" and says, "bordercrossing [is] her tenuous, attenuated trademark" (Dabashi et al., p. 36).

The films of the South African artist-filmmaker William Kentridge illustrate the definition of animation given by the Canadian pioneer of animation, Norman McLaren. "Animation is not the art of drawings that move, but rather the art of movements that are drawn" (Barry Schwabsky, "Drawing in Time: Reflections on Animation by Artists," *Art on Paper*, March–April 2000, p. 36). The technique used in making Kentridge's films is what he describes as "stone-age filmmaking" (Lilian Tone, *William Kentridge: Project 68* show pamphlet, New York: Museum of Modern Art, 1999.); it involves the labor-intensive making of thousands of drawings that are photographed in stop-action after each modification by adding or subtracting elements, photographed again, re-drawn, and so on. The layering and erasure of each drawing results in a rich tactile surface. The charcoal and pastel drawings are always in a state of metamorphosis; every drawing contains a residual memory of the previous drawing

and becomes a palimpsest for future drawings. Only 20 to 40 drawings are left at the end of each film, although thousands of drawing states have been recorded by film (figure 11.8).

Kentridge has called his films a portrait of Johannesburg, which provides the landscape and social background for his political and social narratives. His subject is the scars of apartheid; through his fictional characters, an industrialist and an artist—both aspects of the same person—Kentridge explores individual guilt and social responsibility. What one would predict could be blunt polemics becomes a poignant personal plea. The human condition is achingly presented.

In an interview with Lilian Tone, Kentridge says he has never tried to make illustrations of apartheid, "but the drawings and films are certainly spawned by and feed off the brutalized society left in its wake." He says, "I am interested in political art, that is to say an art of ambiguity, contradiction, uncompleted gestures and uncertain endings." Kentridge says the character, Soho Epstein, was based on "images of rapacious industrialists from Russia and early propaganda drawings of George Grosz and German Expressionism" (see figure 5.8). The drawings shown here come from the film *Stereoscope.* (A stereoscope is an optical device that when looked through makes images appear three-dimensional by presenting each side of the device with a slightly different view of the same scene. It imitates what binocular vision accomplishes; each scene is slightly different when viewed singly, yet together the scene coheres into a single illusionistically dimensional image.) Kentridge uses a stereo-optic technique in his film; a split screen divides a scene into two similar but unsynchronic views. The two main characters, the industrialist and the artist, are a divided self; the rooms that are shown are key components for Kentridge; they represent his feelings about an overcrowded world and one that is empty. The stereoscope symbolizes two different ways of seeing the world. Not only are the rooms doubled, Epstein, too, is a split self. A neon sign that flashes "Give/Forgive" at the end of the film, Kentridge says, is "a way of asking for peace, a stillness and a calm. But I couldn't tell you if it is Soho who is being asked to forgive, or if Soho is asking the forces around him to forgive him" (Tone, *William Kentridge*).

In viewing Kentridge's films one is reminded of Red Smith's comment on the "ease" of writing: "You just open a vein and bleed."

Body Art / Exploring Identity

We have just looked at two artists who are socially engaged and who invite a political reading of their work. Neshat and Kentridge present a political and a personal world at odds. In chapter 10 we discussed body art as a theme shared by contemporary artists. We have seen that our view of the body has always been informed more by culture than by science. Just as the critique of representation of the body has been brought into cultural politics, so the representation of women's bodies by women continues to be a major subject in today's art. In a time when the body is presented as an object for others (especially in the mass media), women using their own bodies as a subject in art is an act of reclamation.

The most radical star in her "theater of operation" is the French performance/body artist whose assumed name is Orlan. A post-Duchampian, she considers her body to be her own readymade. Her body sculpting is both a

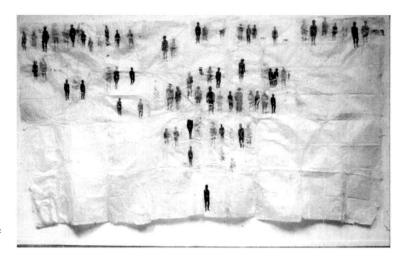

11.9. KIKI SMITH. *Lucy's Daughters*. 1996. Ink on paper with string, 8′ × 14′10″ (2.44 m × 4.52 m). Collection Rose Art Museum, Brandeis University, Waltham, Mass. Hays Acquisition Fund, 1992. Photo: Ellen Page Wilson, © 2004 Kiki Smith.

metaphorical and literal endeavor. She has selected representations of famous women in art history, and through plastic surgery she reproduced their idealized features in her own body, such as the forehead of Leonardo's Mona Lisa, the mouth of Boucher's Europa, and the chin of Botticelli's Venus. Marginality and danger are necessarily elements in her surgery-performances.

Work such as Orlan's has been called Abject art, in which the body is represented as one of resistance and transgression. Abject artists represent the body in defiance of the strictures imposed by society; they expose what the society struggles to contain. The body is seen as a political battleground. The power of Abject art is in its ability to elicit multiple readings and to expose threats to physical and psychological integrity. The artist Kiki Smith says that she has found that making "horrific things" works as a sort of "exorcism . . . making the scariest things you can make and placing them outside you, to protect one's internal psychic being" (Posner, *Kiki Smith*, p. 21).

Smith's work has moved from the body to the cosmological in the 1990s; she remarks on the transition, "I scattered glass stars and animal scat across a field of blue paper. There was also a configuration of blood drops and a big pile of hand-sculpted worms, and scat, and the stars—like an implosion of body, land, and cosmos." (Posner, p. 31). For Smith her many disparate materials serve as a metaphor for the universe as a multiplicity of systems.

Proliferation is a constant theme in Smith's work; in a large 8- by 14-foot drawing called *Lucy's Daughters* she pays homage to our earliest known ancestor; from "Lucy" in Africa female bodies increase in number to the top of the page. Strings seem to tie them to one another and to the earth on which they are grounded (figure 11.9)

The French artist Annette Messager makes work that is a mélange of the real and the fantastic. Messager amalgamates drawing, photography, sculpture, paint, texts, and women's crafts (embroidery and knitting) in service of her goal—upsetting the hierarchies of art. In the work shown here, a detail from *The Pikes* (figure 11.10), the title alludes to the period of Terror during the French Revolution when impaled heads were paraded through the streets. (Again we see another example of the theatrical as a theme of the 1990s.) Rather than heads, Messager has impaled stuffed animals, drawings, photographs, sewn and stuffed rag dolls, and handmade internal organs that look like

11.10. ANNETTE MESSAGER. *The Pikes (Les Piques)*. 1991–1993. Installation view, Musee National d'Art Moderne, Centre Georges Pompidou, Paris, 1993. Detail as shown. Parts of dolls, fabric, nylon, colored pencils, colored pencil on paper under glass and metal poles. Courtesy Annette Messager and Marian Goodman Gallery, New York/Paris. © 2003 Artists Rights Society (ARS), New York/ADAGP, Paris.

they are wearing stocking masks. (Both Messager and Smith explore the inside as well as the outside of the body in their use of internal organs as subject.) The viewer is torn between identifying with the "creature or the creator." Messager delights in this paradox. She says the idea of the poles came from watching demonstrators waving protest banners. Regardless of whether the viewer interprets the work as liberating or oppressing, Messager has presented an intriguing variation on body art.

We have discussed a number of artists who make compound accumulations to feed their art ideas. Messager joins the list of Hammond, Gober, Tansey, and Baechler, whose collections are a mine of images. While preparing for five shows in five different European cities, Messager divided her apartment in half, one labeled "Annette Messager Collector," the other "Annette Messager Artist." The divided collections were a manifestation of the multiple identities she sees in herself and which she explores in her work. She says, "I constantly inspect, collect, order, sort and reduce my findings and store them in album collections" (Conkelton and Eliel, *Annette Messager*, p. 59), which eventually become fuel for her art. Along with other body artists, Messager's goal is to investigate multiple human identities.

Messager's and Smith's work underlines the observation made by the French psychoanalyst Jacques Lacan that individual identity is actually evershifting multiple identities.

Maps / Charts / Plans

A search for self-identity also lies at the core of the work done by Julie Mehretu, who was born in Addis Ababa, Ethiopia. Mehretu turns to the style of Modernist abstraction but with a difference. Taking Modernist traditional, nonreferential abstraction in a new direction, Mehretu adds narrative and figurative images to her built-up surfaces of vellum, Mylar, and paper on which she draws extremely complex, symbolic mapping systems made with ink and

11.11. JULIE MEHRETU. *Implosion/Explosion* (detail). 2001. Ink and latex on wall, dimensions variable. Courtesy The Project and The Studio Museum in Harlem, New York.

acrylic lines. Incorporating classic architectural images with a "psychogeography that collapses time" (Franklin Sirmans, "Mapping a New, and Urgent, History of the World," *New York Times*, December 9, 2001, Art/Architecture 41), she creates action-packed maps that explore fictional worlds. Shown here is one of Mehretu's wall drawings (figure 11.11).

Mehretu says that public spaces—subways, airports, government buildings, and highways—are the subject of her work. She sees them as "structures for characteristic behavior to be played out. Depending on where you are in the system, you can operate differently and see things differently." Curator Christine Kim says the figures in Mehretu's drawings are "caught in an oscillating global landscape. They are purveyors and victims of culture abstracted among the swirls of paint and suspended between layers of acrylic, ink and silica." Mehretu says, "Part of my work is about mapping. I like the idea that everything fits into a structure with a map or even an architectural plan, but part of it is also about mapping who I am and that's a little more complicated. My parents come from such historically opposing points of ethnicity: Polish Jew; French; English; Lynchburg, Virginian; Amharic, Tigre; and Eritrean, but somehow they come together to make me" (Sirmans, 41).

Maps can be used to explore political environments as well as conceptual or poetic notions; they can be a stand-in for new historical landscapes. They can chart imaginary locales or they can be used to expose underlying meanings. A large number of contemporary artists use the map as subject; each artist's technique is different. We discussed Guillermo Kuitca's plans with their panoptic view in chapter 8 (see figure 8.3). Among many artists involved in mapping are Vija Celmins, Dorothea Rockburne, Nancy Graves, and Pat Steir.

In 1992 the Irish artist Kathy Prendergast began making drawings based on contemporary maps of all the capital cities of the world (figure 11.12). Using a B pencil and working on small drawing pads, she begins at the center of the city establishing a north-south axis. She then transcribes, draws, copies,

11.12. KATHY PRENDERGAST. *City Drawings.* 1992 ongoing series. Pencil on paper, 9⁴⁄₉″ × 12³⁄₅″ (24 cm × 32 cm). Collection Irish Museum of Modern Art, Dublin. Purchased 1996. Image © the artist.

and manipulates the scale of maps to maintain continuity in size throughout the series. She has removed what should be critical information in a map, such as street names, signs of buildings, parks, and other city features that would make a map useful. Prendergast unveils an underlying pattern in the world's capitals; the lines that remain show paths of communication and free circulation. In his book *Kathy Prendergast: The End and the Beginning* (1999), critic Francis McKee emphasizes that the key to understanding Prendergast's maps is in their resemblance to the nerve pathways of the human brain. McKee calls attention to the relationship with memory in the maps; he sees the drawings as a portrait of the long history of each city. When seen in a group, resemblances between the cities are apparent, and one cannot help seeing analogies to organic structures and microscopic forms. (In fact, cities do grow organically; they remain in a state of flux, in a condition of incompleteness.) But above all, the lyrical quality of Prendergast's drawing stands out; the quiet, meditative work promotes an enjoyment on a purely formal level. What a rich thematic idea for an ongoing project!

Prendergast's drawings are provocative paradoxes: They furnish us with an experience that cannot be reduced to words. Like all good art, they are a stimulus for self-reflection.

Systems / Structures / Information Art

Ordering the world is a Herculean task, yet many of today's artists seem to welcome the challenge. Matt Mullican's work approaches encyclopedic dimensions both literally and figuratively. In a series of 16 gridded canvases he

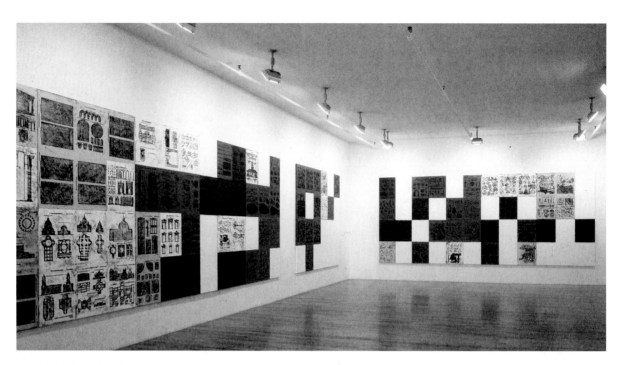

11.13. MATT MULLICAN. Installation photo at Brooke Alexander Gallery, New York.

has reproduced over 400 of the illustrations in a nineteenth-century Scottish encyclopedia (figure 11.13). Mullican converted the images to a raised metal plate from which he made rubbings; the faded images are a metaphor for lost or outmoded knowledge. The rubbings are alternated with squares of color, which are derived from Mullican's own symbolic classification system; for example, yellow stands for "the world framed (the arts)," whereas green symbolizes the natural world; black and white represent language; red stands for the subjective; and blue for "the world unframed (objective)" [Roberta Smith, "An Encyclopedic Mind Flips from C (for Conscious) to U (for Unconscious)," *New York Times*, March 6, 1998, p. B39]. Do the colors reveal or subvert the information relayed in the accompanying images?

In addition to the bombardment of information, the viewer is challenged to listen to and look at videotapes of sessions of hypnosis in which Mullican explores his past and present life. The installation contrasts the cognitive and the intuitive, the subjective and the objective, chaos and order. Information, hierarchy, systems of knowledge, and structures are the basis of Mullican's investigations, which are intellectually stimulating and visually exciting.

New abstraction emphasizes the processes that go into the production of the work. Peter Halley's "pseudo-abstract" images of cells and circuits, which are derived from technical charts, have a visually humorous edge. His "simulated" abstractions make a wry comment on Modernist abstraction, but on a more serious level Halley's work points to abstraction as a controlling force. In his nine-part *Exploding Cell* (figure 11.14), abstracted images of exploding cellular structures—such as nuclear cells, atmospheric cells, rain cloud cells, and computer cells—open up a conceptual space in their com-

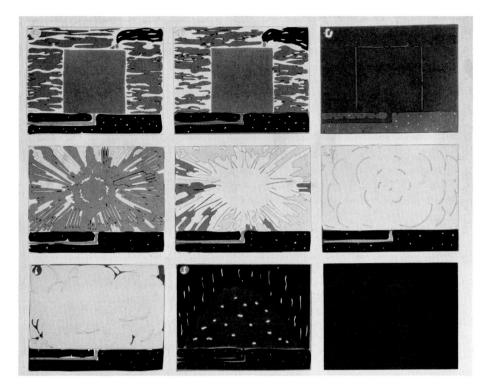

11.14. PETER HALLEY. *Exploding Cell.* 1994. Set of 9 silkscreen prints on museum board, each print 3′1″ × 4′ (93 cm × 1.2 m), each signed and numbered. Edition of 50. Edition Schellmann. Photograph courtesy The Museum of Modern Art, New York.

ment on the rigid, diagrammatic, regimented practices of modern life. Halley's criticism is made with deceptively simple abstract forms that can be interpreted metaphorically, symbolically, literally, and ironically. Irony plays a major role in Post-Modernism. An ironic approach is fitting for a project whose role it is to disclose and criticize. Irony allows an ambivalent stance. In irony, criticism and humor are inextricably bound. At the heart of Post-Modern art is the impulse that all art—including the figurative and the representational—is abstract. All images are at least one remove (and frequently many more) from reality and from a direct experience of the world.

Outsider Art

In most chapters of this book we have included a drawing by so-called Outsider artists; that is, by untrained artists. Outsider art continues to make a strong impact on the art world. Margaret Bodell, a dealer in Outsider art, has proposed the term "neuro-diversity"; she says, "Everyone is just wired a little differently" (Roberta Smith, "Who's to Say Where Inside Meets Outside," *New York Times*, March 29, 2002, p. E36).

An unusual art program called "The Living Museum" has been established at the Creedmore Psychiatric Center in Queens, New York. The program was developed with the idea that the mentally ill could be better helped when they saw themselves as artists rather than patients.

The inaugural exhibition (2002) of art made in the Creedmore program received exciting critical reviews. We will conclude "A Look at Art Today" with

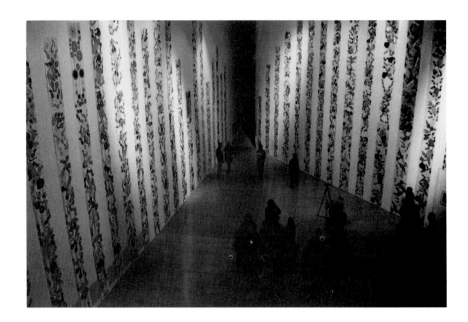

11.15. JOHN TURSI. Installation of series *Tursi Panorama*. 2002. Acrylic on wall paper. From the show "In the Flow: Artists from the Living Museum" at the Queens Museum of Art, Flushing Meadows-Corona Park. Photo: Bill Stanton.

the drawings by John Tursi, an artist who is in the program (figure 11.15). His scroll-like drawings are double-ceiling height and cover the walls of the gallery. Tursi has invented a vocabulary of geometric and organic shapes using triangles, French curves, and other drafting tools to create images of acrobats. Tursi's world of images brings to mind Southeast Asian art—the figures could have been taken from decorative sculptural reliefs found on temples in India.

CONCLUSION

The common styles, purposes, and techniques that traditionally bound art movements together no longer operate in today's art. Contemporary art, with its many subjects, strategies, attitudes, and approaches, is a complex terrain to navigate, but a commitment to making, discussing, and looking at art is one of the most enriching activities in our lives.

Literacy is the ability to decode words. Visual literacy is the ability to decode images—the capacity to discover in them meaning and knowledge about ourselves and our world—a rewarding humanistic endeavor.

In his novel *The Captive*, Marcel Proust writes, "The only true voyage of discovery, the only really rejuvenating experience would not be to visit strange lands, but to possess other eyes, to see the universe through the eyes of another, of a hundred others, to see the hundred universes that each of them sees." Art offers that voyage of discovery.

PART IV

PRACTICAL
GUIDES

Materials

MEDIA ARE PURE POTENTIALITY WAIT-
ing for the artist to give them a chance. Think of all the materials in the world
just waiting to become art. Duchamp said that a drawing could be nothing
more than a breath of air on glass. Ann Hamilton covered 100,000 pennies in
honey and let a film of dust develop over them. Frances Whitehead uses mud,
oil, resins, and perfumes to create her work. Each medium speaks of its origins.
Watercolor washes carry the memory of water; drawing carries hundreds of
memories of substances and surfaces. A large part of the meaning of a drawing
derives from its basic material, its basic substance—what kind of medium is
used on what kind of surface. Qualities such as wet or dry, brittle or supple,
hard or soft, strong or fragile—all enter into our consciousness at first glance.
The materials from which art is made are so intrinsic to it that we frequently
fail to give them credit for the primary role they play.

The relationships among form, content, subject matter, materials, and
techniques are the very basis for art, so it is essential that the beginning stu-
dent develop a sensitivity to materials—to their possibilities and limitations.
The problems in this book call for an array of drawing materials, some tradi-
tional, some nontraditional. The supplies discussed in this chapter are all that
are needed to complete the problems in the book.

PAPER

To list all the papers available to an artist would be impossible; the variety is endless. The importance of the surface on which you draw should not be minimized. The paper you choose, of course, affects the drawing.

Since the problems in the book require the use of a large amount of paper and since the emphasis is on process rather than product, expensive papers are not recommended for the beginning student. Papers are limited to three or four types, all of them serviceable and inexpensive. Experimentation with papers, however, is encouraged—you may wish to treat yourself to better-quality paper occasionally.

Newsprint and *bond paper* are readily available, inexpensive, and practical. Both come in bulk form—in pads of 100 sheets. Newsprint comes either rough or smooth; the rough is more useful. Buying paper in bulk is much more economical than purchasing single sheets. Bond paper, a smooth, middle-weight paper, is satisfactory for most media. Newsprint is good for warm-up exercises. Charcoal and other dry media can be used on newsprint; it is, however, too absorbent for wet media.

Ideally, *charcoal paper* is recommended for charcoal drawing, since the paper has a "tooth," a raised texture, that collects and holds the powdery medium. Charcoal paper is more expensive than bond paper and is recommended only for a few problems, those in which extensive rubbing or tonal blending is emphasized.

A few sheets of black *construction paper* are a good investment. Using white media on black paper makes you more aware of line quality and of the reversal of values. A few pieces of toned charcoal paper would likewise furnish variety. Only the neutral tones of gray or tan are recommended.

A serviceable size for drawing paper is 18 inches by 24 inches (46 cm × 61 cm). If you draw on a smaller format, you can cut the paper to size.

An inexpensive way to buy paper is to purchase it in rolls. End rolls of newsprint can be bought from newspaper offices at a discount. Photographic backdrop paper is another inexpensive rolled paper. It comes in 36-foot (10.98 m) lengths and 10-foot (3.05 m) widths. The paper must be cut to size, but the savings may be worth the inconvenience. The advantage to buying rolls of paper is that you can make oversize drawings at minimal cost. Brown wrapping paper also comes in rolls and is a suitable surface, especially for gesture drawings.

Another inexpensive source of paper is scrap paper from printing companies. The quality of the paper varies, as do the size and color, but it would be worthwhile to visit a local printing firm and see what is available. Office supply stores are a good source of inexpensive papers; look at their inventory of photocopy paper, index cards, gridded papers, lined papers, notebooks, and ledgers.

Shopping for drawing papers can be a real treat. You need to examine the paper for its color, texture, thickness, and surface quality—whether it is grainy

or smooth. In addition to these characteristics you need to know how stable the paper will be. Paper is, of course, affected by the materials from which it is made, by temperature, and by humidity. Paper that has a high acid or a high alkaline content is less stable than a paper made from unbleached rag or cotton; such papers are not lightfast, for example. The selected papers listed on the following page are more expensive than the newsprint, bond, and charcoal paper that are recommended for most of the exercises in this text. Remember to select a paper that seems to you to be right for a given project. Becoming acquainted with various papers and learning their inherent qualities are among the joys of drawing.

Selected Papers for Drawing (high rag content)

Many of the papers listed below come in various weights. Arches, a hot press paper, absorbs ink well, and Arches 140 lb weight is good for colored pencils. Fabriano is suitable for graphite, ballpoint, and colored pencil. Lanaquerelle is a very heavy, smooth paper, good for washes. All papers below (except index) are appropriate for any art media, including wash. Index is a slick paper and is good for pen-and-ink drawing. Rives BFK and Italia are especially good for transfer drawings made with a solvent. Stonehenge is a very serviceable strong paper that will stand up to abrasive actions. Tracing paper and vellum, a stiff translucent paper that breaks easily when bent, are good for transferring or tracing images. They also can be used in collages, especially when layering is used, when it is important to see through to another level. Clay-coated papers are used for silverpoint or watercolors; their surfaces are gessoed and finely sanded; the texture is like a photographic paper.

Arches	22″ × 30″; 25″ × 40″	(56 cm × 76 cm; 64 cm × 102 cm)
Copperplate Deluxe	30″ × 42″	(76 cm × 107 cm)
Fabriano Book	19″ × 26″	(49 cm × 66 cm)
Fabriano Cover	20″ × 26″; 26″ × 40″	(51 cm × 66 cm; 66 cm × 102 cm)
German Etching	31½″ × 42½″	(80 cm × 105 cm)
Index	26″ × 40″	(66 cm × 102 cm)
Italia	20″ × 28″; 28″ × 40″	(51 cm × 71 cm; 71 cm × 102 cm)
Karma (made by Potlatch), a clay-coated paper		
Lanaquerelle 400 lb (very heavy)		
Murillo	27″ × 39″	(69 cm × 100 cm)
Rives BFK	22″ × 30″; 29″ × 41″	(57 cm × 76 cm; 74 cm × 105 cm)
Strathmore Artists	Various sizes	
Stonehenge	Various sizes	
Manila paper	Various sizes	

Some Suggested Oriental Papers (plant fiber content)

Chiri	Traces of bark are in the paper	
Hosho	16″ × 22″	(41 cm × 56 cm)

Kochi	20″ × 26″	(51 cm × 66 cm)
Moriki 1009	25″ × 36″	(64 cm × 92 cm)
Mulberry	24″ × 33″	(61 cm × 84 cm)
Okawara	3′ × 6′	(92 cm × 1.83 m)
Suzuki	3′ × 6′	(92 cm × 1.83 m)

Specialty Papers

French marbleized papers
Indian handmade papers
Other handmade papers (available in some specialty art supply stores)

Sketchbooks

The size of a sketchbook is optional. Choose one that is comfortable to carry; they come in various sizes. Some are hardbound, others are spiral-leaf. You can easily make a sketchbook of unbound papers that are kept in a rigid folder. This method allows you to include a variety of papers. For ease of handling and to protect the edges, they should all be cut to the same size. You can use a plastic slip-on binder for a small number of pages. The advantage to loose-leaf papers is that you can prepare surfaces ahead of time and keep them ready for use in the folder. You can tone the papers with ink or acrylic washes, or with charcoal. Be sure to spray-fix the charcoal papers before placing them in the folder.

An easily portable size is usually no larger than 11 inches by 14 inches (28 cm × 36 cm).

CHARCOAL, CRAYONS, AND CHALKS

Charcoal is produced in three forms: vine charcoal, compressed charcoal, and charcoal pencil.

Vine charcoal, as its name indicates, is made from processed vine. It is the least permanent of the three forms. It is recommended for use in quick gestures since you can remove the marks with a chamois skin and reuse the paper. The highly correctable quality of vine charcoal makes it a good choice for use early in the drawing, when you are establishing the organizational pattern. If vine charcoal is used on charcoal paper for a longer, more permanent drawing, it must be carefully sprayed several times with fixative.

Compressed charcoal comes in stick form and a block shape. With compressed charcoal you can achieve a full value range rather easily. You can draw with both the broad side and the edge, creating both mass and line.

Charcoal pencil is a wooden pencil with a charcoal point. It can be sharpened and will produce a much finer, more incisive line than compressed charcoal.

Charcoal is easily smudged; it can be erased, blurred, or smeared with a chamois skin or kneaded eraser. All charcoal comes in soft, medium, and hard grades. Soft charcoal is recommended for the problems in this book.

Conté crayons, too, can produce both line and tone. They are available in soft, medium, and hard grades. Conté comes in both stick and pencil form. It

has a clay base and is made of compressed pigments. Conté is available in white, black, sanguine, and sepia.

Water or turpentine will dissolve charcoal or conté if a wash effect is desired.

Colored chalks, or *pastels,* can be used to layer colors. These are manufactured either with or without an oil base.

Another medium in stick and pencil form is the *lithographic crayon* or *lithographic pencil.* Lithographic crayons have a grease base and are soluble in turpentine. They, too, can be smudged, smeared, and blurred and are an effective tool for establishing both line and tone. The line produced by a lithographic crayon or pencil is grainy; lithographic prints are readily identified by the grainy quality of the marks. (Lithographic crayons and pencils are specially made for drawing on lithographic stone, a type of limestone.) Lithographic crayons are produced in varying degrees of softness. Again, you should experiment to find the degree of softness or hardness you prefer.

China markers, like lithographic pencils, have a grease base and are readily smudged. Their advantage is that they are manufactured in a wide variety of colors.

Colored oil sticks are an inexpensive color medium that can be dissolved in turpentine to create wash effects.

PENCILS AND GRAPHITE STICKS

Pencils and *graphite sticks* come in varying degrees of hardness, from 9H, the hardest, to 7B, the softest. The harder the graphite, the lighter the line; conversely, the softer the graphite, the darker the tone. 2B, 4B, and 6B pencils and a soft graphite stick are recommended. Graphite sticks produce tonal quality easily and are a time-saver for establishing broad areas of value. Pencil and graphite marks can be smudged, smeared, erased, or dissolved by a turpentine wash.

Colored pencils are made in a wide range of colors, and water-soluble pencils can be combined with water for wash effects.

ERASERS

Erasers are not suggested as a correctional tool, but they are highly recommended as a drawing tool. There are four basic types of erasers. The *kneaded eraser* is pliable and can be kneaded like clay into a point or shape; it is self-cleaning when it has been kneaded. *Gum erasers* are soft and do not damage the paper. A *pink rubber pencil eraser* is recommended for use with graphite pencils or sticks; it is more abrasive than the gum eraser. A *white plastic eraser* is less abrasive than the pink eraser and works well with graphite. A *barrel refillable eraser* feeds the eraser down a tube. It provides more control than a slab eraser.

Although a *chamois skin* is not technically an eraser, it is included here because it can be used to smudge marks made by vine charcoal and to tone paper. It also can be used on charcoal and conté to lighten values or to blend tones. As its name indicates, it is made of leather. The chamois skin can be

cleaned by washing it in warm, soapy water; after it dries it should be rubbed vigorously to soften and restore it to its original pliable condition. A blackened chamois skin can be used to tone paper.

INKS AND PENS

Any good drawing ink is suitable for the problems in this book. Perhaps the most widely known is black *India ink*. It is waterproof and is used in wash drawings to build layers of value. Both black and sepia ink are useful.

Pen points come in a wide range of sizes and shapes. Again, experimentation is the only way to find the ones that best suit you. A crow-quill pen, a very delicate, inexpensive pen that makes a fine line, is recommended.

Felt-tip markers come with either felt or nylon tips. They are produced with both waterproof and water-soluble ink. Water-soluble ink is recommended; washed areas can be created with brush and water applied over the drawn line. Invest in both broad and fine tips. Discarded markers can be dipped in ink and used to produce interesting line quality.

PAINT AND BRUSHES

A water-soluble *acrylic paint* is useful. You should keep tubes of white and black acrylic in your drawing kit. You might wish to supplement these two tubes with an accent color and with some earth colors—for example, burnt umber, raw umber, or yellow ochre.

Brushes are important drawing tools. For the problems in this book you need a 1-inch (2.5 cm) and a 2-inch (5 cm) varnish brush, which you can purchase at the hardware store; a number 8 nylon bristle brush with a flat end; and a number 6 Japanese bamboo brush, an inexpensive reed-handled brush. As your skill and confidence increase, add more brushes to your supply kit. Experiment with various sizes and shapes (square tips and tapered tips).

OTHER MATERIALS

A small can or jar of *turpentine* should be kept in your supply box. Turpentine is a solvent that can be used with a number of media—charcoal, graphite, conté, and grease crayons. Other solvents are alcohol, for photocopy transfers, and gasoline or Nazdar, for transfer of magazine images.

Rubber cement and *white glue* are useful, especially when working on collage. Rubber cement is practical, since it does not set immediately and you can shift your collage pieces without damage to the paper. However, rubber cement discolors with age and becomes brittle. White glue dries transparent, it is long lasting, and it does not discolor. An acid-free paste is available and is highly recommended for use in collage or in attaching a drawing to a backing. This paste is used in book-binding; it does not discolor, and since it is not liquid, it does not shrink or wrinkle the paper. Acid-free spray adhesive is a good choice

for affixing paper, such as photographs or other paper products to a paper or cardboard surface.

Sponges are convenient. They can be used to dampen paper, apply washes, and create interesting texture. They are also useful for cleaning up your work area.

Workable fixative protects against smearing and helps prevent powdery media from dusting off. Fixative comes in a spray can. It deposits uniform mist on the paper surface, and a light coating is sufficient. The term *workable* means that drawing can continue without interference from the hard surface left by some fixatives.

A Masonite *drawing board* is strongly recommended. It should be larger than your largest drawing pad. (If you are using a 24- by 36-inch pad, the board should be 30- by 42-inch.) The pad or individual sheets of paper can be clipped to the board with large metal clips. The board will furnish a stable surface; it will keep paper unwrinkled and prevent it from falling off the easel. If you are drawing on individual sheets of paper, be sure to pad them with several sheets of newsprint to ensure an unmarred drawing surface.

Masking tape, gummed paper tape, a mat knife and blades, single-edge razor blades, scissors, several sheets of fine sandpaper (for keeping your pencil point sharp), and several metal or plastic containers for washes also should be kept in your supply box.

NONART IMPLEMENTS

Throughout the book experimentation with different tools and media has been recommended. This is not experimentation just for experimentation's sake. A new tool does not necessarily result in a good drawing. But frequently a new tool will help you break old habits; it will force you to use your hands differently or to approach the drawing from a different way than you might have with more predictable and familiar drawing media. Sticks, vegetables (potatoes or carrots, for example), pieces of foam rubber or Styrofoam, a piece of crushed paper, pipe cleaners, sponges, and cotton-tipped sticks are implements that can be found easily and used to good effect. The artist Mark Tansey makes his own tools by combining found implements.

In today's art world, many artists intentionally use ephemeral art materials to make art that fades, wears out, dissolves, or disappears. Although Ed Ruscha's carrot, berry, and lettuce juice drawings may cause conservators nightmares, they are still being shown and collected.

Keep your supply box well stocked. Add to it newly found materials and drawing tools. Keep alert to the assets and liabilities of the materials you use. Experiment and enjoy old materials used in new ways, and new materials used in traditional ways—they can give a lift to your art making.

> **WARNING:** Remember to read all warning labels on all products and to work in a well-ventilated room!

Keeping a Sketchbook

It has been observed that the se-
cret life of art is led in drawing. That being so, it can validly be claimed that
the secret life of drawing is led in the sketchbook.

At the end of Chapters 2 through 10 are sections called "Sketchbook
Projects," which propose exercises designed to help you solve formal and con-
ceptual problems encountered in the text. This guide will amplify the role of
a sketchbook as an essential extension of studio activity.

Paul Klee observed that the way we perceive form is the way we perceive
the world, and nowhere is this more strikingly visible than in the well-kept
sketchbook. The sketchbook takes art out of the studio and brings it into daily
life. Through the sketchbook, actual experience is introduced into the making
of art. This is a vital cycle, infusing your work with direct experience and at
the same time incorporating newly acquired abilities learned in the studio.

The first consideration in choosing a sketchbook is that it be portable, a
comfortable size to carry. A good alternative to a sketchbook is a spring binder
with a firm backing to hold loose-leaf papers securely. This device will allow
you to use a variety of papers, permitting you to remove individual sheets to
post in your studio as a source of ideas, and it will provide a means for group-
ing drawings out of sequence. In a folder you can collect collage material that
easily can be removed and stored. Loose-leaf pages can be filed and cataloged

to suit your needs. If you choose to use a spring binder in lieu of a bound sketchbook, it is advisable also to carry a small notebook in which you can jot down both verbal and visual notes.

Any medium is appropriate for a sketchbook, but a small portable drawing kit should be outfitted to accompany the sketchbook. Some useful contents would be crayons, water-soluble felt-tip markers, pencils, pen and ink, a glue stick, a roll of masking tape, and a 6-inch (15-cm) straightedge, along with a variety of erasers, found implements, a small plastic container with a lid, a couple of large clips for holding paper in place, and a small, efficient pencil sharpener or several sharp single-edged razor blades.

Although it may seem artificial and awkward in the beginning, you should use your sketchbook daily—365 days a year. You will soon develop a reliance on it that will prove profitable. The sketchbook will become a dependable outlet for your creativity. In it you can experiment freely; your sensitivity and abilities will become keener with every page.

WHY KEEP A SKETCHBOOK?

Two of the most valuable assets for an artist are a retentive memory and the ability to tap into the unconscious. The memory and the unconscious are both generators of imagery and ideas for the artist. So, by developing your memory and recording your dreams you have a built-in image-making source. Keeping

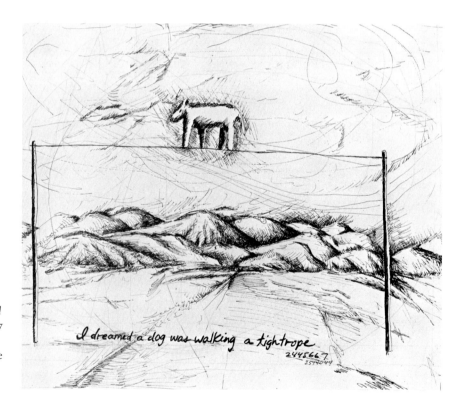

PG.B1. JONATHAN BOROFSKY. *I Dreamed a Dog Was Walking a Tightrope . . . at 2,445,667 & 2,544,044.* 1978. Ink and pencil on paper, 1′ × 1′1″ (30 cm × 33 cm). Private Collection, New York. Paula Cooper Gallery.

records of your dreams and events in your life can jolt your memory, reminding you of important information you might otherwise have forgotten.

Jonathan Borofsky is only one of the many artists who use dream images to bring important insights to their work (figure PG.B1). Shakespeare summed up these observations succinctly: "We are such stuff as dreams are made on."

In the sketchbook, germs of potential forms or ideas take hold. Quick notations can be like storyboards recording nonverbal, non-narrative concepts, worksheets on which ideas can be amplified, transformed, multiplied, enlarged, and extended. It would be impossible for us to carry out all our ideas. The sketchbook is the ideal place to record ideas for selection and development at a later time. Over the years, sketchbooks become a valuable repository. Your growth as an artist can be traced through these records.

An example of how a faithful commitment to keeping a sketchbook can pay off is seen in a work by William Anastasi in which he has photocopied pages from his sketchbooks and journals kept for over 20 years to use as collage on large canvases (figure PG.B2). He has amplified and extended the journals' visual themes by the addition of colored pencil, crayon, Cray-Pas (oil-based crayons), and ink.

In the long run, sketchbooks are time-savers. Quickly conceived ideas are often the most valid ones. Having a place to jot down notations is important.

PG.B2. WILLIAM ANASTASI. *The Invention of Romance.* 1982. Collage, 5'8" × 4'8" (1.73 m × 1.42 m). Collection of Drs. Barry and Cheryl Goldberg. Courtesy of the artist.

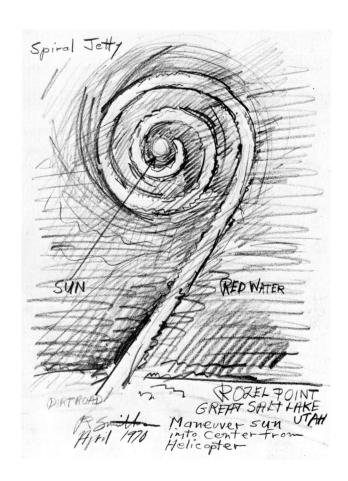

In the drawing: *Spiral Jetty* · SUN · RED WATER · ROZEL POINT · GREAT SALT LAKE UTAH · DIRT ROAD · Maneuver sun into Center from Helicopter · R Smithson April 1970

PG.B3. ROBERT SMITHSON. *The Spiral Jetty.* 1970. Pencil, 11⅞″ × 9″ (30 cm × 23 cm). © Estate of Robert Smithson/ Licensed by VAGA, New York.

Preliminary ideas for Robert Smithson's earthwork *The Spiral Jetty* (constructed on the Great Salt Lake in Utah) were rapidly stated in notational, schematic drawings. The verbal notes are minimal; the drawing style is hasty, yet the finished earthwork demanded exacting technical and mechanical facility to construct (figure PG.B3). Great ideas have modest beginnings.

As is evident in the work by Smithson, the sketchbook can function both as a verbal and visual journal. It serves as a memory bank for elusive feelings and information. It is an appropriate place to record critical and personal comments on what you have read, seen, and experienced. Verbal and visual analogies can be quickly noted for possible use later on.

Claes Oldenburg's voluminous notebooks record his ingenuous visual analogical thinking (figure PG.B4). In pages from one of his sketchbooks we see how the process takes form. In his *Studies for the Giant Ice Bag*, Oldenburg draws an analogy between the ice bag and the U.S. Capitol dome. He plays with the idea of a soft, flexible, mechanical, ice bag-turned-into-building. There is more than enough detail in the sketches to suggest the connection and preserve the idea for future development.

Oldenburg's sketchbooks are filled with verbal amplification and ideas for possible materials to convert the objects into sculptures. The artist employs a time-saving device in his sketchbook drawings, that of drawing over newspaper clippings and photographs as in figure PG.B5. Oldenburg compares the altered advertisement to the cathedral, chapel, and Leaning Tower of Pisa.

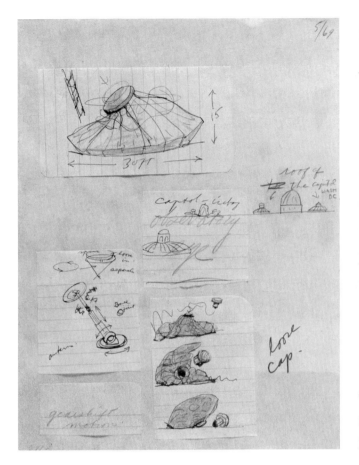

PG.B4. (above left) CLAES OLDENBURG. *Notebook Page: Studies for the Giant Ice Bag.* March–April 1969. Pencil, ball-point pen, felt pen, five sheets, odd sizes. On sheet 11″ × 8½″ (28 cm × 21.6 cm). Photograph by See Spot Run Inc. Courtesy of Claes Oldenburg and Coosje van Bruggen.

PG.B5. (above right) CLAES OLDENBURG. *Ketchup + Coke Too?* from *Notes in Hand.* 1965. Ballpoint pen, 11″ × 8½″ (28 cm × 21.6 cm). Courtesy of the artist.

Picasso, who was rigorous in keeping sketchbooks—hundreds of volumes—showed us the value of playful improvisation. In his drawings titled *An Anatomy* (see figure 8.28) he presents playful variations on a form. Quick thinking, responsive drawing, sensitivity to visual stimuli, heightened analytical abilities, enhanced memory, and immediacy of response—these are only a few of the many benefits of daily sketchbook practice. In Eugene Leroy's gesture studies (see figure 2.19), we see how skills acquired in the studio can be translated to the sketchbook.

Many times the way artists revitalize their work after a period of inactivity is to use the sketchbook as a place of new beginnings. Even an old sketchbook when reviewed after a while offers fresh new ideas. Seeds of ideas take longer than we think to germinate. It is exciting to trace our preferences for certain forms and relationships over an extended period. There is no place better to find those embedded thoughts than in the sketchbook.

APPROPRIATE SUBJECTS FOR A SKETCHBOOK

We could make a one-word entry under the heading of what is appropriate subject matter for sketchbooks: Everything. Every experience in your life, your musings about them, your joy, your despair, your frustrations, your dreams,

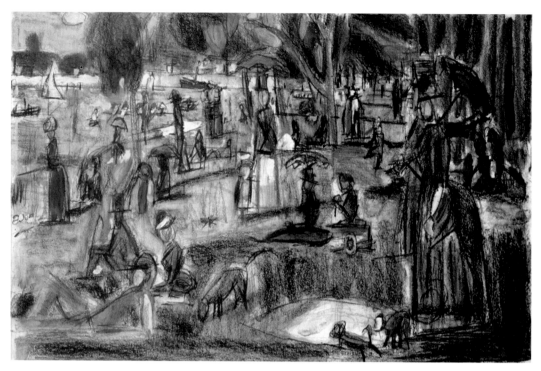

PG.B6. MICHAEL HURSON. *Seurat Drawing #6*. February 24–26, 2001. Graphite, ink, pastel, on paper, 1'2½" × 1'9¼" (36.83 cm × 53.975 cm). Courtesy of the artist and Paula Cooper Gallery, New York.

your fears, your spiritual searches—all have a place in your sketchbook. Fill it up with your life.

Sketchbook activity should not be strictly confined to making marks in a notebook. Idea gathering on a wider scale is really the goal. There are limitless methods of finding subjects and infusing them with ideas.

Art history, as we have seen throughout this text, is a never-ending source for new ideas or old ideas reworked with fresh insights (figure PG.B6). Michael Hurson's sketch, an interpretation of Seurat's painting (see figure II.15) is one such example.

Self-portraits present us with the chance to look in two directions at once as we depict our external as well as our internal selves. Everyday objects can even be stand-ins for the self. Common objects present themselves as familiar companions capable of being transformed, as in Clemente's small— 6- by 3-inch—pastels (figure PG.B7).

Geographic locales, both familiar and exotic, can provide a world of subject matter. You could, like Red Grooms (figure PG.B8), record your travels in memory pictures in your sketchbook. Grooms has compressed time in his rodeo scene where everything is happening at once. This large composite drawing is made up of seventeen sheets of paper, each of which could have been taken from a sketch pad. Grooms has used a shorthand approach to indicate the crowds seated in the arena. His cursory, cartoon style reflects his artist-as-trickster personality. Quick contours and a sketchy cast of characters add up to a droll account of a Wild West ruckus. Not only is the drawing fun to look at, it must have been fun to make.

Travel not only affords graphic insights, it also provides memorabilia, such as ticket stubs and stamps, that can find a home in your sketchbook in the

PG.B7. FRANCESCO CLEMENTE. *From Near and from Afar.* 1979. 20 pastels on paper, 6⅜″ × 3½″ (16.2 cm × 9 cm) to 1′1″ × 1′1¾″ (33 cm × 35 cm). Anthony d'Offay Gallery, London.

PG.B8. RED GROOMS. *Rodeo Arena.* 1975–1976. Colored felt-tip pens on 17 sheets of paper, 3′11″ × 6′8⅜″ (1.19 m × 2.03 m). Collection of the Modern Art Museum of Fort Worth, Museum Purchase and Commission with funds from the National Endowment for the Arts and the Benjamin J. Tillar Memorial Trust. Acc. no. 1976.1.PS. © 2003 Red Grooms/Artists Rights Society (ARS), New York.

PG.B9. ELLSWORTH KELLY. *Tablet No. 34*
Five sketches from the 1950s, 1960s. Ink,
printed paper mounted on mat board,
1′3½″ × 1′9″ (39.4 cm × 53.3 cm).
Courtesy of the artist and Matthew Marks
Gallery, New York. © Ellsworth Kelly.

PG.B10. WILLIAM T. WILEY. *Nothing
Conforms.* 1978. Watercolor on paper,
2′5½″ × 1′10½″ (74.9 cm × 57.2 cm).
Collection of the Whitney Museum of
American Art, New York. Purchased with
funds from the Neysa McMain Purchase
Award.

form of collage. Printed bits and scraps of papers seem to spark the artist's urge to scavenge and salvage.

The artist Ellsworth Kelly has made collections of fragments and doodles that he has accumulated over a period of 25 years. He kept his finds in loose groupings in drawers into which he occasionally dipped for ideas. When the art historian Yve-Alain Bois saw the trove of material, he suggested a show of the then unorganized material. Bois recognized that the boxes of collected material formed a window into Kelly's idea-gathering process of turning randomness into order. The found pieces are a key into how the artist thinks and where he finds ideas. For an exhibition of the material, Kelly arranged the fragments on 200 pieces of large white paper, grouping the scraps and doodles according to his own special visual cataloging system (figure PG.B9). *Tablet,* a suite of 200 collages, shows how the most ordinary, discarded scraps can spark ideas. The distilled, geometric shapes are a mixture of chance, wit, and ephemera.

The studio itself has always been a rich source of imagery for artists. The studio is the artist's contained world; it is a private and personal space, so work using this subject will of necessity have an autobiographical overtone. Figure PG.B10 shows us the kind of metamorphosis that can take place in an artist's studio. Cluttered interiors provide an amazing stock of images.

Every object and image has the potentiality of being transformed into art. The objects that we choose to live with are revelatory on many levels. You might make a series of sketchbook drawings that are based on contents— contents of billfolds, purses, medicine cabinets, closets, tool chests, refrigerators, or pantries, for example.

Alexis Rockman reinvigorates the now-faded tradition of the "studio-in-the-wild" and shows us how an update of this convention can be an effective sketchbook project. For Rockman, paintings are done in the studio, drawings are done on site. His subjects include flora, fauna, and fossils. Whether he is in

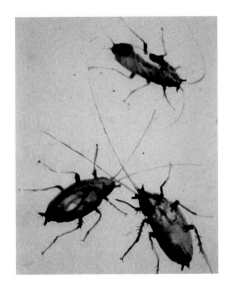

PG.B11. ALEXIS ROCKMAN. *German Cockroaches and Little Brown Bat.* 2001. Leachate and acrylic polymer on paper, 1′ × 9″ (30.5 cm × 22.9 cm) each. Courtesy Gorney Bravin & Lee, New York. © 2003 Alexis Rockman/Artists Rights Society (ARS), New York.

the Amazon basin or in the La Brea tar pits, Rockman uses the materials of the site; for the La Brea series his medium was tar, and the drawings were made with brushes and sticks. For the drawings shown here (figure PG.B11), Rockman drew with leachate, a liquid that drains from garbage landfills. In your own work, making descriptive drawings of flora and fauna will enhance your ability to inspect forms intently and to analyze relationships. Insects, twigs, birds, feathers, leaves, and flowers can be added attractions in the sketchbook's reservoir.

Because the visual world seems to remain constant, it is easy to forget that our visual encounters with the world are unrepeatable. Be moved by the urgency of the visual world.

Subjects for sketchbook need not only be found in the real world. Pierre Alechinsky, a Belgian artist, has copied in handwriting a poem by another poet. It is contained within the body of an imaginary creature (figure PG.B12). Alechinsky has surrounded the figure with erratic squiggles, reversing the lines to white on black. You can use your own or others' writing and respond to the written words by marks or shapes that connect you to the work. You can use imagined, conceptual subjects or invented, abstracted, or nonobjective forms. You might think of some categories that could encompass nonobjective forms, such as vertical horizontals, or horizontal verticals. Explorations of pure form are ideal sketchbook endeavors.

The sketchbook's best companion, however, may be music. Draw while listening to music. Let the music, the drawing implement, and your feelings control your decisions. Strange and wondrous forms can evolve.

Some suggestions for sketchbook drawings:

1. Experiment with form and variations.
2. Note quick visual and verbal ideas.
3. Experiment with different techniques, tools, or media.
4. Develop an object or an idea through several pages of sketches.
5. Experiment with different compositions; place objects and shapes in different juxtapositions.

PG.B12. PIERRE ALECHINSKY. *Was It Snowing?* (in-text plate, folio 4) from *21 Etchings and Poems*, with "Poem" by Christine Dotremont. New York, Morris Gallery, 1960. (Print executed 1952.) Etching and engraving (with etched manuscript by Pierre Alechinsky), print in black, plate; 1′1⅝″ × 9⅝″ (34.7 cm × 24.6 cm). Museum of Modern Art, New York. Gift of Mrs. Jacquelynn Shlaes. © LRZ 127.

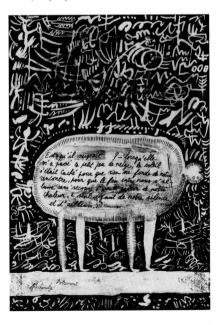

6. Record objects through sustained observation.
7. Investigate. Make preparatory drawings.
8. Use your sketchbook as a diary or journal, recording your interests and activities.
9. Make comments on artwork (your own or others').
10. Attach clippings that interest you.
11. Draw from memory.
12. Draw your feelings.
13. Draw from nature.
14. Record your dreams, both visually and verbally.
15. Experiment with new and playful imagery.

CONCLUSION

Sketchbook practice promotes freshness of vision and intensity of seeing—of seeing something "as if" for the first time. Each page of your sketchbook can become a site of departure for another view, another work. Sketchbooks are filled with new beginnings. When several drawings are made on the same subject, the content level of the drawings increases.

Sketchbooks are a "locus of memories"; a glance through old sketchbooks can trigger memories of images and ideas from the past, as in Pierre Bonnard's quick study of an interior (figure PG.B13). And an image from the past can project ideas into the future.

The important thing to keep in mind about a sketchbook is that you are keeping it for yourself; it is as personal as a diary. You are the one who benefits from it. Both process and progress are the rewards of dedication to keeping a sketchbook.

Looking back through your daily drawings can give you direction when you are stuck, providing a source of ideas for new work. Germs of potential forms and ideas are embedded in sketchbooks. When you use an idea from the sketchbook, you have the advantage of having chosen an idea that has some continuity to it; you have already done some work with that idea. A new viewpoint adds yet another dimension. The sketchbook is a place where your art communicates with itself. It is a book of possibilities.

Who would believe that so small a space could contain all the images of the universe? The sketchbook can hold all the images of your universe, in abbreviated form, of course.

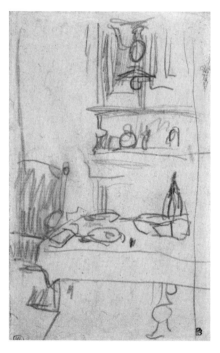

PG.B13. PIERRE BONNARD. *Study of a dining room, a set table.* Black lead pencil, 5′8½″ × 13′6⅗″ (1.74 m × 4.13 m). Musée d'Orsay, Paris. © Réunion des Musées Nationaux/Art Resource, New York. Photo: Michele Bellot. © 2003 Pierre Bonnard/Artists Rights Society (ARS), New York/ADAGP, Paris.

Breaking Artistic Blocks
and Making
Critical Assessments

Generally, there are two times when artists are susceptible to artistic blocks: in an individual piece when they feel something is wrong and do not know what to do about it, and when they cannot begin to work at all. These are problems that all artists, even the most experienced, must face. They are common problems that you should move quickly to correct.

CORRECTING THE PROBLEM DRAWING

What can you do with a drawing you cannot seem to complete? The initial step in the corrective process is to separate yourself, physically and mentally, from the drawing in order to look at it objectively. You, the artist-maker, become the critic-viewer. This transformation is essential to assess your work. The original act of drawing was probably on the intuitive level; now you begin the process of critical analysis. You are going to learn to bring into consciousness what has been intuitively stated.

Turn away from your work for a few minutes. Occupy your mind with some simple task such as straightening equipment or sharpening pencils. Then pin the drawing on the wall, upside down or sideways. Have a mirror handy through which to view the drawing. The mirror's reversal of the image and the new perspective of placement will give you a new orientation so that you can see the drawing with fresh eyes. This fresh viewpoint allows you to be more aware of the drawing's formal qualities, regardless of the subject you have chosen.

When you can see how the formal elements of line, value, shape, volume, texture, and color are used, you are not so tied to the subject matter. Frequently the problem area will jump out at you. The drawing itself tells you what it needs. Be sensitive to the communication that now exists between you and your work. Before, *you* were in command of the drawing; now *it* is directing you to look at it in a new way. At this stage you are not required to pass judgment on the drawing. You simply need to ask yourself some nonjudgmental questions about the piece. The time for critical judgment comes later. What you need to discover now is strictly some *information* about the drawing.

Questions Dealing with Form

Here are some beginning questions dealing with form to ask yourself.

1. What is the subject being drawn?
2. Which media are used and on what surface?
3. How is the composition related to the page? Is it a small drawing on a large page? A large drawing on a small page? Is there a lot of negative space? Does the image fill the page? What kind of space is being used in the drawing? Where is the primary focus? Is there a secondary one? What is the connection between the two? How are the edges and corners treated? Where does the viewer "enter" the drawing—top, bottom, sides, corners, middle? By what means are the viewer's eyes led through the picture plane? Is one area over- or underdeveloped?
4. What kinds of shapes predominate? Amoeboid? Geometric? Do the shapes exist all in the positive space, all in the negative space, or in both? Are they large or small? Are they the same size? Are there repeated shapes? How have shapes been made? By line? By value? By a combination of these two? Where is the greatest weight in the drawing? How is that weight balanced? Are there volumes in the drawing? Do the shapes define planes or the sides of a form? Are the shapes flat or volumetric?
5. Divide value into three groups: lightest light, darkest dark, and midgray. How are these values distributed throughout the drawing? Is value used in the positive space only? In the negative space only? In both? Do the values cross over objects or shapes, or are they contained within the object or shape? Is value used to indicate a single light source or multiple light sources? Does value define planes? Does it define space? Does it define mass or weight? Is it used ambiguously? Are the value transitions gradual or abrupt?
6. What is the organizational line? Is it a curve, a diagonal, a horizontal, or a vertical? What type of line is used—contour, scribble,

calligraphic? Where is line concentrated? Does it create mass? Does it create value? Does it define edges? Does it restate the shape of a value? Again, note the distribution of different types of line in the drawing; ignore the other elements. What kind of line quality is used? Is there more than one kind of line employed in the drawing?

7. Is invented, simulated, or actual texture used in the drawing? Are there repeated textures, or only one kind? Is the texture created by the tool the same throughout the drawing? Have you used more than one medium? If so, does each medium remain separate from the other media? Are they integrated?

This list of questions looks long and intimidating at first glance, but you can learn quickly to make these assessments—make them almost automatically, in fact. Of course, many of these questions may not apply to each specific piece, and you may think of other questions that will help you in making this first compilation of information about your drawing.

Critical Assessment

After letting the drawing speak to you and after having asked some nonjudgmental questions about it, you are ready to make a *critical assessment*. It is time to ask questions that pass judgments on the piece.

To communicate your ideas and feelings in a clearer way, you should know what statements you want to make. Does the drawing do what you meant it to do? Does it say something different—but perhaps equally important—from what you meant it to say? Is there confusion or a contradiction between your intent and what the drawing actually says? There may be a conflict here because the drawing has been done on an intuitive level, whereas the meaning you are trying to verbalize is on a conscious level. Might the drawing have a better message than your originally intended message?

Can you change or improve the form to help the meaning become clearer? Remember, form is the carrier of meaning. Separate the two functions of making and viewing. What is the message to you as viewer?

An important reminder: Go with your feelings. If you have any doubts about the drawing, wait until a solution strikes you; however, do not use this delay to avoid doing what you must to improve the drawing. Try something— even if the solution becomes a failure and the drawing is "ruined," you have sharpened your skills and provided yourself with new experiences. The fear of ruining what might be a good drawing can become a real block to later work.

Be alert to what accidents can offer. A large part of aesthetic intelligence consists of an awareness of accidents and a readiness to employ them to creative effect. To see possibilities in chance events is a talent that should be developed. Be assertive; experiment; do not be afraid to fail. A work of art is a series of discoveries, not of preplanned ideas. The best ideas come when you least expect them.

Extraordinary things can happen very quickly. Be attentive to them.

Problems in an individual piece tend to fall within these five categories:

- inconsistency of style, idea, or feeling
- failure to determine basic structure

- tendency to ignore negative space
- inability to develop value range and transitions
- failure to observe accurately

Inconsistency refers to the use of various styles, ideas, or feelings within a single work. A number of techniques and several types of line may be employed within a single drawing, but the techniques and elements must be compatible with one another and with the overall idea of the drawing. Frequently an artist will unintentionally use unrelated styles in the same drawing; this results in an inconsistency that can be disturbing to the viewer. For example, a figure drawing may begin in a loose and gestural manner and seem to be going well. Suddenly, however, when details are stated, the artist feels insecure, panics, tightens up, and begins to conceptualize areas such as the face and hands. The style of the drawing changes—the free-flowing lines give way to a tighter, more constricted approach. As conceptualization takes the place of observation, the smooth, almost intuitive interrelationship of the elements is lost. The moment of panic is a signal for you to stop, look, analyze, and relax before continuing.

A frequent problem encountered in drawing is the *failure to determine basic structure*, to distinguish between major and minor themes. For example, dark geometric shapes may dominate a drawing, while light amoeboid shapes are subordinate. Although it is not necessary for every drawing to have a major and minor theme, in which some parts dominate and others are subordinate, it is important for the artist to consider such distinctions in light of the subject and intent of a particular drawing. Details should overshadow the basic structure of a drawing only if the artist intends it. The organization of a drawing is not necessarily predetermined; however, at some point in its development, you should give consideration to the drawing's basic structure.

We human beings are object-oriented and have a *tendency to ignore negative space*. We focus our attention on objects. A problem arises for the artist when the space around the object is ignored and becomes merely leftover space. It takes conscious effort to consider positive and negative space simultaneously. Sometimes it is necessary to train ourselves by first looking at and drawing the negative space. When we draw the negative space first, or when positive and negative space are dealt with simultaneously, there is an adjustment in both. In other words, the positive and negative shapes are altered to create interrelationships. There are times when only one object is drawn on an empty page. In these instances, the placement of the drawing on the page should be determined by the relationship of the negative space to the object.

One way to organize a drawing is by the distribution of values. Problems arise when students are *unable to develop value range and transitions*. For many students, developing a value range and gradual value transitions is difficult. The problem sometimes is a lack of ability to see value as differentiated from hue. At other times, it is a failure to consider the range of value distribution most appropriate for the idea of the drawing. Too wide a range can result in a confusing complexity or a fractured, spotty drawing. Too narrow a range can result in an uninteresting sameness.

The final problem, *failure to observe accurately*, involves lack of concentration on the subject and commitment to the drawing. If you are not interested in your subject or if you are not committed to the drawing you are making, this will be apparent in the work.

Once you have pinpointed the problem area, think of three or more solutions. If you are still afraid of ruining the drawing, do three drawings exactly like the problem drawing and employ a different solution for each. This should lead to an entirely new series of drawings, triggering dozens of ideas.

The failure to deal with this first category of problems—being unable to correct an individual drawing—can lead to an even greater problem—not being able to get started at all.

GETTING STARTED

There is a second type of artistic blockage, in some ways more serious than the first: the condition in which you cannot seem to get started at all. There are a number of possible solutions to this problem. You should spread out all the drawings you did over the period of a month and analyze them. It is likely that you are repeating yourself by using the same medium, employing the same scale, or using the same size paper. In other words, your work has become predictable.

When you break a habit and introduce change into the work, you will find that you are more interested in executing the drawing. The resulting piece reflects your new interest. A valid cure for being stuck is to adopt a playful attitude.

An artist, being sensitive to materials, responds to new materials, new media. This is a good time to come up with some inventive, new, nonart drawing tools. Frequently you are under too much pressure, usually self-imposed, to produce "art," and you need to rid yourself of this stifling condition. Set yourself the task of producing 100 drawings over a 48-hour period. Be playful. Employ the "what if" approach. Use any size paper, any medium, any approach—and before you get started, promise yourself to throw them all away. This will ease the pressure of producing a finished product and will furnish many new directions for even more drawings. It may also assist you in getting over the feeling that every drawing is precious.

All techniques and judgments you have been learning are pushed back in your mind while your conscious self thinks of solutions to the directions. Your intuitive self, having been conditioned by some good solid drawing problems, has the resource of past drawing experience to fall back on. Art is constantly a play between what you already know and the introduction of something new, between old and new experience, the conscious and the intuitive, the objective and the subjective.

Art does not exist in a vacuum, and although it is true that art comes from art, more to the point is that art comes from everything. If you immerse yourself totally in doing, thinking, and seeing art, the wellsprings soon dry up and you run out of new ideas. Exhausting physical exercise is an excellent remedy, as is reading a good novel, scientific journals, or a weekly news magazine. A visit to a natural history museum, a science library, a construction site, a zoo, a cemetery, a concert, a political rally—these will all provide grist for the art mill sooner or later. Relax, "invite your soul." Contact with the physical world will result in fresh experiences from which to extract ideas, not only to improve your art but to sharpen your knowledge of yourself and your relation to the world.

Keep a journal—a visual and verbal one—in which you place notes and sketches of ideas, of quotes, of what occupies your mind. After a week reread the journal and see how you spend your time. How does the way you spend your time relate to your artistic block?

Lack of authentic experience is damning. Doing anything, just existing in our complex society, is risky. Art is especially risky. What do we as artists risk? We risk confronting things unknown to us; we risk failure. Making art is painful because the artist must constantly challenge old ideas and experiences. Out of this conflict comes the power that feeds the work.

An artistic block is not necessarily negative. It generally means that you are having growing pains. You are questioning yourself and are dissatisfied with your previous work. The blockage may be a sign of good things to come. It is probably an indication that you are ready to begin on a new level of commitment or concentration, or that you may be ready to begin a new tack entirely. When you realize this, your fear—the fear of failure, which is what caused the artistic block in the first place—is reduced, converted, and put to use in constructive new work. Rigid expectations result in petrified perceptions. Loosen up, draw, draw for the fun of it! Don't put up fences between you and your art.

The richness of art is that it offers such an incredible potentiality for self-growth and expansion. It presents us with a process for self-discovery; and when we think we have come to a dead end, it surprises us with new pathways.

Presentation

Since post-modern artists have questioned every aspect of art making, it is no surprise that the way a work is presented has also been under review. Does putting a frame around a work of art indicate that it is important or that its value is increased? Modernism's stripped-down framing aesthetic is definitely being challenged by Post-Modern framing tactics. Greg Constantine presents *The World's Greatest Hits*, snippets of well-known paintings along with fragments of their historically appropriate frames (PG.D1.).

Some contemporary works on paper are attached directly to the wall by pushpins or clips, such as Jayashree Chakravarty's exhibition of scrolls made of layered, glue-stiffened paper, which twist and turn down from the ceiling and onto the floor (figure PG.D2). Chakravarty's drawings are patterned after Bengali folk scrolls; their surfaces are crumpled, worn; they show the signs of much work and handling. In spite of their monumental size, they can easily be rolled up for storage.

Some works are placed in frames that become an integral part of the art work, inseparable from it, like Jess's intimately scaled collage in its reclaimed, bás-relief frame (figure PG.D3) Some works are a part of an installation like Jennifer Bartlett's *White House*, which coexists with actual three-dimensional counterparts. A three-dimensional fence and model house stand in front of their two-dimensional depiction (PG.D4). And some drawings are made on the wall itself.

PG.D1. (above left) GREG CONSTANTINE. *The World's Greatest Hits.* 1989. Acrylic on canvas and wood, 7′5″ × 11′3″ × 8″ (2.26 m × 3.43 m × 20.3 cm). O. K. Harris Works of Art, New York.

PG.D2. (above right) JAYASHREE CHAKRAVARTY. *Untitled.* 1997. Glue-stiffened layered paper. Photo by Cathy Carver/The Drawing Center.

Richard Tuttle "frames" his drawings with a thin pencil line that is drawn directly onto the wall. Many contemporary artists show their work unframed as a sort of humbling gesture, whereas others use nontraditional, exaggerated framing devices such as those we have just seen.

The selection of drawings to represent your work is an important undertaking. Your student portfolio should show a range of techniques and abilities.

PG.D3. JESS. *Echo's Wake: Part I.* 1960–1966. Paste-up, 9′ × 12′ × 3′6″ (2.74 m × 3.66 m × 1.07 m). Photo by Ben Blackwell. Odyssia Gallery, New York.

PG.D4. JENNIFER BARTLETT. *White House.* 1985. Oil on canvas, 10′ × 16′ (3.05 m × 4.88 m); house: wood, enamel paint, tar paper, 3′9″ × 5′ × 4′10¼″ (1.14 m × 1.52 m × 1.48 m); fence: wood, enamel paint, metal, 3′ × 12′10¼″ × 5″ (91 cm × 3.92 m × 12.5 cm); pool: plywood paint, 7″ × 3′7¾″ × 31½″ (18 cm × 1.11 m × 80 cm). Private Collection. Paula Cooper Gallery, New York.

The four most important criteria to keep in mind are accuracy of observation, an understanding of the formal elements of drawing, media variety and exploration, and expressive content.

After you have chosen the pieces that best incorporate these considerations, your next concern is how to present them. The presentation, in addition to being portable, must keep the works clean and intact, free from being torn or bent. Since framing stands in the way of portability, and since framing is dependent on the work being shown, that option will not be discussed here.

Here are some possible ways to present your work: backing and covering with acetate, stitching in clear plastic envelopes, laminating, dry mounting, and matting. Each method of presentation has its advantages.

ACETATE

A widely used way of presenting work is to apply a firm backing to the drawing and then cover both drawing and backing with a layer of acetate, a clear thin plastic that holds the drawing and backing together. More important, the covering provides protection against scuffing, tearing, and soiling. (Matted drawings can also be covered with acetate.) Backing is a good option if a work is too large for matting or if the composition goes all the way to the edge and you cannot afford to lose any of the drawing behind a mat. The backing can be made from foam core or mat board. An acid-free foam core is available. If you use a backing that is not acid-free, a barrier paper should be placed between the drawing and the backing to ensure that the acid content of the backing does not leach onto the paper.

Another option is to attach the drawing with gummed linen tape to a larger piece of paper and cover it with acetate. The drawing then has a border of paper around it and can retain its edges. The drawing lies on top; it is loose, not pinned back by a mat. The size of the backing paper is an important consideration. The drawing might need a border of an inch (2.5 cm); it might need one several inches wide. Experiment with border sizes before cutting the backing paper and attaching it to the drawing.

Paper is available in more varieties and neutral colors than mat board. The choice of paper is important. The drawing and the paper it is done on should be compatible with the texture, weight, value, and color of the backing paper. Backing paper should not dominate the drawing.

A disadvantage to acetate as a protective cover is its shiny surface. This interferes with the texture of the drawing and with subtleties within the drawing.

PLASTIC ENVELOPES

If flexibility or the idea of looseness is important to the drawing, there is another simple means of presentation: stitching the drawing in an envelope of clear plastic. For a drawing of irregular shape—for example, one that does not have square corners—a plastic envelope might be an appropriate choice. A plastic casing would allow a drawing done on fabric to retain its looseness and support the idea of flexibility.

A disadvantage to clear plastic is its watery appearance and highly reflective surface, which distorts the drawing. The greatest advantage to this method of presentation is that large drawings can be rolled, shipped, and stored easily.

LAMINATION

Lamination is midway in stiffness between drawing paper and a loosely stitched plastic envelope. You are familiar with laminated drivers' licenses and credit cards.

Laminating must be done commercially. It is inexpensive, but cost should not be the most important consideration. The means of presentation must be suited to the concept in the drawing. Laminating is a highly limiting way to present work—once sealed, the drawing cannot be reworked in any way.

DRY MOUNTING

If the likelihood of soiling and scuffing is minimal, you might want to *dry mount* the drawing. You do this in exactly the same way as you dry mount a photograph, sealing the drawing to a rigid backing and leaving the surface uncovered. Dry-mount tissue is placed between drawing and backing. Heat is then

applied by means of an electric dry-mount press, or if done at home, by a warm iron. Dry-mount tissue comes in a variety of sizes; rolled tissue can be found for large drawings. This tissue must be the same size as the drawing. Wrinkling can occur, and since a drawing sealed to backing is not easily removed, extreme care should be taken in the process. Carefully read and follow the instructions on the dry-mount tissue package before you start.

Since dry mounting is done with heat, it is important that the medium used in the drawing not run or melt when it comes in contact with heat. Greasy media such as china markers, lithographic sticks, or wax crayons should not be put under the dry press for mounting.

For mounting drawings made with greasy media, you can use a spray fixative to adhere the drawing to its backing. Acid-free spray-mount should be used to protect the drawing from discoloration.

MATTING

Matting is the most popular and traditional choice for presentation. The mat separates the drawing from the wall on which it is hung and provides an interval of rest before the eye reaches the drawing. Second, a mat gives the drawing room to "breathe." Like a rest in music, it offers a stop between the drawing and the environment; it allows for uncluttered viewing of the drawing. And, finally, the mat furnishes space between the drawing and the glass when framed so that the drawing does not come into direct contact with the glass, since changes in temperature can cause moisture problems, such as wrinkling and discoloration.

Mats should not be the focus of attention nor detract from the drawing. A colored mat screams for attention and diminishes a drawing's impact. White or off-white mats are recommended at this stage, especially since most of the problems in this book do not use color. An additional argument for white mats is that art is usually displayed on white or neutrally colored walls, and the mat furnishes a gradual transition from the wall to the drawing. Most competitive shows call for works on paper to be matted in white mats.

Materials for Matting

The materials needed for matting are:

- a mat knife with a sharp blade
- 100 percent cotton rag mounting board
- gummed linen tape or acid-free paper tape
- a 36-inch-long (96-cm-long) metal straightedge
- a pencil
- a gum or vinyl eraser
- a heavy piece of cardboard to be used for a cutting surface

Change or sharpen the blade in your knife often. A ragged edge is often the result of a dull blade. A continuous stroke will produce the cleanest edge. Mat blades should not be used for cutting more than one mat before being discarded. The expense of a blade is minimal in comparison with the cost of mat board, so be generous in your use of new, sharp blades.

Do not use illustration board or other kinds of board for your mat. Cheaper varieties of backing material, since they are made from wood pulp, contain acid and will harm the drawing by staining the fibers of the paper and making them brittle. Use white or off-white, all-rag mat board, sometimes called museum board, unless special circumstances dictate otherwise. A heavy-weight, hot-pressed watercolor paper can be used as a substitute for rag board.

Masking tape, clear tape, gummed tape, and rubber cement will likewise discolor the paper and should be avoided. They will lose their adhesive quality within a year or so. Use gummed linen or all-rag paper tape, both of which are acid free.

Instructions for Matting

Use the following procedure for matting. Work on a clean surface. Wash your hands before you begin.

1. Carefully measure the drawing to be matted. The edges of the mat's opening will overlap the drawing by ⅜ inch (1 cm) on all sides.
2. For an 18- by 24-inch (46 cm × 61 cm) drawing, the mat should have a 4-inch (10 cm) width on top and sides and a 5-inch (13 cm) width at the bottom. Note that the bottom border is slightly wider—up to 20 percent—than the top and sides.
3. On the front surface of the mat board, mark lightly with a pencil the opening to be cut. You can erase later.
4. Place a straightedge on the mat just inside the penciled line toward the opening and cut. Hold down both ends of the straightedge. You may have to use your knee. Better still, enlist a friend's help. If the blade slips, the error will be on the part that is to be discarded and can, therefore, be corrected. Cut the entire line in one continuous movement. Do not start and stop. Make several single passes from top to bottom; do not try to cut through completely on your first stroke (figure PG.D5).
5. Cut a rigid backing ⅛ inch (.3 cm) smaller on all sides than the mat.
6. Lay the mat face down and align the backing so that the two tops are adjoining. Cut four or five short pieces of linen tape, and at the top, hinge the backing to the mat (figures PG.D6, PG.D7).
7. Minor ragged edges of the mat can be corrected with fine sandpaper rubbed lightly along the edge of the cut surface.
8. Erase the pencil line and other smudges on the mat with a gum or vinyl eraser.
9. Hinge the drawing to the backing at the top only. This allows the paper to stretch and contract with changes in humidity (figure PG.D8).
10. You may cover the matted drawing with acetate, which will protect both the drawing and mat. Place the backed, matted drawing face down on a sheet of acetate 2 inches (5 cm) wider on all sides than the mat. Cut 2-inch (5-cm) squares from each corner of the acetate (figure PG.D9). Fold the acetate over, pulling lightly and evenly on all sides. Attach the acetate to the backing with tape.

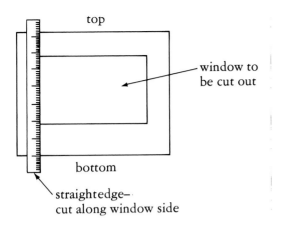

straightedge—
cut along window side

PG.D5. Cutting mat board.

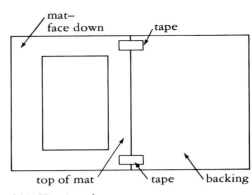

346. Hinging the mat.

PG.D6. Hinging the mat.

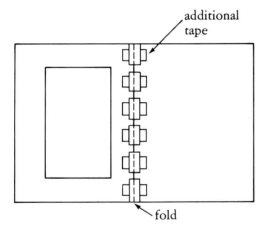

PG.D7. Hinging the mat.

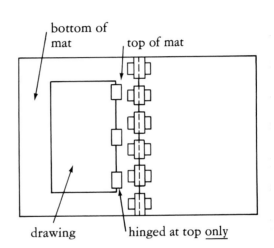

PG.D8. Hinging drawing at the top.

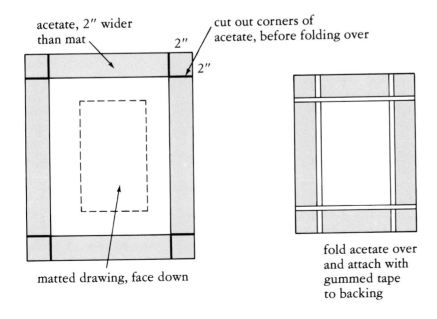

fold acetate over
and attach with
gummed tape
to backing

PG.D9. Cutting acetate.

SUMMARY

SELECTING A METHOD OF PRESENTATION

In making your decision about the most suitable presentation, you should first try to visualize the piece in a variety of ways. If you are attentive, the work itself will probably suggest an appropriate presentation. Matting is generally the safest. Stitching in plastic and lamination should be reserved for only those pieces that absolutely demand that type of presentation. Whatever your choice, remember that compatibility between drawing and method of presentation is essential.

If the manner of presentation is not clear to you, experiment with the piece. Place it in a discarded mat, or use some L-frames to crop the composition exactly right. Assess the drawing without a mat. Lay it on a larger piece of paper. Does the drawing go to the edge? Can you afford to lose half an inch (1 cm) on the borders? Is the idea of looseness or flexibility important to the drawing? Would a reflective covering detract from or enhance the drawing? What kind of surface and media are used in the drawing? What kind of backing would best complement the piece? What size mat or paper backing is the most appropriate? Does a cool white, a warm white, an off-white, a neutral, or a gray look best with the drawing? Does the size of the drawing present a problem?

Large contemporary drawings are frequently attached directly to the wall. Extra care must be taken because of the fragility of the paper and the wear and tear on the edges. Linen tape can be attached to the edges to reinforce them, but this additional weight may change the way the drawing "falls." Large drawings can be rolled and stored in cylinders.

The care and storage of individual drawings is a major professional concern. Minimal good care is simple. You should spray-fix your drawings as soon as they are finished. Remove any smudges by erasure, and store the drawings in a flat, rigid container slightly larger than the largest drawing. Metal drawing files are ideal. A large portfolio with handles is a good investment for transporting your drawings. This ensures that the drawings will not become dog-eared, soiled, bent, or smudged. You should place a clean piece of barrier paper between drawings so that the medium from one does not transfer onto another. It is interesting to note that when the artist Paul Klee died, he left 10,000 paintings, drawings, and prints, along with 4,000 pages of analytical texts. Good conservation pays off in the long run.

Your attitude toward your work influences others' attitudes. A bad drawing can be improved by good presentation, whereas a good drawing can be destroyed by poor presentation. Each drawing does not have to be regarded as a precious monument, but proper care and handling of your work are good habits to establish early in your career.

GLOSSARY

Italicized terms within the definitions are themselves defined in the glossary.

abstraction An alteration of *forms,* derived from observation or experience, in such a way as to present essential rather than particular qualities.

achromatic Relating to light and dark, the absence of *color,* as opposed to *chromatic* (relating to color).

actual texture The *tactile* quality of a surface, including the mark made by a tool, the surface on which it is made, and any foreign material added to the surface. See also *invented texture, simulated texture.*

aerial perspective The means by which atmospheric illusion is created.

aggressive line An emphatically stated *line.*

ambiguity An image or statement that can have two or more meanings; both interpretations cannot be mutually held.

ambiguous space Space that is neither clearly flat nor clearly volumetric, containing a combination of both two- and three-dimensional elements.

amoeboid shape See *organic shape.*

analogous colors Colors adjacent to one another on the color wheel.

analytical line A probing *line* that penetrates space, locating objects in relation to one another and to the space they occupy.

anthropomorphism Ascribing human form or attributes to nonhuman forms.

ant's-eye view Objects seen from below.

appropriated image An image taken from another source and used in a different context than the original.

appropriation A process used by Post-Modern artists employing ready-made ideas or images from high and low culture as subject matter in their own works.

arbitrary value *Value* that does not necessarily conform to the actual appearance of an object; the use of value

based on intuitive responses or the need to comply with compositional demands.

assemblage A work of art composed of fragments of objects or *three-dimensional* materials originally intended for other purposes; the art of making such a work.

automatic drawing A drawing in which the hand moves so quickly that conscious thought does not intervene.

axonometric projection A method of projection in which objects are drawn with their horizontal and vertical axes to scale.

background See *negative space*.

baseline The imaginary *line* on which an object or group of objects sits.

biomorphic shape See *organic shape*.

bird's-eye view Objects seen from above.

blind contour A contour exercise in which the artist never looks at the paper.

blurred line Smudged, erased, or destroyed *line*.

calligraphic line Free-flowing *line* that resembles handwriting, making use of gradual and graceful transitions.

caricature A representation in which a subject's distinctive features are exaggerated for comic effect.

cast shadow One of the six categories of *light*.

chiaroscuro *Modeling*, the gradual blending of light to dark to create a *three-dimensional* illusion.

chromatic Relating to *color*, as opposed to *achromatic* (relating to light and dark).

collage Any flat material, such as newspapers, cloth, or wallpaper, pasted on the *picture plane*.

color Visual assessment of the quality of light that is determined by its spectral composition.

color wheel A circular arrangement of twelve hues.

complementary colors Contrasting colors that lie opposite to each other on the color wheel.

composition The organization or arrangement of the *elements of art* in a given work.

conceptual drawing A drawing that in its essential *form* is conceived in the artist's mind, rather than derived from immediate visual stimuli.

cone of vision Angle of sight.

constricted line A *crabbed*, angular, tense *line*, frequently aggressively stated.

content The subject matter of a work of art, including its emotional, intellectual, *symbolic*, thematic, and narrative connotations, which together give the work its total meaning.

continuous-line drawing A drawing in which the implement remains in uninterrupted contact with the picture plane creating enclosed shapes.

contour line *Line* that delineates both the outside edge of an object and the edges of *planes*, as opposed to *outline*, which delineates only the outside edge of an object.

conventionalized space The symbolic depiction of objects in space, which has become accepted from long use.

cool colors Blues, greens, and violets.

core of shadow One of the six categories of *light*.

crabbed line See *constricted line*.

cross-contour line *Line* that describes an object's horizontal or cross contours rather than its vertical contours. Cross-contour line emphasizes the volumetric aspects of an object.

cross-hatching Creating value with sets of parallel lines that cross each other.

cursive line A line related to handwriting.

diptych A work in two parts.

directional line See *organizational line*.

disegno In Renaissance Italy a term for drawing that embodied the creative idea, the draftsman's dexterity, and the cognitive process.

elements of art The principal graphic and *plastic* devices by which an artist composes a physical work of art. The elements are *color, line, shape, texture, value,* and *volume*.

empty space See *negative space*.

expressive Dealing with feelings and emotions, as opposed to *objective* and *subjective*.

eye level An imaginary horizontal *line* parallel to the viewer's eyes.

facture The hand-made quality in a one-of-a-kind drawing.

field See *negative space*.

figure/field See *positive shape*.

figure/ground See *positive shape*.

force lines A term used by the Italian Futurists to signify lines that convey the idea of speed in space.

foreground/background See *positive shape*.

foreshortening A technique for producing the illusion of an object's extension into space by contracting its form.

form In its broadest sense, the total structure of a work of art—that is, the relation of the *elements of art* and the distinctive character of the work. In a narrower sense, the *shape*, configuration, or substance of an object.

formal elements The art elements of *line, value, shape, texture,* and *color.*

frottage A *textural* transfer technique; the process of making rubbings with graphite or crayon on paper laid over a textured surface.

fumage A *textural* technique that uses smoke as a medium.

geometric shape *Shape* created by mathematical laws and measurements, such as a circle or a square.

gestural approach A quick, all-encompassing statement of *forms.* In gesture the hand duplicates the movement of the eyes, quickly defining the subject's general characteristics—movement, weight, *shape,* tension, *scale,* and *proportion.* See *mass gesture, line gesture, mass and line gesture,* and *sustained gesture.*

grattage A textural technique that incises or scratches marks into a surface prepared with a coating, for example, gesso.

ground See *negative space.*

group theme Development of related works by members of the same schools and movements of art who share common philosophical, formal, stylistic, and subject interests.

highlight One of the six categories of *light.*

hue The characteristic of a *color* that causes it to be classified as red, green, blue, or another color.

icon An image regarded with special veneration.

iconography The study of symbols used in works of art.

illusionistic space In the graphic arts, a representation of *three-dimensional space.*

implied line A *line* that stops and starts again; the viewer's eye completes the movement that the line suggests.

implied shape A suggested or incomplete *shape* that is mentally filled in by the viewer.

incised line A *line* cut into a surface with a sharp implement.

indicative line See *organizational line.*

informational drawing A category of objective drawing, including diagrammatic, architectural, and mechanical drawing. Informational drawing clarifies concepts and ideas that may not be actually visible, such as a chemist's drawings of molecular structure.

installation A hybrid form of art that uses impermanent objects in a temporary space offering the viewer a temporal and spatial experience.

intensity The saturation, strength, or purity of a color.

interspace See *negative space.*

invented texture An invented, nonrepresentational patterning that may derive from *actual texture* but does not imitate it. Invented texture may be highly stylized.

kinetic marks Marks that convey a sense of motion.

light In the graphic arts, the relationship of light and dark patterns on a *form,* determined by the actual appearance of an object and by the type and direction of light falling on it. There are six categories of light as it falls over a form: *highlight, light tone, shadow, core of shadow, reflected light,* and *cast shadow.*

light tone One of the six categories of *light.*

line A mark made by an implement as it is drawn across a surface. See also *aggressive, analytical, blurred, calligraphic, constricted, contour, crabbed, implied, lyrical, mechanical,* and *organizational* line.

line gesture A type of gesture drawing that describes interior forms, utilizing *line* rather than *mass.* See *gestural approach.*

linear perspective See *perspective.*

local color The known color of an object regardless of the amount or quality of light on it.

lyrical line A *subjective* line that is gracefully ornate and decorative.

mass In the graphic arts, the illusion of weight or density.

mass and line gesture A type of gesture drawing that combines broad marks with thick and thin lines. See *gestural approach.*

mass gesture A type of gesture drawing in which the drawing medium is used to make broad marks to create *mass* rather than line. See *gestural approach.*

mechanical line An *objective* line that maintains its width unvaryingly along its full length.

modeling The change from light to dark across a surface; a technique for creating spatial illusion.

monochromatic A color scheme using only one color with its various hues and intensities.

montage A technique that uses pictures to create a composition.

motif A recurring thematic image, a repeated figure or design.

multiple perspectives Different *eye levels* and perspectives used in the same drawing.

negative space The space surrounding a *positive shape;* sometimes referred to as *ground, empty space, interspace, field,* or *void.*

nonobjective In the visual arts, work that intends no reference to concrete objects or persons, unlike *abstraction,* in which observed forms are sometimes altered to seem nonobjective.

objective Free from personal feelings; the emphasis is on the descriptive and factual rather than the *expressive* or *subjective*.

one-point perspective A system for depicting *three-dimensional* depth on a *two-dimensional* surface, dependent upon the illusion that all parallel lines that recede into space converge at a single point on the horizon, called the *vanishing point*.

optical color Perceived color modified by the quality of light on it.

organic shape Free-form, irregular *shape*. Also called *biomorphic* or *amoeboid shape*.

organizational line The *line* that provides the structure and basic organization for a drawing. Also called *indicative* or *directional line*.

outline *Line* that delineates only the outside edge of an object, unlike *contour line*, which also delineates the edges of *planes*.

Outsider art Art made by untrained, nonprofessional artists.

papier collé The French term for pasted paper; a technique consisting of pasting and gluing paper materials to the *picture plane*.

pastiche A combination of several imitated styles in one work.

pentimento, *plural* **pentimenti** The Italian term for the revealing of a part of a work that has been drawn or covered over, a correction that remains visible.

perception The awareness of objects through the medium of the senses.

perspective A technique for giving an illusion of space to a flat surface.

photomontage A technique that uses photographs to create a composition.

pictorial space In the graphic arts, the illusion of space. It may be relatively flat or *two-dimensional*, illusionistically *three-dimensional*, or *ambiguous space*.

picture plane The *two-dimensional* surface on which the artist works.

planar analysis An approach in which *shape* functions as *plane*, as a component of *volume*.

plane A *two-dimensional*, continuous surface with only one direction. See also *picture plane*.

plastic The appearance of *volume* and space in a *two-dimensional* painting or drawing.

pochade A French term for a quick sketch.

positive shape The *shape* of an object that serves as the subject for a drawing. The relationship between positive shape and *negative space* is sometimes called *figure/field*, *figure/ground*, *foreground/background*, or *solid/void* relationship.

predella A series of small paintings, sculptures, or drawings that form the lower edge of an altarpiece.

primary colors Red, blue, and yellow.

private theme Development by an individual artist of a personal, sustained, related series of works.

pronkstilleven Seventeenth-century Dutch still life.

proportion Comparative relationship between parts of a whole and between the parts and the whole.

reflected light One of the six categories of *light*.

rubbing A means of transferring texture from an actual tactile surface to a flat surface.

saturation See *intensity*.

scale Size and weight relationships between *forms*.

schematic drawing A drawing derived from a mental construct as opposed to visual information.

scribbled-line gesture A type of gesture drawing using a tight network of tangled *line*. See *gestural approach*.

secondary colors Colors achieved by mixing primary colors; green, orange, and violet.

semantics A branch of linguistics that deals with the study of meaning and the relationships between signs and symbols and what they represent.

semiotics A program whose goal is to identify the conventions and strategies used by art and literature to produce their effects of meaning.

sfumato A means of creating a smoky haziness that softens outlines; literal definition: "in the manner of smoke."

shadow One of the six categories of *light*.

shallow space A relatively flat space, having height and width but limited depth.

shape A *two-dimensional*, closed, or implicitly closed configuration. The two categories of shape are *organic* and *geometric shape*.

shared theme Thematic work in which the same images or subjects are used by different artists over a long period of time.

sighting The visual measurements of objects and spaces between objects.

silhouette Any dark two-dimensional shape seen against a light background.

simulated texture The imitation of the *tactile* quality of a surface; can range from a suggested imitation to a highly illusionistic duplication of the subject's texture. See also *actual texture* and *invented texture*.

simultaneity Multiple, overlapping views of an object.

solid/void See *positive shape* and *negative space*.

stacked perspective See *stacked space*.

stacked space The use of stacked parallel baselines in the same composition.

stippling A drawing or painting technique that uses dots or short strokes.

structural line *Line* that helps locate objects in relation to other objects and to the space they occupy. Structural lines follow the direction of the *planes* they locate.

stylistic eclecticism The use side by side of varying philosophies, styles, techniques, materials, and subjects.

subjective Emphasizing the artist's emotions or personal viewpoint rather than informational content; compare *objective.*

sustained gesture A type of gesture drawing that begins with a quick notation of the subject and extends into a longer analysis and correction. See *gestural approach.*

symbol A *form* or image that stands for something more than its obvious, immediate meaning.

symbolic space See *conventionalized space.*

tactile Having to do with the sense of touch. In the graphic arts, the representation of *texture.*

tenebrism Extreme contrast of light and dark.

tertiary colors Colors that result when a *primary* and a *secondary color* are mixed.

texture The *tactile* quality of a surface or its representation. The three basic types of texture are *actual, simulated,* and *invented texture.*

theme The development of a sustained series of works that are related by subject, that have an idea or image in common. See *private theme, group theme,* and *shared theme.*

three-dimensional Having height, width, and depth.

three-dimensional space In the graphic arts, the illusion of *volume* or volumetric space—that is, of space that has height, width, and depth.

three-point perspective A system for depicting *three-dimensional* depth on a *two-dimensional surface.* In ad-

dition to lines receding to two points on the horizon, lines parallel and vertical to the ground appear to converge to a third, vertical *vanishing point.*

transferred texture Texture produced by using solvents to move a printed image to the drawing.

triptych A work in three parts.

trompe-l'œil The French term for trick-the-eye illusionistic techniques. See also *simulated texture.*

thumbnail sketch A small, quick preparatory drawing to note ideas.

two-dimensional Having height and width.

two-dimensional space Space that has height and width with little or no illusion of depth, or *three-dimensional* space.

two-point perspective A system for depicting *three-dimensional* depth on a *two-dimensional* surface, dependent upon the illusion that all parallel lines converge at two points on the horizon.

value The gradation of tone from light to dark, from white through gray to black.

value scale The gradual range from white through gray to black.

vanishing point In *one-point perspective,* the single spot on the horizon where all parallel lines converge.

vanitas A still life that underscores the transitory nature of life itself.

void See *negative space.*

volume The quality of a *form* that has height, width, and depth; the representation of this quality. See also *mass.*

warm colors Reds, oranges, and yellows.

window into space The Italian Renaissance concept to convey the illusion of *three-dimensional space* on a flat surface.

works on paper A classification that includes drawings, prints, photography, book illustrations, and posters.

SUGGESTED READINGS

Suggested Readings concentrate on contemporary art and artists.

Students may also find helpful such periodicals as *ARTBYTE: The Magazine of Digital Arts, Art Forum, Art in America, Art International, Art Journal, Art News, Art on Paper, Artweek, Contemporanea, Drawing, Flash Art, New Art Examiner,* and *October.*

SURVEYS AND CRITICISM

Ades, Dawn, et al. *Art in Latin America: The Modern Era, 1920–1980.* New Haven, Conn.: Yale University Press, 1993.

Alloway, Lawrence. *American Pop Art.* New York: Macmillan, 1974.

American Abstract Drawing, 1930–1987. Little Rock: Arkansas Arts Center, 1987.

Arnason, H. H. *History of Modern Art.* 3rd ed. New York: Harry N. Abrams, 1986.

Atkins, Robert. *Artspeak. A Guide to Contemporary Ideas, Movements and Buzzwords.* New York: Hacker, 1990.

Battcock, Gregory. *Super Realism.* New York: Dutton, 1975.

Bean, Jacob. *100 European Drawings in the Metropolitan Museum of Art.* New York: Metropolitan Museum of Art, 1964.

Behr, Shulamith. *Women Expressionists.* New York: Abbeville, 1988.

Beier, Ulli. *Contemporary Art in Africa.* New York: Praeger, 1968.

Benezra, Neal, and Olga M. Viso. *Distemper: Dissonant Themes in the Art of the 1990s.* Washington, D.C.: Smithsonian Institution, 1996.

Berger, John. *The Sense of Sight.* New York: Pantheon, 1985.

Berger, John. *Ways of Seeing.* London: BBC and Penguin, 1972.

Berman, Patricia. *Modern Hieroglyphs: Gestural Drawing and the European Vanguard.* Philadelphia: University of Pennsylvania Press, 1995.

Bown, Matthew Cullerne. *Contemporary Russian Art.* New York: Philosophical Library, 1990.

Butler, Cornelia H. *Afterimage: Drawing Through Process.* Los Angeles: Museum of Contemporary Art, 1999.

Carlin, John, and Sheena Wagstaff. *The Comic Art Show.* New York: Whitney Museum of American Art, 1983.

Casslman, Bart, ed. *The Sublime Void: On the Memory of the Imagination.* New York: Ludion, 1995.

Cathcart, Linda L. *American Still Life 1945–1983.* Houston: Contemporary Arts Museum, 1983.

Celant, Germano, ed. *Biennale di Venezia [XLVII Esposizione, 1997].* Venice: Electa, 1997.

Clay, Jean. *Modern Art, 1890 to 1990.* New York: B. K. Sales, 1989.

Cole, Robert. *Their Eyes Meeting the World: The Drawings and Paintings of Children.* Boston: Houghton Mifflin, 1995.

Colpitt, Frances. *Minimal Art, The Critical Perspective.* Seattle: University of Washington Press, 1993.

Constructivism and the Geometric Tradition. New York: McCrory Corporation Collection, 1979.

Cooper, Douglas. *The Cubist Epoch.* New York: Praeger, 1971.

Danto, Arthur C. *The Philosophical Disenfranchisement of Art.* New York: Columbia University Press, 1986.

Danto, Arthur C. *The State of the Art.* New York: Columbia University Press, 1987.

Davies, Hugh M., and Ronald J. Onorato. *Blurring the Boundaries: Installation Art 1969–1996.* San Diego: Museum of Contemporary Art, 1997.

Dennison, Lisa. *New Horizons in American Art.* New York: Solomon R. Guggenheim Museum, 1989.

Dietich-Boorsch, Dorothea. *German Drawings of the 60s.* New Haven, Conn.: Yale University Press, 1982.

Dowell, M., and D. Robbins. *Cubist Drawings, 1907–1929.* Houston: Janie C. Lee Gallery, 1982.

Drawings from the Permanent Collection. Fort Worth, Tex.: Modern Art Museum of Fort Worth.

Drawings: Recent Acquisitions. New York: Museum of Modern Art, 1967.

Drawn-Out. Washington, D.C.: Corcoran Gallery of Art, 1987.

Elderfield, John. *The Modern Drawing: 100 Works on Paper from the Museum of Modern Art.* London: Thames and Hudson, 1984.

Foote, Nancy, ed. *Drawings: The Pluralist Decade.* Philadelphia: Institute of Contemporary Art, 1981.

A Forest of Signs, Art in the Crisis of Representation. New York: Museum of Contemporary Art, 1989.

Foster, Hal, ed. *The Anti-Aesthetic: Essays on Postmodern Culture.* Port Townsend, Wash.: Bay Press, 1983.

Fox, Howard N., Miranda McClintic, and Phyllis Roxenzweig. *Content, A Contemporary Focus 1974–1984.* Washington, D.C.: Smithsonian Institution, 1984.

Fusco, Coco. *English Is Broken Here: Notes on Cultural Fusion in the Americas.* New York: New Press, 1995.

Gablik, Suzi. *Conversations Before the End of Time.* New York: Thames and Hudson, 1995.

Garcia, Rupert. *Aspects of Resistance.* New York: Alternative Museum, 1994.

Godfrey, Tony. *Drawing Today, Draughtsmen in the Eighties.* Oxford: Phaidon, 1990.

Godfrey, Tony. *The New Image: Painting in the 1980s.* New York: Abbeville, 1986.

Golden, Thelma, et al. *Art: 21: Art in the Twenty-First Century.* New York: Harry N. Abrams, 2001.

Gottlieb, Carla. *Beyond Modern Art.* New York: Dutton, 1976.

Grynsztejn, Madeleine. *About Place: Recent Art of the Americas.* Chicago: Art Institute of Chicago, 1995.

Heller, Reinhold. *Art in Germany 1909–1936. From Expressionism to Resistance.* New York: Milwaukee Art Museum, 1990.

Heller, Reinhold. *Brucke, German Expressionists Prints from the Granvil and Marcia Specks Collection.* Evanston, Ill.: Northwestern University, 1989.

Horst, De la Croix, and Richard G. Tansey. *Gardner's Art Through the Ages,* 8th ed. New York: Harcourt Brace Jovanovich, 1986.

Humphries, Lloyd. *Art of Our Time: The Saatchi Collection.* Vols. 1–4. New York: International Publishing, 1985.

Jones, Lois S. *Art Information and the Internet: How to Find It, How to Use It.* Greenwood, N.C.: Greenwood Publishing Group, 1998.

Kurtz, Bruce D. *Contemporary Art, 1965–1990.* Englewood Cliffs, N.J.: Prentice-Hall, 1992.

Kuspit, Donald. *Donald Kuspit: The Dialectic of Decadence.* Boston: MIT Press, 1995.

Large-Scale Drawings from the Kramarsky Collection. Ridgefield, Conn.: Aldrich Museum of Contemporary Art, 1998.

Lauter, Estella. *Women as Mythmakers.* Bloomington, Ill.: Indiana University Press, 1984.

Lee, Pamela, and Christine Mehring. *"Drawing Is Another Kind of Language."* Cambridge, Mass.: Harvard University Press, 1997.

Leslie, Clare Walker. *Nature Drawing: A Tool for Learning.* New York: Simon and Schuster, 1980.

Lippard, Lucy. *From the Center.* New York: Dutton, 1976.

Lippard, Lucy. *Six Years: The Dematerialization of the Art Object from 1966 to 1972.* New York: Praeger, 1973.

Livingstone, Marco. *Jim Dine: Flowers and Plants.* New York: Harry N. Abrams, 1994.

MacGregor, John M. *The Discovery of the Art of the Insane.* Princeton, N.J.: Princeton University Press, 1989.

Maresca, Frank, and Roger Ricco. *American Self-Taught: Paintings and Drawings by Outsider Artists.* New York: Alfred A. Knopf, 1995.

Martin, Marianne. *Futurism Art and Theory, 1909–1915.* London: Oxford University Press, 1968.

Marx, Sammburg. *Beuys, Rauschenberg, Twombly, Warhol.* Munich: Prestel Verlag, 1982.

McQuiston, Liz. *Graphic Agitation: Social and Political Graphics Since the Sixties.* New York: Phaidon, 1993.

McQuiston, Liz. *Women in Design: A Contemporary View.* New York: Rizzoli, 1988.

Modern Latin American Painting, Drawings and Sculpture. New York: Sotheby, 1989.

The Monumental Image. Rohnert Park, Calif.: Sonoma State University, 1987.

Morgan, Stuart, and Frances Morris. *Rites of Passage: Art for the End of the Century.* London: Tate Gallery Publications, 1995.

Moskowitz, Ira, ed. *Great Drawings of All Time, III. French 13th Century to 1919.* New York: Shorewood, 1962.

Newman, Charles. *The Post-Modern Aura.* Evanston, Ill.: Northwestern University Press, 1985.

Norris and Benjamin. *What Is Deconstruction?* London: St. Martin's, 1988.

Objects and Drawings II. Little Rock: Arkansas Art Center, 1994.

Paz, Octavio. *Convergences: Essays on Art and Literature.* San Diego: Harcourt Brace Jovanovich, 1987.

Perry, Gill, et al. *Primitivism, Cubism, Abstraction: The Early Twentieth Century.* New Haven, Conn.: Yale University Press, 1993.

Pincus-Witten, Robert. *Postminimalism.* New York: Out of London Press, 1977.

Plagens, Peter. *Sunshine Muse.* New York: Praeger, 1974.

Plous, Phyllis, and Mary Looker. *Neo York.* Santa Barbara, Calif.: University Art Museum, 1989.

Raven, Arlene, et al., eds. *Feminist Art Criticism: An Anthology.* Ann Arbor, Mich.: UMI Research Press, 1988.

Rawson, Philip. *Drawing.* University of Pennsylvania Press, 1987.

Re-Aligning Vision: Alternative Currents in South American Drawing, 1960–1990. New York: Museo del Barrio, 1997.

Revelations. Little Rock: Arkansas Arts Center, 1984.

Risatti, Howard, ed. *Postmodern Perspective: Issues in Contemporary Art.* Englewood Cliffs, N.J.: Prentice-Hall, 1990.

Rose, Barbara. *Drawing Now.* New York: Museum of Modern Art, 1976.

Rose, Bernice. *Allegories of Modernism.* New York: Museum of Modern Art, 1992.

Rosenzweig, Phyllis D. *Directions '86.* Washington, D.C.: Hirshhorn Museum and Sculpture Gardens, 1986.

Rowell, Margit. *Objects of Desire: The Modern Still Life.* New York: Museum of Modern Art, 1997.

Rubin, William S. *Dada and Surrealist Art.* New York: Abrams, 1969.

Rye, Jane. *Futurism.* London: Dutton, 1972.

Sandler, Irving. *Art of the Postmodern Era from the Late 1960s to the Early 1990s.* Boulder, Colo.: Westview, 1996.

Selz, Peter. *Art in Our Times: A Pictorial History 1890–1980.* New York: Harcourt Brace Jovanovich/Abrams, 1981.

75th American Exhibition. Chicago: Art Institute of Chicago, 1986.

Smagula, Howard. *Currents: Contemporary Directions in the Visual Arts.* Englewood Cliffs, N.J.: Prentice-Hall, 1983.

Solomon, Elke M. *American Drawings 1963–1973.* New York: Whitney Museum of American Art, 1973.

Stebbins, Theodore E. *American Master Drawings and Watercolors: A History of Works on Paper from Colonial Times to the Present.* New York: The Drawing Society, 1976.

Steinberg, Leo. *Other Criteria: Confrontations with Twentieth-Century Art.* London: Oxford University Press, 1972.

Stella, Frank. *Working Space.* Cambridge, Mass.: Harvard University Press, 1986.

Storr, Robert, et al. *Art: 21: Art in the Twenty-First Century.* New York: Abrams, 2001.

Tansey, Richard G. *Gardner's Art Through the Ages.* Wadsworth, 2000.

Tiberghien, Gilles A. *Land Art.* Princeton, N.J.: Princeton Architectural Press, 1995.

Tomkins, Calvin. *Post-to-Neo, The Art World of the 1980s.* New York: Henry Holt, 1989.

Tuchman, Maurice, ed. *The Spiritual in Art—Abstract Painting 1890–1985.* New York: Abbeville, 1986.

Tucker, Marcia. *Bad Painting in "Bad" Painting.* New York: New Museum, 1978.

Tupitsyn, Margarita, curator. *After Perestroika: Kitchenmaids or Stateswomen.* New York: Independent Curators, 1993.

Twenty-fourth Bienal de São Paulo. São Paulo: Fundacão Bienal de São Paulo, 1998.

Varnedoe, Kirk, and Adam Copnick. *High and Low: Modern Art and Popular Culture.* New York: Abrams, 1990.

Varnedoe, Kirk, and Adam Copnick, eds. *Modern Art and Popular Culture: Readings in High and Low Art.* New York: Abrams, 1990.

Vergine, Lea. *Art on the Cutting Edge: A Guide to Contemporary Movements.* Milan: Skira, 1996.

Vogel, Susan. *Africa Explores: 20th Century African Art.* New York: Center for African Art, Munich: Prestel Verlag, 1991.

Vogel, Sabine. *4th International Istanbul Biennial.* Istanbul Foundation of Culture and Arts, 1995.

Waldman, Diane. *British Art Now: An American Perspective.* New York: Solomon R. Guggenheim Museum, 1980.

Waldman, Diane. *Collage, Assemblage, and the Found Object.* New York: Abrams, 1995.

Waldman, Diane. *New Perspectives in American Art.* New York: Solomon R. Guggenheim Museum, 1983.

Wallis, Brian, ed. *Art After Modernism. Rethinking Representation.* Boston: New Museum of Contemporary Art, 1985.

Warren, Tracey, and Amelia Jones. *The Artist's Body.* London: Phaidon, 2000.

Weber, Bruce. *The Fine Line: Drawing with Silver in America.* West Palm Beach, Fla.: Norton Gallery of Art, 1985.

Whitney Museum's Biennial Catalogs. New York: Whitney Museum of Art, from 1981 to 2001.

Wilkins, David G., and Bernard Schultz. *Art Past/Art Present:* New York: Abrams, 1990.

Wolfe, Townsend. *The Face.* Little Rock: Arkansas Art Center, 1988.

Wolfe, Townsend. *The Figure.* Little Rock: Arkansas Art Center, 1988.

Wolfe, Townsend. *National Drawing Invitational.* Little Rock: Arkansas Art Center, 1994 and 1998.

Wolfe, Townsend. *Revelations: Drawing—America.* Little Rock: Arkansas Art Center, 1988.

Wolfe, Townsend. *Twentieth-Century American Drawings.* Little Rock: Arkansas Art Center, 1984.

Wolfe, Townsend, and Ruth Pasquine. *Large Drawings and Objects.* Little Rock: Arkansas Art Center, 1996.

Women Choose Women. New York: Worldwide Books, 1973.

Works on Paper. Washington, D.C.: Smithsonian Institution Press, 1977.

Wye, Deborah. *Committed to Print.* New York: Museum of Modern Art, 1988.

COLOR

Albers, Josef. *Interaction of Color,* rev. ed. New Haven, Conn.: Yale University Press, 1972.

Birren, Faber. *Principles of Color.* New York: Van Nostrand Reinhold, 1969.

Doyle, Michael E. *Color Drawing.* New York: Van Nostrand Reinhold, 1981.

Fabri, Frank. *Color: A Complete Guide for Artists.* New York: Watson-Guptill, 1967.

Itten, Johannes. *The Art of Color.* New York: Van Nostrand Reinhold, 1974.

Poling, Clark V. *Kandinsky's Teaching at the Bauhaus: Color Theory and Analytical Drawing.* New York: Rizzoli, 1986.

PERSPECTIVE

Cole, Rex Vicat. *Perspective: The Practice & Theory of Perspective as Applied to Pictures.* Philadelphia: Lippincott, 1922.

D'Amelio, Joseph. *Perspective Drawing Handbook.* New York: Leon Amiel, 1964.

Dubery, Fred, and John Willats. *Perspective and Other Drawing Systems.* London: Herbet, 1983.

Montague, John. *Basic Perspective Drawing/ A Visual Approach.* New York: Van Nostrand Reinhold, 1985.

Norton, Dora M. *Freehand Perspective and Sketching.* New York: Bridgman Publishers, 1929.

Powell, William. *Perspective.* New York: W. Foster, 1989.

Walters, Nigel V., and John Bromham. *Principles of Perspective.* New York: Watson-Guptill, 1974.

WORKS ON INDIVIDUAL ARTISTS

John Baldessari
Tucker, Marcia, and Robert Pincus-Witten. *John Baldessari.* New York: The New Museum, 1981.

Van Bruggen, Coosje. *John Baldessari.* New York: Rizzoli, 1990.

Balthus
Clair, Jean. *Balthus.* New York: Rizzoli, 2001.

Jennifer Bartlett
Goldwater, Marge. *Jennifer Bartlett.* New York: Abbeville Press, 1990.

Russell, John. *Jennifer Bartlett: in the Garden.* New York: Abrams, 1982.

Georg Baselitz
Corral, Maria, and Elvira Maluquer. *Georg Baselitz.* Madrid: Fundacion Caja de Pensiones, 1990.

Waldman, Diane. *Georg Baselitz.* New York: Guggenheim/Abrams, 1995.

Jean-Michel Basquiat
Marshall, Richard. *Jean-Michel Basquiat.* New York: Whitney/Abrams, 1995.

Romare Bearden
Romare Bearden: The Prevalence of Ritual. New York: Museum of Modern Art, 1971.

Linda Benglis
Linda Benglis 3-Dimensional Painting. Chicago: Museum of Contemporary Art, 1980.

Joseph Beuys
Adriani, Götz. *Joseph Beuys: Drawings, Objects and Prints.* Berlin: Institute for Foreign Cultural Relations and the Goethe Institute, 1995.

Schade, Werner. *Joseph Beuys: The Early Drawings.* New York: Shirmer/Mosel/ Norton, 1995.

Temkin, Anne, and Bernice Rose. *Thinking Is Form: The Drawings of Joseph Beuys.* Philadelphia: Philadelphia Museum of Art/Thames and Hudson, 1995.

Jonathan Borofsky
Rosenthal, Mark, and Richard Marshall. *Jonathan Borofsky.* New York: Philadelphia Museum of Art/Whitney, 1984.

Louise Bourgeois
Bourgeois, Louise, and Lawrence Rinder. *Drawings & Observations.* New York: Bulfinch, 1996.

Paul Cézanne
Chappeuis, Adrien. *The Drawings of Paul Cézanne.* Greenwich, Conn.: New York Graphic Society, 1973.

Christo
Schellman, Jorg, and Josephine Benecke, eds. *Christo Prints and Objects.* New York: Abbeville Press, 1987.

Francesco Clemente
Percy, Ann, and Raymond Foye. *Francesco Clemente: Three Worlds.* New York: Rizzoli, 1990.

Chuck Close
Guare, John. *Chuck Close: Life and Work 1988– 1995.* London: Thames and Hudson, 1995.

Yau, John. *Chuck Close: Recent Paintings.* Los Angeles: Pace Wildenstein Gallery, 1995.

Joseph Cornell
Joseph Cornell. Museum of Modern Art. 1990.

Waldman, Diane. *Joseph Cornell.* New York: Braziller, 1977.

Richard Diebenkorn
Richard Diebenkorn, Paintings and Drawings, 1943–1980. Buffalo, N.Y.: Rizzoli, for Albright-Knox Art Gallery, 1980.

Jim Dine
Gordon, John. *Jim Dine.* New York: Praeger/ Whitney Museum of American Art, 1970.

Livingstone, Marco. *Jim Dine: Flowers and Plants.* New York: Abrams, 1994.

Jean Dubuffet
Drawings, Jean Dubuffet. New York: Museum of Modern Art, 1968.

Marcel Duchamp
Marcel Duchamp. New York: Museum of Modern Art and Philadelphia Museum of Art, 1973.

Baruchello, Gianfranco, and Henry Martin. *The Imagination of Art (How to Imagine and Why Duchamp).* Kingston, N.Y.: McPherson, 1986.

Lucian Freud
Penny, Nicolas, and Robert Johnson. *Lucian Freud: Works on Paper.* London: Thames and Hudson, 1988.

Alberto Giacometti
Bonnefoy, Yves. *Giacometti.* New York: Abbeville, 1995.

Giacometti, Alberto. *Giacometti, A Sketchbook of Interpretive Drawings.* New York: Abrams, 1967.

Robert Gober
Marta, Karen, ed. *Robert Gober.* New York: Dia Center for the Arts/D.A.P., 1995.

Nancy Graves
Padon, Thomas. *Nancy Graves: Excavations in Print.* New York: Abrams, 1996.

Juan Gris
Rosenthal, Mark. *Juan Gris.* Berkeley, Calif.: 1983.

Red Grooms
Tully, Judd. *Red Grooms and Ruckus Manhattan.* New York: Braziller, 1977.

George Grosz
George Grosz. Love Above All, and Other Drawings: 120 Works by George Grosz. New York: Dover, 1971.

Philip Guston
Dabrowski, Magdalena. *The Drawings of Philip Guston.* New York: Museum of Modern Art, 1988.

Jane Hammond
Snyder, Jill. *Jane Hammond: The Ashbery Collaboration.* Cleveland: Cleveland Center for Contemporary Art, 2001.

David Hockney
Luckhardt, Ulrich, and Paul Melia. *David Hockney: A Drawing Retrospective.* Los Angeles: Chronicle Books, 1995.

Melia, Paul, ed. *David Hockney.* New York: St. Martin's Press, 1995.

Tuchman, Maurice, and Stephanie Barron. *David Hockney: A Retrospective.* New York: Museum of Modern Art, 1988.

Jenny Holzer
Waldman, Diane. *Jenny Holzer.* New York: Abrams, 1990.

Yvonne Jacquette
Yvonne Jacquette. Catalog with essay by Carter Ratcliff. New York: Museum of Modern Art, 1990.

Neil Jenney
Rosenthal, Mark. *Neil Jenney.* Berkeley: University Art Museum, 1981.

Jess
Jess: A Grand Collage 1951–1993. Buffalo: Albright-Knox Art Gallery, 1993.

Jasper Johns
Castleman, Riva. *Jasper Johns: A Print Retrospective.* New York: Museum of Modern Art, 1986.

Francis, Richard. *Jasper Johns.* New York: Abbeville Press, 1984.

Rosenthal, Mark. *Jasper Johns Work Since 1974.* Philadelphia: Philadelphia Museum of Art, 1988.

Shapiro, David. *Jasper Johns: Drawings, 1954–84.* New York: Abrams, 1984.

Ilya Kabakov
Ilya Kabakov: The Man Who Never Threw Anything Away. New York: Abrams, 1996.

Wassily Kandinsky
Grohmann, Will. *Kandinsky.* London: Thames and Hudson, 1959.

William Kentridge
Tone, Lilian. *William Kentridge.* New York: Museum of Modern Art, 1999.

Anselm Kiefer
Rosenthal, Mark. *Anselm Kiefer.* New York: Te Neues, 1988.

Paul Klee
Grohmann, Will. *Paul Klee.* New York: Abrams, 1945.

Barbara Kruger
Linker, Kate. *Love for Sale: The Words and Pictures of Barbara Kruger.* New York: Abrams, 1990.

Rico Lebrun
Rico Lebrun: Drawings. Berkeley: University of California Press, 1968.

Fernand Léger
Fabre, Gladys C., Barbara Rose, and Marie-Odile Briot. *Léger and the Modern Spirit, An Avant-Garde Alternative to Non-Objective Art.* Houston: Museum of Fine Arts, 1983.

Sol LeWitt
Minimalism. Seattle: University of Washington Press, 1990.

Reynolds, Jack, and Andrea Miller-Keller. *Sol LeWitt: Twenty-Five Years of Wall Drawings, 1968–1993.* Seattle: University of Washington Press, 1995.

Roy Lichtenstein
Waldman, Diane. *Roy Lichtenstein.* New York: Rizzoli/Guggenheim Museum, 1993.

Richard Long
Seymour, Anne, and Hamish Fulton. *Richard Long: Walking in Circles.* New York: Braziller, 1995.

Robert Longo
Fox, Howard N. *Robert Longo.* New York: L.A. County Museum/Rizzoli, 1989.

Nino Longobardi
Rose, Barbara. *Living on the Edge.* Lund, Sweden: Kalejdoskop Förlag, 1987.

David Macaulay
Macaulay, David. *Great Moments of Architecture.* Boston: Houghton Mifflin, 1978.

Brice Marden
Kertess, Klaus. *Seeing in Imaging: Brice Marden, Paintings and Drawings.* New York: Abrams, 1992.

Lewison, Jeremy. *Brice Marden Prints, 1961–1991.* London: Tate Gallery, 1992.

Henri Matisse
Elderfield, John. *Henri Matisse: A Retrospective.* New York: Museum of Modern Art, 1992.

Matisse as a Draughtsman. Greenwich, Conn./ New York: Graphic Society/Baltimore Museum of Art, 1971.

Mario Merz
Eccher, Danilo. *Mario Merz.* New York: Hopeful Moster, 1995.

Annette Messager
Conkelton, Sheryl, and Carol S. Eliel. *Annette Messager.* New York: Harry N. Abrams, 1995.

Grenier, Catherine. *Annette Messager.* Paris: Flammarion, 2001.

Joan Miró
Rowell, Margit. *The Captured Imagination: Drawings by Joan Miró from the Fundacio Joan Miró, Barcelona.* New York: American Federation of the Arts, 1987.

Piet Mondrian
Hammacher, A. M. *Mondrian, De Stijl and Their Impact.* New York: Marlborough, 1964.

Mondrian, Piet. *The New Art—The New Life: The Collected Writings of Piet Mondrian.*

Edited by Harry Holtzman and Martin St. James. Boston: G. K. Hall, 1986.

Henry Moore
Andrews, Julian, et al. *Celebrating Moore: Works from the Collection of the Henry Moore Foundation.* Berkeley and London: University of California Press, 1998.

Garrould, Ann, ed. *Henry Moore Drawings.* London: Thames and Hudson, 1988.

Giorgio Morandi
Vitale, Lamberto. *Giorgio Morandi.* 2 vols. Florence, Italy: Ufizzi, 1983.

Robert Morris
Minimalism. Seattle: University of Washington Press, 1990.

Bruce Nauman
Bruce Nauman Drawings, 1965–86. Basel: Museum für Gegenwartskunst, 1986.

Van Bruggen, Coosje. *Bruce Nauman.* New York: Rizzoli, 1987.

Alice Neel
Hills, Patricia. *Alice Neel.* New York: Abrams, 1983.

Shirin Neshat
Dabashi, Hamid, et al. *Shirin Neshat.* Milan: Charta, 2002.

Claes Oldenburg
Baro, Gene. *Claes Oldenburg: Prints and Drawings.* London: Chelsea House, 1969.

Celant, Germano, and Mark Rosenthal. *Claes Oldenburg: An Anthology.* New York: Guggenheim/Abrams, 1995.

Haskell, Barbara. *Claes Oldenburg: Objects into Monument.* Pasadena, Calif.: Pasadena Art Museum, 1971.

Oldenburg, Claes. *Notes in Hand.* New York: Dutton, 1971.

Philip Pearlstein
Philip Pearlstein Watercolors and Drawings. New York: Alan Frumkin Gallery, n.d.

A. R. Penck
Grisebach, Lucius, ed. *A. R. Penck.* Munich: Berlin National Galerie. Prestel Verlag, 1988.

Yau, John. *A. R. Penck.* New York: Abrams, 1995.

Pablo Picasso
Picasso: His Recent Drawings 1966–68. New York: Abrams, 1969.

Rose, Bernice. *Picasso and Drawing.* New York: Pace Wildenstein, 1995.

Sigmar Polke
Sigmar Polke Drawings 1962–1988. Bonn: Kunstmuseum, 1988.

Jackson Pollock

Friedman, B. H. *Jackson Pollock: Energy Made Visible*. New York: McGraw-Hill, 1972.

O'Connor, Francis V. *Jackson Pollock*. New York: Museum of Modern Art, 1967.

Kathy Prendergast

McKee, Francis. *Kathy Prendergast: The End and the Beginning*. London: Merrell Publishers, 1999.

Robert Rauschenberg

Hopps, Walter, and Susan Davidson. *Robert Rauschenberg: A Retrospective*. New York: Guggenheim Museum, 1997.

Paula Rego

Paula Rego. London: Tate Gallery Publishing, 1997.

Gerhard Richter

Obrist, Hans Ulrich, ed. *Gerhard Richter, The Daily Practice of Painting, Writings 1962–1993*. Cambridge, Mass.: Anthony d'Offay/MIT, 1995.

Schwarz, Dieter. *Gerhard Richter: Drawings 1964–1999*. Düsseldorf: Kunstmuseum Winterthur/Richter Verlag, 1999.

Larry Rivers

Rivers, Larry. *Drawings and Digressions*. New York: Clarkson Potter, 1979.

Julian Schnabel

Julian Schnabel Works on Paper 1975–1988. Munich: Prestel Verlag, 1990.

Kurt Schwitters

Elderfield, John. *Kurt Schwitters*. London: Thames and Hudson, 1985.

Richard Serra

Serra, Richard. *Richard Serra: Writings/Interviews*. Chicago: University of Chicago Press, 1994.

Kiki Smith

Posner, Helaine. *Kiki Smith*. New York: Bulfinch, 1998.

Robert Smithson

Robert Smithson: Drawings. New York: New York Cultural Center, 1974.

Robert Smithson Unearthed: Drawings, Collages, Writings. New York: Columbia University Press, 1991.

Saul Steinberg

Rosenberg, Harold. *Saul Steinberg*. New York: Knopf, 1978.

Pat Steir

Arbitrary Order: Paintings by Pat Steir. Houston: Contemporary Arts Museum, 1983.

Steir, Pat. *Pat Steir*. New York: Abrams, 1986.

Donald Sultan

Donald Sultan. New York: Museum of Contemporary Art, Chicago, and Abrams, 1987.

Stephen Talasnik

Stephen Talasnik: Drawings 1990–1994. Greensboro: University of North Carolina Press, 1995.

Mark Tansey

Freeman, Judi. *Mark Tansey*. San Francisco: Chronicle Books, 1993.

Robbe-Grillet, Alain. *Mark Tansey*. Los Angeles: L.A. County Museum, 1995.

Wayne Thiebaud

Beal, Graham W. J. *Wayne Thiebaud Painting*. Minneapolis: Walker Art Center, 1981.

Tsujimoto, Karen. *Wayne Thiebaud*. San Francisco: San Francisco Museum of Modern Art, 1985.

Wayne Thiebaud Survey 1947–1976. Phoenix, Ariz.: Phoenix Art Museum, 1976.

Jean Tinguely

Hulten, K. G. Pontus. *Jean Tinguely: Meta*. Greenwich, Conn.: New York Graphic Society, 1975.

Mark Tobey

Rathbone, Eliza E. *Mark Tobey*. Washington, D.C.: National Gallery of Art, 1986.

Richard Tuttle

The Poetry of Form: Richard Tuttle Drawings from the Vogel Collection. Amsterdam; Institute of Contemporary Art, 1992.

Cy Twombly

Bastian, Heiner, ed. *Cy Twombly: Catalogue Raisonné of the Paintings Volume IV 1972–1995*. Berlin: Schirmer/Mosel, 1995.

Andy Warhol

McShine, Kynaston. *Andy Warhol: A Retrospective*. New York: Museum of Modern Art, 1989.

William T. Wiley

Wiley Territory. Minneapolis: Walker Art Center, 1979.

Terry Winters

Phillips, Lisa. *Terry Winters*. New York: Whitney Museum of American Art, 1991.

Plous, Phyllis. *Terry Winters, Painting and Drawing*. Santa Barbara, Calif.: University Art Museum, 1987.

INDEX